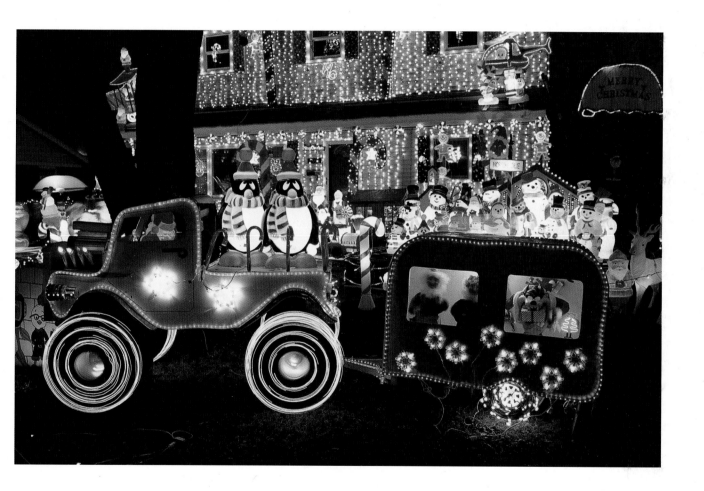

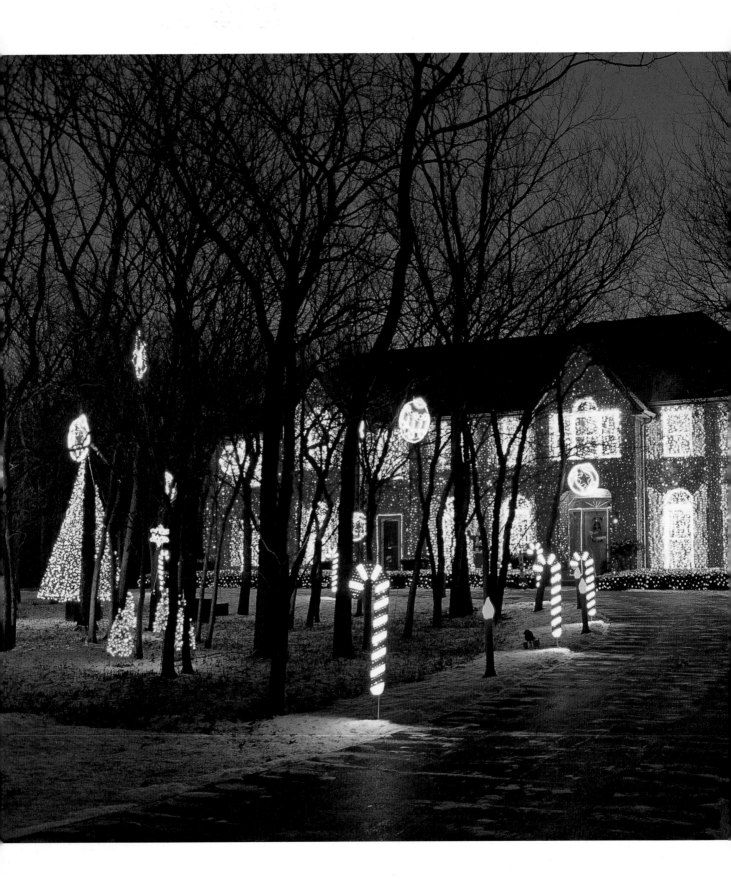

The Best CHRISTMAS DECORATIONS in Chicagoland

Your Guide to More Than 200 Spectacular Holiday Displays

MARY EDSEY

Voyageur
Press

First published in 2008 by Voyageur Press, an
imprint of MBI Publishing Company, 400 First
Avenue North, Suite 300, Minneapolis, MN 55401 USA

Copyright © 2008 by Mary Edsey
Photographs copyright © 2008 by Mary Edsey, unless otherwise noted
Revised from the original edition published in 1995 by Tabagio Press

The information in this book is true and complete to the best
of our knowledge. All recommendations are made without any
guarantee on the part of the Author or Publisher, who also
disclaim any liability incurred in connection with the use of
this data or specific details.

We recognize, further, that some words, model names, and
designations mentioned herein are the property of the trademark
holder. We use them for identification purposes only. This is not
an official publication.

Voyageur Press titles are also available at discounts in bulk
quantity for industrial or sales-promotional use. For details write
to Special Sales Manager at MBI Publishing Company, 400 First
Avenue North, Suite 300, Minneapolis, MN 55401 USA.

To find out more about our books, join us online at
www.voyageurpress.com.
For decorator updates, photo licensing, bus-tour information, and
more, visit www.christmashouses.com.

ISBN-13: 978-0-7603-3229-0
Editor: Margret Aldrich
Designer: Jennifer Tischler
 Danielle Smith

Printed in Singapore

Library of Congress Cataloging-in-Publication Data

Edsey, Mary.
 The best Christmas decorations in Chicagoland: your guide to
more than 200 spectacular holiday displays / Mary Edsey. – Rev. ed.
 p. cm.
 Includes index.
 ISBN 978-0-7603-3229-0 (pbk. : alk. paper) 1. Christmas
decorations–Illinois–Chicago Metropolitan Area–Guidebooks.
2. Chicago Metropolitan Area (Ill.)–Social life and customs–
Guidebooks. I. Title.
 TT900.C4E43 2008
 917.73'11—dc22
 2008008604

On the front cover: The Disalvio/Moser home in the Portage Park
neighborhood on Chicago's northwest side (p. 50)

On the frontis: A homemade holiday truck and camper trailer at
the Kasper home in south–suburban Chicago Ridge (p. 110)

On the title pages: The Kazmier home in northwest–suburban
South Barrington (p. 105)

On the back cover: The Merchandise Mart in downtown
Chicago (p. 18), Courtright's Restaurant in south–suburban
Willow Springs (p. 120), Juniper Lane in the Kane County
town of South Elgin (p. 153)

Author photo by Jennifer Girard

To my dear friend Dave Ireland,
whose loving memory will forever
bring joy to my life.

Antioch

Lake Villa

Zion

Round Lake Beach

Grayslake

McHenry County

Woodstock

Oakwood Hills

Lake County

Wauconda

Libertyville

Lake Forest

LAKE MICHIGAN

Vernon Hills

Crystal Lake

Cary

Lake Zurich

Long Grove

Fox River Grove

North Barrington

Barrington

Sleepy Hollow

South Barrington

Palatine

Wheeling

North-brook

Glencoe

Winnetka

Cook County Northwest

Arlington Heights

Cook County North

Glenview

Wilmette

Mt. Prospect

Niles

Skokie

Hoffman Estates

Des Plaines

Morton Grove

Lincolnwood

Elgin

Streamwood

Schaumburg

Rosemont

Park Ridge

Evanston

Roselle

Elk Grove Village

South Elgin

Bensenville

Chicago North

Kane County

Wayne

Glendale Heights

Schiller Park

River Grove

Elmwood Park

St. Charles

Wheaton

Glen Ellyn

Elmhurst

River Forest

Chicago Downtown

Geneva

DuPage County

Oak Brook

Cook County West

Oak Park

Batavia

Lisle

Downers Grove

Westmont

Westchester

Riverside

Chicago South

Brookfield

La Grange

Sugar Grove

Aurora

Naperville

Woodridge

Bridgeview

Evergreen Park

Willow Springs

Oak Lawn

Palos Hills

Chicago Ridge

Bolingbrook

Lemont

Crestwood

Cook County South

Lockport

Orland Park

Orland Hills

Tinley Park

South Holland

Crest Hill

Mokena

Sauk Village

South Chicago Heights

Hammond

Dyer

Schere

Will County

NW INDIA

Bishop Hill

Monee

East Peoria Belleville

Chicago and Vicinity

N

W E

S

0 MILES 10

Contents

Acknowledgments

This publication of *The Best Christmas Decorations in Chicagoland* would have been unlikely were it not for the successful sales of the first self-published edition. With only a short stack remaining from the skidloads that once filled my basement, I would first like to sincerely thank all the people who helped make room for my shop tools once again. Special thanks to my family, who sold books to their friends, made sales pitches to storeowners, delivered books from the trunks of their cars, allowed me to use their homes as distribution sites, and attended my book signings more than once. To my friends, who threw release parties, gave my book away as presents, did clerical work amid the chaos, and listened to me talk about Christmas in June. To the decorators, who didn't mind my annual requests for updates. To all the booksellers and librarians who gave my book shelf space. To all the media who considered it newsworthy. And to everyone who bought the book, especially those who took the time to tell me they enjoyed it.

Having survived self-publishing, I am now delighted to thank my editor, Margret Aldrich, for being so nice to work with. And to Michael Dregni and the folks at Voyageur Press for their enthusiasm and for taking some of the load off.

On this second go around, I would once again like to give special thanks to my mom, who boosts my confidence with her unfailing love, support, and encouragement, as only a mother can do. And to my sister Cathy, who has been my sounding board, my human thesaurus, my companion on house hunts, and my faithful source of encouragement as only a sister can be. To my brother David for his kind and professional legal assistance. To my brother Michael, my sister-in-law Pam, and my nephew Mark for lending me their cameras. To my brother Steve for his professional sales advice and helpful contacts. To my brother Tom and Lynda, Luke, Tyler, and Kyle and my brother Don for helping find houses. To my sister Chris in LA for thankfully being available for late night calls and much-needed winter vacations.

Heartfelt thanks to Chris Grygiel, whose dear friendship, legible penmanship, and wonderful sense of direction made the annual house searches in her neck of the woods more fun and less confusing. Thanks also to Linda and Al Honrath, Ken Draus, Dave Ireland, Lori Goldberg, and John Kazmier, who aided in the hunt and added to the fun in their direction. To Connie and Ellis Matheu, Kathleen Van De Graaff, Cathy Fulton, and the many other people who led me to new displays. To Howard Mundt, Nancy Sullivan, Anna Ramaglia, Phyllis Greco, Carol and Lou Munao, Joy Belluomini, Barbara Owens, Marge Bajus, Millie Munao, Carl Turano, Larry Wardzala, Carl Morello, and James Hempe for their additional information on Candy Cane Lane. And to all the librarians, public relations staff, and others who provided holiday facts.

Sincere gratitude to Diane Jaroch, Sharon Roth, Dave Spohn, and Pattie Hall for their publishing advice. To Mary Norris for her kind referral. To Robert Preskill and Amy Cook for their legal assistance. To Ken Draus and the kind man at the light bulb company for their electrical expertise. To Kristin Mount, Collette Wilde, Bob Skeet, and Paul Martin for their computer assistance. To Ruth Broder for her organizational assistance. To Precision Imaging and Photo Inc., Precision Camera Works, Bernie Aguirre, and the folks at DigitalWork for their kind service. To Ray Reiss for his photography advice.

Thanks to Cathy Collins, Dave Panozzo, Sue Paremba, Jeff Shank, and Lesley Martin for their emergency clerical assistance. To Sandy Belford for her clerical help and for joining me in frequent walks that got me away from the computer. To my neighbors for shoveling my snow when I had no time to do it myself. To Tim Andersen for his surprise meals. To Margarete Gross, Cynthia Gallaher, Ottmar Brandau, Paula Harris, Peter Van De Graaff, and Pam Danzinger for their kind assistance. And to the woman who helped organize my photos several years ago and anyone else who helped that I can't remember.

Most of all, thank you so much to all the decorators in this book, especially those who have been at it since the last edition, for taking the time to share your stories and decorating hints with me. You have made this experience a joy. And to decorators everywhere for working so hard to brighten our long winter nights and add so much cheer to our holidays.

Opposite page: The city's towering Christmas tree is one of the holiday attractions at Daley Plaza in downtown Chicago (p. 15).

Introduction

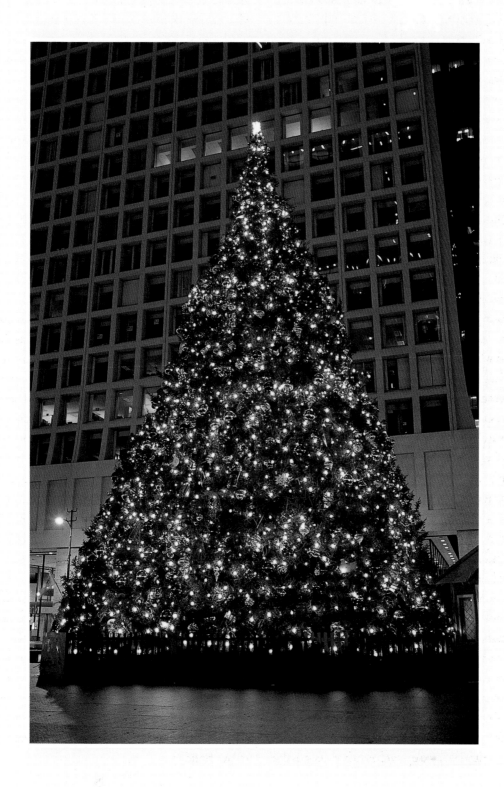

Thirteen years since the original edition of *The Best Christmas Decorations in Chicagoland* was first published, it is finally back by popular demand. Completely revised, this award-winning guide currently features 157 new displays in addition to 79 repeat locations that have grown better each holiday season.

The Best Christmas Decorations in Chicagoland celebrates a holiday decorating tradition with origins as far back as the days of the Roman Empire. Though today's plastic, lighted figurines may differ from the greenery that trimmed homes for the ancient Roman new year's celebrations, both express the human desire to add merriment to a feast by dressing up our surroundings.

The Americanization of this tradition can be traced to the New York home of Edward Johnson, a colleague of Thomas Edison, who in 1882 became the proud owner of the first electrically lighted Christmas tree. Trimmed in eighty hand-wired bulbs of red, white, and blue, the glistening evergreen marked the beginning of our love affair with holiday lights.

By the late 1880s, the General Electric Company was mass-producing the small bulbs. However, installation required the costly service of a "wireman," who would connect the lights to separate wires and then to an overhead light fixture. At thousands of today's dollars, it was a custom reserved for the wealthy. In 1903, the Ever-Ready Company manufactured the first ready-made Christmas light wiring. The strands were called "festoons" and came with twenty-eight sockets and bulbs. Though less expensive than the previous methods, the cost was still equivalent to the weekly salary of the average man.

Holiday lights moved outdoors in 1909 when the first all-weather wiring prompted the city of Pasadena, California, to light a community tree atop Mt. Wilson. It was not until 1925, however, that General Electric began promoting the use of outdoor Christmas lights to the public. In a letter to GE employees, company executive J. K. Kewley wrote: "The use of incandescent lamps for the lighting of Christmas trees inside the home is now almost universal. Only in scattered instances, however, has there been any attempt to emphasize the application of lamps to outdoor Christmas time decorations." To publicize the concept, the company exhibited a glowing display of Christmas trees, signs, stars, festoons, and floodlighting outside its headquarters in Cleveland, Ohio, and has been displaying an outdoor lighted exhibit every year since.

Meanwhile, as early as 1899, *Good Housekeeping* magazine had suggested decorating outdoors with "a stiff round wreath hung in the center of the window sash." By the late thirties and early forties, gardening writers were promoting decorating the outside of the home for holiday fun. However, the trimmings were still a luxury in this era when a large number of homes had no running water, let alone electricity for decorations.

It was not until after World War II that outdoor Christmas displays finally became popular with the middle class. The end of the war brought a feeling of optimism and prosperity unknown to most who had lived through both the Depression and the war. "The late forties and early fifties were the heyday of outdoor illumination," says Gene Teslovic, a collector of Christmas lights and manufacturers' catalogs. "Mass-production brought down the cost, making lights more affordable for the average homeowner, and magazine advertisements featuring elaborately decorated homes brought the idea to the public's attention."

Homemade displays had been a popular addition to the trimmings until the early fifties when ready-made decorations made their appearance. Union Products, one of the oldest manufacturers of lawn ornaments, sold their first two-dimensional outdoor Christmas display of a sleigh and reindeer in 1952. Two years later they began selling three-dimensional foam-plastic outdoor figures. "They were very spongy and a favorite toy of dogs, who loved to eat them," said Don Featherstone, vice president of the company. By 1956 styrene was found to be a plastic that could withstand the heat of a bulb, so the company began to use the material to mass-produce, through injection molding, plastic lighted figurines similar to those sold today. "At about the same time, aluminum Christmas trees became popular. Together with plastic figurines, they created a more carefree attitude about house decorations that required less effort," said Teslovic.

The energy crisis of 1973 brought an abrupt halt to the decorating craze, as Americans complied with President Nixon's request to refrain from holiday lighting. "We were a multi-million-dollar business, whose sales dropped to

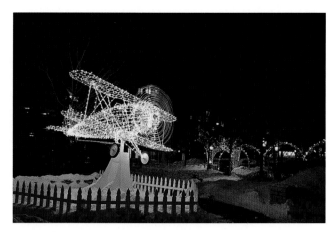

A glistening bi-plane with a spinning propeller is among the handcrafted creations of Arlington Heights Park District employees for North School Park (p. 87).

$100,000 that year," Featherstone stated. "It took five or six years before people started buying decorations again as they had."

As the baby-boom generation began buying houses, the country experienced the second rise in the popularity of elaborate outdoor displays, which continues today. Nostalgic for the past, decorators are re-creating their holiday childhood memories for their own children. New technology, low-cost miniature bulbs, blow molded plastic figurines, mass-produced animated dolls, wire displays, and inflatable decorations have made decorating more affordable than ever. According to several recent surveys, over 60 percent of Americans now trim the outside of their homes for Christmas.

Throughout the years, Chicagoans have enjoyed this yuletide trend, now familiar throughout North America. The city's earnest displays have certainly been influenced by the local plant facilities of NOMA Christmas and Silvestri Corp., two of the world's largest light manufacturers. Polk Bros. appliance and furniture store also had a significant impact on local decorators by offering a 5-foot 3-inch lighted plastic Santa with every major purchase. Over the course of the four-year promotion, which began in 1962, 250,000 "Jolly Polk Santas" began appearing on lawns all over Chicagoland.

Joint neighborhood efforts were first seen here in the thirties, when the affluent homes of Longwood Drive in the Beverly neighborhood were drawing crowds with their lighted homes and shrubbery. "At that time to see

Christmas lights outlining a house was really something," recalls longtime Chicagoan John Ryan. In the late forties, the northwest-side neighborhood of Sauganash was a holiday attraction with its numerous lights and homemade decorations. The themed streets of the "Candy Cane Lane" neighborhood and the well-lit suburb of Lincolnwood were popular places to view decorations on the north side in the fifties and sixties. And in Evanston, manger scenes flourished as the Christian Family Christmas Committee sponsored its first "Put Christ Back into Christmas" drive in 1952, awarding an 8-inch bench saw for the best religious display. In downtown Chicago, the Merchandise Mart began to glow with the largest "Merry Christmas" sign in the world in 1941, and Marina Towers, built in 1964, lit up the Loop with its balconies of white lights.

Today, downtown gleams with more decorated skyscrapers and lobbies than ever before, and neighborhoods twinkle from Tinley Park to Zion. *The Best Christmas Decorations in Chicagoland* takes you on a holiday tour of 236 of the most unique and outstanding displays that brighten the area, while also featuring notable exhibits of the past. Though unforeseen circumstances may arise, the author has made every effort to include only locations in which the decorators plan to continue their displays for many years. In fact, most of the exhibits grow more elaborate each season. But just to be sure, readers can check the author's website www.christmashouses.com for annual decorator updates before planning an excursion.

As the stories reveal, the decorators range in age from youngsters helping their parents to senior citizens still climbing out on the roof. They include families that work together and women who tackle the task alone. However, in most households interviewed, the men decorate the outside of the house and the women the inside. Decorating budgets vary from the frugal use of aluminum foil and the kids' stuffed animals to an annual splurge on commercial animation and computerized systems. Tastes and styles may differ among those who practice this holiday craft, but to all it seems to be a source of creative expression.

To help you enjoy the displays, the book is divided alphabetically by county with the first three chapters devoted to the city of Chicago. Each chapter is subdivided alphabetically by town (or neighborhood within Chicago)

and then by street address. If the town has a municipal display, it is listed first. Each location, except for references to past exhibits, is preceded by a number, which can be found on the map at the beginning of each chapter. To locate a display, find the number on the map and then refer to the detailed directions at the end of the story about the display. In the directions, mileage is estimated to the nearest ¼ mile. Distances given in blocks (bl.) refer to the number of streets passed (whether cross streets or T's). Decorating times are sometimes longer than listed during the week before Christmas. Decorating hints and additional holiday stories are highlighted in sidebars.

For an extra-pleasant tour, pack a flashlight (so your navigator can read the directions), ice scrapers (so your passengers can keep the inside of the windows clear), and hot chocolate (just for the fun of it). To avoid possible crowds, visit the displays early in the holiday season, after Christmas Day, or on weekdays before Christmas week. And whether you are loading the kids in the car with their pajamas under their snowsuits, taking Granny for a holiday ride, enjoying a romantic evening for two, or treating yourself to a yuletide drive—here's wishing you a fun-filled holiday adventure!

Franklin Park's Roger Hammill Square at Belmont and Edgington provides a lovely backdrop for holiday photos in a horse-drawn sleigh.

Opposite page: *Trimmed with stars, reindeer, potted Christmas trees, and thousands of lights, Navy Pier's Dock Street (p. 16) provides a magical holiday walk with a terrific view of the city's skyline.*

CHAPTER 1
Chicago~Downtown

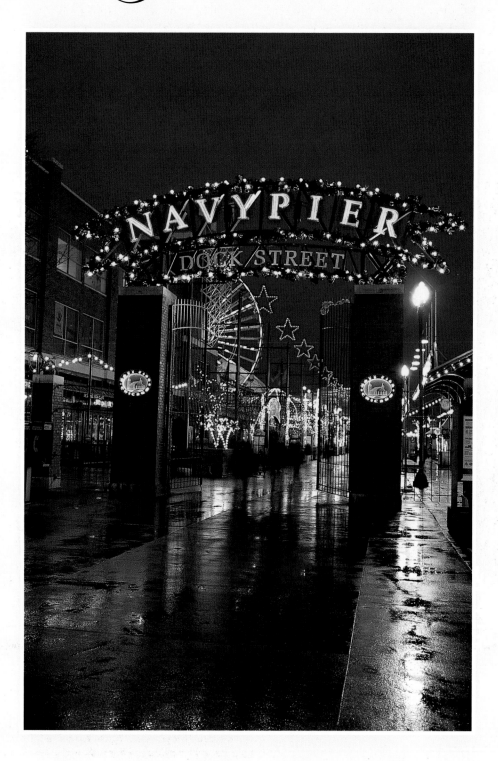

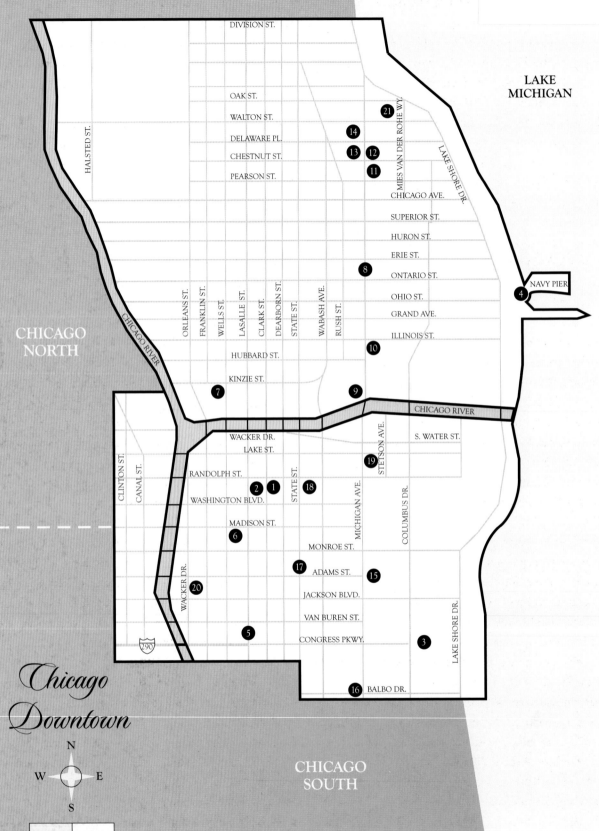

LAKE
MICHIGAN

DIVISION ST.

OAK ST.

WALTON ST.

DELAWARE PL.

CHESTNUT ST.

PEARSON ST.

CHICAGO AVE.

SUPERIOR ST.

HURON ST.

ERIE ST.

ONTARIO ST.

OHIO ST.

GRAND AVE.

ILLINOIS ST.

HALSTED ST.

MIES VAN DER ROHE WY.

LAKE SHORE DR.

NAVY PIER

CHICAGO
NORTH

CHICAGO RIVER

ORLEANS ST.
FRANKLIN ST.
WELLS ST.
LASALLE ST.
CLARK ST.
DEARBORN ST.
STATE ST.
WABASH AVE.
RUSH ST.

HUBBARD ST.

KINZIE ST.

CHICAGO RIVER

S. WATER ST.

STETSON AVE.

WACKER DR.

LAKE ST.

RANDOLPH ST.

WASHINGTON BLVD.

STATE ST.

MICHIGAN AVE.

COLUMBUS DR.

CLINTON ST.
CANAL ST.

MADISON ST.

MONROE ST.

ADAMS ST.

JACKSON BLVD.

WACKER DR.

VAN BUREN ST.

CONGRESS PKWY.

LAKE SHORE DR.

290

BALBO DR.

Chicago
Downtown

N
W E
S

0 MILES 1/4

CHICAGO
SOUTH

1 THE CHICAGO CHRISTMAS TREE AND "CHRISTKINDLMARKET CHICAGO" DALEY PLAZA

On the evening of December 24, 1913, twelve mounted trumpeters of the First Illinois Cavalry escorted Mayor Carter H. Harrison from City Hall to Grant Park to light the town's first municipal Christmas tree.

The 85-foot Douglas spruce decorated with six hundred colored lights was the main attraction of the evening. One hundred thousand onlookers were also treated to the songs of American opera singers, who projected into megaphones from the balcony of the Chicago Athletic Association, and the Paulist and Swedish choruses, who chanted from the portico of the Art Institute. As entertainment for the children, motion pictures were projected onto a large outdoor screen that could be seen from two blocks away.

Throughout the century the tradition of the city Christmas tree continued while changing with the times. Though the glorious evergreen maintained its stature, by 1956 it was constructed of one 45-foot crowning tree, mounted at the top of a pole, and eighty-five to ninety smaller trees that filled in the base. With over 2,000 ornaments, 4,400 lights, and a huge star at the top, it was a spectacular sight at its Congress Parkway and Michigan Avenue location, where it appeared each Christmas through 1965.

The grand tree was moved to the Civic Center plaza (now Daley Plaza) in 1966, where it has stood every year since (with the exception of 1981–1982 when Mayor Jane Byrne had it moved to State Street and Wacker Drive). At its most grand, it measured 90 feet in height with a central system of platforms and ladders that made it possible to walk up the center. It also grew to a cost of nearly $150,000 and required a week's labor of workers from six city bureaus. In 1991, the tree was shortened to half the height and a third of the budget. When the plaza was renovated in 1995, the city's tree returned to its grand height, and in 2002 expanded to 40 feet in width. A delightful G-scale train layout was also added to the plaza, as well as symbols of the holidays of various cultures.

At the tree-lighting ceremony on the Friday after Thanksgiving, Santa Claus now shares the spotlight with the Christkindl, a fairy-like woman with golden trusses, who officially opens "Christkindlmarket Chicago."

Inspired by the famous holiday market in Nuremberg, Germany, the Chicago market, held in Daley Plaza since 1997, features daily entertainment and over fifty open-air vendors in log-style booths with gaily striped canopies, selling traditional nutcrackers, beer steins, cuckoo clocks, and wooden ornaments as well as tasty sausages, schnitzel, stollen, strudel, and glühwein.

Tree: Fri. after Thanksgiving–Jan. 6, Day and night. (312)744-3370. www.cityofchicago.org/specialevents. Christkindlmarket: Fri. after Thanksgiving–Dec. 23, 11:00AM–9:00PM, Thanksgiving and Christmas Eve –4:00PM. (312)494-2175. www.christkindlmarket.com. *At Clark St. and Washington St. See photograph on p. 9.*

2 COUNTY BUILDING/CITY HALL 118 NORTH CLARK STREET 121 NORTH LASALLE STREET

Throughout the holiday season, Room 112 of the Office of Cook County Treasurer celebrates the ethnic diversity of its constituents with "Holiday Trees from Around the World." Representing a good portion of the 137 spoken languages in the county, nearly ninety colorful trees line the marble counter and fill the aisles. A Kenyan tree is covered in clay faces, gourds, and drums. A Slovenian tree is filled with foil-wrapped candy, nuts, and wooden apples. And a Native American Indian tree hides a small pouch of tobacco for a special blessing. Buddhist, Hindu, Muslim, Jewish, and Kwanzaa feasts are also represented.

The trees are decorated by organizations or individuals, some of whom spend hours trimming their tree. "Watching the decorators put love and respect into the tree of their culture is a joy," said Cook County Treasurer Maria Pappas, who initiated the effort in 2003. "But when all the trees are done, they are one thing—a miracle of unity."

Further down the lobby at City Hall, the holiday fun continues with a sleigh, a G-scale train chugging around a 15-foot Christmas tree, and lunchtime performances by local school choirs.

County exhibit: Fri. after Thanksgiving–Jan. 10, (M–F) 9:00AM–5:00PM. (312)603-6268. Lunchtime concerts: 1st Mon. of Dec.–Fri. before Christmas, (M–F) 12:00PM–1:00PM. (312)744-3370. www.cityofchicago.org/specialevents. Free admission. *Between Randolph St. and Washington St.*

3 BUCKINGHAM FOUNTAIN
COLUMBUS DRIVE AND
CONGRESS PARKWAY

From April to October, Buckingham Fountain produces a spectacular water and light display that has dazzled viewers since the Grant Park fountain was completed in 1927. Chicago philanthropist Kate Buckingham, who financed the construction and subsequent upkeep of the fountain as a gift to the people of Chicago and a memorial to her brother, worked with lighting technicians for many nights testing glass filters and currents to achieve the "soft moonlight" effect she envisioned.

Were she alive today, she would likely approve of the Chicago Park District's effort to light Buckingham Fountain in the winter months when the fountain is still and dark. Six staff electricians spend up to eight days carefully draping 38,000 lights around the basins of the pink marble fountain to give the appearance the water is still flowing. **Fri. after Thanksgiving–Feb. 13, 4:30PM–7:00AM.** *From Michigan Ave., W on Congress Pkwy. 2 bl.*

4 NAVY PIER
600 EAST GRAND AVENUE

Dressed in 2,894 C-9 bulbs, a cascade of eighty-two giant snowflakes and a 150-foot Ferris wheel whirling with lights against the night sky, Navy Pier beckons all who pass to enter its gates and explore its holiday splendor. Lake Michigan's chilly winter winds may cause some locals to shiver at the notion, but the off-peak season is the perfect time to see what all the tourists are crowing about. There are plenty of indoor activities—the Crystal Gardens (a 32,000-square-foot botanical getaway), Chicago Children's

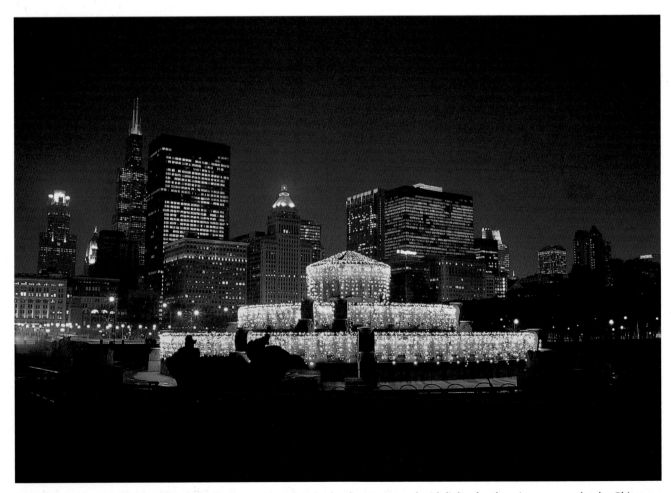

Buckingham Fountain, one of Chicago's most notable landmarks, has been trimmed with lights for the winter season by the Chicago Park District since 1996.

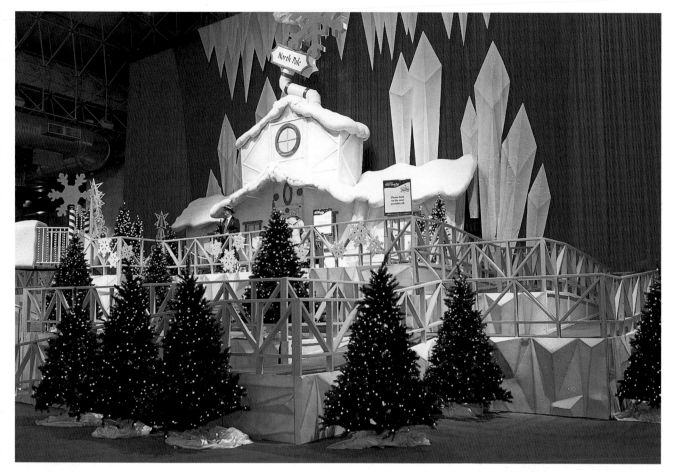

Mr. and Mrs. Santa receive children's e-wishes perched high atop "North Pole Mountain."

Museum, IMAX Theater, Smith Museum of Stained Glass Windows, and dozens of unique shops and restaurants. And no Chicagoan worth their salt should miss a brisk outdoor stroll along Dock Street with a fabulous view of the Chicago skyline and a pathway glimmering with lights.

Since 2001, "Winter WonderFest" has added to the yuletide gaiety with 150,000 square feet of colorful sights and fun activities for kids of all ages. Over five hundred twinkling Christmas trees and 750,000 lights transform Festival Hall (normally an exhibition area) into a dazzling playland.

A trackless train takes riders on a tour of "Reindeer Village" and circles around the fest's magnificent 42-foot Christmas tree. Costumed holiday characters amuse the kids as they wait to enjoy unique rides and games including inflatable slides and obstacle courses, virtual skiing and snowboarding games, a too-cool game station, a giant rocking horse, a musical carousel, and a 50-foot Ferris wheel. Little ones can send Santa an e-wish on "North Pole

Mountain" or frost their own cookie at "Create-a-Cookie Cottage." Displays of Santas from around the world and Christmas trees trimmed by professional designers and ethnic organizations provide quiet entertainment between rides. Local groups and professional entertainers perform on two stages, while skaters are welcome to perform their own feats on the 150-foot "Artic Ice Rink."

And for those who can't stay up until midnight on December 31, Navy Pier also hosts a family-style "New Year's Eve Bash" with early fireworks at 7:00 p.m. **Navy Pier lights: Fri. after Thanksgiving–2nd Fri. of Feb., Dusk–12:00AM. Navy Pier holiday hours: Dec. 7–Jan. 6, (Su–Th) 10:00AM–8:00PM, (F–Sa)– 10:00PM. Dec. 24–5:00PM. New Year's Eve–6:30PM. Closed Christmas. Free admission. Activity fee or other fees may be applicable. Parking fee or take free trolley from State St. (800)595-PIER. www.navypier.com.** *From Lake Shore Dr., W on Illinois St. or Grand Ave. 1 bl.*

5 CHICAGO BOARD OF TRADE 141 WEST JACKSON BOULEVARD

The classy holiday trimmings in the plaza and lobbies of this beautiful Art Deco building offer viewers another reason to stop in for a visit.

Mon. after Thanksgiving–New Year's Eve, (M–F) 8:00AM–5:00PM. *At LaSalle St.*

6 181 WEST MADISON BUILDING

Approaching the Loop on the Dan Ryan Expressway at Christmastime, building engineer José Chavarria proudly directs his children's attention to this glowing red and green skyscraper he helped to light. A beacon of holiday cheer since 1991, the fifty-story 181 West Madison Building was a pioneer in the growing trend to paint the skyline in holiday hues. José and four other engineers— Jerry Palmere, Glenn Georgen, Joe Dudek, and Walt Schickel—spend several chilly hours on five levels of balconies manually covering sixteen exterior lamps with colored glass filters and one hundred older lamps with heat-resistant colored film and duct tape to create the delightful effect.

Currently managed by MB Real Estate, the office building's yuletide spirit continues in the lobby (open to the public), where an elaborate holiday scene, created by

Children are welcome to ride the train on weekends in the playful lobby of the 181 West Madison Building.

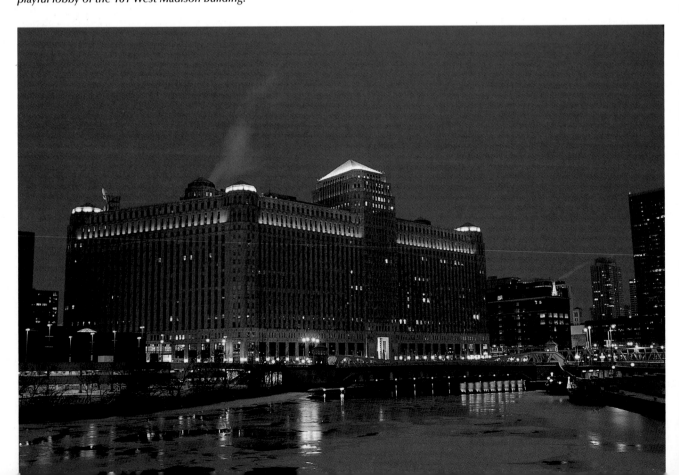

Greens By White, Inc., features over 120 stuffed animals surrounded by a rideable train. Ranging in size from an 8-inch owl to a life-size deer, the plush figures are offered for "adoption" at the end of the season to building tenants. The display sells out in three days, and the money is donated to a local charity.

With such themes in past years as "The Madison Express," "Circus Under the Big Top," "It's Snowing Cats and Dogs," and "A Holiday at the Zoo," a visit to mommy or daddy's office during the holidays is anything but dull. The kids may even get free candy and a train ride. **Tower: Mon. after Thanksgiving–Jan.1, 5:00PM– 1:00AM. Lobby: Mon. after Thanksgiving–Sun. before Christmas, (M–F) 7:00AM–6:00PM, (Sa–Su) 8:00AM– 3:00PM. Free train rides: 1st three weekends of Dec., 10:00AM–2:00PM.** *At Wells St.*

7 MERCHANDISE MART

When the second-largest building in the United States is festooned for the holidays, it dusts the city with its joyful spirit like a fairy godmother spreading good cheer. The Merchandise Mart had been adorned since 1941 with up to 16,000 light bulbs that formed an annually changing display and a giant "Merry Christmas" sign. With the energy crisis of the seventies, all the building's outdoor lighting was discontinued, including the white incandescent floodlights that had illuminated the facade year-round.

The costly bulbs were eventually replaced with energy-efficient 150-watt high-pressure sodium floodlights. They not only reflect a golden glow around the massive building's two-block perimeter each evening, but since 1992 have allowed the Mart to dress for the holidays once again.

"We were able to develop a way to do it that was economical," explained the building's former electrical engineer Chuck Lorenz, who designed the current system. Hinged metal frames were custom crafted for the 556 12" x 12" lights. When the colors are changed, theatrical gels are installed in the frames in an operation that four workers can complete in an afternoon. The lights, spaced 10 feet apart, rest on the balconies that surround the

Opposite page: The massive Merchandise Mart paints the city's skyline in holiday hues.

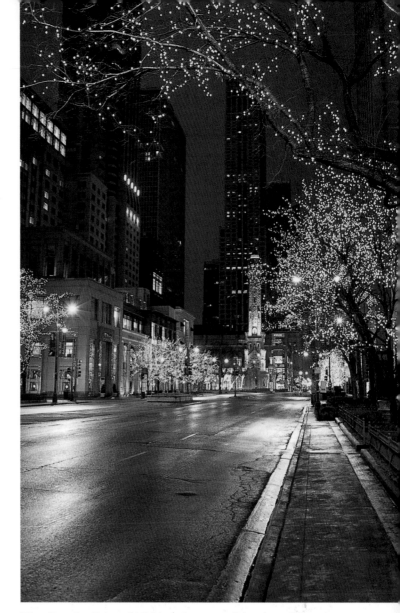

The glistening lights of Michigan Avenue and the glow of the famed Water Tower create a peaceful stillness in the wee hours of a winter night.

building, making them easily accessible. So accessible that current electrical engineer Mike Murphy and his crew now change the color of the lights for St. Patrick's Day, Mother's Day, Fourth of July, and other special occasions. **Thanksgiving–New Year's, Dusk–11:00PM.** *At the Chicago River between Wells St. and Orleans St.*

8 NORTH MICHIGAN AVENUE

In 1959 Saks Fifth Avenue was located across the street from its present location, and Joe Kreis was the store's display artist. Having recently sold the ornate Christmas tree that traditionally decorated Saks's exterior, Kreis was looking for a new idea.

He approached local display manufacturer George Silvestri, with whom he had worked in the past. Silvestri was enthused about some inexpensive strands of small white lights he had found while traveling in Italy. The tiny lights were quite a departure from the large multicolored bulbs being used at the time and seemed too fragile to withstand Chicago's winter winds. However, the two men had come up with an exciting idea that for merely three cents a light they were willing to try.

Kreis hired Arrow Sign Co. to outline every limb of the six bare elm trees in front of the store with the unusual lights. After spending an entire day on one tree, the company increased their bill for the tedious task to Kreis's total holiday display budget. The end result was worth the price. It dazzled not only Joe Kreis, but other Michigan Avenue merchants as well.

The following year several other stores began to follow suit, and the Michigan Avenue tradition was born. It took a little over ten years, however, for the street to reach its well-lit appearance and become known as the "Avenue of White Lights."

Lighting ceremonies in the early sixties included such nationally famous personalities as Betty Hutton, Carmen Miranda, Betty Grable, Geraldine Page, and Jerry Lewis. But after a few years the ceremony was discontinued, and the lights turned on with little fanfare.

RUDOLPH THE CAB

Those who enjoy taxi rides with colorful cabbies will certainly thrill to being driven by a man from the North Pole dressed in a red velvet suit and cap. He's easy to spot—his cab sports giant antlers and a flashing red nose.

Passengers lucky enough to catch one of the "Rudolph the Cab" taxis will receive a free ride and candy as well. Yellow Cab Company and Checker Cab Company will donate the amount on the meter to a charitable organization. Riders are welcome to make additional contributions.

Early Dec.–Christmas, during business hours.
(312) TAXICAB

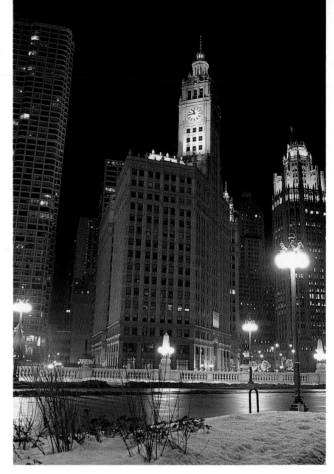

The Wrigley Building's new energy-efficient lighting system not only uses 50 percent less power, but colors its crown in red and green for Christmas.

In 1992, The Greater North Michigan Avenue Association initiated a lighting procession that traveled south from Oak Street to Pioneer Court. Horse-drawn carriages, double-decker buses, Santa Claus, strolling musicians, carolers, and elves illuminated the trees block by block and attracted a crowd of over 50,000 onlookers.

Today the exclusive stores on Chicago's famous "Magnificent Mile" dazzle shoppers with more than a million lights on two hundred trees. Hundreds of thousands of spectators pack the sidewalks on the Saturday before Thanksgiving for "The Magnificent Mile Lights Festival," a fun-filled day of ice-carving, musical entertainment, hands-on children's activities, and other special events, culminating in a spectacular parade of more than two dozen lighted floats and Disney characters and a fireworks display over the river. Master of ceremonies Mickey Mouse leads the crowd in a countdown on every block to magically set the trees aglow in a style Joe Kreis and George Silvestri could only have imagined in their wildest dreams.

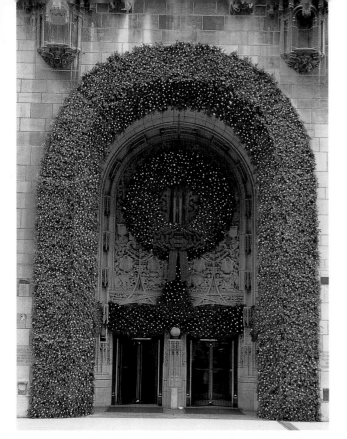

Visitors awed by the Tribune Tower's glistening entry shouldn't miss the stunning 18-foot lobby tree decorated by staff volunteers.

Lights: Sat. before Thanksgiving–Feb. 1, Day and night. Lights Festival: 11:00AM–10:00PM. Parade: 6:00PM–7:00PM. (312)642-3570. www.themagnificentmile.com. *From Oak St. to the Chicago River.*

9 WRIGLEY BUILDING
400 NORTH MICHIGAN AVENUE

With its white, terra-cotta facade illuminated by 129 floodlights beaming from the roof of the Kirk soap factory nearby, the 425-foot Wrigley Building was not only the tallest structure in Chicago when it was first occupied in 1921 but the most brilliant feature on the city's skyline. Its glow reached farther still—across the city and over the lakefront—with a searchlight lantern, 9 feet in diameter, that crowned its magnificent clock tower.

Though the lantern has long been retired, the facade has remained lit each evening with the exception of World War II, a new light installation in 1971, and the energy crisis of the midseventies. The Wrigley Building is still one of the country's largest commercial light displays.

Yet during past holiday seasons, when many prominent downtown buildings lit their towers in seasonal hues, the most famous lighted structure in the city retained its standard white glow and celebrated the holiday instead with a forest of twenty-six lighted evergreens on its third-floor bridge and 8-foot wreaths over its entryways.

But in 2005, when the third generation of floodlighting was installed and the lantern was restored, the oldest office tower on North Michigan Avenue not only had the most state-of-the-art lighting system in town but the capability for the easiest holiday light show.

Changing the colors of the lights on most buildings requires hours of labor—sliding colored tubes over fluorescent bulbs or covering hundreds of floodlights on chilly rooftops with theatrical gels. With the new LED floodlighting system at the top of the clock tower, Wrigley Building engineers can change the colors of the lantern and ornamental colonnade by simply typing in a few changes on a computer screen in the warmth of an office. With a limitless palette and an assortment of commands, the building not only dons a red and green crown for the Christmas season, but puts on a kinetic multicolored show for New Year's. With an entire calendar of over twenty seasonal and commemorative light displays now scheduled throughout the year, Operations and Project Manager Rita Gaskins admits, "We're having a lot of fun with this. I especially like the mock pumpkin for Halloween."

Housekeeping Manager Helen Pitorak has joined in the gaiety as well. "I ordered colored bows and ribbons for the trees and wreaths on the building," she said. "They looked so plain with the new lighting."
Sat. before Thanksgiving–New Year's, Dusk–dawn. *At the Chicago River.*

10 TRIBUNE TOWER
435 NORTH MICHIGAN AVENUE

The Tribune Tower, built in 1925, is a fascinating landmark inside and out. When dressed in its holiday finest, it beckons visitors to share its rich history.

A double band of fresh evergreen boughs bathed in 15,000 twinkling white lights frames the three-story Gothic main entrance. A massive, red-ribboned wreath hangs over the doorway where the stone-carved figures of Aesop's fables can be seen peering through the branches.

Within the building, a stunning 18-foot Christmas tree reaches toward the oak-beamed ceiling in grand style. Surrounded by famous quotations inscribed in the marble walls, the tree bears its own message of the spirit of the season. The ornaments change yearly with the theme, from a world peace tree decked in white doves to one adorned with ornaments made by parents for their children.

The tree is assembled, lit, and trimmed on a lift from the top down by a crew of six volunteers (some of whom have been volunteering for over twenty-five years), who work four weekends on their own time to complete the task. Mary Jo Mandula, Vice President of Tribune Properties, who purchases the trimmings and manages the decorating explains, "It's an awful lot of work, but when the lobby is dimly lit and the tree just glows, it's pretty cool."

Along the south exterior wall are eighteen bronze plaques of historic *Tribune* front pages, among them Commander Perry's 1909 discovery of the North Pole.

No mention of Santa Claus is made. Three evergreen trees glisten between the ornate vertical columns of the annex entryway in the Nathan Hale Court. Though over 150 stones from famous structures throughout the world are imbedded in the building's exterior limestone walls, within the Nathan Hale Lobby are the stones which to many are the most revered—fragments from the Cave of the Nativity in Bethlehem, widely believed to be the birthplace of Christ.

2 weeks before Thanksgiving–Jan. 2, Day and night.
Between Illinois St. and the Chicago River.

11 WATER TOWER PLACE
835 NORTH MICHIGAN AVENUE

If over one hundred shops and restaurants aren't enough to entice holiday shoppers to Water Tower Place, surely the custom-crafted trimmings that can be seen from Michigan Avenue will beckon viewers to at least stop in for a ride up

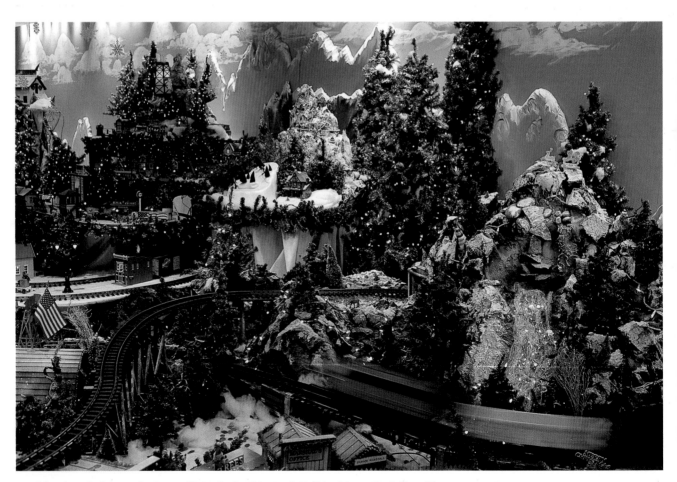

Model trains wind through snowy villages in the "Hancock Holiday Mountain Railroad."

JOHN DAVID MOONEY

"Electric Sheep" by artist John David Mooney graze in the yard of the Fourth Presbyterian Church.

the two-story escalator. Climbing above potted ficus trees festooned in glittering lights, riders have been treated in various years to giant whimsical jesters, hot-air balloons, and fanciful snow queens dangling overhead that return for five to seven holiday seasons. Those who ride to the second floor can also sneak a peek at the decorations in like theme that dramatically drop six levels from the ceiling of the eighth-floor atrium.
Mid-Nov.–New Year's, 10:00AM–10:00PM (store hours vary). (312)440-3166. www.shopwatertower.com.
From the Chicago River, N on Michigan Ave. ½ mi.

12 JOHN HANCOCK CENTER
875 NORTH MICHIGAN AVENUE

The towering John Hancock Center reigns over the holiday skyline with a crown of red and green lights, thanks to efforts of its building's engineers. Two men spend forty hours covering 550 of the fluorescent lights that circle the tower with colored gel tubes to create the effect. But the yuletide spirit in one of the city's tallest buildings doesn't stop on the top floor.

One hundred stories below, the Salvation Army presents its annual "Tree of Lights" with the generous support of building owner Golub and Company. Magnificently trimmed with 80,000 multicolored bulbs, each representing a donation needed to meet the organization's holiday fundraising goal, the towering tree may be the largest live Christmas tree in the city.

The fun continues indoors where the lower concourse features the "Hancock Holiday Mountain Railroad," a delightful 1,400-square-foot model train layout featuring O- and G-scale trains chugging through tunnels and over bridges past the North Pole, "Cows on Parade," and other animated holiday scenes.

On weekends, visitors to the Hancock Observatory get an extra holiday treat for the regular price of admission— "A Great View and Santa Too" offers not only a stunning aerial view of the city's Christmas lights but a chance to visit with Santa (of "The Magnificent Mile Lights Festival") and Mrs. Claus and receive a free digital photo with the merry couple in their bright red sleigh.
Tower lights: Sat. before Thanksgiving–Jan. 2, Dusk–dawn. Train: 3rd Wed. of Nov.–Jan. 2, 9:00AM–9:00PM (hours may vary). Tree: 3rd Thurs. of Nov.–Jan. 2, Dusk–dawn. Santa: Fri. after Thanksgiving (thereafter Sat. and Sun. only)–Dec. 24, 11:00AM–5:30PM. (888)875-8439. www.hancockobservatory.com.
Between Chestnut St. and Delaware Pl.

13 FOURTH PRESBYTERIAN CHURCH
NORTH MICHIGAN AVENUE AT
CHESTNUT STREET

The Fourth Presbyterian Church has always provided a tranquil oasis in the midst of the bustling shops of North Michigan Avenue. During the holiday season when the stores are at their busiest, this downtown sanctuary once again treats its visitors to a place of calm repose. For beneath its gothic arches trimmed with yuletide greenery, five grazing sheep with fleece of white lights twinkle in concert with the sparkling trees of the boulevard.

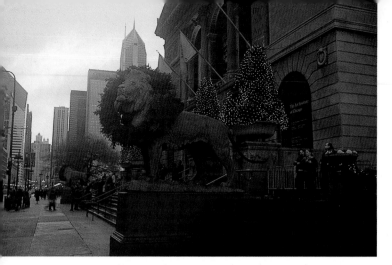

The Art Institute lions have dressed for the holidays since the 1950s.

The "Electric Sheep" sculptures are the work of well-known Chicago-based environmental artist John David Mooney. Though shown at the Chicago International Art Exposition in May of 1993, twelve sheep, each one unique, were originally commissioned by Prime Minister John Major for the European Community Summit held in Edinburgh, Scotland, in 1992. Within view of the visiting twelve heads of state, the flock grazed on the highest hill in the city as an expression of the "new Europe."

Sat. before Thanksgiving–Jan. 6, Dusk–dawn.
Between Chestnut St. and Delaware Pl.

14 THE 900 SHOPS
900 NORTH MICHIGAN AVENUE

It's certain that none of the architects from Perkins & Will or Kohn Pedersen Fox Associates, who collaborated on the design of this unique structure, ever imagined there would be a desire to change the colors of the four giant turrets that distinguish this building on the city's skyline. The blueprints would surely have included a system less arduous than that required of plant superintendent Paul Kennedy and his crew.

Sixty-four 400-watt and sixty-eight 100-watt mercury vapor lights are manually covered with colored lens paper secured in sheet-metal frames. The crew uses a long, hooked pole to reach the lights, some measuring as much as 40 feet above floor level. The system once required the assembly and reassembly of cumbersome scaffolding but has been perfected over the years. The crew can now complete the task in eight man-hours.

Their engineering skill surely does the architects proud as the building adorns the skyline with its festive crown, which seems to resemble four candles on an Advent wreath.

The interior lobby of the shopping area is bedecked for the season in as grand a style. A 45-foot tree adorned with 4,200 ornaments and 3,500 lights majestically greets shoppers through four levels of the atrium.

Sat. before Thanksgiving–New Year's. Lobby hours: (M–F) 10:00AM–8:00PM, (Sa) 9:30AM–8:00PM, (Su) 11:00AM–6:00PM. (312)915-3916. www.shop900.com.
Between Walton St. and Delaware Pl.

15 THE ART INSTITUTE OF CHICAGO
111 SOUTH MICHIGAN AVENUE

The Art Institute lions proudly attired in luxuriant balsam wreaths have come to symbolize the holiday season in Chicago. Created by American sculptor Edward L. Kemeys in 1894, the bronze pair first donned their yuletide apparel in the fifties.

The city's affection for the stately felines prompted the Art Institute in 1992 to make the "Wreathing of the Lions" an annual public celebration. On the Friday morning after Thanksgiving, a crowd filling the museum's steps is treated to goodie bags and a musical performance while waiting for the festive moment. At 10:00 a.m. the 200-pound wreaths are lifted over the lions' heads, and onlookers count down to light the four Christmas trees that flank their path.

Inside the museum, children's ornament-making workshops, holiday-themed lectures, and performances by school choirs in the grand staircase, adorned with a radiant poinsettia tree, make a yuletide visit to this Chicago treasure a unique Christmas adventure.

Outdoor decorations: Fri. after Thanksgiving–New Year's, Day and night. Museum hours: (M–W, F) 10:30AM–5:00PM, (Th) –8:00PM (free after 5:00PM), (Sa–Su) 10:00AM–5:00PM, (F–Sa after Thanksgiving and week after Christmas) –6:30PM. Closed Thanksgiving, Christmas, and New Year's. Admission fee. (312)443-3600. www.artic.edu. *At Adams St.*

16 HILTON CHICAGO
720 SOUTH MICHIGAN AVENUE

Those wishing to see the largest gingerbread house in Chicago need only follow their noses through the lobby

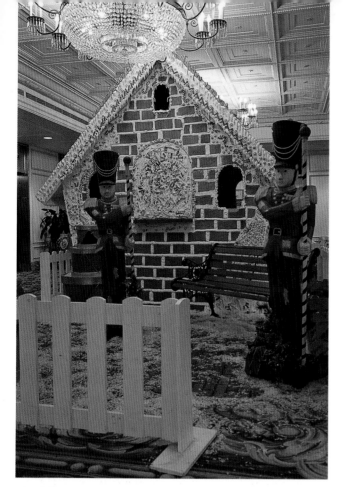

The delectable Hilton Chicago gingerbread house measures 12 feet high, 10 feet wide, and 8 feet long.

of the Hilton Chicago, where the yummy scent of ginger, nutmeg, cinnamon, and cloves leads to the 12-foot-high sugary confection.

Made with 800 pounds of flour, 175 pounds of brown sugar, 450 pounds of corn syrup, 100 pounds of powdered sugar, 200 pounds of butter, 30 gallons of egg whites, 18 pounds of spices, and 1,000 pounds of candy, the gingerbread house is as rich and sweet in the making as it is in the ingredients. Since 2000, twenty fifth graders from the Doolittle Elementary School have spent a fun-filled day helping the Hilton pastry chefs decorate the house with gingerbread, icing, and candies.

Preparations begin in late October when pastry chefs Andy Lofton and Wing Au discuss the color and design of the "bricks" for the coming season. Assistant Pastry Chef Lydia Tan then spends the following week baking two thousand gingerbread bricks according to their plan.

After staff carpenters reassemble the building's wooden framework, all seven chefs in the pastry staff spend two days using royal icing to glue ginger shingles and bricks and an assortment of candies to the roof, front, and back of the house, leaving the sides empty for the kids' big day.

Tables piled with candy canes, chocolate drops, lollipops, malted milk balls, nonpareils, peppermint pinwheels, fruit sours, Jordan almonds, and gingerbread bricks greet the students as they arrive in the lobby on the Tuesday before Thanksgiving. Working in groups, each supervised by a chef, the kids spend a delightful forty-five minutes choosing the candies and gluing them to their section of the house. "The first year we just let the kids go, and everything was all over the place," recalled Senior Pastry Chef Andy Lofton. "So we're a bit more organized now." When the young decorators finish the big gingerbread house, they each have a little one of their own to decorate however they like.

"The kids are not only given a special memory of the time they went to a big hotel downtown and built a gingerbread house," Andy said, "but many of them leave saying they want to be pastry chefs, just like us."

Tue. before Thanksgiving–Dec. 31, Day and night. (312)922-4400. www.hiltonfamilychicago.com.
From Congress Pkwy., S on Michigan Ave. 2 bl.

17 STATE STREET

To many Chicagoans and out-of-towners alike, Christmas shopping on State Street is a holiday tradition that a mall could never replace. Highlighted by the animated window displays of Macy's (formerly Marshall Field & Co.), the famous thoroughfare features over one hundred retail stores, restaurants, and hotels dressed in their yuletide finest. From Wacker Drive to Congress Parkway, subway stations, lampposts, and parkway trees add to the merriment with fanciful trimmings that vary from year to year.

On Thanksgiving morning, hundreds of thousands of onlookers fill the sidewalks for the Chicago Thanksgiving parade, an annual tradition since 1934, that kicks off the holiday shopping season. Originally a caravan of toys and merchandise from State Street stores, the parade has been famous for many years for its elaborate floats, giant helium balloons, award-winning marching bands, and noted celebrities.

2nd week of Nov.–mid-Jan., Dusk–dawn. Stores: (312)782-9160. www.chicagoloopalliance.com. Parade: (312)235-2217. www.chicagofestivals.org.
From Wacker Dr. to Congress Pkwy.

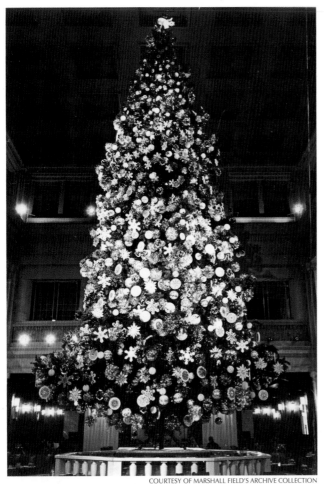

The magnificent "Great Tree" has made the Walnut Room a holiday dining favorite for over a century.

18 MACY'S (MARSHALL FIELD & CO.) 111 NORTH STATE STREET

Forty-two golden trumpets herald the start of the holiday shopping season from this department-store location world-famous for its Christmas displays both inside and out.

The tradition began when Marshall Field's first visual merchandiser, Arthur Frazier, pioneered in his industry by creating the store's first elaborate window displays in the 1890s. He imported items from Germany and France and handcrafted many himself, which were the most enchanting.

In 1941 his successor, John Moss, designed the first holiday story that went from window to window. It was an adaptation of Clement Moore's poem, "A Visit from St. Nicholas."

The store's Christmas mascot, Uncle Mistletoe, was created in 1946 by Addis Osbourne, an instructor at the Art Institute and husband of a Field's associate. The fictional character's Christmas window stories, created in-house, changed yearly with magic carpet adventures that took children around the world. Uncle Mistletoe was later joined by Aunt Holly, Freddie and Martha Fieldmouse, and Mistletoe Bear. He even had his own television show from 1948 to 1952. Within the store Uncle Mistletoe's "Cozy Cloud Cottage" is still Santa's home away from home.

In 1990 Marshall Field's was purchased by Dayton Hudson Corporation, a Minneapolis-based retailer renowned for its own elaborate animated re-creations of classic fairy tales. In following holiday seasons, the Field's visual merchandising staff joined Dayton Hudson's tradition by designing its thirteen window vignettes to tell the tales of such storybook figures as Cinderella and Pinocchio. Despite three subsequent acquisitions of Marshall Field's and a name change in 2006, the animated holiday windows remain the store's gift to the city.

Throughout the interior of Macy's, the decorations continue with the most fanciful creations adorning the first floor and culminating with the famous Walnut Room Christmas tree. Begun in 1907 on a grand but smaller scale, it was not until the midthirties that the 45-foot "Great Tree" with over 12,000 miniature lights was introduced. Until 1990, the tree was decorated in a different theme each year, using five thousand handmade ornaments. In-house artists created twenty-seven designs in three sizes,

The tale of Pinocchio unfolds in a 1994 Field's window display.

THE CTA HOLIDAY TRAIN

Until taking to the air on Christmas Eve, Santa seems to prefer traveling no higher than the elevated tracks of the CTA on his off-days from the toy shop. Perched with his sleigh and reindeer in an open-air flatcar glistening with decorated trees, he welcomes commuters throughout the season to a fanciful ride aboard a six-car holiday train bedecked inside and out with ribbons, garland, and thousands of lights. The train, whimsically trimmed with candy-cane hand poles and mock advertisements as though straight from the North Pole, has been a favorite of riders since 1992.

On the Friday after Thanksgiving, the Holiday Train circles the Loop for the city's tree-lighting ceremony in Daley Plaza. But from mid-November to late December, it travels from one train line to the next on selected days, so Santa can greet visitors all over Chicagoland and deliver food boxes to the needy.
Weekend before Thanksgiving–weekend before Christmas (select days only). Approximate times: (Sa–Su) 1:00PM–9:00PM, (M–F) 3:00PM–7:00PM (schedules vary per line). Normal fares apply. Schedules and routes: (312)836-7000. www.transitchicago.com.

which a staff of five art students from around the country created as summer employment. The ornaments were donated to veterans' hospitals at the end of each season. Though no longer created in-house, the fanciful trimmings are still handcrafted with the same attention to detail.

For many years the "Great Tree" was a live evergreen. It was well guarded by two full-time firemen and a specially installed sprinkler system. In 1962, fire regulations required that the real tree be replaced by an artificial one, which is still being used today. The tree didn't lose its magic, however—customers continued to remark on its lovely fragrance.
Window display: 2nd week of Nov.–1st week of Jan., 8:00AM–11:00PM. Holiday store hours: (M–F) 10:00AM–8:00PM, (Sa) 9:00AM–9:00PM, (Su) 11:00AM–7:00PM. (312)781-1000. www.macys.com. Walnut Room: No reservations taken. (312)781-3139. *Between Randolph St. and Washington St.*

19 PRUDENTIAL PLAZA
180 NORTH STETSON AVENUE

Since 1996, Prudential Plaza has generously hosted "Seasons of Hope," a holiday tree display and fundraising event for Chicago Youth Programs, a nonprofit organization that provides activities and services for nearly five hundred at-risk children. The lobby is dazzlingly dressed for the occasion with huge wreaths, cascading lights, and an 18-foot Christmas tree, but the special event is what stops the show.

Approximately fifteen 7-foot trees comprise the exhibit, each sponsored by a local corporation and uniquely decorated in an annually changing theme. Three are trimmed by youngsters in the program, and the others by members of design firms and schools that volunteer their time.

Building tenants and visitors are invited to fulfill the children's Christmas wishes by obtaining one of their letters from the lobby and depositing a gift in the giant toy drum. Thanks to the building's giving holiday spirit, every child not only gets a Christmas present but a great field trip to see their handiwork on display.
Sun. after Thanksgiving–New Year's, (M–F) 6:00AM-7:30PM. *From Michigan Ave., E on Lake St. 1 bl., S on Stetson Ave.*

20 SEARS TOWER
233 SOUTH WACKER DRIVE

The building with the tallest occupied floor in the western hemisphere may boast of 110 stories, 4.5 million

Giant holiday figures in the lobby of Prudential Plaza serve as a collection station for donated Christmas gifts.

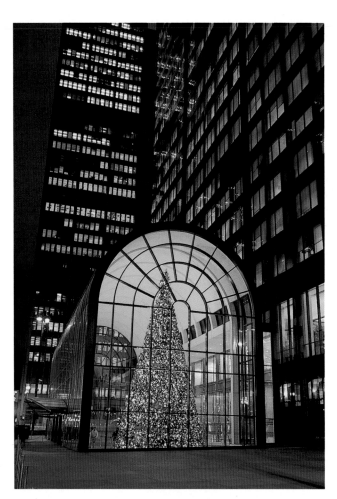

On the Monday after Thanksgiving, a lucky tenant flips the switch that lights the glistening tree in the Sears Tower atrium.

executive pastry chef and creator of a nationally famous gingerbread display.

In 1989 when one hundred executives handed him ideas for the first rendition, Raul decided instead to create the village from imaginary pictures that were in his head, and that's the way he's done it every year since.

The work begins in early October. Raul draws his original patterns on cardboard. With the help of six other pastry chefs, the walls of as many as two dozen buildings are cut out of gingerbread sheets and "glued" together with chocolate. A mixture of sugar, egg whites, and cream of tartar forms a royal icing for the roofs, while hard candies and cookies add detail to the delectable treats.

When the buildings, bridges, and train station are complete, Raul assembles the town on a 12' x 20' table surrounded by a curtain until time for its unveiling. The houses are placed at different levels, and three toy trains, a mountain, and townspeople are added to the scene.

The village houses are completely edible. However, it is recommended that visitors try Raul's frozen raspberry soufflé instead.

Dec. 1–New Year's, 7:00AM–8:00PM. (312)787-2200. www.thedrakehotel.com. *At Michigan Ave.*

gross square feet of floor space, 16,100 windows, and 796 lavatory faucets, but when the holidays roll around, it's the tower's 48-foot Christmas tree that draws the attention.

Designed for the building's atrium in 1994 by the Becker Group of Baltimore, Maryland, the magnificent shimmering tree flaunts a few impressive statistics of its own. With 7,000 white lights, 1,020 ornaments, and 192 feet of ribbon, it is the largest indoor Christmas tree in Chicago. **Mon. after Thanksgiving–Sat. after New Year's, Day and night. Lobby hours: (M–F) 6:00AM–11:00PM.** *Between Adams St. and Jackson Blvd.*

21 THE DRAKE HOTEL
140 EAST WALTON PLACE

When Raul Cuevas began working at the Drake Hotel as a dishwasher over thirty-five years ago, he had no idea his hidden talents would eventually earn him the position of

The lobby of the Drake Hotel features a delectable gingerbread village designed by the pastry staff.

Opposite page: Bill and Chester Cholewa's homemade wooden decorations made their family's Portage Park home a holiday landmark for nearly twenty years (p. 49).

CHAPTER 2
Chicago ~ North

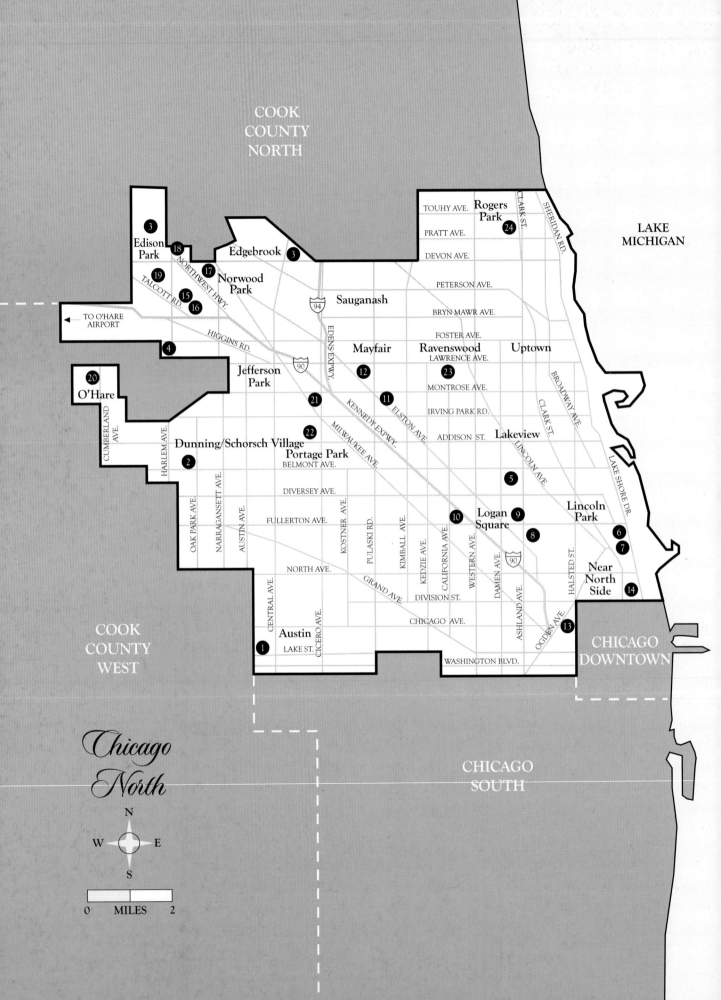

COOK
COUNTY
NORTH

LAKE
MICHIGAN

TOUHY AVE.

Rogers
Park

PRATT AVE.

24

DEVON AVE.

3

Edison
Park

18

Edgebrook

3

PETERSON AVE.

17

Norwood
Park

19

BRYN MAWR AVE.

94

Sauganash

15

FOSTER AVE.

16

TO O'HARE
AIRPORT

HIGGINS RD.

Mayfair

Ravenswood

Uptown

LAWRENCE AVE.

4

12

23

90

MONTROSE AVE.

Jefferson
Park

21

11

IRVING PARK RD.

20

O'Hare

22

ADDISON ST.

Lakeview

Dunning/Schorsch Village

Portage Park

BELMONT AVE.

2

5

DIVERSEY AVE.

Logan
Square

9

Lincoln
Park

FULLERTON AVE.

10

8

6

7

NORTH AVE.

Near
North
Side

14

GRAND AVE.

DIVISION ST.

13

CHICAGO AVE.

CHICAGO
DOWNTOWN

1

Austin

LAKE ST.

COOK
COUNTY
WEST

WASHINGTON BLVD.

Chicago
North

CHICAGO
SOUTH

N

W E

S

0 MILES 2

Swedish Advent stars fill the windows of Jerry Ehernberger's historic home.

AUSTIN

1 5749 WEST RACE AVENUE

On a snowy Christmas Eve night in 1962, a loving step-father called his seven-year-old boy outside to discover a pile of wrapped presents on the porch and a trail of footprints leading off in the snow. The magic of that Christmas Eve began a fascination for young Jerry Ehernberger that would shape his life for years to come.

Growing up an only child in a house on a lonely Nebraska prairie, Jerry would satisfy his frequent longing for Christmas by sneaking a peek at the box of holiday decorations packed carefully away in the storage room. A 1967 magazine article on the history of Christmas lights inspired him to start a collection of his own. He knocked on neighbors' doors asking for old Christmas bulbs and pestered General Electric and Westinghouse with countless questions. Two years later the same Nebraska magazine printed a story about Jerry's collection.

In 1970, Interstate 80 was constructed just north of the Ehernbergers' once-secluded home. Jerry seized the opportunity to turn the family's front yard into a roadside holiday attraction. He outlined the house in lights, put angels on the roof, lined the driveway with blinking bells and candy canes, and built a large wooden nativity for one end of the yard and a sleigh and reindeer for the other. He delighted in watching cars slow down and hearing truckers honk as they passed on the highway.

Jerry's collection and knowledge of Christmas lights had grown to such proportions that in 1978 he and fellow collector Gil Kaufman collaborated in publishing *The History and Catalog of Electric Christmas Light Bulbs*. He had also made numerous acquaintances who shared his passion for antique Christmas decorations, so in 1980 he formed a club called The Golden Glow of Christmas Past. What began as twenty-three members meeting in a bee-infested barn has now grown to an organization of over one thousand members from around the world.

True to his taste, Jerry now resides in a historic home designed by architect Frederick Schock on Chicago's west side, which he has been faithfully restoring over the past fifteen years. His love of the holidays now takes him on regular trips to European cities, where the flavors of Christmases past abound. Though the decorations on his

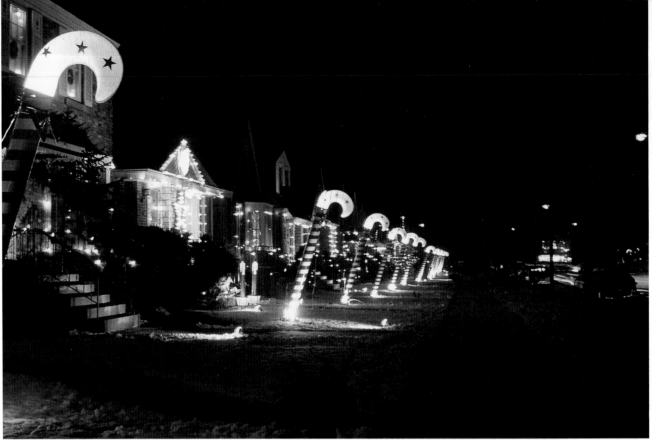

Ten-foot candy canes on each front lawn transformed the 3200 block of North Nottingham into "Candy Cane Lane."

nineteenth-century home are appropriately simple, his windows always hold unusual finds that reflect his unique fascination with Christmas.

1st week of Dec.– mid-Jan. (even-numbered years only), 5:00PM–10:00PM. *From Lake St., N on Austin Blvd. 2 bl., E on Race Ave. 2 bl.*

DUNNING/SCHORSCH VILLAGE

"CANDY CANE LANE"

"Candy Cane Lane was the big thing when I was a kid," recalls Wayne Basica, who trims his Round Lake Beach tavern with authentic decorations he collected from the once-famous neighborhood. "Traffic was so heavy, we'd walk up and down the streets with a whole group of relatives. The people who lived in the houses would stand out front and give us cookies and chocolate. When you're a kid . . . that's seventh heaven. I knew then when I had a house, I would decorate."

"My uncle would pile my siblings, my cousins, and me into his station wagon every Christmas to go to Candy Cane Lane," says decorator Maria Pilat of Bensenville. "I looked forward to it all year and knew if I ever had my own house I'd want to decorate it like they did."

Throughout Chicagoland, baby-boomers who decorate their homes for Christmas repeatedly credit their childhood holiday memories of this northwest-side neighborhood as the inspiration for their decorating.

Just north of Belmont and east of Harlem, the area was at the height of its popularity from 1953 to 1972. A 1962 feature article in *Health* magazine called it "one of the wonder spots of Chicago during the holidays." It was a community effort unlike any other at the time. Block after block, neighbors transformed their streets into fantasy lanes, each with a different theme.

A 20-inch wooden letter trimmed with dozens of white lights covered the second-floor window of each home on the 7000 block of West School Street, spelling "Merry Christmas" on the south side of the street and "Happy New Year" on the north. Homemade lighted stars adorning the peak of each home on the 7000 block of West Henderson created "Star Lane." The 6900 block of West Melrose became "Choir Lane," trimmed with 4-foot choral singers. The 3200 block of North Nordica was

"Poinsettia Lane," where giant red blooms were displayed on every lawn, and on "Santa Claus Lane," the 3400 block of North Neva, the jolly old elf waved from every chimney. Other nearby blocks became "Bell Lane" and "Christmas Tree Lane."

On Nottingham Avenue, the 3400 block was "Vigil Lane," trimmed with 10-foot candlesticks. The 3300 block was "Reindeer Lane," decorated with 4' x 6' Rudolphs with glowing red noses. And the 3200 block, decorated in 10-foot striped candy canes, became the most famous of them all and the street by which the area was known— "Candy Cane Lane."

The huge decorations, which came with two spotlights, were purchased from Frederick's International Advertising Company, a commercial display manufacturer, at an average cost of $20 to each homeowner. Neatly displayed in the same position on each front yard, the matching decorations created quite a dramatic effect in addition to the large outdoor Christmas lights that glowed from every home. "My husband, John, would stand on the corner and line up all the candy canes," recalled Minnie Munao. Several Nottingham neighbors also constructed wooden frames that would hold the lights neatly around the outline of their houses. Some contend that Commonwealth Edison had to rewire the entire neighborhood because of a transformer blowout caused by the display.

BOB DIENETHAL

To recreate the magic of a childhood fairy tale, LeRoy and Evelyn Hardell turned their Schorsch Village brick home into a homemade candy house every Christmas from 1951 to 1961.

Individual homeowners added to the block decorations with touches of their own. Many built festive door trimmings. Some rigged outdoor speakers to their record players. "When my neighbor wasn't playing his music, I'd play mine," remembered Candy Cane Lane resident Gus Guarino.

Others created unique displays that left indelible memories for all who viewed them. George Morrison, whose School Street home bore the letter "N" on Merry Christmas and Happy New Year Lane, decorated his house with a homemade helicopter, captained by a life-size Santa Claus, and a huge stocking brimming with gifts. Across the street Louis Munao's house was not only decorated with a giant "T," but was famous for its live sheep in a manger scene. A town of miniature buildings covered the corner lot at Neva, and the Guarino home won first place awards for its "Christmas on the Moon" display.

The Snyder family on the 3200 block of Newland greeted guests from around the world with holiday messages in a dozen different languages posted across their lawn, while one block north the Duda family's reproduction of a "Swedish Crown" tree of concentric golden hoops was a stunning symbol of the neighborhood's European heritage.

On the 3200 block of Newcastle from 1951 to 1961, LeRoy and Evelyn Hardell completely transformed the face of their brick home into a candy house by covering it with sheets of Masonite painted white and covered with glitter. "It fit exactly. No one could see any hardware," Evelyn said proudly. While she did much of the painting, her husband, who had been a mechanical engineer for Stewart-Warner, spent three months meticulously creating dozens of peppermint sticks, pastel cream patties, candy corns, cinnamon hearts, sugar cookies, butterscotch caramels, and lollipops using only scrap materials and hand tools.

The couple filled one flowerbed with a garden of suckers and ice cream cones and another with old-fashioned candies, from gumdrops to peanut brittle, made from cement and rocks. Carols played from a speaker hidden in a handmade steepled church that hung over the doorway. A pink, flocked Christmas tree gently rotated in the bay window, like a giant stick of cotton candy. "A lot of people took pictures," Evelyn recalled. "We were picking up flash bulbs all the time."

The entire neighborhood was featured every year on television and radio and in newspapers and magazines. A local policeman offered horse-drawn sleigh rides down the streets, and the U.S. Marines put barrels on the corners for their "Toys for Tots" campaign. "A lot of kids would come singing by your door," recalled Minnie Munao. During the two weeks that the displays were lit, cars would fill the streets and families would fill the sidewalks. "As a choir member for many years, it was always a gamble whether or not I could get to church in time for midnight Mass," remembered resident Mary Ann Ryan. "Our alleys saved us," recalled Louise Frawley of Choir Lane.

Old-time residents credited the success of Candy Cane Lane to the pride and camaraderie of the Schorsch Village community, which already had a long history of working together. Most of the homes were constructed by Village Home Builders Inc., which was owned by the six brothers of the Schorsch family, four of whom lived in the neighborhood. "There was a family spirit to begin with," remarked resident John Ryan. The Schorsch Village Improvement Association, the oldest community organization in the United States, had been sponsoring

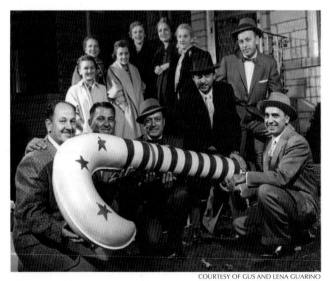

COURTESY OF GUS AND LENA GUARINO

The decorating committee that originated "Candy Cane Lane" proudly displays one of the canes that made their neighborhood famous in this photograph from 1957. (From l. to r.) Bottom row: Ed Minor, John Munao, William Carey, Phil Phillips, John Ogorzalek, Gus Guarino. Top row: Florence Ogorzalek, Veronica Carey, Millie Munao, Marianne Minor, Lena Guarino, Lucille Phillips.

events from snow removal to bowling leagues since it was established in 1931.

In 1939, one of the brothers, Louis Schorsch, established an annual Lawn Prize. "All the lawns in the area were so well taken care of that it was a showplace during the summer months," noted former village historian Mildred Losey. In 1940, members established a Christmas Lighting Display contest, awarding prizes to the winning homes. That year Natoma Avenue was the first in the area to begin the tradition of spelling "Merry Christmas" with a letter on every house. Radio stations broadcast news of the attraction, and sightseers were already beginning to tour the neighborhood.

During the war years, the displays were discontinued to conserve energy, and the prize money was donated to the U.S.O. The Schorsch Village Improvement Association put its efforts into organizing Victory Gardens, paper drives, and a chapter of the Red Cross, among other causes.

In 1945, the Christmas displays resumed and, as more houses were built in the neighborhood, the event grew too. "After World War II there was a sense of public-spiritedness and togetherness," remarked Steve Schorsch, son of one of the developers. So many homes were being decorated that the association expanded the number of awards with categories and block prizes. In 1953, each homeowner on School Street won a prize for the block's giant rooftop holiday greeting. In 1956, Candy Cane Lane was born, and the following year the remaining blocks joined the effort that flourished until the early seventies.

Many hoped that the magic of Candy Cane Lane would never end, but as the organizers grew older, many became less enthusiastic. "How sad it was when a few people stopped putting their letter up," Steve Schorsch remembered. "Some people fought vigorously to keep it going," recalled Mary Ann Ryan. "They would say to a new neighbor, 'I'll put your letter up for you.' Then I guess it just got to be too hard to keep it going."

During the 1973 energy crisis, the streets went dark. When the fantasy lanes came alive again in 1974, they proved merely a swan song, as the decorations gradually diminished in the years to follow. Remarked Gus Guarino, "I guess the energy crisis was a good excuse for people to finally bow out." ❄

An animated manger scene is one of the imaginative decorations created by Frank Patano and lovingly restored by his son, Dominic.

2 6959 WEST SCHOOL STREET

Several weeks before Christmas, young Dominic Patano climbs up the roof to repair the fragile Star of Bethlehem that hangs year-round from the peak of his family's north-side home. "I do it for him," Dominic says in reference to his father, Frank, who built the star some twenty years ago. "I'm afraid it might fall apart completely if I take it down. And I want to keep my dad's original inventions."

Though indoor manger scenes were the traditional holiday decorations of Frank Patano's southern Italian boyhood home, a visit to Disneyworld and love for his family inspired this handy heating and air-conditioning specialist to employ his technical skills to create one of the most inventive and heartfelt displays on the city's north side. Red, white, and green disco lights outlined the house, dancing in the colors of the Italian flag. Old washing machine motors from his mother's garage and wire coat hangers comprised the mechanisms of a swirling Santa and Frosty. A pulley system and an old record player caused teddy bears to jump up and down in the windows and red velvet bows to sway to and fro. The Star of Bethlehem glistened at the peak of the roof with 270 alternating lights that Frank individually assembled in a three-month summer project. And a manger scene came to life with a rocking cradle and turning figures of Mary and Joseph at the suggestion of young Dominic. Frank's wife, Palma, joined in the fun, decorating three indoor trees and hosting a holiday party for their children, who loved to boast that you could see the house lit up from their school two blocks away.

In 1993, Frank suffered a fatal recurrence of the cancer that had plagued him five years before. Though filled with pain, he assembled his Christmas display one last time to avoid disappointing his young son and was awarded a prize in the neighborhood decorating contest.

Though Dominic was only eleven years old when his father died the following March, he vividly remembers how much he loved helping his dad with the Christmas decorations every year. For the first few years after Frank's death, Dominic attempted to carry on his dad's tradition by putting up whatever decorations he could manage. At the age of sixteen with the help of his neighbor Amado Lopez, Dominic assembled his dad's entire display and mustered the nerve to climb the roof to hang the Star of Bethlehem, of which Frank had taken so much pride.

Though Dominic has had to rebuild the manger scene, replace the lights and some of the motors, retire the window teddy bears, annually repair the Star of Bethlehem, and recruit the help of his godfather Ray for the heavy lifting, he tries to keep the decorations as his dad had them lovingly displayed. The only addition is a sign made by his family that simply reads, "In loving memory of Frank Patano 1945-1994."

Dec. 1–Dec. 31, 8:00PM–11:30PM. *From Belmont Ave., N on Harlem Ave. 1 bl., E on School St. 4½ bl.*

EDGEBROOK/EDISON PARK

3 HAPPY FOODS
6415 NORTH CENTRAL AVENUE
6783 NORTHWEST HIGHWAY

When Chris and Nick Tarant opened Happy Foods in the 1950s at its first location on Clark and Granville, little did they know just how happy the grocery store would be. Now in two Chicago locations—Edgebrook and Edison Park—each store sports a huge smiley face that only hints at the merriment that occurs inside.

For nearly twenty years at Christmastime, current owners Barbara Eastman, Dale Eastman, Bill Tarant, and their employees have decorated the tops of every food rack, refrigeration unit, and freezer in every aisle of both stores. While a blizzard of snowflakes twirls overhead, shoppers may find a family of penguins skiing above the frozen desserts, animated elves working in a toy shop over

Santa's elves set up shop above the produce section of Happy Foods.

the butter and eggs, or wooden nutcrackers marching through snow above the canned hams.

Barbara orchestrates the decorating each year in the slow time immediately following the Thanksgiving rush. From a collection of decorations that takes up nearly a third of the stores' attics, she moves things around to suit her fancy and the new corrugated backdrop she buys every year. "Part of the fun is that it's not so detailed—we can't be Marshall Field's," Barb explains. When a rain forest backdrop was ordered one year by mistake, no one seemed to mind that Santa's elves had been displaced from the North Pole.

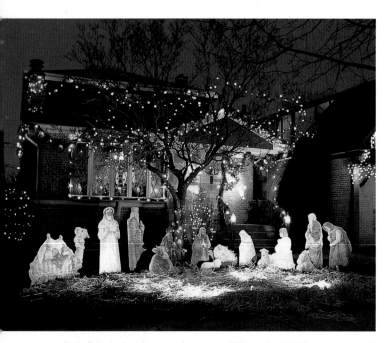

A homemade manger scene over fifty years old fills the Hojnacki front yard.

Perhaps it was the infectious atmosphere of the well-decorated Lincolnwood Towers area nearby that initially inspired the owners to decorate the Edgebrook store. "But it's the smiles on the faces of the kids who are so happy to come shopping that keeps us going," Barb admits.

The second week in December the Edgebrook store also features a tree-trimming ceremony and hayrides through Lincolnwood Towers. The adults get a treat too as live musicians are featured on Christmas Eve from 10 a.m. to 2 p.m. in front of the potato chips. **Mon. after Thanksgiving–Jan. 6. Store hours: (M–F) 7:00AM–8:00PM, (Sa) –7:00PM, (Su) –5:00PM. Closed Christmas. Edgebrook: (773)774-4466.** *NW corner of Devon Ave. and Central Ave.* **Edison Park: (773)763-5877.** *From Devon Ave., NW on Northwest Hwy. ½ mi.*

JEFFERSON PARK

4 4831 North Nordica Avenue

In 1976, Barb and Tom Hojnacki bought the Jefferson Park home where Tom's uncle, John Silvon, had lived for the last ten years. A talented craftsman, John had a basement workshop, where he constructed simple wood projects as a hobby. For many years he particularly enjoyed making nativities for his family and friends, using split Christmas tree branches to build the stables and ceramic figures from Kresge's dime store.

When Barb and Tom moved into John's home, they inherited a fourteen-piece outdoor wooden nativity scene and a 6-foot waving Santa that John and Tom's dad, Henry, had built together some twenty years before from wood patterns popular at the time. "I still remember being down in Uncle John's workshop watching them build it," Tom recalls.

For the first few holidays Tom and Barb lived in the house, they carefully assembled the entire display to continue Uncle John's tradition. But Santa ultimately proved too unwieldy and found a new home after being sold in a garage sale.

A testament to fine craftsmanship and quality materials, the fifty-year-old nativity figures are only now showing signs of wear. But Tom doesn't seem worried . . . among Uncle John's possessions was another set of the original wood patterns.

Dec. 18–Jan. 6, Dusk–10:00AM.

From Lawrence Ave., N on Harlem Ave. 1 bl., W on Ainslie St. 4 bl., S on Nordica Ave. ½ bl.

LAKEVIEW

5 3058 NORTH HONORE STREET

Even a child bundled in layers of clothes for a brisk buggy ride is guaranteed to bounce for joy when the stroller rolls past the home of Jay and Dale Bolante. Like a peephole box filled with colorful surprises, the north end of their yellow brick apartment building magically awakens each Christmas season, as every window and doorway on two floors reveal hundreds of miniature snowmen within. They dance about in the front hallway and smile gaily from ten windows overhead, while those in the five basement windows give the stroller-bound a bird's-eye view all their own.

The gleeful accumulation began with a little snowman candle Dale's mom gave her over thirty-five years ago. Frequent flea-market shoppers—already on the lookout for toy sewing machines, flashlights, dragonflies, hand tools, and smiley-face items (which fill the windows in February)—the Bolantes were inspired with a new theme. Their snowy collection now numbers over two thousand unique snowmen.

Among the miniature statuettes are snowmen candles, nutcrackers, snow globes, lanterns, banks, mugs, wind chimes, dog toys, and bird houses made of clay, plastic, wood, metal, straw, wax, gourds, tree bark, Styrofoam, sea urchins, puff balls, embroidery thread, hand-blown glass, fiber optics, and neon lights. "It's amazing what three balls can become," Dale says.

Though snowmen filling the windows tend to block the sun, the inside of the Bolantes' apartment is brightened by the remainder of their snowman collection from the pictures on the walls to the doorstops on the floors, much to the amusement of their nine grandchildren. Large snowmen decorate every table and chair in the living room and dining room. Kitchenware is replaced by a snowman timer, cookie jar, cake platter, and candy dish and snowmen salt and pepper shakers, measuring cups, potholders, towels, and place mats. The theme continues in the bathroom with a snowman shower curtain, bathmat, toilet seat cover, and several snowman soap dispensers. "I still haven't found a snowman napkin holder," Dale laments.

The Bolantes' collection continues to grow each year with new finds and anonymous gifts left in their doorway. After reading a newspaper story about their collection, a Wisconsin woman sent the Bolantes a delicate little snowman that had belonged to her aged aunt. Made of chipboard painted with blue glitter, it was carefully wrapped in tissue and packed in a small box with a note that read, "Just want to get it a good home."

Dec. 1–3rd week of Jan., 5:00PM–11:00PM.

From Belmont Ave., S on Ashland Ave. 1 bl., W on Barry Ave. 3 bl.

Visitors can search for a snowman playing a drum, riding a motorcycle, or dressed like an angel to add to the fun at the Bolante's window display.

LINCOLN PARK

6 LINCOLN PARK ZOO
2001 NORTH CLARK STREET

A day trip to Lincoln Park Zoo with its ape house, children's zoo, and petting farm can be a fanciful adventure for kids and adults alike. A nighttime trip to Lincoln Park Zoo's annual "ZooLights" holiday festival—when the sky is dark, the animals mysterious, the lights spectacular, and the events surprising—can be an adventure remembered for a lifetime.

With the generous support of ComEd, the zoo comes alive with over a million lights—gleaming lions, glistening giraffes, and giant animated frogs that greet visitors at

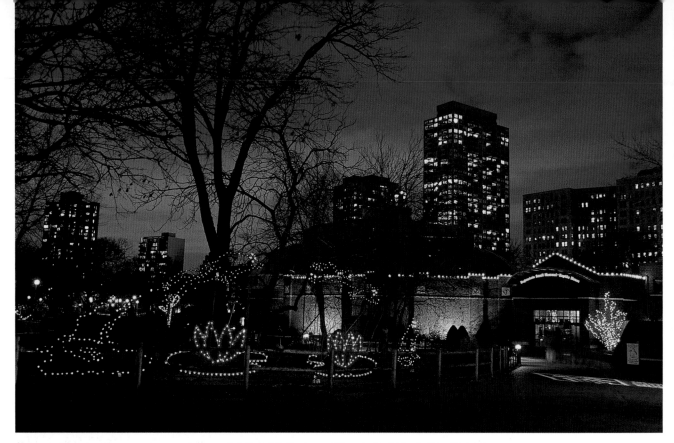

Animated leaping frogs are among dozens of delightful displays at Lincoln Park Zoo's "ZooLights."

every turn along the outdoor paths. More surprises await inside the animal houses, where guests can visit Santa and the animals while surrounded by festive decorations. Animal ice carving, family crafts, and other special events are featured throughout the park.
Fri. after Thanksgiving–2nd Sun. of Dec. (F–Su only); 3rd Fri. of Dec.–Jan.1 (open daily except Christmas Eve and Christmas), 5:00PM–9:00PM. Free admission. Parking fee. (312)742-2000. www.lpzoo.org.
From Lake Shore Dr. (I-41), W on Fullerton Pkwy. ¼ mi.

7 LINCOLN PARK CONSERVATORY
2391 NORTH STOCKTON DRIVE

In the midst of bustling urban living and hectic holiday activities, Lincoln Park Conservatory's "Winter Flower and Train Show" offers a peaceful retreat to nature in the city's own front yard. Over one thousand brilliant poinsettias in an assortment of the latest varieties form a colorful landscape for five G-scale trains that chug past two dozen replicas of Chicago landmarks built of twigs, bark, and acorns by Kentucky artist Paul Busse.

The display changes from year to year thanks to the efforts of train buff and former Como Inn restauranteur Larry Marchetti, who directs the setup, and horticulturist Steve Meyer, who designs the floral theme.
2nd Sat. of Dec. (date may vary)–Sun. after New Year's, 9:00AM–5:00PM. Open daily. Free admission. (312)742-7736. www.chicagoparkdistrict.com.
From Lake Shore Dr. (I-41), W on Fullerton Pkwy. 2 bl., S on Stockton Dr.

8 CHARLIE'S ON WEBSTER
1224 WEST WEBSTER AVENUE

Alex Lampugnani and German Sosa may share most duties of managing this north-side family restaurant, but when it comes to decorating for the holidays, Alex insists on going it alone. "Nobody helps decorate, because I like to do it all myself," he admits, even though his holiday obsession may find him hanging ornaments from the ceiling alone until three in the morning four nights in a row.

In his quest to set Charlie's apart from other restaurants in this trendy neighborhood, Alex keeps his eyes open for unusual finds year-round while shopping at antique shops, art fairs, and hobby stores. A large painted Santa head hangs amidst his other found treasures, surrounded by glittering wreaths and garland, while nearly

five hundred ornaments suspended from fishing line seem to float beneath the tin ceiling overhead. If the glow from indoors isn't enough to beckon visitors, the animated deer and huge lighted Christmas tree out front will surely lure them in along with the aroma of Charlie's American home cooking.

Though Alex's equally delightful Halloween display may spook some of the little ones, families return year after year to enjoy Charlie's festive atmosphere. They can even add to the tradition by buying a Christmas tree in the transformed beer garden next door.

Dec. 1–New Year's, (M) 12:00PM–2:00AM, (Tu–Th) 5:00PM–2:00AM, (F) 12:00PM–2:00AM, (Sa) 11:00AM–3:00AM, (Su) 11:00AM–2:00AM. Closed Christmas. Reservations recommended. (773)871-1440. www.charliesonwebster.com.
From Fullerton Ave., S on Halsted St. 2 bl., W on Webster Ave. 1 mi.

9 AUGIE'S BOOZE AND SCHMOOZE
1721 WEST WRIGHTWOOD AVENUE

While sifting though a pile of items to decorate the walls of their yet unnamed bar and restaurant, building owners Roger "Ozzie" Babilla and Steve Buerger happened upon a picture of Steve's grandfather. When Steve announced that his relative had had three wives, lost all his money gambling, and died of cirrhosis of the liver, the pub was immediately dubbed Augie's in homage to a man who was obviously out for a good time.

Since opening their establishment in October 1994, Ozzie and current business partner Javier Benitez, though not condoning Augie's excesses, have offered a wealth of opportunities for good clean fun in addition to an affordable menu. Site of a boxing ring in the forties, Augie's now features a sand volleyball court outside, television sets in the floor, and a thirteen-car G-track model train that circles about the ceiling. In the summer, this popular bar hosts volleyball leagues three nights a week and sponsors seventeen softball teams. Throughout the year, Augie's announces a new theme every month to its mailing list of over three hundred patrons. Themes often include decorations and a special event, such as the Hawaiian party in August, which raises thousands of dollars annually for Misericordia Home.

But the most popular monthly theme is Christmas, when Augie's is bursting with decorations. "The bartenders hate me at Christmastime 'cause I move everything around behind the bar to make room for the holiday displays," Ozzie confesses. The cash register makes way for a toboggan slide. Liquor and glassware are moved below for four snowy village scenes. Shelves become home to an assortment of stuffed animals, and ceiling fans are replaced with revolving saucers filled with yuletide scenes.

The train is trimmed with ribbons and bows, and every nook and cranny is dressed for the season with lights, ornaments, garland, and snowflakes. Even the mounted deer head sports a Santa hat. Outside the trees are lighted year-round, and at Christmastime the planters are filled with snowmen, Santas, and reindeer. Ozzie got a lot of tips from his good friend Butch McGuire (see p. 44).

Throughout the holiday season, Augie's is crowded with merrymakers enjoying the festive atmosphere. Many bring their kids back during the day to see the decorations. The annual Christmas party on the first Saturday of December starts off with a kids' party from 11:00 a.m. to 3:00 p.m. and a visit from Santa, followed by an adult party and free buffet from 4:00 p.m. to 7:00 p.m. Augie would most certainly approve.

"There's not an inch that doesn't get used," says co-owner Ozzie Babilla of the trimmings at Augie's.

Nov. 15–Jan. 10, (Su–F) 11:00ᴀᴍ–2:00ᴀᴍ, (Sa) –3:00ᴀᴍ. Kitchen closes at 11:00ᴘᴍ. Children welcome before 8:00ᴘᴍ when accompanied by an adult. Open Christmas and New Year's. Available for parties. (773)296-0018. *From Fullerton Ave., N on Ashland Ave. 2 bl., W on Wrightwood Ave. 3 bl.*

LOGAN SQUARE

10 2656 Wᴇsᴛ Lᴏɢᴀɴ Bᴏᴜʟᴇᴠᴀʀᴅ

In 1970, Frank Lopez began selling picture frames he had constructed from wire. The business gradually grew to become Chicago Wire Design Co. on North Kimball Street, a manufacturer of custom wire products. Among the large variety of items Frank designed were lighted wire deer for commercial holiday displays in 1972— well before lesser-quality models were widely available in stores.

But it was not until 1986, five years after purchasing his elegant Victorian home, that Frank began to trim his own house for Christmas with his wares. Located in the historic Logan Square landmark district, Frank's corner lot now draws crowds to a wondrous display that has expanded as much each year as his fanciful ideas for new handcrafted decorations. "I have so many things . . . I have to hang them from the ceiling," Frank laughs.

With a grand collection of lighted wire items, old and new, from which to choose, Frank playfully rearranges the decorations each season. Over the years, his display has featured not only dozens of peaceful deer that graze on the lawn and trim the fence posts, but playful deer that spin on the corners of the house, fly from the rooftop, and whirl about in a merry-go-round. Circling doves, twirling trees, spinning swans, giant wreaths, papier-mâché–covered piñatas, the Eiffel Tower topped with a rotating globe, and an angel playing a glockenspiel

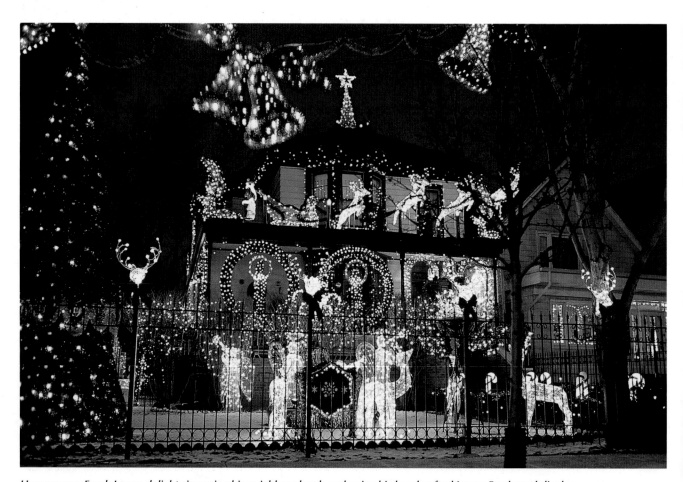

Homeowner Frank Lopez delights in seeing his neighbors laugh and enjoy his handcrafted Logan Boulevard display.

have filled his front, side, and back yards and covered his porch and garage. He has disguised his whole house as a castle and his roof as a launching pad for Santa and his reindeer.

In addition to his exquisite wire creations, Frank has encircled the roof with flags from around the world and designed over two dozen Christmas shadow boxes, after receiving a carton of miniature figures from a friend. He continues to create new, scenes and recently added an electric train in a 6' x 8' display case. He also has an elaborate Halloween display.

Frank directs the Christmas trimming, which begins in early November, but leaves the legwork to company employees, who cheerfully complete the task wearing Santa hats all the while.

"I entertain myself and my neighbors by decorating the house," Frank says, already excited about his secret plans for the coming year.

Dec. 1–Jan. 6, 5:00PM–1:00AM. *From Fullerton Ave., N on Western Ave. 2 bl., W on Logan Blvd. 5 bl.*

MAYFAIR

11 GOOFY'S HOCK SHOP
4369 NORTH ELSTON AVENUE

From the outside, Goofy's Hock Shop appears to be a typical neighborhood tavern. Inside on a normal night, the long winding bar, Wrigley stadium seats, and old barber chair may set it slightly apart from the rest, but a slow glance around, a chat with the management, and a visit with some of the regular patrons reveal a homey atmosphere that makes Goofy's someplace special.

"You could leave your house in a bad mood, and when you come in here, you want to smile. You're with friends every day," says Kathy McAleer, manager of Goofy's for over a decade. Employees and patrons alike seem to share the friendly spirit of Donny "Goofy" Aussem, owner of the establishment since 1996. If friends can be measured in "Goofyana," Donny certainly has many. Over five hundred Goofy statues, signs, and assorted trinkets, given to him by friends to celebrate his namesake, decorate the bar and fill an adjacent storage room.

"We try to make this a place where people feel at home," Donny says proudly.

Lights galore and a cozy fireplace warm the friendly atmosphere at Goofy's Hock Shop.

In addition to hosting a pool league; sponsoring softball leagues, bowling teams, and an annual golf outing; and having pizza parties for Bear games, Goofy's celebrates birthdays, retirements, and anniversaries.

And since "there's no place like home for the holidays," it's the holidays when Donny and Kathy try to make Goofy's seem most like home. The walls are trimmed with eggs at Easter and stockings bearing the customers' names at Christmas. The ladies are given candy on Valentine's Day. Customers vie for prizes at the annual Halloween costume contest. And hats, noisemakers, and horns are provided for the New Year's Eve party that fills the house.

With every holiday, the decorations change to suit the occasion. Though Halloween takes a close second, Christmastime is when Kathy and Donny go all out.

"We buy decorations all year," Kathy confesses. The decorations that don't fit in the bar's basement are stored at her house.

Despite having once been knocked in the head by a ceiling fan blade when trimming a shelf, Kathy prefers to decorate on her own. "I'm just a laborer," Donny laughs. She completes the three-week process during slow times and advises, "Never, ever decorate when customers are there or you'll be hearing 'If I were you I would. . . .'"

Kathy covers the shelves with glittery snow, three hundred trees, and fanciful adornments to create eight miniature villages, including the entire town of Bedford Falls from *It's a Wonderful Life*. A special display encased in Plexiglas is created each year for the front window. And a liquor cabinet behind the bar becomes a fake fireplace, thanks to Joe Guth, a Goofy's regular.

The "Tree Trimming Party" on the second Saturday of December marks the official start of the season. Customers are invited to bring an ornament of their own to trim an 8-foot tree that replaces a corner booth. The first year of the tradition, fifty-six patrons participated, some bringing ornaments from their youth. A DJ plays Christmas music, and Donny gives everybody a present. "There are a lot of people with no place to go. It makes them feel like they are part of a family," Kathy says.

Throughout the season, which lasts until February to include the holiday of the Serbian patrons, customers bring kids, parents, and grandparents to see the display and munch on a free candy cane. George Bailey's town of Bedford Falls appears to be more than a miniature in this friendly little neighborhood bar.

Christmas display: 2nd Sat. of Dec.–Feb. 1. Bar hours: (M–F) 8:00AM–2:00AM, (Sa) –3:00AM, (Su) 11:00AM–2:00AM. Children welcome before 8:00PM when accompanied by an adult. Open Christmas and New Year's. Available for parties. (773)282-9458. *From Montrose Ave., SE on Elston Ave. ½ bl.*

12 MARIE'S PIZZA & LIQUORS
4127 WEST LAWRENCE AVENUE

As a young boy during the Depression, George Karavidas got his feet wet in the restaurant business cleaning tables, sweeping floors, and waiting tables before and after school at his parents' west-side diner. It seemed only natural that after

At Marie's Pizza & Liquors, custom-made elves and twirling presents add to the festive mood.

returning from the service in World War II, he would take over the family's liquor store and begin selling pizza there as well. A caring and likable man, George grew Marie's Pizza & Liquors into a thriving neighborhood establishment, while himself becoming a pillar of the community.

With a warm family atmosphere year-round, Marie's became the location of choice for neighbors to celebrate the holidays. George's wife, Lillian, added to the festive appeal with a new boxload of imported expandable foil decorations she and the busboys would hang from the ceiling each year on the Sunday before Thanksgiving. Though business was expectedly hectic throughout the Christmas season, George enjoyed the opportunity to extend holiday wishes and complimentary toasts to customers, many of whom were his friends.

For the Karavidas family, non-traditional holidays had become standard fare. "When we were kids, Santa didn't come until my dad got home," recalls Nadine Karavidas. "And when my brother and I grew old enough to help out during the holiday rush, the Christmas season seemed like a speeding train. On Christmas Day, when the liquor store closed at 4:00 p.m., we'd run over to a relative's house for dinner. But it was the Christmas I grew up knowing, and we were always together."

After George Karavidas died in 2000, Nadine and her boyfriend, Cliff Davis, put their successful careers in the entertainment business on hold to manage Marie's. "I was very close to my father. I didn't want to see the family business go away that he had worked so hard to build over sixty years," Nadine confides. "The chef has been here since 1957. Forty families earn their income here. Marie's is a cornerstone in this community."

In George's tradition, Chef Pietro Benecasa and his faithful staff continue to serve up tasty pizza and Italian dishes. Busboys continue to hang foil decorations from the ceiling at Christmastime. The community continues to enjoy a neighborhood establishment. And Nadine Karavidas and her boyfriend continue to faithfully manage the business and even perform there on Wednesday nights.

Christmas display: Sun. before Thanksgiving–Jan. 6. Restaurant hours: (M–Sa) 11:00AM–12:00AM, (Su)12:00PM–11:00PM. Closed Thanksgiving and Christmas. Available for parties. Liquor store: Open daily. (773)725-1812. www.mariespizzaandliquors.com. *From Pulaski Ave., W on Lawrence Ave. 2 bl.*

NEAR NORTH SIDE

13 SAINT JOHN CANTIUS CHURCH
825 NORTH CARPENTER STREET

Completed in 1895 with enough seating for 1,500 parishioners, Saint John Cantius Church had once been the heart of a thriving Catholic immigrant community, locally known as "Expatriate Poland." Decades later, the neighborhood experienced rapid decline when homes were demolished and traffic increased following construction of Ogden Avenue (Route 66) in the 1920s and the Northwest (Kennedy) Expressway in the 1950s.

By the 1980s, Saint John's congregation consisted of an elderly and dedicated few.

In 1988, newly appointed pastor Fr. C. Frank Phillips rejuvenated the parish by restoring the rich traditions of the Catholic faith—the Latin Mass, solemn devotions, classic music, and treasured art. Now a diverse community of 1,300 parishioners travel from neighborhoods throughout the city and suburbs to Saint John's to experience the profound beauty of the Tridentine and Novus Ordo Masses enhanced with the music of renowned classical composers in the magnificent setting of this Renaissance-Baroque church.

Saint John's is more wondrous still at Christmastime, when over one hundred poinsettia plants and thirteen lighted trees flood an altar already resplendent with

A handcrafted 250-year-old Neapolitan presepio *is the season's highlight in the sacred art museum at Saint John Cantius Church.*

glorious works of art. Though a lovely manger scene is displayed at the side altar, those who venture to the church's second floor museum experience an even grander treat. Among the collection of Roman vestments and sacred art is a 250-year-old Italian *presepio*—a traditional nativity featuring the Holy Family surrounded by scenes of peasant life. The unique display was acquired by Fr. Phillips in 1998 through the generosity of a Chicago-based religious foundation dedicated to the preservation of Catholic art.

The ninety figures, handcrafted by a noted eighteenth-century Neapolitan presepio artist, are classic examples of traditional presepio art with bodies of hemp and wire, heads of terra cotta, hands and feet of wood, and clothes of fabric. The landscapes and buildings are made of cork. Parishioners David and Linee Tutwilers spent a month and a half painting the background and assembling the display.

While showing the presepio in February 2005, the parish deacon noticed that the statues of Mary and Joseph were missing. Further inspection revealed that twenty-five of the rare antique figures had been stolen from the case. A little over a year later, an unexpected package arrived via a charity in Indiana returning all the figures carefully wrapped and completely unharmed.

Church Christmas display: Dec. 24–Jan. 6. Museum presepio: Year-round, (Su) 8:00AM– 2:00PM, (M–Sa) by appointment. (312)243-7373. www.cantius.org.
From Halsted St., W on Chicago Ave. ¼ mi., N at Carpenter St.

14 BUTCH MCGUIRE'S
20 WEST DIVISION STREET

The folks who crowd this north-side restaurant from morning to night throughout the Christmas season will attest that a visit to Butch McGuire's is a holiday treat. Both the restaurant and bar are packed with delightful mechanical displays swinging, twirling, and rocking from nearly every inch of the ceiling and walls. Stuffed toy cartoon characters dressed in snowsuits, Santa outfits, and holiday sweaters whirl about on parachutes, merry-go-rounds, wooden sleds, and big bass drums, while over one hundred train cars take an endless ride on four tracks around the rooms.

It's little wonder that Butch McGuire's should exude an abundance of cheer in this season of giving, for the man whose name it bears was known for his benevolent and creative spirit. "My dad didn't come from a lot of money, so he thought it was important to help people out," says Butch's son Bobby, who currently manages the bar. "He was always very generous to his employees and friends and sometimes complete strangers. He was also an architect, so the bar was always a project with some part of it usually under construction."

In a 1994 interview, Butch recalled, "It was 1962, our second year of business. Our Italian porter, Mike, said, 'You've got no decorations up for Christmas. I'll bring you some Italian ones.' The decorations he brought were balloons with sparkles on them. We hung them around, and everybody liked them. The customers brought in more things. We hung those around, and that's how it got started."

In his third year of decorating, Butch purchased five huge boxes of remnant store decorations from Marshall Field's at a bargain price. They sold him a second batch a few years later, as did Bonwit Teller. "Every year I'd say, 'Get more,'" Butch remembered.

Tom Sheu, a Chicago fireman who was doing odd carpentry jobs for Butch part-time, was enlisted to hang the display along with carpenters Richie Weiler and John Prunkle. "Butch always let me go off on my own," Tom said, so he started designing new display ideas. "I couldn't put anything on the floor because the bar was so crowded, so I started hanging things from the ceiling." Thus were born

The ceiling of Butch McGuire's whirls and spins with amusing mechanical displays.

The golden glow of the Anton home shines brightly in historic Old Norwood Park.

the original mechanical mobiles that featured everything from elves in a hot-air balloon to the ever-popular Santa reading a magazine in an outhouse.

When Butch began acquiring train cars donated by local businesses with their logos on the sides, Tom constructed clear plastic train platforms that hung around the perimeter of the rooms, so customers could see the trains from underneath. (Guard rails were added a few years later after a few derailed trains landed in people's food and sent an injured, though bemused, customer to the emergency room.) With four LGB trains running nearly twenty hours a day, Butch also needed the help of a train expert to prevent the recurring breakdowns. When he visited the Garden Railroad at the Chicago Botanic Garden looking for assistance, he was surprised to find that his old friend and former Como Inn restauranteur Larry Marchetti was in charge of the display. "I'll see you tomorrow," Larry promised and has been coming in to fix the broken cars ever since.

Tom Sheu, who eventually opened Christmas Inn in Lemont and his own display business, continued to manage Butch's holiday trimmings until 1989. After two years of using hired help to assemble the display, the decorations became the nearly full-time job of Eddie Carr, a political cartoonist and illustrator, who started working at Butch's as a doorman in 1978 and rents studio space upstairs. Eddie created panoramic backdrops for the train layout that not only feature the usual North Pole and Santa's workshop but local stores and humorous fictional businesses of some of the regulars. He continues to work year-round repairing the old displays and creating new ideas of his own. "I have to put the outhouse up or people make a fuss," Eddie admits.

Since the decorations reached their current proportion around 1980, Butch McGuire's has done as much business in December as June, July, and August combined. Though Butch McGuire passed away in 2006, patrons continue to raise a glass in toast to the man who exemplified the true spirit of the season.

Nov. 7–Jan. 15, (M–F) 11:00AM–4:00AM, (Sa) 8:00AM–5:00AM, (Su) 11:00AM–4:00AM. (312)787-4318. www.butchmcguires.com. Parking available at nearby city lots. *From Clark St., E on Division St. 1½ bl.*

NORWOOD PARK

15 6835 WEST ARDMORE AVENUE

Kathy and Tom Anton prefer their trimmings simple and traditional—gold lights, real greenery, Santa Claus and his reindeer, and a polar bear or two. Though perhaps the decorating isn't quite so simple . . . the Antons search high and low each year to find gold lights and travel to Kouts, Indiana, to buy fresh greenery. And maybe it's not so traditional . . .Tom, a mechanical engineer, assembles the rooftop Santa and leaves the rest of the decorating to his wife, their daughter Annie, and granddaughter Michelle, the electrical genius in the family.
Thanksgiving–Jan. 6, 4:00PM–11:00PM. *From Harlem Ave., SE on Talcott Ave. 4 bl., NE on New Hampshire Ave. 2 bl., W on Ardmore Ave.*

16 5732 NORTH NEW HAMPSHIRE AVENUE

Christmas decorating now follows close on the heels of Thanksgiving. But in the early 1950s, when Christmas trees were of the "live" variety and lights were large and hot, homeowners preferred, for safety's sake, to decorate their trees only a few days before Christmas. The timing was much to the advantage of young Janet Loose, whose birthday was on December 21. The half-day of school that signaled the beginning of Christmas vacation also marked the traditional afternoon for Janet's birthday party. The usual festivities were highlighted by a special seasonal treat—decorating the family Christmas tree with her

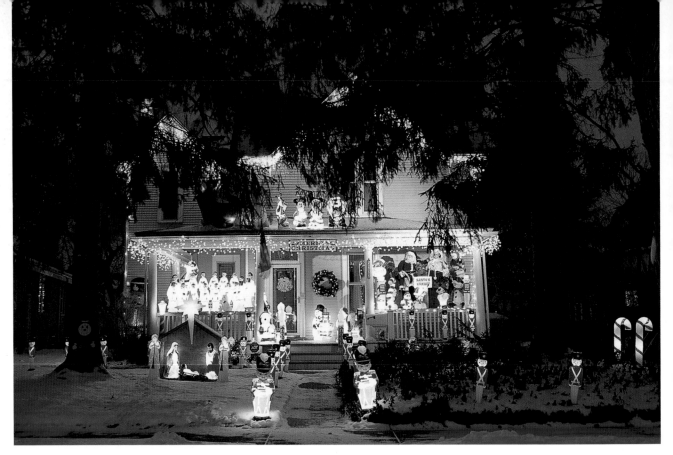

The front porch of the Groll home gleams with holiday cheer.

girlfriends. Janet's fond memories of these delightful days fostered a love of decorating she has had ever since.

Two doors down, the family of Janet's future husband, young Jim Groll, was creating "warm" Christmas traditions of another variety—in flannel. Every holiday season Jim's mother would take her two sons to the fabric store to pick out flannel material. She would then sew matching flannel shirts for the boys and her husband to wear on Christmas Eve for the family photo. The feelings of love and togetherness the holidays inspired have stayed with Jim ever since.

When Janet and Jim got married in 1969 two days after Christmas, they combined their nostalgia for Christmases past and inherited a few old decorations from their parents. Jim's mom, apparently continuing her affinity for things that match, bought new ornaments all the same color for herself and gave Janet and Jim the assortment of old glass ornaments she had collected over the years. Janet's family contributed several pieces from an old train set and additional glass ornaments. The young couple also coaxed Jim's parents into relinquishing the "Jolly Polk Santa" stored in their attic for the outside of the house.

When the couple moved into an 1840s farmhouse two blocks from where they grew up, they were inspired to create some holiday traditions of their own. Two children and Jim's side job as an electrician eventually added to the inspiration. The "Jolly Polk Santa," which initially stood alone on their huge front porch, was gradually joined by an assortment of other holiday characters. When the porch got too crowded, several figures found their way to the roof and the front yard.

Out back a flagpole serves as the trunk of a giant Christmas tree made from nineteen strands of large outdoor bulbs. While indoors, old decorations and garage store finds add so well to the nostalgic decor that in 1999 the home was used as a set for a Christmas segment of the television show *It's a Miracle*.

The Grolls' efforts have surely added to the Christmases of all who pass. One family in the neighborhood has made a tradition of driving by their decorations every year after midnight Mass. Many families have seen the Groll home on the Norwood Park Historical Society "Holiday House Tour." And in addition to an inscribed handmade ornament they receive from Mom and Dad every year, the

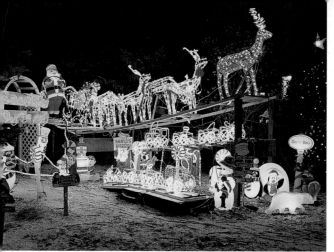

Mary Ann Trussler's Norwood Park display glows with an enthusiasm that defies her age.

Homemade snowmen add to the fun at the Brody home on Newland Avenue.

holiday display gives the two Groll children a wonderful Christmas remembrance of their youth, just like their parents have.

Thanksgiving–weekend after New Year's, 4:00PM–11:00PM. *From Harlem Ave., SE on Talcott Ave. 4 bl., NE on New Hampshire Ave. 3 bl.*

17 6330 NORTH NEWARK AVENUE

Sixty-something Mary Ann Trussler advises holiday decorators to "let your imagination go and be a kid again." With her corner lot filled to the brim with a huge assortment of holiday decorations, it's certain she follows her own advice and has a good time doing it.

As a child Mary Ann helped her dad decorate the family Christmas tree and the windows of the small grocery store her parents owned at St. Louis and Barry in the Logan Square neighborhood. "We put up a little artificial Christmas tree that had a music box in it and was lit by one bulb in the bottom. Then we'd set up little houses and surround them with cotton for snow," she recalls. "I realized then how much people enjoy looking at decorations."

Mary Ann's fond memories inspired her to decorate her own home as soon as she owned one. Her skill with a hammer and saw helped too. She built a stable of lodgepole pine, a ramp for Santa and his reindeer, and tracks for a train. "I get the Christmas spirit going for me and others," she says. "I may even be shaming my neighbors into doing this too when they see this old lady up on a ladder."

One year while she was decorating, a carload of teenage boys stopped to tell her how much they liked her display and offered to help. She did not take them up on the offer,

preferring to do the work herself. However, in 2005 when back surgery prevented her from doing any heavy lifting, she was forced to solicit help from friends, neighbors, and relatives. With Mary Ann supervising the decorating, they were able to finish in two days what would normally take her six weeks to complete. Despite this discovery, the stalwart decorator confesses, "I'll probably need two to three days of help, but I hope to do most of the work myself again."

Dec. 8–Jan. 6, (M–Th) Dusk–10:00PM, (F–Su) –12:00AM. *From Harlem Ave., E on Devon Ave. ½ mi., S on Newark Ave. 1 bl.*

18 6466 NORTH NEWLAND AVENUE

The ash tree in the parkway of this Norwood Park home is likely the most handsomely lighted tree on the city's northwest side, and not surprisingly so. It is homeowner Howard Brody's traditional day-after-Thanksgiving grand finale to as many as forty-two straight days of lighting the trees on Michigan Avenue with fellow employees of the White Way Sign Company. Having been part of the crew since 1979, Howard has his technique down to a science and employs the same expertise on his own tree. He hoists himself up in the company lift truck and wraps lights around each branch, using nearly sixty 100-light strands in all. The glistening result would likely blend in with the other two hundred lighted trees on the Magnificent Mile but alone on this block-long street, it's the crowning jewel of Newland Avenue.

With a few additional strands outlining the roof, Howard's handiwork lights the way to the fanciful

trimmings of his wife, Chris, who gladly takes over the decorating where Howard leaves off. "I'm lighted out," Howard admits. A talented crafter, Chris has been known to delight her neighbors with her imaginative displays. Years ago, when money was tight, she trimmed the outdoor tree with Coke and 7-Up cans for a touch of red and green. She now enjoys embellishing store-bought decorations, while adding some handmade items of her own.

When the last stitch is sewn and the last light is hung, Chris and Howard measure their success not on the professional quality of their trimmings but on the reaction of their twin grandsons and the kids across the street when they stare wide-eyed and jump with glee.

Dec. 5–New Year's, Dusk–10:00PM.

From Harlem Ave., E on Devon Ave. 3 bl., NE on Imlay St. 2 bl., N on Newland Ave. ½ bl.

19 5920 NORTH OCONTO AVENUE

Family and friends carrying heavy boxes, sofas, and mattresses grew more annoyed with each trip from the moving van, while passing John Richards as he gaily wound Christmas lights on his railings and bushes and lined toy soldiers along his walkway. But, after all, it was the first of December, and John could no longer contain his excitement over decorating his new home for the holidays.

In the seasons to follow, John's love of Christmas and of his growing family would define his unique homemade display. As a fireman and licensed electrician, he had both the time and the know-how to build decorations of his own design. Though he may advise that "a little decorating goes a long way," John went all out on his first attempt with a 30-foot snowman constructed of rebar, conduit, rope lights, and plastic twist ties. Three slightly

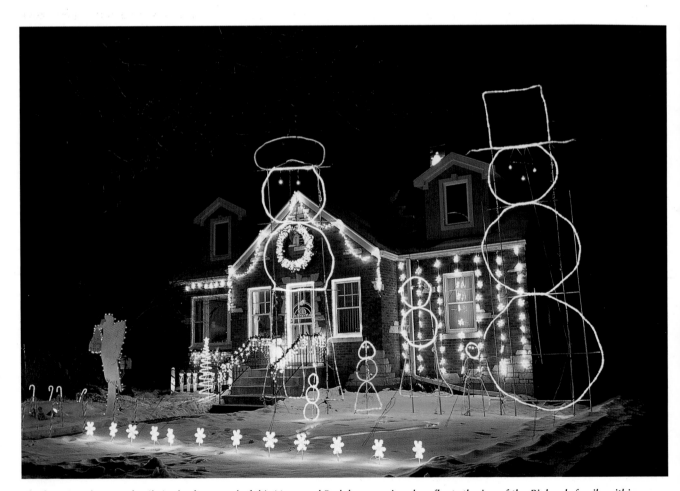

The homemade snow family in the front yard of this Norwood Park home uniquely reflects the joy of the Richards family within.

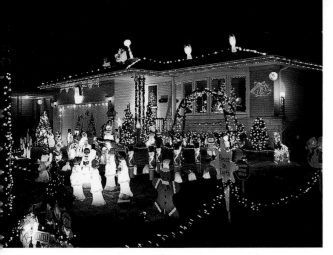

A smiling gingerbread man is among the characters delighted to appear on the lawn of John Smith.

wobbly circles with two eyes, a nose, and a huge stovetop hat produced an adorable, unmistakably homemade character that instantly put his home on the neighborhood Christmas map.

The success of his first endeavor inspired John to build his snowman a mate in honor of his wife, Teri—a slightly smaller snowlady wearing a colored skirt and fashionable tam. And as his family grew, the snow family grew as well with a little snow person added to the scene with the birth of each child and a light in the snowlady's belly if a baby was on the way. The Richards' four daughters, Niki, Kelly, Ashley, and Tiffany, now each have a snowgirl of their own with the dress color of their choice.

Except for the snowman hat, which is removable, the snow people are each stored in one piece in John's garage. Though the large characters may appear simple, they required over thirty man-hours to build. Setup requires three people, and John's buddies, Leo Baranowicz and Matt Wieclawek, have happily come to his aid.

Teri prefers to leave the heavy, freezing work to John but does an equally elaborate job of decorating the inside of the house. The girls, however, eagerly lend a hand with the smaller outdoor decorations, many of which pay homage to one of John's favorite books, *The Grinch Who Stole Christmas*. They put up the candy canes that line the walk and the snowflakes, garland, and lights on the railings. "If the kids put them up crooked, I leave them that way," John says, fully aware of his priorities. "The girls and I often stand out front just staring at the display and admiring our handiwork."

Thanksgiving Day–New Year's, 4:00PM–2:00AM. *From Harlem Ave., NW on Talcott Ave. 1 bl., N on Oconto Ave. ½ bl.*

O'HARE

20 4648 NORTH OAKVIEW STREET

John "Smittie" Smith loves holidays. A smattering of lights and figurines to match the occasion appear on his front lawn for St. Patrick's Day, Memorial Day, the Fourth of July, Labor Day, and Halloween. But at Christmastime, Smittie pulls out all the stops, inside and out.

Fond memories of Christmases past—his dad's decorations, his mom's powdered pecan balls, his Lionel and American Flyer trains, the piles of presents, and the Mitch Miller tunes—inspire Smittie to create a special memory for all who pass.

At three in the morning one season, while assembling the final touches inside, he spotted a couple of Chicago policemen gazing at the display while passing in their squad car. He acknowledged them with a hoist of his beer and received a cheery thumbs-up in approval of his efforts. **Dec. 9–Jan. 5, 5:00PM–1:00AM.** *From Cumberland Ave., W on Lawrence Ave. ¼ mi., S on Oakview St. ½ bl.*

PORTAGE PARK

YEAR-ROUND HOLIDAY CHEER

As two young boys were riding their bikes past Bill Cholewa's house a few days before Halloween, Bill overheard one boy say, "Look at that cool Halloween house!" The other boy replied, "Oh, that's nothing—you should see it at Christmas!"

With a garage and three sheds filled with over one hundred handmade decorations that trimmed the house on Christmas, Halloween, Valentine's Day, St. Patrick's Day, Easter, Memorial Day, and the Fourth of July and an award-winning garden lush with flowers and a fountain in the summer, it was no wonder the house on the corner of Grace Avenue and Long Street became locally famous throughout the year.

Bill's dad, Chester, started the decorating trend when he retired in 1988 and began making a few displays for various holidays from purchased wood patterns. Bill took

over in 1996, when his dad's eyesight began to fail, and eventually filled both sides of their corner lot and the backyard with his own creations. No sooner did he take down the Halloween display and discard the bags from the 27 pounds of candy he gave trick-or-treaters, than he began decorating for Christmas.

Though Bill's efforts were annually awarded with a prize from the local neighborhood association, it was the notes of thanks from passersby and the smiles on children's faces that were his inspiration. Sadly, Bill passed away in January 2007, but the joy he brought to his neighbors will be etched in their memories for years to come. (See photograph on p. 29.) ❄

21 4844 West Pensacola Avenue

After nine years of elaborately adorning the interior of their two-story Princess Anne home for the holidays, Tony Disalvio and Jeff Moser were content simply decorating outdoors at ground level with a few strands of lights, some garland, and a manger scene. That is . . . until their neighbor John Sobun stepped in. A self-described computer geek, John took digital pictures of Tony and Jeff's modest front-yard display and, just for fun, airbrushed white lights all along the roofline of the house. The men were so impressed with the effect that the following year they not only used the photo for their Christmas card but purchased six hundred clear bulbs and a 40-foot extension ladder to trim the eaves front and back. With additional accents in red, a 6-foot Santa in the upstairs window, and life-size toy soldiers on the front lawn, the meticulously executed display caught the eye of the local neighborhood association, which awarded the twosome first prize in the holiday decorating contest.

Several years and awards later, Tony and Jeff now traditionally make plans for their upcoming outdoor Christmas display in July while relaxing with a beer in their backyard pool—every year providing a new twist on a red and white theme. Before the weather turns cold, Tony climbs the ladder to hang the lights from the high peaks and cleans the gutters and windows while he's at it.

"In the summer, Tony's so meticulous with the lawn that if he could get down on his knees with a magnifying glass and a scissors, he would," Jeff says. "But after thinking about how he wants to put up the Christmas decorations for months, he just gets them out and up. Then it's up to me to finesse." Tony adds, "I don't have Jeff's patience with the lights, but I know how I want it done. I just give him his assignments."

Although new outdoor electrical outlets have been added to every side of the house, Tony admits that figuring amperages is also not his forte: "I just keep plugging. When I run out of outlets, Jeff replugs things and adds more extension cords. It's a real puzzle." Yet circuits still blow and outlets fry, so nary a year has gone by that the decorators' electrician and friend Paul Esrosinisto has not been summoned to come to their aid. "These two are an electrician's nightmare," Paul jests, but Tony proudly adds, "We have never been shocked." Their only shock is likely their electric bill. "ComEd comes by with a separate truck just to drop it off," Jeff laughs.

Throughout the holidays, neighbors compliment the display, families line up their kids on the porch for Christmas photos, and Tony and Jeff gaze at their handiwork from different angles across the street. But when the season is over, Tony says, "I just get up there and yank, and the lights all come flying." Then Jeff folds everything and puts it neatly away.

1st weekend of Dec.–Jan. 6, 4:30PM–11:00PM.
From Montrose Ave., S on Cicero Ave. 1 bl., W on Pensacola Ave. ½ bl. See photograph on front cover.

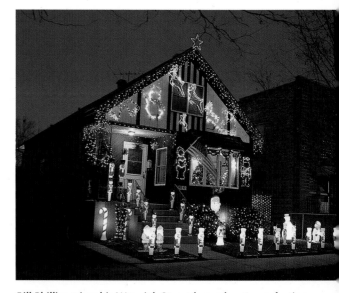

Bill Phillips trims his Warwick Street bungalow to perfection.

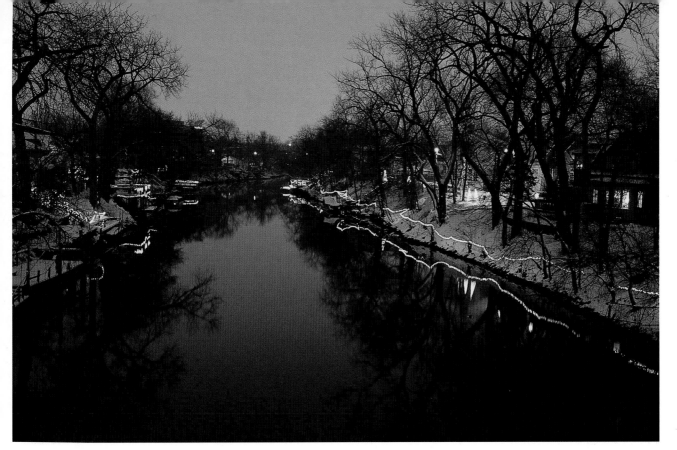

The bridge at Wilson Avenue provides a striking view of the holiday spirit reflected in the North Branch of the Chicago River as it winds through the Ravenswood community.

22 4818 WEST WARWICK STREET

In the forty-some years that Bill Phillips has been in the construction business, wrecking and removing debris, he has prided himself in being a perfectionist. "I believe in doing a job right," he says. In the twenty-some years he has been decorating his home for Christmas, he has earnestly applied the same standards. "Everything has to be perfect—straight up and down and straight across," Bill proclaims.

Though he preferred to do the decorating on his own in the past, Bill now enjoys the help of his young granddaughter, Julia, with some of the easy tasks. She already knows that "Papa" won't settle for an untidy job. "I tell her how to do it, and she does it right," Bill says proudly. Their workmanship pays off as families annually pose out front for holiday photos amid toy soldiers standing neatly at attention.

Each evening, Bill flips one master switch that powers the four outdoor outlets he installed the first year he lit the display. "When I want to close up for the night, I hit the switch and everything's off," he says. At the end of the season, Bill neatly stores the decorations in his three grown children's empty bedrooms. He admits, "When the kids were still at home, the decorations were here, there, and everywhere. That was kind of hard."

Dec. 7–Jan. 10, Dusk–12:00AM. *From Addison St., N on Cicero Ave. 3 bl., W on Warwick St. ¼ bl.*

RAVENSWOOD

23 WILSON AVENUE AND THE CHICAGO RIVER

Tucked away on the northwest side of the city, a variety of homes, large and small, line the banks of the North Branch of the Chicago River from Lawrence to Agatite, forming a small riverfront community, unexpected in the midst of an urban setting.

Since 2002, the neighbors west of the river in Ravenswood Manor and east of the river in Ravenswood Gardens have come together as the Ravenswood River Neighbors Association. The highlight of this diverse

group's activities is the annual lighting of the riverbank the first week of December. Residents illuminate both sides of the river, stringing white Italian lights on bushes, trees, fences, and piers along the bank behind their homes. Neighbors John Krenger and John Freidman engage the help of local high-school students to hang an additional 3,000 to 4,000 feet of lights for the twenty-some families unable to trim their yards themselves. The effect is lovely from the Wilson Avenue bridge, as the lights seem twice as bright reflected in the river below.

1st week of Dec.–end of Feb., Dusk–dawn.

From Lawrence Ave., S on Kedzie Ave. 3 bl., E on Wilson Ave. ½ mi.

ROGERS PARK

24 1817 WEST LUNT AVENUE

When Larry Wardzala was a little boy, he loved to help his mother decorate the Christmas tree. He would hang ornaments on the bottom branches as high as he could reach. Then his mom would lift him up to drape the garland and put the angel on top. "It didn't look too nice," Mrs. Wardzala recalls. "But he got a kick out of knowing that he put it there." Little did she realize that years later, not sharing his mother's tolerance for misplaced ornaments, her son would be rearranging the decorations after she hung them.

At twelve years old, Larry began to decorate the outside of the house, trimming the banisters and awnings with lights. Over the years the display became more elaborate and Larry more meticulous. To achieve deep colors unavailable in commercial lighting, Larry covered thousands of bulbs with swatches of theatrical lighting gel secured with small rubber bands. He wrapped floral wire around light strands to keep the bulbs pointing in the same direction and secured wires running across the walkway within sidewalk cracks. But thanks to his good taste and detailed handiwork, in 1995 his parents' elegantly decorated home was featured on the cover of the first edition of this book.

Though Larry no longer decorates his parents' Elmwood Park home to the same degree, he does an artful job at his new home in Rogers Park despite its electrical limitations—built circa 1893, the house has only a 100-amp

ANOTHER USE FOR SIDEWALK CRACKS

To hide electrical cords that cross over the sidewalk, Larry Wardzala of Rogers Park tucks the cords into the cracks between the squares of cement. He secures the wiring in place by wrapping it on both sides of the pavement around 8-inch gutter spikes, which are then pushed into the ground.

Several decorators also get power across the sidewalk by building an arch (see page 154), wrapping it with lights, and putting the female end of the strand on the parkway side.

electrical service. But Larry exclaims, "In the next few years I hope to increase the electrical service, so I can decorate this wonderful old Victorian with the holiday trimmings it deserves." Until then, he keeps the indoor lights dimmed and does his creative best outdoors with low wattage.

Fri. after Thanksgiving–2nd Sun. of Jan., Dusk– 11:00PM. *From Touhy Ave., S on Clark St. 3 bl., W on Lunt Ave. 1½ bl.*

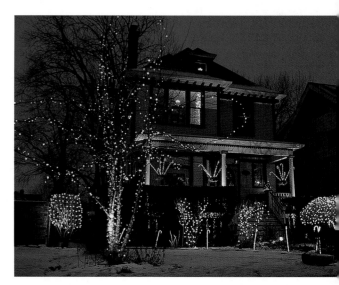

The elegant decorations on Larry Wardzala's Victorian home may not be as subtle when he increases his electrical service.

Opposite page: Garfield Park Conservatory (p. 56) dresses for the holidays with a lush garden of poinsettias and lighted evergreens. (Courtesy of Chicago Park District)

CHAPTER 3
Chicago ~ South

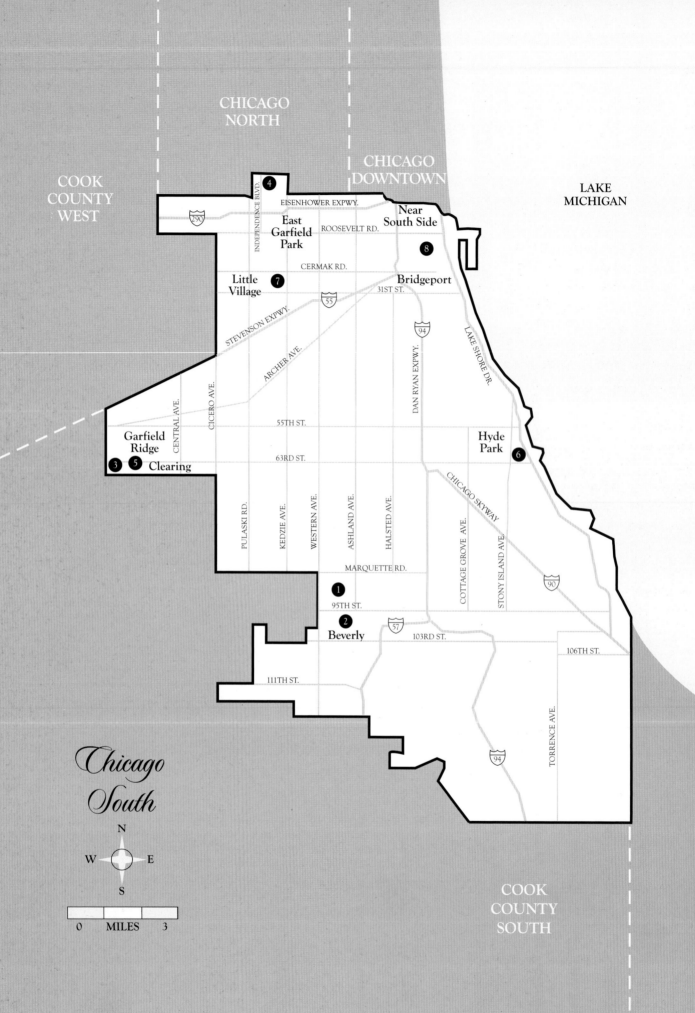

CHICAGO
NORTH

COOK
COUNTY
WEST

CHICAGO
DOWNTOWN

LAKE
MICHIGAN

4

EISENHOWER EXPWY.

290

East
Garfield
Park

ROOSEVELT RD.

Near
South Side

8

CERMAK RD.

Little
Village

7

31ST ST.

Bridgeport

55

STEVENSON EXPWY.

ARCHER AVE.

INDEPENDENCE BLVD.

94

DAN RYAN EXPWY.

LAKE SHORE DR.

CICERO AVE.

CENTRAL AVE.

55TH ST.

Garfield
Ridge

63RD ST.

3 **5** Clearing

Hyde
Park

6

PULASKI RD.

KEDZIE AVE.

WESTERN AVE.

ASHLAND AVE.

HALSTED AVE.

COTTAGE GROVE AVE.

STONY ISLAND AVE.

CHICAGO SKYWAY

90

MARQUETTE RD.

1

95TH ST.

2

Beverly

57

103RD ST.

106TH ST.

111TH ST.

TORRENCE AVE.

94

*Chicago
South*

N

W ✦ E

S

COOK
COUNTY
SOUTH

0 MILES 3

BEVERLY

1 9357 SOUTH LEAVITT STREET

When John and Annette Trellicoso were kids living on the south side of Chicago, each of their family's annual holiday traditions included driving around Beverly to look at Christmas decorations. When the couple married and moved to Beverly themselves, they decided to join the holiday fun.

The huge evergreen on the side of their stately English bungalow offered the perfect opportunity. Standing at a height of 55 feet and climbing, the tree is now gaily trimmed with forty lighted candy canes, hundreds of feet of glittering garland, and 1,800 feet of large multicolored C-9 bulbs. The decorating feat requires a series of outdoor outlets, six 20-amp circuits, 2,000 feet of extension cords, and the help of TL Tree Service and a cherry-picker truck.

John and Annette create the design, repair and replace the decorations, and gladly pay the extra $100 on the electric bill, happy to know their home may become a part of other people's holiday traditions.

Dec. 6–Jan. 5, 5:00PM–1:00AM. *From Western Ave., E on 95th St. 4 bl., N on Leavitt St. 1½ bl.*

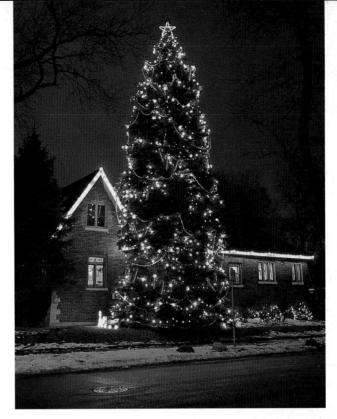

A 55-foot decorated tree greets passersby rounding the bend by the Trellicoso home.

2 9800 SOUTH LEAVITT STREET

Ed Laski has been adding decorations to his Beverly display since 1988. He outlines the entire Dutch colonial frame in

The Laskis' well-lit home sparkles safely.

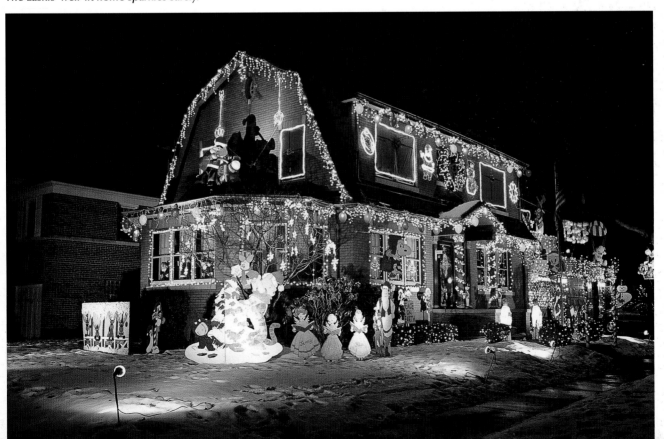

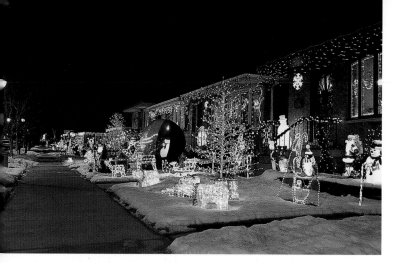

With Midway Airport only 2 miles away, the gleaming blocks of South Harlem Avenue can easily be spotted from the air.

multicolored C-9 bulbs, trims the windows and bushes in Italian lights, spotlights his daughter's homemade wooden figurines, illuminates his assorted plastic decorations, and animates his window displays. The electric bill increases nearly $200 for the season.

In 1992, when the display first reached this well-lit dimension, the fuse box in the basement began to hum. Ed's wife, Sue, would turn off lights in the house each evening until the noise stopped.

One night Ed found the basement full of smoke. Suspecting it was an electrical problem, he dashed to the fuse box. It was glowing red. Immediately he shut off all the breakers and called an electrician. "He said my main breaker had melted in the open position and that if I hadn't shut down all the breakers, the house would have burned down," Ed recalls.

Though the following day was Sunday, he hired two electricians to completely redo the circuits. Twelve hours later, when the job was complete, the electricians assured Ed that everything was fine and that it would even be okay to add more lights. Sue sighed, "That's the worst thing you could have said to him."

Dec. 10–Jan. 6, 5:00PM–12:00AM. *From Western Ave., E on 95th St. 4 bl., S on Leavitt St. 3 bl.*

CLEARING

3　6300 AND 6400 BLOCKS OF (OLD) SOUTH HARLEM AVENUE

When construction of a two-block stretch of modest brick bungalows was completed in the summer of 1991 on the east side of old Harlem Avenue across from a Bedford Park factory, it attracted numerous first-time homebuyers.

As the initial holiday season for the new homes drew near, residents Jim and Debbie Krystyniak gleefully seized the opportunity to be one of the first couples to decorate their house for Christmas. "I used to decorate my condo before this, and Debbie decorated her parents' house." Jim says. "I just like getting out there and decorating."

As if part of the duties of homeownership, one by one, every homeowner down the street got out their ladders, lights, and luminarias and trimmed their houses and yards until both blocks were dazzlingly aglow.

Though not a joint effort, the unspoken tradition has continued every year since. Jim admits, "Everybody does their own thing, and every year it gets bigger and bigger."

Pride in homeownership now shines so brightly at Christmastime on this far corner of Chicago's southwest side that it causes drivers on 63rd Street to turn their heads, passengers landing at Midway to feast on an aerial show, and the folks on old Harlem Avenue to revel in their good fortune.

Fri. after Thanksgiving–New Year's, Dusk–10:00PM. *From 63rd St., S on Harlem Ave. (IL-43) 500 ft., Right at fork to E on 65th St. ¼ mi., N on (Old) Harlem Ave.*

EAST GARFIELD PARK

4　GARFIELD PARK CONSERVATORY 300 NORTH CENTRAL PARK AVENUE

Four thousand brilliant poinsettias, ornamental peppers, Jerusalem cherries, plumbago, and other wintry blooms nestled in a forest of glittering fir trees are featured in Garfield Park's annual holiday flower show. The lustrous seasonal plants are grown by Chicago Park District floriculturists from cuttings of several varieties.

In the midst of a blustery Chicago winter, the conservatory is a wonderful place to escape for an early breath of spring.

Thanksgiving Day–Sun. after New Year's, (F–W) 9:00AM–5:00PM, (Th) –8:00PM. Open daily. Free admission and parking. (312)746-5100. www.garfield-conservatory.org. *From Eisenhower Expwy. (I-290), N on Independence Blvd. 1 mi., E on Washington Blvd. ¼ mi., N on Central Park Ave. 2 bl. See photograph on p. 53.*

GARFIELD RIDGE

5 6358 SOUTH NARRAGANSETT AVENUE

In the 1960s, Chicago Lawn resident Frank Guzik was locally famous during the holidays for his elaborately decorated home at 53rd and Tripp. His life-size manger scene, flagpole Christmas tree, animated Santa dressed in velvet, and expansive house trimmed in colored lights drew crowds from throughout the south side. When he suddenly passed away in 1968, his daughter Gloria Bodoki and her husband, John, who had helped with the display, decided to carry on the tradition in Frank's honor at their own south-side home.

Along with Frank's tradition came his enthusiasm and fame. In the years to follow, the Bodoki home also became a popular south-side holiday destination, not only at Christmas but at Easter, Fourth of July, Halloween, and throughout the summer months when the couple's award-winning garden blooms with over three thousand flowers. "The decorations flow from Halloween to New Year's Day," says John, whose imagination is also spurred from his first job supervising Marshall Field's nine-story holiday warehouse.

The Bodokis' corner lot provides a wide pallet for decorating. The Christmas display features a children's theme and a religious theme, which alternates from one side of the house to the other, as suits John's fancy. The front picture window changes to match with either Disney animation or an elegant 24-inch nativity set in a handmade cedar stable. "People beep and give thumbs-up all the time," says Gloria, who's in charge of adding seasonal accents to the flowerpots.

After annually attracting crowds to their display for sixteen years, the Bodokis decided in 1992 to take a sabbatical from assembling their elaborate display and treat themselves to a winter vacation in Disney World. There they could experience the thrill of spectacular Christmas decorations without lifting an extension cord.

Much to their surprise, upon returning from their trip, they were greeted by relieved neighbors who, accustomed to the regularity of their decorating, had assumed one of them had taken ill or died. "People were stopping by for the next year checking to see if we were okay," John remarks. "I guess it was nice to know our decorations were appreciated."

The couple now intends to continue the tradition every year. "The little break was all we needed," John confesses. "Christmas decorating is in our blood."

Fri. after Thanksgiving–Jan. 6, 5:00PM–9:00PM.
From Harlem Ave., E on 63rd St. 1 mi., S on Narragansett Ave. 2 bl.

HYDE PARK

6 THE MUSEUM OF SCIENCE AND INDUSTRY
57TH STREET AND LAKE SHORE DRIVE

Chicago is a town of many cultures and holiday traditions, which the Museum of Science and Industry has been

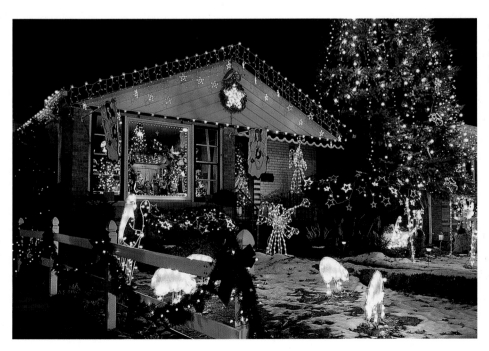

From a block away, the Bodokis' 30-foot evergreen, trimmed in alternate years with glowing angels or colorful ornaments, hints at the front-yard theme.

celebrating since 1942 in an exhibit entitled "Christmas Around the World."

In what began as a United Nations Day salute to American Allies during World War II, the exhibit now features close to fifty trees and crèches throughout the museum, decorated by various ethnic community groups with a theme that changes from year to year. A tree from Wales is adorned with the Welsh "love spoons" that suitors traditionally carve upon proposing marriage. A Native American tree is trimmed by the young and old of thirty tribes with handmade natural ornaments. A Japanese tree is decorated with the intricately folded figures of origami. Throughout the holiday weekends, performers from many of the countries entertain with traditional yuletide songs and dances.

In 1994, the museum added the "Holidays of Light," an exhibit depicting festive traditions of cultures that celebrate light and enlightenment. These include Chinese New Year, Hindu and Sikh Diwali, African American Kwanzaa, Muslim Ramadan, Jewish Hanukkah, Buddhist Visakha Puja Day, and Swedish Santa Lucia Day.

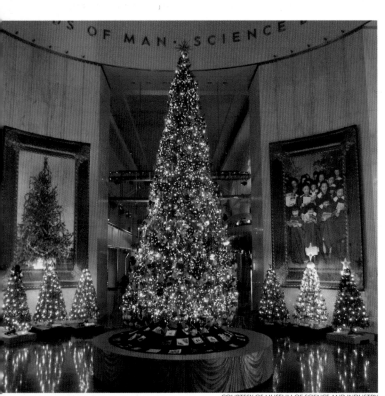

COURTESY OF MUSEUM OF SCIENCE AND INDUSTRY
Holiday trees from around the world surround the "Grand Tree" in the rotunda of the Museum of Science and Industry.

Fri. before Thanksgiving–Sun. after New Year's (ending date may vary), (M–Sa) 9:30AM–4:00PM, (Su) 11:00AM–4:00PM. Admission and parking fees. Extended hours and free admission some days. (312)684-1414. www.msichicago.org. *From Lake Shore Dr., W on 57th St.*

LITTLE VILLAGE

7 2816 SOUTH CHRISTIANA AVENUE

When Isabel Favela was a child in Guadalajara, Mexico, her nativity scene consisted of Mary, Joseph, two kings, and a shoebox. In the United States this may not have seemed far from a complete set, but in Guadalajara, where families display elaborate heirloom collections and the famed nearby pottery town of Tlaquepaque hosts an annual nacimiento (nativity scene) competition, Isabel yearned for more.

Isabel's modest Chicago home now boasts a nacimiento display case that nearly fills the entire front yard—the product of three days of carpentry work by her husband, Everardo, and a clever design that incorporates a lamppost and the trunk of an evergreen tree right into the structure.

As each Christmas season nears, the family helps carry boxes out to the front yard, but the rest of the decorating is left to Isabel. "She doesn't like help," Everardo laughs. Each day for a full week, Isabel crawls inside the display case and creates her nacimiento from hundreds of figures and rocks she has collected from all over Mexico, as well as a collection over forty years old she inherited from her grandmother Maria Martinez. "The neighborhood kids sit on the grass and watch, and the neighborhood ladies come by and say, 'Why don't you do it this way?' But I like to do it myself," Isabel proclaims. In a space that is barely 4-feet high at its peak, Isabel has been known to scratch her head on nails protruding from the roof, but that doesn't seem to quell her enthusiasm. "I make scenes for other holidays too," she adds.

The completed diorama changes every year but is always split into two themes to celebrate the family's two homelands. The left side depicts an American town with Santa in his sleigh flying over houses, shops, and churches, trimmed with lights and covered in snow. The right side replicates a traditional Mexican nacimiento with a well surrounded by dozens of people fetching water, washing clothes, making

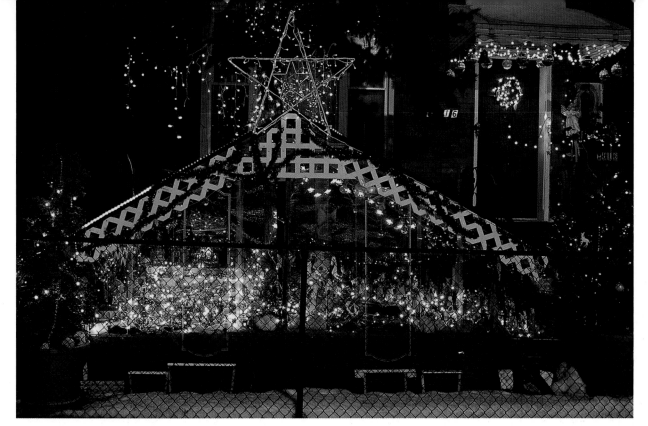

A traditional nacimiento with a twist of Americana provides delightful viewing in the front yard of the Favela home.

tortillas, and tending sheep, while up on a hill an angel watches over the Holy Family nestled in a stable.

"We call her collection 'her toys,'" Isabel's oldest son, Eddie, teases. "When we were kids, she had just as much stuff as she has now, but she put it all in our 12' x 12' living room. The waterfalls and mountains took up so much space we only had room for the TV and one chair, which my brothers and I would all fight over."

Though Isabel would like Everardo to build a bigger front-yard display case for the ever-growing collection of figures she adds to each year on her annual trips back home,

THE EARLY BIRD STAYS ON THE ROOF

By getting all the ladder and rooftop work for his Christmas display done in time for Halloween, Tom Johnson of Streamwood not only gets double mileage from his decorations but completes the tough jobs early to ease his task. He also avoids having to climb on an icy roof in blustery weather.

Bill Phillips of Chicago also recommends starting early while the weather's a bit warmer—there's less chance electrical wires will break or crack.

she has had to settle for lesser improvements. When squirrels were discovered drinking water from the well and a cat was found sleeping amongst toppled figures in Bethlehem, Everardo enclosed the front of the manger in Plexiglas. When Isabel wanted to hang a comet overhead in the evergreen tree, she persuaded a passing fireman in a hook and ladder to give her a hand and paid him in tamales.

In Guadalajara the Christmas season comes to a close on February 2 with the feast of La Candelaria, commemorating the presentation of the Christ Child in the temple forty days after his birth. Local families celebrate by bringing the statue of Jesus in from the nacimiento, dressing him in fancy baby clothes, and enjoying a feast. Isabel admits, "I don't do that in Chicago. It's too cold to go out and get him."

Mid-Nov.–Feb. 2, 4:30PM–12:00AM. *From Kedzie Ave., W on 26th St. 3 bl., S on Christiana Ave. 2½ bl.*

NEAR SOUTH SIDE

8 CLARKE HOUSE AND GLESSNER HOUSE
 1800 SOUTH PRAIRIE AVENUE

The one-hour evening "Candlelight Tours" of these Chicago landmarks during the holiday season offer visitors

The schoolroom in the Glessner House is trimmed with a small candlelit tree and an assortment of children's gifts—dominoes, tin soldiers, dolls, a tea set, and a toy stove.

an authentic taste of two very different Christmases of the past, a half-century apart.

The Clarke House, originally built in 1836 on Michigan Avenue near 16th Street, is one the oldest houses in Chicago. Its middle-class furnishings and 1850s holiday trimmings are reminiscent of the town's early frontier days. It was two decades before Christmas was a national holiday. New Year's was celebrated on a grander scale, while going house to house for a drink was typical Christmas fare. The trimmings were quite simple—a bowl of scented ornaments made from carved oranges decorated with cloves freshened the house, while small trees crafted from gumdrops or fruits, which were hard to acquire, added a touch of holiday merriment.

The Glessner House, built in 1887 by American architect Henry Hobson Richardson, is one of the few late-nineteenth-century mansions remaining on the once-exclusive Prairie Avenue. Its fresh pine roping, red satin bows, natural adornments, elaborately trimmed Christmas tree, and formal dining feast provide a glimpse of the holiday traditions of the wealthy class of the Gilded Age.

Toward the end of the nineteenth century when tall Christmas trees became the trend, the Glessners began chopping down an evergreen at The Rocks, their summer farm in Littleton, New Hampshire, and shipping it home by train in time to be trimmed on Christmas Eve. The

Christmas tree that currently decks the Glessner House each season is trimmed with many of their original ornaments and is still shipped from the site of their former summer estate, which is now a Christmas tree farm.
2nd weekend of Dec., 6:00PM, 6:30PM, and 7:00PM. Admission fee. Reservations required. (312)326-1480. www.clarkehousemuseum.org, www.glessnerhouse.org. *From State St., E on 18th St. 4 bl., S on Indiana Ave.*

PREVENTING ELECTRICAL SHORTS

To prevent moisture from causing electrical shorts on rainy nights, many decorators tightly wrap the connecting plugs in plastic wrap secured with electrical tape. Some place the plugs in plastic food containers or pop bottles with trap doors cut in the sides, and seal them shut with tape. Some apply caulk around the connections. Others keep the connections off the ground. And some make the connections as tight as they can and claim to have no problems at all.

Opposite page: The giant birch reindeer standing peacefully in the O'Neills' Lincolnwood yard offers no hint of how he got there (p. 73).

CHAPTER 4
Cook County ~ North

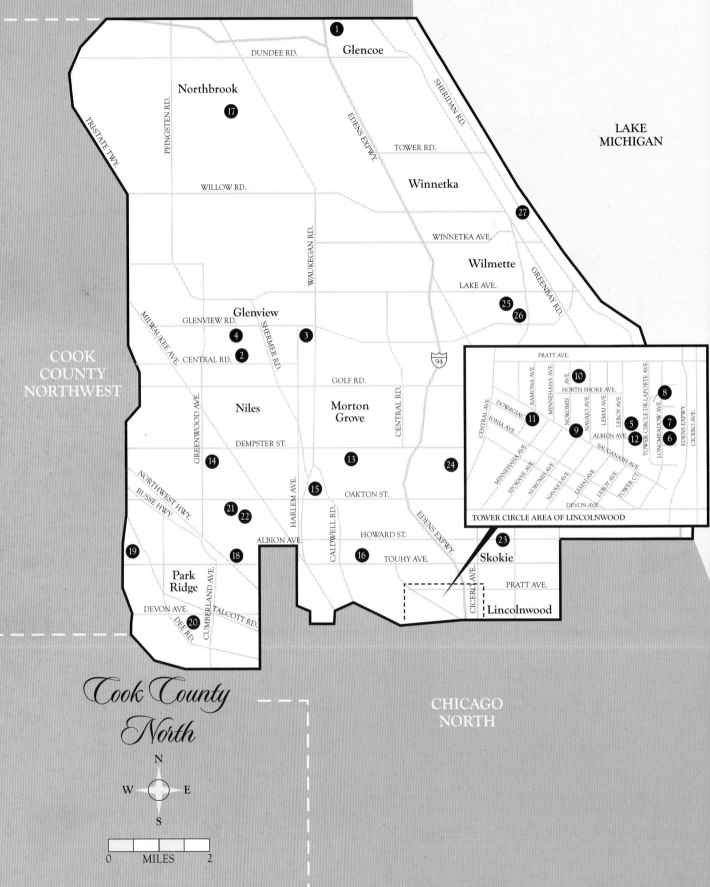

LAKE
COUNTY

Glencoe

DUNDEE RD.

Northbrook

PFINGSTEN RD.

TRI-STATE TWY.

SHERIDAN RD.

EDENS EXPWY.

TOWER RD.

LAKE
MICHIGAN

Winnetka

WILLOW RD.

WAUKEGAN RD.

WINNETKA AVE.

Wilmette

GREENBAY RD.

LAKE AVE.

Glenview

GLENVIEW RD.

MILWAUKEE AVE.

SHERMER RD.

CENTRAL RD.

COOK
COUNTY
NORTHWEST

GREENWOOD AVE.

Niles

Morton
Grove

GOLF RD.

CENTRAL RD.

I-94

DEMPSTER ST.

NORTHWEST HWY.

BUSSE HWY.

HARLEM AVE.

OAKTON ST.

CALDWELL RD.

ALBION AVE.

HOWARD ST.

EDENS EXPWY.

Park
Ridge

DEVON AVE.

CUMBERLAND AVE.

DEE RD.

TALCOTT RD.

TOUHY AVE.

CICERO AVE.

Skokie

PRATT AVE.

Lincolnwood

TOWER CIRCLE AREA OF LINCOLNWOOD

PRATT AVE.

CENTRAL AVE.

IONIA AVE.

DOWAGIAC

RAMONA AVE.

MINNEHAHA AVE.

NOKOMIS AVE.

NORTH SHORE AVE.

NAVAJO AVE.

LEMAI AVE.

LEROY AVE.

ALBION AVE.

TOWER CIRCLE DR.

LAPORTE AVE.

LONGMEADOW AVE.

EDENS EXPWY.

CICERO AVE.

SAUGANASH AVE.

MINNEHAHA AVE.

SPOKANE AVE.

NOKOMIS AVE.

NAVAJO AVE.

LEMAI AVE.

LEROY AVE.

TOWER CT.

DEVON AVE.

CHICAGO
NORTH

Cook County
North

N
W E
S

0 MILES 2

Creator Robert L. May attaches the famous glowing red nose to his front-yard Rudolph with daughters Betsy and Martha at his side in this photo circa 1964.

EVANSTON

RUDOLPH'S HOME

From the fifties through the seventies, the May family's front lawn was the holiday home of the season's most popular reindeer. With a red nose visible from a block away, the life-size papier-mâché Rudolph stood mid-air with reins of white lights leading his way to the rooftop. When the family moved from their Evanston home on Hamlin to Avers Avenue near Church Street, the lovable deer came too, like one of the family. And no wonder—the father of the household was no other than Robert L. May, the creator of Rudolph, the Red-Nosed Reindeer.

A copywriter for Montgomery Ward & Co., May was known for his humorous puns and poetry written for office parties. As a lark he was asked to write a holiday story to be used as a toy department giveaway.

He began writing about a reindeer, who at first had bright eyes instead of a shiny nose and was named Rollo and then Reginald before becoming Rudolph. May would read the tale to his daughter and her friends to get their reaction.

The initial story was rejected by May's boss, who felt that the red nose would be associated with alcoholism and inappropriate for Christmas. Determined, May headed for Lincoln Park Zoo to recreate his character from live models. With the help of the company art department, he was able to create a reindeer that pleased enough Ward executives to sway his boss.

May's poem with illustrations by staff artist Denver Gillen was printed in 1939 as a thirty-two-page booklet and given to 2.4 million children. In 1946, after World War II, the booklet was reprinted, and 3.6 million copies were distributed.

Montgomery Ward then felt that Rudolph had played out its usefulness, but Robert May recognized the enormous popularity his reindeer had gained. He requested ownership of the copyright, which was granted, and took a seven-year leave of absence to manage Rudolph. The character that had earned him a byline and a Christmas bonus its first year provided a business opportunity that is still helping to support May's family today.

The story has sold millions of copies in over twenty languages. The song "Rudolph, the Red-Nosed Reindeer," written by May's brother-in-law, Johnny Marks, and recorded by Gene Autry in 1949, not only was a bestseller but forever engraved the story of Rudolph in children's minds. The 1964 television special continues to delight audiences yearly. May's six children operate the Robert L. May Company to satisfy the demand for licensed Rudolph products from stuffed animals to boxer shorts in the United States, Japan, New Zealand, Australia, and the UK.

SANTA LOSES HIS HEAD

Several years ago, the central shopping district of Evanston was decorated with a huge 16-foot Santa Claus. On an unusually blustery day, the firm that supplied the enormous display received an emergency call. It seemed Santa's head had come loose and was rolling down the middle of the street.

Robert May, an unassuming man who eventually returned to his job at Montgomery Ward, considered the success of Rudolph to be good luck and an amazing blessing. Recalls his daughter Elizabeth, "You could tell it thrilled him every year when people would pay attention to Rudolph. He would really feel proud and special at Christmastime."

He enjoyed sharing his pride each season by mailing hundreds of reindeer Christmas cards with red noses individually hand-colored by his children. During the holidays a parade of cars would pass to view Rudolph at the May home. Children would have their pictures taken on Rudolph's back, and carolers would come to sing the famous deer's theme song.

After Robert May's death in 1976, the family donated the life-size Rudolph to May's alma mater, Dartmouth College in Hanover, New Hampshire, where it is displayed with other Rudolph memorabilia in memory of a loving man who gave a simple gift to the children of the world. ❄

GLENCOE

1 CHICAGO BOTANIC GARDEN
1000 LAKE COOK ROAD

Though many may visit the Chicago Botanic Garden from spring to fall when greenery is lush and flowers are in bloom, the snow-laden evergreens and bare winding branches of winter offer a majestic beauty of their own, well worth a cold-weather trip. And during the season's longest nights, when the Garden presents "Wonderland Express," a glorious holiday display of 750,000 lights, enchanting railroad gardens, and delightful events, the Chicago Botanic Garden is a destination not to be missed.

The Garden's flowerbeds, prairies, woods, islands, and waterways host a stunning light display worthy of its grand setting. Lighted tree trunks form glistening columns along the walkways, dramatically interrupted by entire trees wrapped in lights from trunk to twig. Colorful spheres of lights

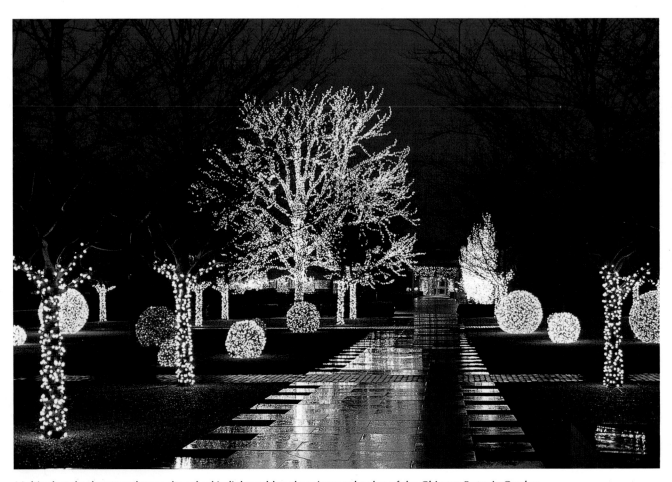

Multicolored spheres and trees drenched in lights add to the winter splendor of the Chicago Botanic Garden.

dance playfully across the Esplanade, while here and there alone in the distance a stately elm awakens from its slumber, loftily silhouetted in lights against a dark winter landscape.

The Garden's outdoor Model Railroad Garden, which features G-scale trains in a magnificent setting of handcrafted U.S. landmarks from May to October, puts on a local face in grander scale and moves indoors for the holidays to the galleries of the Regenstein Center. The Krehbiel Gallery greets visitors with an English country train winding through a colorful garden of poinsettia, kalanchoe, amaryllis, and other seasonal blooms, while the spacious Nichols Hall features a magnificent 10,000 square-foot model train display. Ten G-scale trains chug across a path of bridges, trestles, waterfalls, and seventy miniature Chicago landmarks as snow falls from overhead. Designed by Paul Busse of Applied Imagination, the models are cleverly constructed of natural materials, such as twigs, bark, and acorns.

Visitors are also welcome to shake winter's chill in the greenhouses—which feature palm trees and cactus plants, mingling for the occasion with poinsettias, lighted evergreens, and topiaries—or feast on a moderately priced seasonal meal at the Garden Cafe.

Though the "Wonderland Express" special events vary from year to year, the kick-off "Reindog Parade" seems here to stay. Over four hundred canines have paraded in playful holiday costumes, including a group of French poodles dressed as the Sugar Plum Fairies.

Fri. after Thanksgiving–1st week of Jan., 10:00AM– 7:00PM, (Dec. 24) –3:00PM. Closed Christmas. Admission and parking fees. Dogs allowed only on parade day. (847)835-6900. www.chicagobotanic.org. *From I-45, E on Lake Cook Rd. ¼ mi.*

GLENVIEW

2 2744 CENTRAL ROAD

"I designed it myself, so I could wear Christmas year-round," says Carrie Sansing, proudly referring to the crisscrossed candy canes and sprig of holly tattooed on the small of her back.

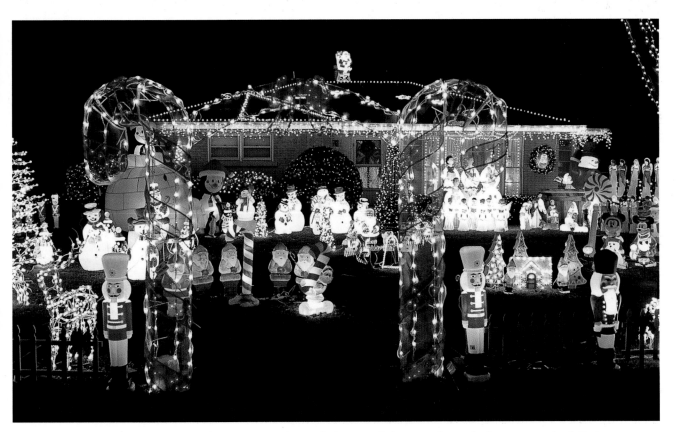

With a wide assortment from which to choose, Carrie Sansing designs a new theme each year for her computerized display.

An obvious Christmas enthusiast, the Glenview homeowner is also an avid collector of lighted plastic figurines (or blow molds as they are called in the trade). Her collection of over six hundred figures and nearly a mile of extension cords fill a barn and shed and has prevented the family from parking in the garage for the last ten years.

Other Christmas items, which include a new system to computerize the display to music, are additionally stashed in closets and under beds throughout the house. "My husband, David, had no idea how much I really had until he decorated for me in 2006, when I was too sick to do it myself. My cover was blown," Carrie says. "And he only put out 125 blow molds. It was really bad."

When his wife drove all the way to Coon Rapids, Minnesota, to pick up the Three Kings from an Internet purchase, David commented, "You know, honey, you're really sick. There should be a twelve-step program for this."

One of few women who tackle the outdoor holiday display on their own, Carrie credits her skill and enthusiasm to her mom, Lois Polales, who started buying lighted figurines before they were even plastic. "Every year when the Christmas catalogs would come out, we'd look to see what they had that was new," Carrie recalls fondly. "I'd come home from school after the package had arrived, and my mom would have a new sleigh and reindeer set up in our living room." Without the assistance of her dad or two brothers, Carrie and her mom would assemble the decorations. By the age of twelve, she had been taught how to calculate amperages and knew how to plug everything in.

With many of her mom's items still part of her display, Carrie stands alone in the dark every year after assembling her decorations, looks up at the sky and says affectionately, "What do you think, Mom?"

Sun. after Thanksgiving–Jan. 6, (M–Th) 6:30PM– 10:00PM, (F–Su) –11:00PM. *From Greenwood Rd., E on Central Rd. ½ mi.*

3 GLENVIEW HOUSE
1843 GLENVIEW ROAD

A favorite local tavern, restaurant, and gathering place since 1878, Glenview House has also doubled as a boarding house, barbershop, dance hall, and church at

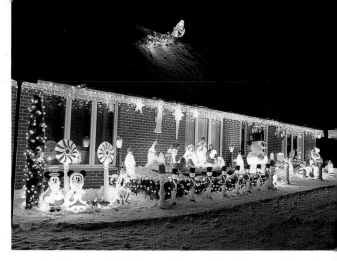

A rooftop Santa and sleigh, manufactured in 1956, were the inspiration for Danny Murov's collection of over four hundred plastic figurines.

various times in its history. Originally known as Eustice's and later Dilg's, the popular establishment hosted many a serious card game as well as the 1899 incorporation proceedings for the Village of Glenview.

With a reasonably priced sandwich menu and a location near the train depot, the tavern still attracts crowds of local residents throughout the year. At Christmastime, when covered in multicolored lights inside and out and topped with a rooftop Christmas tree, the atmosphere couldn't be more inviting.

Dec. 1–Jan. 10, Dusk–dawn. Restaurant hours: (Su–F) 11:00AM–2:00AM, (Sa) –3:00AM. Children welcome when accompanied by an adult. Available for parties. (847)724-7999. www.glenviewhouse.com. *From Waukegan Rd., W on Glenview Rd. ½ mi.*

4 2749 GLENVIEW ROAD

A few weeks after Danny Murov was born, his grandfather Rayner Rehberger unpacked a forgotten Santa and sleigh he had stored in his attic and displayed it in the family's front yard in honor of his first grandchild. Two Christmases later, when Rayner mounted the decoration on the roof, the toddler excitedly pointed at Santa every time he went outside. In the years to follow when his grandpa readied to pack the figures away, Danny so much enjoyed standing beside the Santa, who was just about his size, that Rayner left the figures in the yard until Easter just so his grandson could play with them.

Danny's dad also recognized his son's fascination with Christmas decorations, so he began purchasing new lighted figurines each holiday season that they would set

up on the lawn together. As a special treat, he would take Danny on an annual summer trip to the holiday mega-store Bronner's Christmas Wonderland in Frankenmuth, Michigan, where his enthusiastic son was soon on a first-name basis with owner Wally Bronner. By the time Danny was twelve, his ever-growing display won first place and $100 in a contest judged by a busload of Glenview senior citizens.

In his early teens, Danny took charge of the decorating himself. With the help of his friends Bill Kasper and Tony Maris, his cousin Mike, and his brother David, Danny now trims the house not only for Christmas but for Easter, Fourth of July, and Halloween with a collection of over four hundred plastic figurines. An expert on the figures, Danny adds to his collection year-round from stores, garage sales, and people's front yards—he once made Mike ring someone's doorbell to see if they wanted to sell a clown snowman he saw on their lawn and ended up buying the entire display.

GETTING YOUR CANDY CANES IN A ROW

For a perfectly spaced row of plastic figurines all pointing in the same direction, Danny Murov of Glenview recommends premounting the figures to 2x6 boards. He first drills a ¼-inch hole at a 45-degree angle an inch above and through the bottom of each figure on the left and right sides. After marking where each figure will be placed on the flat side of a 2x6, he aligns one figure at a time to the board and secures it through the drilled holes with 2-inch drywall screws and ¼-inch fender washers.

To secure the boards to the ground, he uses a rebar snapper to cut two 8-inch lengths of rebar per 8-foot board. (A hacksaw may also be used.) He then uses a rebar bender to bend the rebar, approximately 6 inches from the end, into an L-shape. After putting the figurines in position, he pounds the long end of the rebar into the ground so that the short end overlaps the board and forces it down at each end. Using a power screwdriver, Danny removes the figures at the end of the season for easier storage. "It's a beautiful system," he beams.

At the end of the Christmas season, the boys spend weeks washing, wrapping, boxing, and storing the figures in the garage, attic, basement, and closets until all are packed away—with the exception of one. The original Santa, which his grandpa continues to put on the roof each year, is carefully placed in a corner of Danny's bedroom, inspiring his dreams 'til Christmas comes again.
Thanksgiving–Jan. 6, (M–Th) 4:30PM–9:00PM, (F–Su) –10:00PM. *From Harlem Ave., W on Glenview Rd. 1 mi.*

LINCOLNWOOD

Longtime residents of the Lincolnwood Towers neighborhood in this north-side suburb recall area homeowners drawing crowds of visitors to their holiday displays clear back to the 1950s.

Jim and Irene Archambault on LeMai Avenue created the most popular attraction by disguising their two-car garage as a manger scene. The outside of the garage was camouflaged with boughs. Life-size statues of the Holy Family shared the cave-like interior with live sheep, a rooster, and a donkey, which the couple brought from their Wisconsin farm. The attraction drew such large crowds that businessman and Lincolnwood neighbor Andy Frain offered to send ushers.

On Nokomis Avenue, Mary Kriengberg decorated her yard with a magnificent choir of sixteen boys in white gowns, a gilded pipe organ surrounded by a forest of lighted trees, two white reindeer with golden antlers, and a Victorian couple hanging a wreath—all of which she sculpted herself. Mary's daughter, Ruth Miles, who lived on Ramona Avenue, joined her mom's efforts by displaying a large elf, who was keeping Santa's records at his desk. Dr. Vladimir Skul, a Croatian immigrant, celebrated his freedom on LaPorte Avenue with a patriotic display of flags and toy soldiers that surrounded his entire yard. Animated dolls and life-size movable Santas in suits of gold and red velvet appeared in picture windows throughout Lincolnwood Towers, as residents of this affluent neighborhood shared their good fortune with all who passed.

By the midsixties, three families at the intersection of Sauganash and Nokomis avenues were again causing traffic jams—over three hundred cars an hour. The LiPomi home on the northeast corner was best known for its

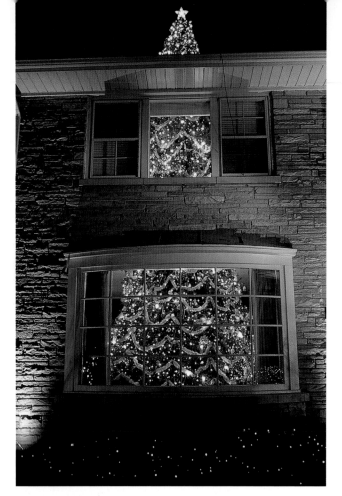

The Noonans' three-story Christmas tree pops through the roof of their two-story house.

animated scene of elves in a candy-cane factory. Across the street the Cascio family had a seal on the front porch that spun a ball on its nose, a mechanical Santa in the window, giant ornaments hanging from the eaves, soldiers lining the driveway, and a wreath encircling a huge elf over the entryway, which once decorated State Street. The Bongiovanni family on the southwest corner displayed a life-size nativity scene, four animated elves constructing toys, a golden angel swinging on the porch, a clown performing flips, and a snoring Santa snoozing in his chair.

Contrary to rumor, each family owned their decorations and assembled the displays themselves. For over two decades that the families decorated, they were featured regularly on television news programs.

The LiPomis are still decorating (see page 71). The Cascios moved away in 1990. And though the Bongiovannis discontinued their display in 1992, they sold all their decorations to the Stefani family, who display them with some added attractions of their own at their home on the southeast corner of LeMai and Albion avenues.

Mary Noonan, whose Lincolnwood home is famous for the Christmas tree coming out of the roof (see story below), recalls her dad taking the family to see the decorations in the fifties. Though she fondly remembers the "long drive" from their Rogers Park home and the awesome displays, Mary never knew exactly where she had been. During the first holiday season in her Lincolnwood home, she suddenly realized she was living in her childhood dreamland.

Though the displays have changed, the Lincolnwood Towers holiday tradition continues. In addition to the homes featured on the following pages, viewers are encouraged to drive up and down all the streets to look for additional surprises. ❄

5 6601 North LeRoy Avenue

Years ago when Kevin Noonan was in grade school, his teacher asked the class to name a family holiday tradition, and Kevin responded, "We get a Christmas tree." The students were unimpressed until the proud youngster added, "And it's so big that it goes through the roof!" With wide-eyed admiration his classmates gasped, "Wow, that's your house!"

Children and adults from miles around have come to know the famous 24-foot tree, too large for its 20-foot house. Its base, which measures 11 feet in diameter, takes up the entire living room picture window. The tree begins to taper off as it rises to the second floor, but none too soon, as its last 3 feet burst through the ceiling and out to the roof.

It takes Mary and Mike Noonan and their six adult children two weeks to decorate this enormous tree with 25,000 lights, 450 ornaments, hundreds of feet of garland, sixty stale candy canes, several strands of plastic (thank goodness!) popcorn, and a tree skirt that barely covers half the base. Mary gives the kids a decorating date, and they are all required to show up. Though the Noonans really enjoy the end result, they admit the tradition of decorating the Christmas tree, which might find the perfect family bonding in love and togetherness, wreaks havoc when the task is this overwhelming. Mike jokes, "Our family is bound together by one thing at Christmastime—we all hate decorating."

The colossal Noonan family tradition began in 1982 when Mike brought home the first Christmas tree for their

new home. It was much taller than their 8-foot ceiling. Mike tried smashing it into the room until it looked like it was cracked in two. It was then that the idea struck him— the tree would ascend into the second-floor bedroom, where the top would show through the window. Though the family was happy with Dad's solution, it was not big enough for Mike. He proclaimed, "Next year it will go through the roof!" And it has ever since.

For several holiday seasons, the family had the tree special-ordered and delivered from Michigan. In the spirit of Christmas, Mary dutifully vacuumed the endless needles and cleaned the sap. However, the year that a chain saw was used in her well-kept living room to shorten the trunk, the smell of fresh pine somehow lost its appeal. The following season a custom-ordered artificial tree replaced the live one.

From the first year the tree was displayed, the family has heard the sound of passing motorists who stop and back up in a baffled double take. Those convinced that the tree actually goes through the roof have been known to wager bets, mistakenly thinking the Noonans would resolve their dispute. But Mary and Mike simply reply, "It's the magic of Christmas," and the children (who are sworn to secrecy) respond, "The ceiling has a hole in it, and the roof has an insulated louvered trap door."

Another attraction of the Noonan display is the life-size Santa and sleigh, pulled by two stuffed reindeer. Mike bought the antique figures from a museum in Union, Illinois. He acknowledges that the services of a taxidermist have been needed to repair both animals over the years, but the Noonan children have always been more concerned with attaching a red nose to one of them. It seems the nose staying on in cold weather is the least of their problems—the figures may soon be retired as they deteriorate beyond repair.

Mike adds lights to the bushes and moving figures in the windows each year. Mary, a former school teacher, also sets up a special window display, which she attributes to her "bulletin board mentality." An electrical supply salesman, Mike is able to store the decorations in a warehouse at work and move the large pieces in a company truck.

With crowds of spectators arriving late at night to see the display, it had become increasingly difficult for Mike to turn off the lights without boos and hisses from late-night visitors. At first he attempted to sneak behind the bushes to reach the connections and avoid the jeers but finally resorted to using timers.

A few years ago, a neighbor happened to be watching *America's Funniest Videos* on television when footage of the Noonan's tree appeared on the screen. The voice on the tape, telling his wife he had bought a tree that didn't fit in the house and had improvised to make it work, belonged not to Mike but to an imposter. Though understandably miffed that someone would try to take credit for their efforts, the Noonans laughed the incident off since no prize money was involved. Oh, the magic of Christmas! **Dec. 10–Jan. 2, (Su–Th) 5:00PM–11:00PM, (F–Sa) –1:00AM.** *From Cicero Ave., W on Pratt Ave. 4 bl., S on LeRoy Ave. 2 bl.*

6 6601 NORTH LONGMEADOW AVENUE

As a young typist for a local publishing firm, Pat Domanik was given the assignment of decorating the company bulletin board for Christmas. While searching books and magazines for a fitting holiday phrase, she found a poem entitled "To Believe in Christmas." Pat printed it on parchment and hung it on the office board. Fellow employees were deeply moved by its message. Pat kept the poem and committed it to memory.

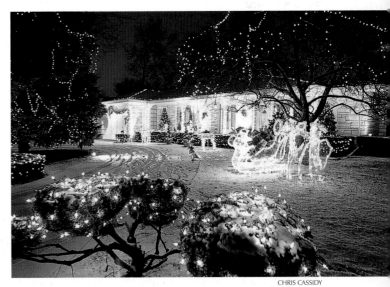

CHRIS CASSIDY

Wire-mesh angels, which Pat Domanik included as fixtures in the purchase of her home, blow their horns in the glisten of white lights.

As the years have passed, she has displayed the love of the holiday that the poem inspired. Standing amid shelves of decorations that fill two rooms of her basement and the garage, Pat admits, "My heart flies out of me when I have to put these things away. I kiss everything goodbye with a promise to see it again next year."

In a town where the holiday traffic is so heavy some neighbors choose to leave town, Pat Domanik revels in the excitement of the crowds. "That's the fun of the whole thing," she exclaims. The first year she moved in, Pat and her nieces sang carols and gave away candy canes to passersby. Another year, sick and unable to get her decorations up in time, Pat yelled out to a busload of touring senior citizens to please return the following week. Former owner of an hors d'oeuvre catering company that began in her kitchen as a special-occasion cake business, Pat is no stranger to decorating. She exhibits her flair in an elegant Christmas display that tastefully combines a variety of unique decorations.

A 9-foot antique Santa Claus greets visitors on the north end of her front yard. One of Pat's decorating helpers spotted it collecting dust in a storage attic and knew immediately where Santa would find a good home.

At the center of her yard, a huge evergreen strung with Italian lights towers over the display. Her white brick home and the surrounding shrubbery glow with thousands more

Adina Lohan's toy train scene is a favorite of children, who love to see the reindeer up close and pose for pictures with them.

lights, initially hung by her friend Ken Sowizrol, then a city electrician who decorated the Daley Center tree. The two met by fate when Pat sold him her previous house.

Greeting visitors at the front walk, Mr. and Mrs. Goose sport four different holiday outfits throughout the season. A giant picture window that provides a glimpse of the merriment inside is backdrop to a porch trimmed with enchanting holiday surprises including a lovely dollhouse. And at the center of all the decorations shines a verse encased in plastic that relays the heartfelt message of a woman who truly believes in the spirit of the season. **Dec. 1–Jan. 8, 5:00PM–12:00AM.** *From Cicero Ave., W on Devon Ave. 2 bl., N on Longmeadow Ave. 3½ bl.*

7 6607 NORTH LONGMEADOW AVENUE
Dozens of decorations and thousands of white lights playfully fill the yard and tastefully trim the roofline of this sprawling corner ranch home in a manner consistent with neighboring homes in the elaborately decorated Lincolnwood Towers area. A toy train climbs a mountain of snow, a herd of deer grazes peacefully among the trees, a snowman greets passersby with a tip of his hat, and a sign on the roof offers greetings of "La Multi Ani." La Multi Ani? Well . . . maybe it's not so consistent.

The greeting is a Romanian "Happy New Year" wish from homeowners Adina and Tony Lohan, who immigrated to the United States with their families when they were children. Though it is apparent that they have joyfully embraced at least one American holiday tradition, the customs of their homeland remain dear.

In a country whose impoverished economy does not allow elaborate outdoor displays, Romanian people are just beginning to trim the outside of their homes with simple decorations. However, the festivities within the homes relay a richness no lack of income could displace.

On the eve of St. Nicholas Day, December 6, Romanian children polish their shoes and leave them on the windowsill, where they will discover them in the morning filled with chocolates, candy, and trinkets. Two weeks before Christmas, a freshly cut evergreen tree is lit with one set of large multicolored lights and decorated with dozens of pieces of *salone*—chocolate-covered marzipan candy wrapped in brightly colored foil. Throughout the Christmas season, children sneak pieces of candy from

The Americus family's decorated tree house boasts more lights per square inch than any house in the neighborhood.

the tree and return the empty wrappers. On Christmas Eve, the children use the foil wrappers to decorate stars they cut from cardboard. While caroling from house to house, they carry the stars and receive coins or sweets from the neighbors.

Later in the evening, groups of teenagers and adults carol from house to house gathering people as they go. At every house the carolers enjoy traditional holiday foods, such as *mezeluri* (an assortment of salamis), *sarmale* (stuffed cabbage rolls), *cozonac* (pastry dough with walnut or cheese filling), *prajitura* (cream-filled pastries), and *palinca* (a plum liquor). *Mos Craciun* (Santa Claus) arrives on Christmas Eve and leaves presents.

To preserve their Romanian heritage and pass the traditions down to their children, the Lohans fill their children's shoes on St. Nicholas Day with trinkets and candies, decorate their tree with salone, prepare traditional dishes, and carol with Romanian friends on Christmas Eve. However, Adina does depart from Romanian custom in one regard—she puts up the outdoor display all by herself, even though her husband is an electrician.
1st week of Dec.–Jan. 6, 5:00PM–11:00PM.
From Cicero Ave., W on Devon Ave. 2 bl., N on Longmeadow Ave. 3½ bl.

8 6638 NORTH LONGMEADOW AVENUE

Among the elaborately adorned homes in the Lincolnwood Towers neighborhood that garner praise each holiday season, the one that guarantees a smile is nestled 10 feet in the air in an old oak tree.

Homeowners Norman and Violet Americus had the tree house built for their seven grandchildren in the mid-1990s and decided a few years later it would be fun to decorate it for Christmas. They acquired the services of their handyman John, who had originally constructed the lofty residence according to Norman's design, to install electrical power and annually hang the holiday trimmings. No sooner did John cover the house with several thousand lights, then a family of Christmas characters moved in and started waving to passersby.
1st week of Dec.–Jan. 2, 5:00PM–12:00AM.
From Cicero Ave., W on Devon Ave. 2 bl., N on Longmeadow Ave. 4 bl.

9 6601 NORTH NOKOMIS AVENUE

The LiPomis are the last remaining "old-time" decorators from Lincolnwood's glory days of the 1960s. Theirs is also the last of the three outstanding displays that caused a gaper's block at the intersection of Nokomis and Sauganash avenues for over twenty years.

The family's decorating tradition goes back further still to their former home in Sauganash, where Salvatore and Connie LiPomi lived with their three daughters from

ISN'T IT ROMANTIC

One holiday season a young man appeared at the door of Violet and Norman Americus and asked permission to display a lighted sign asking for his girlfriend's hand in marriage under their decorated tree house. The couple readily agreed and told him to knock on the door if she accepted.

The Americuses and the four couples visiting their home for dinner anxiously watched out the window. When the doorbell rang, the newly engaged couple joined the party for champagne and later sent Violet and Norman an invitation to the wedding.

Since 1963, animated elves have been cheerfully assembling candy canes on the front lawn of the LiPomi home.

1954 to 1963 and elaborately trimmed their lawn with lights and figurines. The Sauganash area, adjacent to Lincolnwood, had been famous for its many lighted homes in the postwar years. It seems, however, that when the LiPomis moved to their new suburban neighborhood, the tradition of elaborate displays came with them. In the years to follow, the number of decorated homes in Sauganash began to decrease as the displays in Lincolnwood grew grander each year.

Connie was not fond of the cold and left the decorating to her husband. Salvatore, a precision machinist, was a creative man who appreciated fine workmanship. He had seen many animated figures displayed in picture windows but imagined a scene of animated figures on his new front lawn.

He acquired the services of Silvestri Corp., a manufacturer of custom indoor displays. Using weatherproof materials and a 100-watt light bulb to keep the motor from freezing, an artisan at the company created Salvatore's first outdoor moving figurine—a little elf that bends over laughing. It was followed by an elf putting candy canes in a wheelbarrow and another trying to budge a stubborn donkey. Together with seven other unique inanimate figures, the candy cane factory run by elves that Salvatore had envisioned came to life.

The side of the house was also trimmed with choir boys and a huge wreath that bore the names of all the members of the family. Candy canes lined the circular drive and flanked the garage door. "And Dad had so many lights, my mother was afraid the house would burn down," remembers Salvatore's daughter Stella. "On the weekends we'd set the alarm for 1:00 a.m., so we could get up, put our boots on, and go out to the garage to turn off all the lights."

Since her father passed away, Stella, her cousin Peter Fontana, and her electrician friend Jim McDunnah have continued to assemble the candy-cane factory every year in Salvatore's memory. One season Stella did not display one of the small figures because it was damaged and she assumed no one would notice. The doorbell rang one night. It was a man who said he had been coming to see the display for years and noticed one of the figures was missing. Stella had the figure repaired and put it up again the next year. She has since learned how to repair the figures herself so that none will be missing again.

2nd Sat. before Christmas–Sat. after New Year's, (Su–Th) 6:30PM–10:30PM, (F–Sa) –12:00AM.
From Central Ave., E on Devon Ave. 3 bl., NE on Nokomis Ave. 3 bl.

10 6719 North Nokomis Avenue

Nine-year-old Arden Miner pointed to the neighbor's Christmas decorations and sweetly suggested, "We should do something like that, Dad." With a father's soft spot for his little girl's desires, Art Miner decided to build a display for her. As an architectural and interior designer, his skills equipped him well for the task.

Using 3-rpm motors, lightweight copper tubing to lessen wear, copper contact disks to prevent lights from getting tangled in moving parts, and gears from his daughter's old bicycle, Art assembled a spinning 8-foot Ferris wheel and a holiday merry-go-round that whirls

Santa's reindeer beneath a glistening canopy. Both displays are cleverly assembled in a few hours with bolts and wing nuts securing the modular frameworks.

Enlarging a pattern from a 1985 issue of *Family Circle Magazine*, he also constructed a handsome three-dimensional crèche of oak and walnut stained in various colors and built a welcoming archway over the walk of conduit, garland, lights, and peppermint candy canes.

For his efforts Art has won an achievement award from the town, has been featured on the local news, and has lit the eyes of many a child. But his biggest thrill is knowing that his daughter Arden, now a grown woman, is just as tickled as always to see his decorations.
Dec. 15–New Year's, 6:00PM–1:00AM. *From Central Ave., E on Pratt Ave. 4 bl., S on Nokomis Ave.*

11 6700 SAUGANASH AVENUE
When Jim Persino, a Roman Catholic, married Gail Truster, a Reform Jew, both agreed they would raise their children in the Jewish faith but expose them to both religions. When they moved in 1979 to the famously decorated Lincolnwood Towers neighborhood, the couple decided to join the holiday fun but continued their oath to promote the customs of both faiths.

For over twenty years the right side of the house has been trimmed with a menorah, Maccabee, Star of David, "Shalom" sign, and the blue and white lights of Hanukkah, while the left side of the house has featured

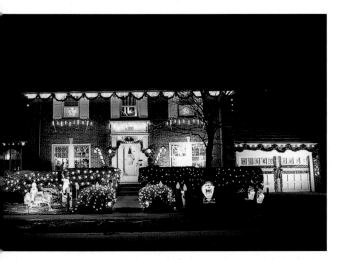

The Persinos custom-ordered their new garage door with enough windows to accommodate the spelling of "Merry Xmas."

elves, presents, Santa and Mrs. Claus, and the red and green lights of Christmas.

Their unique dual display has drawn equally unique responses. One freezing night when Jim was shoveling snow, a young couple, who had been staring at the decorations for some time from their car, approached him and asked if he and his wife had a mixed marriage. They were also of Jewish and Christian faiths and proceeded to seek advice on how they could marry and deal with their parents' disapproval. Though Jim's and Gail's parents had been more accepting, they offered their thoughts for nearly an hour until the grateful young couple returned to their car bidding much thanks. Several months later the Persinos received an announcement that the young couple had married. The two couples have been exchanging holiday greeting cards ever since.
1st week of Dec.–Jan. 6, (M–Th) Dusk–11:30PM, (F–Su) –12:30AM. *From Pratt Ave., S on Carpenter Rd./ Central Ave. 1 bl., SE on Sauganash Ave. 2 bl.*

12 6610 NORTH TOWER CIRCLE DRIVE
When Lu and Jerry O'Neill moved into their Lincolnwood Towers home in the winter of 1985, they were completely unaware that, as Christmas drew near, the front yard two doors down would sprout Santa sliding down a toboggan shoot, the house at the corner would be surrounded by dozens of toy soldiers, the roof around the bend would have a giant tree popping through it, the whole neighborhood would become a holiday tourist attraction, and cars and tour buses would make it nearly impossible to reach their house by car.

Surprised but happy to go along with the tradition, the couple hastily hung two wreaths on the front doors with a few strands of white lights. In the holiday seasons to follow, they added decorations to the interior and backyard, but, unable to think of an appealing and grandiose idea of their own, continued to hang the same two wreaths and lights out front for the next fifteen years.

But in 2002, when driving home in a jolly mood from a holiday party, Lu and Jerry happened to spot a large reindeer made of birch logs on a Christmas tree lot nearby. It was just the decoration they'd been waiting for—simply stated, yet striking. But the reindeer was not for sale—the tree lot operator had built it himself and

spent eight hours searching the woods near his home in Escanaba, Michigan, for two matching branches for the antlers. However, when Lu remarked that the beautifully designed reindeer was a work of art, the man realized she appreciated his effort and agreed to sell the deer and set it up in the O'Neills' front yard.

A few days later, two huge trucks carrying the disassembled reindeer and a Bobcat pulled up in front of the couple's home and confirmed that the deer was not the lightweight fabricated model the O'Neills originally thought it to be. "It didn't look that big on a lot full of Christmas trees with four burly guys standing around it," Lu confesses. "While watching the men assemble the pieces," Jerry adds, "I realized the antlers alone were at least twenty feet tall, and the deer was basically a large tree. I wondered what we had gotten ourselves into."

Glowing in white lights with a nose of red, the reindeer that towered over their two-story home was an instant hit. After twenty years, the O'Neills finally had a display worthy of the neighborhood's holiday reputation. But the question loomed, "How are we going to take this down?"

Four-time overall winners of the Chicago Yacht Club's renowned "Race to Mackinac" and members of the elite Island Goat Society, the O'Neills used their extensive knowledge of moving heavy sailing rigs to devise a plan. Though the huge reindeer posed a new challenge, a spare block and tackle attached to two adjacent trees provided the solution to hoist the reindeer and allow the 10-inch bolts to be ratcheted out and the parts disassembled. The legs and body were rolled into the garage. The antlers were roped to the top of the car and, along with the head and neck, transported to their office garage for storage. The entire process took several days.

The reindeer assembly has since become cause for a yearly off-season wine party to acquire the assistance of their sailing buddies, whom they now refer to as their "deer" friends. The experienced group has the process down to a science. The 8-foot body and 8½-foot legs are first rolled onto the front lawn. Then, like in a giant game of Cootie, the neck and head are attached, then two legs on one side, then two on the other. The antlers are last. The reindeer, which is still lying on its side, is then cranked into a standing position with ropes and pulleys.

Though it may not be as tough as a race across Lake Michigan, Jerry admits, "It's an engineering feat that, like sailing, requires trusted friends who work well together and don't let up."

Dec. 1–Sat. after New Year's, Dusk–12:00AM.
From Cicero Ave., W on Devon Ave. 2 bl., N on Longmeadow Ave. 2 bl., NW on Tower Circle Dr. 1¼ bl. See photograph on p. 61.

MORTON GROVE

13 8633 NORTH CALLIE AVENUE

Nick Loiotile has everything it takes to be a successful Christmas decorator—a love for the holiday, an inspired youth, a creative mind, skilled hands, an enthusiastic spirit, a cute house, a supportive wife, cooperative neighbors, a good friend who's a mechanic, and enough money to pay the electric bill.

As a small boy growing up in Bari, Italy, he delighted in helping his family decorate the living room at Christmastime with an elaborate miniature nativity, as was his country's custom, surrounded by a homemade village scene constructed of papier-mâché. When he was thirteen years old, his family moved to Chicago and purchased a home near Harlem and Belmont, site of the famous "Candy Cane Lane" neighborhood (see page 32). Viewing block after block of lighted streets, Nick grew to love the holiday customs of his new country as well.

As an adult, he and his wife, Alicia, live in an adorable white brick home in Morton Grove. A talented handyman and operations manager for a baking company, Nick is always working on a household project, from installing new windows to cementing the driveway. So when Alicia suggested several years ago that he build a holiday train for the front lawn, it was no surprise that he happily embarked on creating what would eventually become one of the most delightful homemade displays in the area.

Sizing his proportions from a small Christmas ornament, Nick built the "Santa Express" out of plywood and sheet metal, put Santa in the window of the steam engine, and filled the two freight cars with packages made of Coroplast. In the following two years, he constructed a North Pole sign and a teeter-totter standing on toy drums

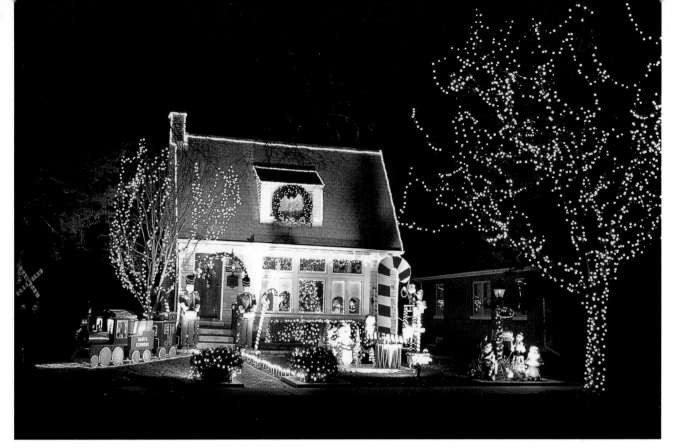

Though Nick Loiotile has no room to add to his handmade holiday display, he continues to improve on his current decorations.

from PVC, plywood, and spray foam insulation. Variable speed motors made stuffed teddy bears twirl about the pole and bounce up and down on the seesaw.

Each year he continued to add to the collection, often reconfiguring purchased items. Though he's one of those people who can see something once and make it himself, if he's unsure whether it will work, he checks out his idea with his coworker Joe Moshi, who is happy to act as his mechanical advisor.

An elf that once held a beverage tray now trims a candy cane on a ladder. A light post doubles as a mailbox pole for letters to Santa. Two papier-mâché snowmen, formerly displayed at Marshall Field's, are safely weatherproofed—Nick carefully removed their felt clothing and faces, braced the insides with stones, 2x4s, and spray foam insulation, and coated the outside with liquid rubber spray before regluing the felt. Suits of armor purchased at a roadside shop in Branson, Missouri, are currently toy soldiers guarding the front door—Nick hired a seamstress to sew the uniforms from a store-bought pattern, found the hats on the Internet, and made the heads from basketballs.

It seems Nick is not the only one who is a master of disguise, however. When it appeared someone was cutting his wires in the night, Nick installed a security system to videotape the offenders—only to find rabbits as the culprits. **Fri. after Thanksgiving–Jan. 7, 5:00PM–11:30PM.** *From I-94, W on Dempster St. ¾ mi., S on Callie Ave. ½ bl.*

NILES

14 8423 WEST AMELIA DRIVE
Christmas is the favorite holiday of Jozef Baluszynski. He delights in buying new Christmas items each year and filling his front yard with lights and figurines.

This native of Poland does not limit his decorating to his suburban home, however. When his brother Eddie and cousin Ted came to visit from the family's hometown of Nowy Sacz, he sent them off with lights and decorations.

Thanks to Jozef, this small Polish mountain village may soon resemble a glistening corner of Niles. **Dec. 8–Jan. 6, 5:00PM–12:00AM.** *From Greenwood Ave., E on Dempster St. 3 bl., S on Cumberland Ave. 6 bl., W on Amelia Dr.*

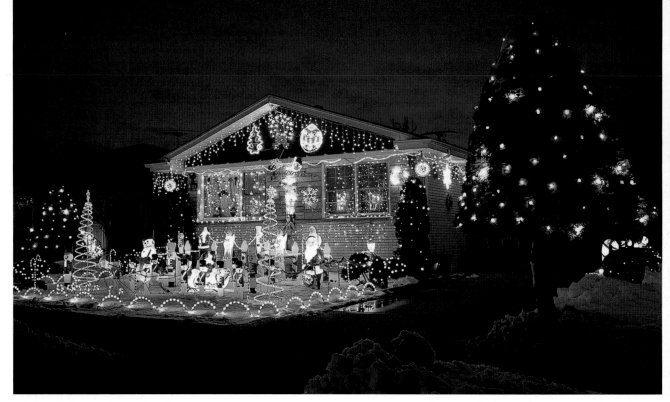

Lights abound at the Baluszynski home on West Amelia Drive.

15 7000 BLOCK OF OAKTON COURT

The wide front yards and low rooflines of the houses on the 7000 block of Oakton Court are so "decoratable" that during the Christmas season the street becomes a beacon of holiday cheer thanks to the efforts of homeowners Anne Schnur and Greg Dittemore, Sal Jazrawi, Karen Schertzing, and Kathleen Rizzo. And with the unobstructed view from both Oakton and Waukegan roads and the built-in audience at the public library across the street, it's a decorator's paradise that has even attracted Santa on occasion.

Dec. 1–Jan. 6, Dusk–10:30PM. *From Oakton St., N on Waukegan Rd. 1 bl., E on Oakton Ct.*

16 LEANING TOWER YMCA
6300 WEST TOUHY AVENUE

The world's only replica of the Leaning Tower of Pisa is an exact half-size reproduction of its Italian counterpart with four exceptions: 1) In 1933, the Niles tower was built as a water tower by Robert A. Ilg to supply three swimming pools at this former park. The Pisa tower was built as a bell tower for the town cathedral. 2) The Niles tower is a concrete and steel structure on a concrete foundation. The Pisa tower is a marble structure on wood pilings. 3) Each level of the Niles tower is a separate floor connected by stairways from the balconies. The Pisa tower is hollow with steps inside the walls. 4) The Niles tower is adorned for the holidays in bows, garland, and lights of red, white, and green, which happen to be the colors of the Italian flag. The Tower of Pisa just continues to lean.

Thanksgiving–Jan. 31, Dusk–dawn. *From Milwaukee Ave., E on Touhy Ave. 1 mi.*

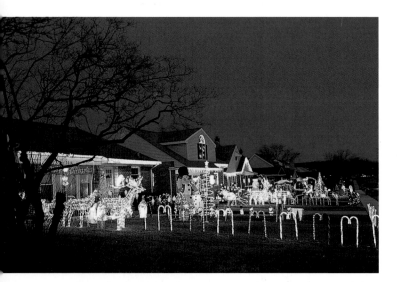

Like-minded next-door neighbors on Oakton Court create a dazzling holiday effect.

Niles' own Tower of Pisa leans festively for the holidays.

NORTHBROOK

17 2107 OAK AVENUE

The Nuccios' yellow brick home is tastefully decorated each Christmas season with a theme that changes from one year to the next, but the glistening lights and holiday music are only a hint of the holiday spirit beaming inside.

Lynn and Ron Nuccio also decorate the home of elderly neighbors nearby and on Christmas Eve go caroling down Oak Avenue while delivering baskets of goodies. Lynn also joins fellow members of the "You All Come" Northbrook choir singing to shut-ins each holiday season.

"Christmas is a time to reach out and spread the joy of the season right in your own backyard," Lynn says, while the glow of hundreds of lights decorating her backyard beam through her kitchen window.

4th Sun. before Christmas–Jan. 6, (Su–Th) 5:00PM–10:00PM, (F–Sa) –11:00PM. *From Dundee Rd., S on Western Ave. 1 mi., E on Oak Ave. 2½ bl.*

PARK RIDGE

18 SHOPPING DISTRICTS

Victorian homes, quaint shops, and gas street lamps flavor the city of Park Ridge with the charm of an era past. In like

The theme of the Nuccio display alternates each Christmas season.

fashion, the holiday season finds the town trimmed with traditional greenery, while residents enjoy celebrations that have gone on for over forty-five years.

Along the town's main thoroughfares, nearly one hundred gas lamps are circled in wreaths, draped in garlands, and trimmed with bright red bows. In Hodges Park at Prospect and Touhy avenues, a 30-foot evergreen is decorated with ornaments, handmade by members of local organizations.

On the Friday after Thanksgiving, the Park Ridge merchants' associations sponsor a holiday open house. Santa arrives by fire truck at the library and makes his way to his cottage at Hodges Park, where he visits with the kiddies and ice carvers create carvings that decorate shops throughout the town. Double-decker buses take one-way scenic tours north on Prospect Avenue and south on Courtland Avenue from one shopping district to the other. Despite the cold, riders vie for open-air seating on the upper level of the bus for a better view of decorated homes along the route. Shop owners at both ends stay open past regular business hours and provide complimentary holiday treats.
Fri. after Thanksgiving–New Year's, Dusk–dawn.
Open house: Fri. after Thanksgiving, 3:00PM–9:00PM.
Uptown Shopping District: Intersection of Northwest Hwy., Touhy Ave., and Prospect Ave. South Park Shopping District: West Devon Ave. from Cumberland Ave. to Courtland Ave.

Charming gas lamps trimmed with lighted wreaths and bows lend an old-fashioned air to the Park Ridge shopping districts.

The Schumachers' Murphy Lake home is best viewed by looking through the trees on the west side of Dee Road.

19 408 NORTH DEE ROAD

Throughout the winter, Murphy Lake glistens with the reflection of the home of Don and Sarah Schumacher. Don and two friends, Tom Herman and Bill MacDonald, spend a few weeks of their spare time decorating this sprawling two-story home. Using 750 strands of white Italian lights, they outline every corner, window, eave, roofline, and chimney, along with the bushes, trees, and gazebo.

For once, rumors that the owner has his own electric company are true. Don is the CEO of Schumacher Electric Corporation in Chicago.
Thanksgiving–Jan. 4, 4:00PM–4:00AM. *From the Tri-State Twy. (I-294), E on Touhy Ave. ¾ mi., N on Dee Rd. 2½ bl.*

20 1243 SOUTH LINCOLN AVENUE

As an electrical designer and vice president of Super Electric Construction Co. in Chicago, Carl A. Turano engineered such complex commercial lighting systems as those for the Lincoln exhibit at the Chicago Historical Society and the exterior of the former 1st National Bank Building downtown. His outstanding designs during his

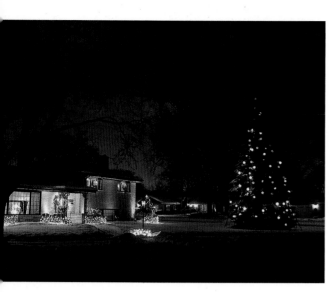

Retired electrical engineer Carl Turano puts his skills to good use with his handcrafted display and even makes his own wreath out of trimmings from his cedar bushes.

thirty-five years in the industry earned six awards from the Chicago Lighting Institute and the Illuminating Engineering Society of North America.

During those same years, he also employed his talent at Christmastime to exquisitely light six elms surrounding his Harwood Heights home and trim his garage door, in alternate years, with a 6-foot wreath or "Season's Greetings" sign of his own design.

When Carl retired in 1999 and moved to a corner house in Park Ridge, it was no wonder that he used his spare time and electrical genius not only to remodel the entire home with innovative ideas but to create an elegant one-of-a-kind Christmas display.

The 38-foot Colorado blue spruce at the corner of Carl's lot now draws visitors from blocks away, gleaming with two hundred colored spheres of one hundred lights each. The tree limbs, which could easily have been dragged down by the weight of the 10-pound light fixtures, are spared by a system Carl designed using aluminum poles and PVC "branches" that not only carry the weight but distribute the lights throughout the tree and make the annual installation an easier task.

The seven 24-inch wreaths trimmed with bright red bows that decorate all but the picture window of his home shimmer in the glow of hidden spotlights Carl custom-made to fit his eaves. The lights on his indoor Christmas tree

automatically switch from LED to candle lights by remote control. In the front picture window, a beautiful 24-inch nativity, which he purchased years ago from a local Italian artist, is placed in a setting Carl built. His Star of Bethlehem appears to twinkle to and fro thanks to a gently blowing hidden fan, while the Christ Child glows in the manger below in the light of his own special spotlight. **Dec. 1–Jan. 6, Dusk–9:30PM.** *From Greenwood Ave., W on Devon Ave. 2 bl., S on Lincoln Ave. 1 bl.*

21 613 WEST OAKTON STREET

On a Park Ridge lawn a simple manger cradles the Christ Child, while Mary and Joseph kneel at his side. They are joined by the three wise men—no, wait, it's not three wise men, and it's not a shepherd with his flock. It's just a flock—a flock of geese, that is, and they're dressed for the occasion.

Mr. Goose wears a furry red coat and hat with a full white beard about his beak. The Mrs. hides her feathers in a red shawl, bonnet, and muff. The goslings pose as angels—or are they angels posing as goslings? Either way they have an extra set of wings.

The true identities of this deftly disguised family of fowl are Lester and Lucy, the 2-foot 70-pound adult geese, and their 10-pound cement children Linus and Lulu. Their playful owners, Doris and Bob Kyllingstad, began outfitting

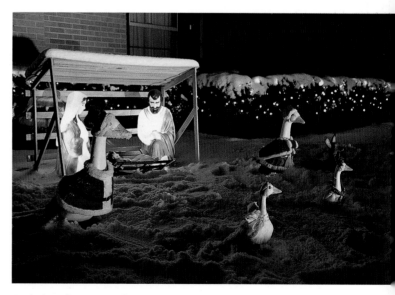

At their Oakton Street home, Lester, Lulu, Lucy, and Linus Goose spread good cheer by dressing for the holidays.

them for Christmas and many other holidays in 1989 to the delight of motorists on this well-traveled street.

The Kyllingstads originally purchased one goose with a Fourth of July Uncle Sam costume. A few months later, they bought him a mate and several matching outfits. Much to Doris and Bob's surprise, drivers began slowing down and were even mailing notes of thanks for brightening their day.

A truck driver confessed he had altered his daily route just to pass the geese. A mother was grateful that the amusing fowl, especially in their Ninja Turtle outfits, had made her reluctant six-year-old look forward to attending his school across the street. Another thankful woman bought the geese French navy clothing to celebrate Bastille Day.

Buoyed by the attention, Bob decided it was time Lester and Lucy had a family. On April Fool's Day, he introduced Linus and Lulu with goose family members appropriately dressed in pink and blue. Signs announced their arrival, proclaiming "It's a Boy" and "It's a Girl." It didn't take long before a congratulatory plant with a shower card was delivered by a passing motorist.

Doris now devotes a section of her closet entirely to goose clothing, with outfits from raincoats to negligees for over twenty occasions. Hangers are bent into "A" shapes to accommodate the unusual goose form.

Fri. after Thanksgiving–New Year's, Dusk–11:00PM.
From Milwaukee Ave., W on Oakton St. 1 mi.

22 PARK RIDGE COUNTRY CLUB
636 NORTH PROSPECT AVENUE

Founded in 1906, the exquisite Park Ridge Country Club is famed for hosting the annual local amateurs Champion of Champions men's and women's golf tournaments. Site of the 1944 Women's PGA Western Open, the course has been played by such notable legends as "Babe" Zaharias, Patty Berg, Bobby Jones, Gene Sarazen, Tom Kite, Mark O'Meara, and Arnold Palmer.

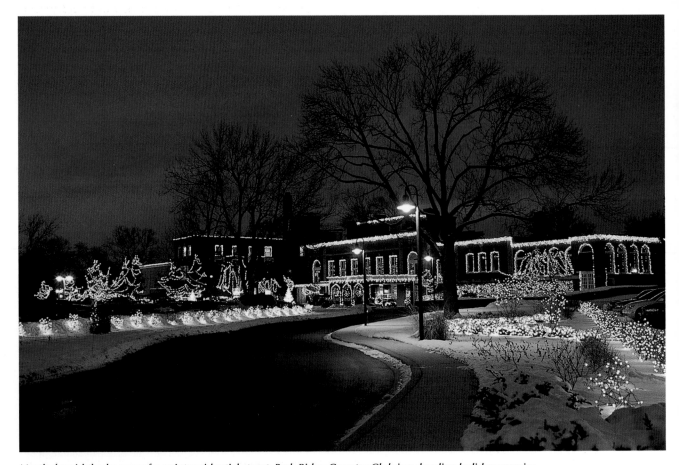

Nestled amid the homes of a quiet residential street, Park Ridge Country Club is a dazzling holiday surprise.

But to those who do not know the game of golf, the club's most "shining" achievement is likely the glorious light display it dons each Christmas season—50,000 lights outline every window, doorway, and roofline of the sprawling neo-Georgian clubhouse, thanks to the two-week effort of building manager Don Noe and his crew. Though the lights have changed somewhat over the years, Don says, "People think it's cool no matter what we do."
Thanksgiving–New Year's, Dusk–dawn. *From Milwaukee Ave., W on Oakton St. ¾ mi., S on Prospect Ave. ¼ mi.*

SKOKIE

23 4207 WEST HOWARD STREET

When Ismael Rosas was a small boy living in Michoacan, Mexico, he would wake up Christmas morning and find no presents under the tree. "Santa doesn't like us," young Ismael thought. "He passed us by." It was not until he grew older that Ismael understood that his loving father had all he could do to feed his family of twelve children. As soon as he was able, young Ismael took over his father's annual task of climbing a nearby mountain to cut down a Christmas tree that would make his family's holiday something special.

At the age of seventeen, Ismael immigrated to the United States in search of a more prosperous life. His first job as a dishwasher barely paid enough to feed him, but with determination and hard work, he quickly advanced to cook, then waiter, and eventually supervisor of food and beverages at a private downtown club, where he works today. A U.S. citizen, loving husband, and father of three, Ismael celebrates his prosperity by treating himself and his family to abundant Christmases he never knew as a child.

When he purchased his first single-family home in 1992, Ismael decorated the house with as many Christmas displays as the front yard would hold. After working the whole weekend to get everything in place, he and his wife were awakened at two o'clock in the morning by the sound of a loud truck. Though scared away by the lights in the house, thieves drove off with half of Ismael's decorations. Determined not to have his family's Christmas ruined, Ismael went to the store

the next day and repurchased everything that had been stolen, along with enough chains and locks to secure each item.

Encouraged by his children's glee, Ismael continues to add to the display every year with anything new he sees at the stores. He bubbles with excitement when talking about his decorating plans, and when Christmastime finally arrives, he decorates for several days from 6:00 a.m. to 10:00 p.m. without even stopping to eat. In this predominantly non-Christian community, Ismael delights in the overwhelming approval he receives from his neighbors, who often leave anonymous notes of thanks at his door. The man who had once felt forgotten by Santa now proudly declares, "I feel like a celebrity at Christmas."
Dec. 1–2nd week of Jan., 4:30PM–2:00AM. *From Crawford Ave., W on Howard St. ¼ mi.*

24 8449 NORTH LARAMIE AVENUE

When Nick Burghgraef was a child, his father made him a plywood Santa Claus for their front yard in Fair Lawn, New Jersey. Many years and Christmases later the treasured though weather-beaten Santa was among the possessions Nick took along when he moved to his own home. Badly in need of repair, the Santa lay in Nick's basement for several years until his young son Rich found it there. Together they repainted the figure and added it to their growing Christmas display.

From the age of six, Rich had enjoyed helping his dad put up the outdoor holiday decorations. Despite Nick's concern over their rising electric bill, his excited little boy somehow managed to coax him into purchasing new items every year.

It soon became an annual tradition for Nick and Rich to decorate the outside of their home on the Friday after Thanksgiving. "We'd start around 9:30 in the morning and blow our first fuse by 10:15," Rich recalls with a laugh. Ready for a break by 12:30, they'd head over to Nick's mom's for turkey sandwiches. Then home again to perfect the display until it was time to go back to Grandma's for leftover turkey dinner. Though the trip back home was less then a mile, Nick would meander for nearly an hour down neighborhood streets looking for other houses that were lit up. "My dad had a rule that we couldn't light

The homemade Santa on the Burghgraefs' Skokie lawn has been in the family for three generations.

WILMETTE

25 410 ILLINOIS ROAD

Peter and Katie Tetzlaff's simple two-story frame home may go unnoticed most of the year, but at Christmastime, when the whole house is wrapped in a wide red ribbon with a giant matching bow and sprinkled with glittering white lights, the "Christmas Present House," as it is locally known, beams as proudly as the nose on Rudolph's face.

Though the unique and tasteful trimmings rightfully deserve some added attention, the seemingly modest house warrants more than mere holiday fame. Built in the mid-nineteenth century, the modified saltbox home is one of the oldest houses in Wilmette. It was moved by a single horse in the 1920s from its original location on the now 1700 block of Wilmette Avenue to the small farm property of Katie's great grandfather, Albert Meier. A Swiss immigrant, Meier was one of the early trustees of the Village of Gross Point before it was annexed to Wilmette in 1926.

Dec. 1–New Year's, 4:00PM–11:00PM. *From Gross Point Rd./Ridge Rd., W on Wilmette Ave. ¼ mi., NW on Illinois Rd.*

26 2032 WILMETTE AVENUE

When Bill Lambrecht was assembling his 2005 Christmas display, never before had he caused so much excitement for people in the neighborhood. Even the sight of cables descending from his spruce tree caused passersby to stop and ask, "Is that what I think it is? Oh, I'm so glad." For although Bill had been decorating his home nicely for many years, this was the first year he displayed the decorations of his dear neighbor and friend Warren Perkins.

The Perkins' playful handmade display at the corner of Linden Avenue and 7th Street had been a holiday fixture for residents of Wilmette since 1949. The last many years featured a sleighload of toys pulled by five prancing reindeer that climbed 30 feet into the sky as a railroad gate dropped and flashing lights warned "Stop Reindeer Crossing." Sixty-four cascading snowflakes blinked in a magical flurry across the front of the house, while a side sunroom became a winter diorama showcasing Mr. and Mrs. Santa and their busy elves. A giant Christmas tree

our lights until we saw ten houses with their lights on," Rich says.

When Rich grew up and moved to Skokie, Nick let him take most of the decorations, including his father's Santa Claus. Now every year on the Friday after Thanksgiving, Rich carefully places his grandfather's Santa, his fading snowman, and his old candy canes on his front lawn along with all the new decorations his fuse box can handle. At noon his wife, Heather, calls him in for a turkey sandwich. He counts lighted houses on his way home from work before lighting his display. And on the second weekend of December, he returns home to New Jersey to put up his parents' display with his dad.

Fri. after Thanksgiving–Sat. after New Year's, 5:00PM–10:30PM. *From Skokie Blvd., W on Dempster St. ½ mi., SW on Gross Point Rd. 1 bl., S on Laramie Ave. 5½ bl.*

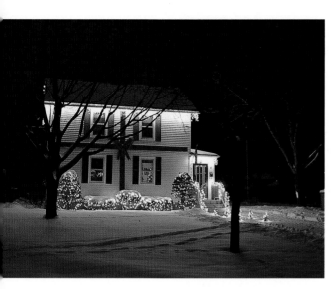

Drenched in a blanket of snow with a lighted tree peeking through the window, the Tetzlaffs' picture-perfect "Christmas Present House" is a gift to all who pass.

spun a path of dancing colored lights, a gazebo of carolers filled the air with the melodies of the season, and messages of peace and joy alternately flashed from the garage.

Warren was in high school when he first created the wooden sleigh and reindeer. His father, Warren Sr., an engineer with International Harvester, later created the motor and pulley system that pulled Santa's crew to the treetop. The spinning Christmas tree became the delight of many neighborhood kids, who were invited each year to bring aluminum tins to trim the tree. It was then that young Billy Lambrecht, who lived two houses away, started coming over to help assemble the display. "I would just hang around and be their gofer," Bill remembers. The experience inspired him to build life-size Peanuts characters that he displayed on his parents' roof for many years. The Perkins family eventually put Billy in charge of making sure the display ran smoothly when they left town for a few days every holiday season.

In the years to follow, Warren married, became an industrial arts teacher at Lincoln Junior High School, took over the family home, and continued elaborating on the Perkins Christmas display. Bill returned to Wilmette after starting a family and becoming superintendent of parks and planning with the Wilmette Park District. Throughout the years Warren and Bill would often run into each other in town, and their conversations would usually revolve around decorating for Christmas.

In 1992, Bill's siblings, knowing his fondness for Warren's Christmas decorations, asked Warren for a few of his old decorations as a gift for Bill's fortieth birthday. Warren was happy to find a welcome home for the giant waving Coca-Cola Santa, which had grown too cumbersome for him to display on his roof, and the six blinking snowflakes he had built in 1960, which had been replaced with an updated version. As expected, Bill was thrilled to receive the decorations he remembered so dearly. When he excitedly displayed them the following season, he was amazed by the number of drivers who would stop and ask if the decorations were from the Perkins display.

In the midnineties, Warren's health began to fail. Though concerned neighbors offered to help with the decorations, Warren continued putting them up with the help of his nephew, Fred Fettinger, until the last two years of his life. A few months before he died, he called Bill and asked if he would like to have his display. Bill said he would be honored.

Before he picked up the decorations, Bill sat with Warren for two hours as he explained how everything worked. The sleigh, which had gone up and down an average of 20,000 times per season for nearly fifty years, returned by gravity and had a heating system and an automatic thermostatically controlled manual override, which prevented icy ropes from causing a malfunction when the temperature dipped below freezing. A clothesline marked with knots indicated where the lights would go for the reindeer. The power unit for the sleigh had to be anchored because, "If you don't and the sleigh gets stuck, you'll find the box hanging from the pulley in the tree." A homemade timing device with a 9-rpm motor tripped eight cam-operated switches to alternately light the snowflakes, which were stenciled on translucent plastic and lit from behind. The animated figures in the window were purchased from Hamberger Displays in New Jersey (now Center Stage Productions), which would also make needed repairs.

In an effort to do Warren proud, Bill soon began making preparations to accommodate the decorations. He realized that what Warren could easily fit on his corner house would be a challenge on his smaller lot, so he got his sister Trisha to agree to let the decorations spill

Warren Perkins' handmade sleigh and reindeer, remain a part of Wilmette holiday tradition thanks to homeowner Bill Lambrecht.

onto her front lawn next door. He added four dedicated 20-amp circuits and three time clocks to his electrical service. And he constructed a 22'x70' garage to store the decorations, which he aptly christened "The Warren A. Perkins Garage and Christmas Storage Facility."

Warren could not have chosen a better friend to keep up his tradition. With the help of his son, Bill III, Bill spends six hours a day for two weeks assembling the display and keeps a supply of repair parts on hand at all times to keep it operating. With some assistance, Bill has already repainted the face on Santa and repaired the motor on the sleigh, which tends to be a bit finicky these days. He also has plans to restore the rotating tree to its original real variety.

Though Bill has preserved a Wilmette tradition and kept Warren Perkins's legacy alive through his efforts, he admits there is something in it for himself as well. "It reminds me of when I was a kid in the old neighborhood," Bill remembers fondly. "I would lie in bed at night at Christmastime. Cars would stop, and the sleigh would light up my bedroom every time it went to the top of the tree. Now I can hear the cars and see the light from my bedroom just like old times. It's great."

Fri. after Thanksgiving–Jan. 9, 4:30PM–11:30PM. *From Ridge Rd. (Gross Point Rd.), W on Wilmette Ave. 2 bl. (At Old Glenview Rd.)*

WINNETKA

27 191 SHERIDAN ROAD

A winding path of glittering white lights on sculptured shrubs, manicured hedges, and stately pines adds to the magic of this storybook mansion of gables and stone on the shores of Lake Michigan.

Fri. after Thanksgiving–Jan. 2, (Su–Th) Dusk– 11:00PM, (F–Sa) –12:00AM. *From Winnetka Ave., N on Sheridan Rd. ½ bl.*

Richard and Patricia Kent's Sheridan Road mansion looks as though it was built with Christmas in mind.

Opposite page: *Burgermeister Park is but one of several brilliantly lit parks in Rosemont (p. 103).*

CHAPTER 5
Cook County ~ Northwest

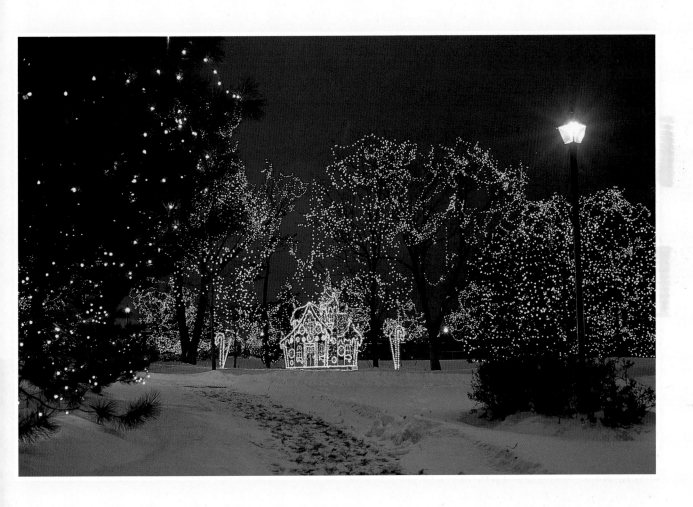

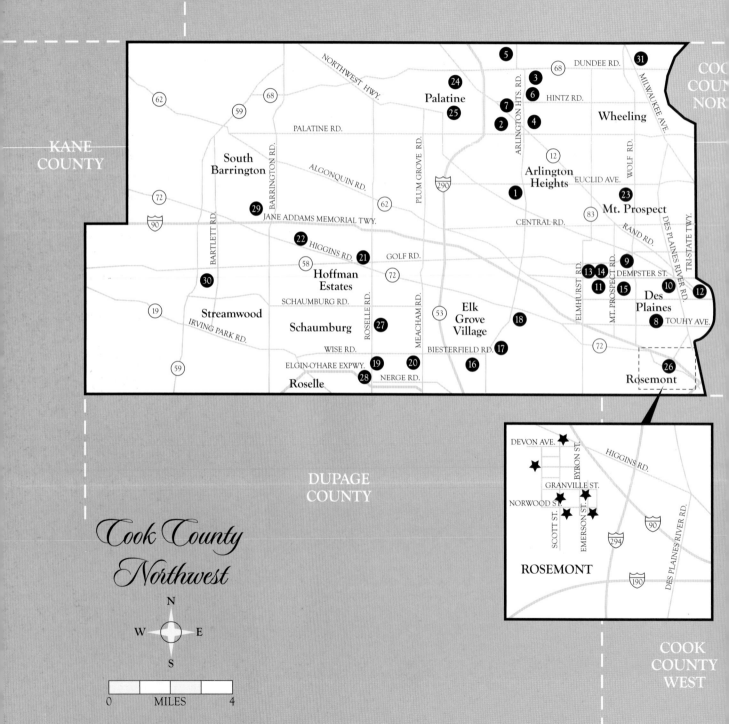

MCHENRY
COUNTY

LAKE
COUNTY

COOK
COUNTY
NOR

KANE
COUNTY

NORTHWEST HWY.

5

24

Palatine

68

62

59

68

PALATINE RD.

DUNDEE RD.

68

3

6

HINTZ RD.

7

25

2

4

Wheeling

ARLINGTON HTS. RD.

12

South
Barrington

ALGONQUIN RD.

PLUM GROVE RD.

62

WOLF RD.

MILWAUKEE AVE.

31

BARRINGTON RD.

72

1

Arlington
Heights

EUCLID AVE.

83

Mt. Prospect

23

59

290

29

JANE ADDAMS MEMORIAL TWY.

CENTRAL RD.

90

BARTLETT RD.

22

HIGGINS RD.

21

GOLF RD.

58

Hoffman
Estates

72

RAND RD.

DES PLAINES RIVER RD.

TRI-STATE TWY.

9

13 14

DEMPSTER ST.

ELMHURST RD.

MT. PROSPECT RD.

11

15

10

12

30

ROSELLE RD.

SCHAUMBURG RD.

MEACHAM RD.

53

Elk
Grove
Village

Des
Plaines

8

TOUHY AVE.

19

Streamwood

IRVING PARK RD.

Schaumburg

27

WISE RD.

18

72

BIESTERFIELD RD.

17

59

ELGIN-O'HARE EXPWY.

19

28

20

NERGE RD.

16

26

Roselle

Rosemont

DUPAGE
COUNTY

Cook County
Northwest

N

W E

S

0 MILES 4

DEVON AVE.

BYRON ST.

HIGGINS RD.

GRANVILLE ST.

NORWOOD ST.

SCOTT ST.

EMERSON ST.

90

294

ROSEMONT

DES PLAINES RIVER RD.

190

COOK
COUNTY
WEST

ARLINGTON HEIGHTS

1 NORTH SCHOOL PARK
ARLINGTON HEIGHTS ROAD
AT EASTMAN STREET

Clink, pop, beep, boop . . . the sounds of Santa's workshop are heard coming from inside the maintenance building of the Arlington Heights Park District. Though evidence seems to indicate that employees Alan Welk, Richard Knox, Greg Wright, Charles Reinhold, Ray Mammoser, and Manny Trejo may be elves working here part-time, there have yet been no sightings of green tights or jingle-belled toes.

It's only known that since 1991 on many a rainy day, manikins, motors, polyester fiberfill, steel rods, chicken wire, sheet metal, garden hoses, and other scrap materials have entered the building and, unseen for several months, magically reappeared at Christmastime, transformed into North School Park's spectacular yuletide displays. Fairy dust must surely have been sprinkled on Angelo Capulli, former director of parks, and Jerry Oaks, former executive director of the park district, who had the original vision for the seasonal event.

The artistry behind most of the dazzling sculptures is credited to the former park district fabricator and artisan Louis Nagy, who built and welded new figures each year until his retirement in 2007. Like an enchanted road to fairyland, ten lighted arches form a path to a stunning collection of beautifully welded forms drenched in white lights that glisten throughout the park. Though the figures alternate from year to year due to limited space, the assortment includes an old-fashioned locomotive train, a turning windmill, a moving rocking horse, a Gay Nineties couple twirling on an ice rink, a bi-plane with a spinning propeller, and a three-masted fourteenth-century Spanish ship. Sheet metal creations, which are delightful day or night, include a 1927 dump truck and a magnificent revolving carousel with five wooden horses. Colorful tinseled displays include giant toy soldiers, a 10-foot teddy bear, four reindeer pulling Santa's sleigh, and three spinning Hanukkah dreidels.

Though the park staff has built and maintained all the decorations in recent years, local professional sculptor Fran Volz was one of the original elfin crew who designed

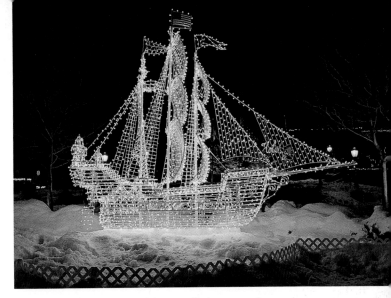

A fourteenth-century Spanish caravelle is among the magnificent lighted holiday sculptures created by Arlington Heights Park District staff at North School Park.

and helped construct many of the first figures in the early years of his sculpting career. (Popularly known for the magnificent snow sculptures on his front lawn down the street and his annual Randhurst snow sculpting competition, Fran's professional works include the town's bronze statue of founder William Dunton, as well other local civic sculptures.) At one end of the park, his 8-foot snowman welcomes visitors, while at the other a furry panda bear twirls upon a brightly wrapped present.

Additional highlights include a large wooden sleigh, perfect for a family holiday photo, and the 30-foot Christmas tree annually donated from the yard of a resident. On the Friday after Thanksgiving, thousands fill the park to witness the flipping of the switch that lights the display and marks the official start of the holiday season. All weekend long a Christkindl Market on Eastman Street at the south end of the park offers German holiday gifts and foods to add to the merriment.

Fri. after Thanksgiving–Jan. 6, Dusk–11:00PM.
From Euclid Ave., S on Arlington Heights Rd. 2 bl. (At Eastman St.)

2 1414 CAMBRIDGE STREET

Though Christmas lights may come in blue, orange, yellow, and white, Art Massa has always been a traditional red and green kind of guy. As a teenager in Cincinnati, he decorated his parents' home in red and green lights for six years. As an adult he has continued the motif on his own home since 1985.

Spotlights drenching the branches of Art Massa's front yard trees add a mystical holiday glow to his red and green display.

Nine hundred alternating red and green Italian lights outline the windows, 510 alternating red and green C-9s trim the gutters and bushes, which surround a red and green spiral tree. A red and green "Happy Holidays" sign is projected on the garage door, which is outlined in red and green lights and surrounded by bushes lit in red and green. A red and green candy cane hangs on the wall nearby. Each of four large trees in the front features either two green or two red 150-watt floodlights illuminating the bare branches above and has its trunk wrapped in red and green lights. Green spotlights illuminate a wreath on the side of the house and another on the front door. The front porch is trimmed with three gift boxes outlined in red and green lights, and porch lights are converted to red and green bulbs.

Art continues to add new lights to his display each year—red and green ones, of course.

Dec. 7–New Year's, 6:00PM–11:00PM. *From Arlington Heights Rd., W on Palatine Rd. 800 ft., W on Frontage Rd. ½ mi., N on Yale Ave. 4 bl., W on Cambridge St.*

3 1521 DUN LO DRIVE

Marianne and Doug Winter are both in the retail business, and happily so. Though others in their trade may have

their holiday enthusiasm thoroughly snuffed out by overexposure to crazed shoppers, Christmas carols, and holiday cheer, Marianne and Doug revel in the experience and even take it home with them.

As store merchandisers, the couple is in the habit of trimming windows and countertops to match every occasion. So when it comes to decorating their own home, they just can't seem to stop themselves from replacing all their bric-a-brac with seasonal items in a different theme for every room. There's a nutcracker theme in the living room, a snowman theme in the dining room and bath, a toy soldier theme in one bedroom and a Santa theme in another, a Disney theme in the mother-in-law apartment and bath, and a nostalgic Marshall Field's theme in the basement in homage to Marianne's past employer. In store-like fashion, fourteen windows are each decorated with a large Christmas tree—a striking complement to their simple outdoor trimmings.

In order to ease the daunting decorating task at a time of year when the Winters put in an average twelve-hour workday, the couple starts the week before Halloween so they have time to enjoy the decorations, and Marianne admits, "I steal ideas from stores."

Thanksgiving Day–Jan. 14, 6:00PM–10:00PM. *From Buffalo Grove Rd., W on Dundee Rd. 3 bl., S on Betty Dr. 1 bl.*

4 2031 NORTH PINETREE DRIVE

Visitors to Santa Claus's northwest suburban manufacturing facility in the living room of Allen LeHew and Randi Merel are welcome to walk up to the window and take a closer peek, but are cautioned by Santa to take extra care for he knows how much trouble the couple went through to accommodate him and his elves.

After Allen and Randi's original front yard Christmas display was vandalized several times, Allen was ready to call it quits. So Randi decided to surprise him by purchasing online a life-size animated Santa, originally used in a 1970s Sears display, that Allen could display indoors in their picture window. The surprise was on her, however, when only Santa's head arrived in the mail. The body followed later, after much hassling and an additional payment. Undeterred, Randi continued to search online for other figures to add to the scene and eventually acquired from various sources a fiberglass fireplace and a collection

The realistic animated scene in Allen LeHew and Randi Merel's picture window had some neighbors wondering if Allen posed as Santa every night.

of gnome-like elves painting, drilling, hammering, and sawing. Santa rewarded her fortitude by adding her name six times to the bottom of his list below the names of neighborhood children.

When one of the gnomes arrived with nothing in his moving hand, Allen constructed a small ladder for the elf to stand on and gave him an ornament to decorate the tree. He also built a 10' x 14' three-sided backdrop to enclose the entire scene.

Though the effect is lovely from the outside, the display takes up most of the couple's 12' x 20' living room. When all the decorations are plugged in, Allen and Randi cannot use the microwave or vacuum without tripping a

circuit, and the constant "clunk, clunk" of the hammer and "eek, eek" of the motors make the room virtually uninhabitable during the season. The couple also had to stop short of purchasing two double-hung windows to replace the picture window when they realized it would ruin their Christmas display.

But to Allen and Randi the inconveniences are minor compared to the delight they find in a job well done that highlights their home and tickles their neighbors. Admitting a childlike thrill of her own, Randi says, "Sometimes when I'm home alone at night, I stand in the display window looking at Santa and the elves, and I start feeling like I'm part of the workshop." Her feelings seem to be shared by their cat, Mia, who often is seen perched contentedly on the sill of the picture window.

Sat. after Thanksgiving–New Year's, 5:00PM–12:00AM.
From Elmhurst Rd., W on Palatine Rd. 2 mi., N on Pinetree Dr. 1½ bl.

5 4003 NORTH RIDGE AVENUE

Whether you're a kid who puts glitter on every project you do or a kindergarten teacher who avoids glitter 'cause it gets all over everything, you're sure to love the glittery holiday display at the Duski home—where the colored sparkly flecks are used in the way they were meant to be.

A shimmering sign welcomes visitors to a front yard imaginatively transformed into "Toyland" with a delightful assortment of handmade decorations carefully crafted by

Glittery blocks and a spinning carousel are among the handmade decorations that have made the Duski home an award-winning favorite for over fifteen years.

homeowner Paul Duski—giant red and green building blocks spell out "Merry Christmas," a 6-foot silver bi-plane gets ready for takeoff, Santa peeks from the doorway of his glistening castle, a toy soldier pops up from a mechanical jack-in-the-box, and horses twirl in a gleaming carousel. The decorations sparkle day and night thanks to Paul's special ingredient. "I spread glitter on the second coat of paint when it is still wet," he explains. "Then I seal it with polyurethane." The result is a magical display that not only draws crowds but often appears in holiday greeting cards as the backdrop for local family Christmas photos. **1st week of Dec.–Jan. 7, (M–Th) 5:00PM–10:00PM, (F–Su) –11:00PM.** *From Dundee Rd., N on Arlington Heights Rd. ½ mi., W on Nichols Rd. 5 bl., N on Ridge Ave. 1 bl.*

6 2727 NORTH VISTA ROAD

On a snowy day this lovely home outlined in glimmering white is picture perfect as it peeks through the barren trees. Its cathedral windows reveal a stunning 18-foot Christmas tree, trimmed with over eight thousand colored lights and eight hundred ornaments.

Homeowners Bruce and Janet Green special order the giant balsam each year from a nursery in Upper Peninsula Michigan. Even with the help of their three children, it takes an entire week to trim. A pole is needed to hang decorations toward the top.

The Greens' 18-foot tree shines amid a wintry landscape.

Getting a tree this large into the house is one thing, but getting it out, once the branches have dried and fallen open, is another. The Greens strip all but the top 5 feet and throw the branches out the window. The uppermost section is left to dry for the summer and covered with snakes and spiders for Halloween. The trunk is cut into pieces and burned as a yule log the following Christmas

In a tradition begun by Janet's father, the family saves a slice of the trunk, woodburns the date in it, and dips it in polyurethane. The slices hang on the wall each holiday season as a reminder of all the happy Christmases the family has shared. **Dec. 14–Jan. 7, Dusk–10:30PM.** *From Arlington Heights Rd., E on Hintz Rd. ¼ mi., N on Vista Rd. (Douglas Ave.)*

7 2607 NORTH WALNUT AVENUE

When Louise Eischen's four children and five grandchildren met at her home in 2006 to help put up the Christmas decorations, it was a bittersweet occasion. Her husband, Al, who had taken such pride in his handcrafted Christmas display, had died only months before. A talented mechanical engineer with a life-long love of Christmas, Al zealously created a beautiful award-winning display that spanned the width of their 107-foot lot for over thirty-five years. The decorations had been so much a part of his life that his family felt it was important to continue his tradition, no matter how difficult the task. "We wanted to honor my dad," his daughter Lisa says.

Having only helped in the past with holding the ladder or lifting the heavy Alpine roof that straddled the driveway, the Eischens were unfamiliar with how to assemble the display. Al had once said, "I would rather do the work myself, so I know who to blame if anything goes wrong." But he was a very well-organized man and one of the rare decorators who took as much time to take his display down as to put it up. At the end of every season, he spent eighty hours disassembling, repairing, replacing, and storing his decorations. With a skill he credited to his mother, he efficiently packed each item in the garage according to a chart he created "for optimum packing density."

When Al's family began the seemingly arduous task of unloading his lights, motors, and wooden figures, they happened upon his chart, and it seemed that Al was

Al Eischen's unique homemade creations continue to decorate the front lawn with the loving touch of his family.

with them showing the way. They were also guided by a memoir he had surprisingly handwritten only two months before his death, which detailed each of his homemade displays—the Santa Claus and motorized "strongest deer around," the teddy bear rising up and down from a box that used "an extension spring . . . to overcome a high load," the 15-foot Alpine arch trimmed with "red bell lights in sync with Christmas bell melodies," the Star of Bethlehem "suspended 25-feet high via a cable between two tall spruce trees and a pulley system," the rocking dog with a speed-reduction motor that allowed him to "decrease the RPMs and increase the torque," the manger scene he enlarged from a table-top model by "dividing the pattern and enlarging the sections," the lighted window frames he designed "to get uniform, preferred spacing of lights," and the numerous wooden figures he made from purchased patterns that "are easy to store and require minimum space."

The memoir also not only explained Al's motivation for decorating his home but his yearly participation trimming the Austrian tree at the Museum of Science and Industry: "As a child in the late 1930s, I was awed by the tinseled Christmas tree that would magically appear Christmas morning—a custom via my Austrian maternal grandparents. To me, the tree was more important than the presents under the tree." Inspired by the traditions of his forebears, Al expressed his desire to inspire his own family: "I hope some of my grandchildren become motivated to help keep my decorating tradition alive." Those who pass his Alpine display for years to come will know his family is doing the best they can to make his wish come true.

Dec. 12–Jan. 10, 6:00PM–10:00PM. *From Palatine Rd., NW on Rand Rd. 1½ mi., E on Hintz Rd. ½ mi., S on Ridge Rd. 1 bl., E on Kingsbury Dr. 1 bl., S on Walnut Ave. ½ bl.*

DES PLAINES

8 LAKE PARK
LEE STREET AND TOUHY AVENUE

Lake Park is a lovely community recreational area that bustles with attractions spring, summer, and fall—fishing and boating at Lake Opeka, a summer concert series, a par-three golf course, jogging paths, exercise stations, a sand volleyball pit, a children's playground, and a picnic area.

It now comes alive in winter as well when the Des Plaines Park District and Chamber of Commerce present the "Lake Wonderland Winter Festival." Hungry for

Trimmed with crackers, bananas, and a teapot, Mrs. V's holiday tree is among the delightful assortment decorated by local businesses and groups at Lake Park in Des Plaines.

cold-weather park activities, nearly three thousand people attend the two-day kick-off event, which not only sets the park aglow with a forest of lights but offers food, entertainment, dancing, costumed characters, and a visit from Santa in a real fire engine. Visitors are also invited to take a horse-drawn sleigh ride around the lake and view over thirty trees, decorated by local businesses and families. The decorations remain throughout the Christmas season, beckoning visitors to take a peaceful walk (or healthy jog) around the lake.

2nd Sat. of Dec.–New Year's, Dusk–11:30PM. Festival: 2nd weekend of Dec., 11:00AM–6:00PM. (847)391-5700. www.desplainesparks.org. *From Des Plaines River Rd., W on Touhy Ave. 1¼ mi., N on Lee St. ½ bl.*

9 317 HARDING AVENUE

What becomes of a corporate electronic engineer who formerly expressed his wild creative side by designing pyrotechnics, black lights, and chaser spots for bands such as the Spit Balls, Crash, and the Moody Blues?

At the suburban residence of Bill Christoffel, now a happily married father of three, the black lights have been replaced with bulbs of red and green, the chaser lights are rotating about a Christmas tree, and the closest thing to fireworks is a cheery Santa popping up and down out of a red brick chimney. Though "Nights in White Satin" has been replaced by "Jingle Bells," Bill has found that delighting his neighbors can be just as much fun as causing a hippie to utter, "Party, man."

The first Christmas after Bill and his family moved into the area, the neighbors watched curiously as he spent two weeks covering his house with lights. They were amused when the glass block windows blinked in a sequence of reds, yellows, and greens. They were impressed when the nativity star beamed a light to the manger through a tube of plastic. They smiled at the two little skaters balancing on a glittering pond. But when they passed by the house and caused music to play and Santa to emerge from a chimney and shout, "Ho, Ho, Ho," they were truly awestruck by Bill's electronic wizardry.

With an elevator-like chain-driven system, the 3-foot "Pop-Up Santa," as the neighborhood kids have dubbed him, rises from a chimney equipped with ice scrapers, a heater, and an FM remote soundtrack. His sudden appearance is triggered by a passive infrared sensor. A digital sound system allows Santa's message to be reset without repeating the entire chorus of the music. In 2004, Bill added a penguin spinning on a snow disk to the

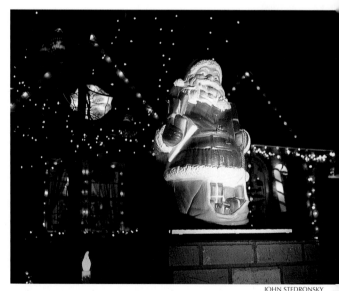

JOHN STEDRONSKY

Bill Christoffel's "Pop-up Santa" is but one of his high-tech holiday creations.

triggered sequence and replaced several of the lights with energy-saving LEDs.

At the suggestion of Bill's oldest son, Santa's innards now double as the workings of an Easter Bunny jumping out of his basket. This has inspired the possibility of a pop-up character for every occasion. Neighbors have only one response—"Party, man."

Dec. 11–Jan. 15, Dusk–12:00AM. *From Wolf Rd., W on Golf Rd. 1 bl., S on Warrington Rd. 3 bl., W on Harding Ave. ½ bl.*

10 CHRIST CHURCH
1492 HENRY AVENUE

A life-size crèche stands in the front yard of this colonial church with the figures of the Holy Family, shepherds standing watch, and kings bearing gifts. It is a sight familiar to all the Christian world, depicting the birth of Jesus.

But these figures are not carved in wood or cast in plastic or stone. In the manger scene at Christ Church, they are members of the parish who volunteer an hour of their busy lives to experience the hush of a straw-filled stable.

Joseph wears hiking boots under his tunic. One shepherd holds her staff with ski mittens. Another's furry hood protrudes from her garb. Cars pull up and parishioners chat over hot cocoa. Yet, somehow, it doesn't seem to take away from the feeling in the air of a holy time when a Child was born in Bethlehem.

Dec. 17–Dec. 23, 7:00PM–8:00PM. *From Des Plaines River Rd., W on Algonquin Rd. 2 bl., N on Cora St. 2 bl.*

11 966 EAST LEAHY CIRCLE

From the looks of Jim and Cheryl Jakubek's Christmas display, they like to do things big. A 35-foot evergreen

A towering 18-foot snowman is among the colossal displays that trim the Jakubek home.

tree is trimmed with 1,500 C-9 bulbs and crowned with a 2-foot star. Giant snowflakes dangle from the parkway trees. Oversized candy canes line the driveway. And big C-9 bulbs hang from the eaves.

So it's little wonder that when the couple was offered the 18-foot snowman that originally stood in the lobby of Binks Manufacturing in Franklin Park, they readily agreed to accept it. Though the large Styrofoam and wood figure could be broken down into five separate pieces, it still required five truckloads to transport the snowman to the auto body shop Jim co-owns with his brother Dave (see page 166), where it could be repaired and stored.

It's also little wonder that a few years later, when the Jakubeks wanted to add a moving train to their display, they would not settle for the G-scale garden variety. After searching on the Internet, Jim found a company in Florida that manufactured rideable trains used in shopping malls. He was able to purchase one secondhand that could hold up to twelve kids. (And he often gives free rides to those who happen to catch him outside.)

With so many huge items in their display, the Jakubeks must annually hire a tree service with a bucket truck to light the top of the evergreen, hang the snowflakes in the trees, and put the hat on the snowman. But the couple continues to think big. They made giant pastel eggs for Easter. They bought a covered wagon to trim the lawn for Halloween and Thanksgiving. And they plan to extend their railroad track so it goes all the way around the house.
Dec. 7–New Year's, Dusk–10:30PM. *From Algonquin Rd., N on Mt. Prospect Rd. 2 bl., W on Walnut Ave. 3 bl., N on Leahy Cr.*

12 10050 Meadow Lane

When Jackie and Al Tinker's three children grew up and got married, the couple hoped to soon be blessed with grandchildren. But none of their kids seemed to be in any hurry to start their own families.

With little recourse to reach their objective, the couple decorated the outside of their home for the holidays with Santas, candy canes, snowmen, and lights, thinking that when their children came home for Thanksgiving and Christmas they just might imagine how much fun "Grandma and Grandpa's" would be . . . if only they had kids. Though the Tinkers don't claim complete credit, the

plan seems to have worked, for they are now the proud grandparents of little twin girls.

The couple recently moved to a new home on a wider lot and intend to expand their Christmas display. They have already planted four 10-foot pine trees, just so they can decorate them for the holidays. And they have been busy building gingerbread people, angels, and giant lollipops for the front yard. Apparently, the decorations are not the only thing they hope to see expanding.
Thanksgiving–Jan. 6, 6:00PM–10:00PM. *From Milwaukee Ave., W on Central Rd. ¼ mi., S on Dee Rd. 1 bl., W on Harrison St. 3 bl., N on Meadow Ln. 1 bl.*

13 445 West Millers Road

When Art and Pat Lukowicz began dating in high school, Art enjoyed helping Pat's dad hang Christmas lights in the large evergreen tree in her family's front yard. When the couple married and began decorating their own home in 1961, they continued the tradition by trimming the little evergreen in front of their house with one strand of seven large C-9 bulbs. In every season that followed, the tree grew another foot and required more strands of lights.

At last count, the 50-foot blue spruce was decorated with over two thousand lights and is now visible from blocks away. The tree alone requires seven 20-amp electrical circuits. No longer able to reach the branches with a pole, Art now hires a company with a bucket truck to complete the operation. The lights are wrapped around the branches, and each plug connection between strands is tied in a knot to keep them secure in heavy winds.

Equal care is taken decorating the 8-foot natural pine wreath that frames the home's front entryway. Pat and her daughter, Tammy, spend an entire afternoon each year individually wiring one thousand Italian lights to the fresh boughs along with nametags for each of the nine grandchildren. The rest of the display in the front yard and back is tastefully designed by Pat, who changes the theme from year to year and gives Art directions on how to set it up. "We work very well together on this," she says. "I'm just the grunt," Art playfully retorts.

The garage door provides the surface for Art's most creative decorating project. Once again acknowledging the grandchildren, he cuts out nine characters in keeping with Pat's theme from ½-inch Styrofoam insulation. With

The lighted evergreen that towers over the Lukowicz home draws visitors to a yard full of surprises.

the help of Tammy and her husband, Jim, Art covers the door with heavy-duty aluminum foil, taped around the edges of each panel, and glues the figures and other decorations to the foil. By cutting the material where the door panels come together, he is still able to use the garage. Whether the grandkids have been portrayed as penguins, snowmen, elves, or gingerbread men, they excitedly look forward to seeing the house lit every year and having their pictures taken in front of the garage door to see how much they've grown since years past.

And as the kids and the tree have grown, so have the Lukowicz displays—their adult sons, Craig and Keith, have taken the old decorations from previous themes and used them to decorate their own homes in Schaumburg and Lake Barrington in the classy Lukowicz style.

1st weekend of Dec.–Jan. 6, Dusk–10:00PM.

From Dempster St. (Thacker St.), N on Elmhurst Rd. 2 bl., E on Millers Rd. to 1st cul-de-sac on right.

14 755 SHAWN LANE

When Joe Covello and his brother Frank were little over ten years old, they excitedly pooled nearly all their savings and purchased a strand of Christmas lights to decorate the porch railing of their family's apartment. After only one night of enjoying their holiday handiwork, Joe vowed never to decorate there again when he discovered all the bulbs stolen from their sockets.

It was not until after he bought his first home in 1982 that Joe's pent-up desire to decorate for Christmas became evident. Though he has prudently confined his purchases to three to five new items a season, over twenty-five years of buying have resulted in a garageload of soldiers, carolers, teddy bears, angels, stars, elves, candy canes, nativity figures, and lights. "He has so much stuff now, he could probably decorate the whole block," his wife, Geraldine, teases.

When the couple's two children, Jack and Gina, were old enough to carry a plastic snowman, they

Homemade wooden stands kept at least part of the Covello display in view after a heavy snowfall.

started helping their dad decorate the outside of the house for the holidays. "I wanted the kids to know that Christmas was not just about the gifts and the craziness," Geraldine says, "but having family time and doing things together."

Joe and the kids would start each season mapping where everything should go. Then they would unpack the decorations from the attic, carry them out to the front lawn, and set them up according to plan. Pleased that her family was working together on a project, Geraldine would decorate the inside of the house and prepare hot chocolate for her crew when they came in for a break.

As the children have grown older and started designing ideas of their own, togetherness has taken a new twist. Jack teases his dad about how serious he is about the decorations, and Gina says, "Daddy, don't put it over there."

"Now my job is keeping the peace and singing 'Tis the season to be jolly,'" Geraldine laughs. "After arguing about whose plan to use, Joe and the kids inevitably realize that all the plans are quite similar. Then they put it all together. It looks beautiful. Everybody's happy. And I bring out the hot chocolate."

Thanksgiving –Jan. 6, 5:00PM–10:00PM. *From Mt. Prospect Rd., W on Dempster (Thacker St.) ½ mi., N on Marshall Dr. 1 bl., E on Ambleside Rd. 1 bl., N on Shawn Ln.*

15 WESTFIELD GARDENS

During the holiday season of 1991, Amanda Wozny and Scott and Stephanie Howard went looking at Christmas decorations with their parents. They visited Schiller Park, where many of the streets had a common yuletide theme. When the youngsters returned to their homes, there was more than cocoa and Christmas cookies on their minds. "We should do that around here," they said. Inspired by their children's enthusiasm, the parents agreed to the plan, and "Candy Cane Land" was born.

After the idea received a favorable response from some of the neighbors, the Wozny and Howard families sent letters to all the households in Westfield Gardens inviting them to join in the effort. A local store owner agreed to discount the price of 30-inch plastic candy canes to those who presented the letter.

Over 70 percent of the residents participated the first year. At last count, over 90 percent of the homes light the five-block area with a total of 440 candy canes.

The idea has not only lit up the streets, but the community spirit of the area as well. Elderly residents, unable to assemble their own displays, are assisted by generous neighbors. "We have gotten to know everybody. It has really brought the neighborhood together," says Jim Wozny, who makes nightly rounds to repair burnt-out bulbs. Though Scott, Amanda, and Stephanie used to accompany him in the car when they were younger, several kids on the block now join him riding up and down the blocks with spare bulbs in a decorated golf cart.

It seems that in Westfield Gardens the simple notion of a child has created a spirit of neighborhood camaraderie among the young, the old, and everyone in between. And wasn't that the plan of another little child from the start?

Sun. after Thanksgiving–New Year's, Dusk–10:00PM. *From Algonquin Rd., N on Mt. Prospect Rd. ¼ mi., E on Walnut Ave.*

ELK GROVE VILLAGE

16 "WINTER WONDERLAND"
BIESTERFIELD ROAD
AT WELLINGTON AVENUE

The Elk Grove Park District's "Winter Wonderland" holiday display on the grounds of the Pavilion Community Center has nearly as many decorations as the park has activities. With fabulous facilities that offer everything from carousel rides to hypnosis classes and a park that's gleaming with hundreds of thousands of lights, it's little wonder that Santa and his reindeer decided to take up temporary residence in the park's storage buildings, which have been gussied up for the occasion. On the third Sunday in December, the jolly old elf even joins visitors for brunch and a swim after his morning workout at the Pavilion Aquatic Center.

Fri. after Thanksgiving–Jan. 6, Dusk–dawn.

From Arlington Heights Rd., W on Biesterfield Rd. 2 bl.

17 69 AVON ROAD

Doug Moeller had been decorating his home for over ten years with little fanfare until his neighbor Bob Zable entered him in the 2005 "Elk Grove Village Jaycees Holiday Home Decorating Contest." Though his children's delight had been enough reward in the past, the thrill of his address in lights on the village marquee and a photo of his home on display at Village Hall suddenly became like a vision of sugarplums dancing in his head.

But Christmas came and went, and Doug received no word from the judges. So when a warm day arrived the last week of December, he took advantage of the weather and disappointedly took down his decorations. He removed the sleigh and reindeer he had cleverly suspended on a cable between two trees and crawled on the roof to remove Santa's runway. He pulled out the candy-cane rope lights neatly wedged around his picture windows and disconnected the icicle lights that hung gaily from

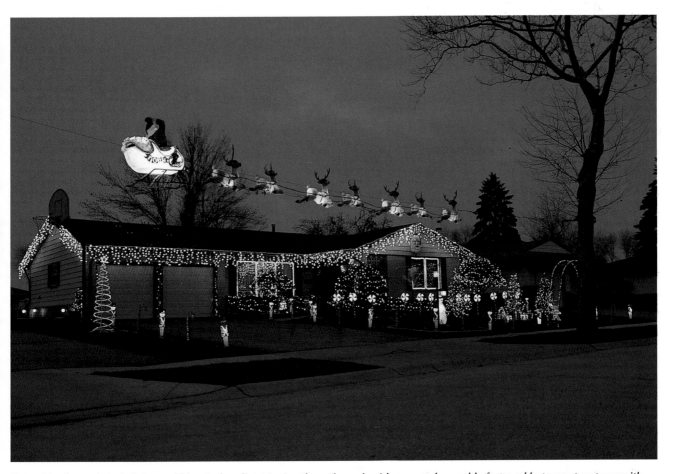

Doug Moeller suspends Santa and his reindeer by stringing them through with garage-door cable fastened between two trees with heavy chains and then lifting and tightening the assembly with a come-along hand cable winch.

his roofline. He collapsed the spiral Christmas tree that shined brightly on his front lawn and the lighted archway that framed three artificial trees now neatly disassembled. He cut the cable ties securing the twelve peppermint lollipops, sixteen lighted soldiers and eighteen candy canes that perfectly lined the lawn, pulled the conduit stakes from the ground, and packed up the plastic snowman. As his next-door neighbor Jan Charzan pulled out of her driveway, she woefully sighed that another holiday season had come to an end.

At 5:00 p.m., when everything but the lights on the bushes was boxed and stored away, the telephone rang. It was the Elk Grove Village Jaycees gleefully telling Doug his home had won the prize for best traditional display. Doug was stunned. Twenty minutes later, when an Elk Grove Police Department photographer arrived to take a photo for the winning plaque, Doug was less then elated. He knew the village marquee sign would announce a winning display residents would no longer be able to see. He knew the display he had worked so hard to refine would not be pictured on his winning plaque.

Aware of his disappointment, his wife, Sally, suggested that he cancel their plans for the evening and put the decorations back up. Though "What are you, nuts?" was his initial response, he soon realized Sally's suggestion was the only way to relieve his frustration. With the help of his nephew Jeff Rozny and Bob Zable, Doug immediately began reassembling the display and by midnight had most of the decorations back up where they had been only hours before. Returning for the evening, Jan Charzan appeared a bit confused when she pulled into her driveway, "I did see you taking the decorations down. Didn't I?"

Doug completed the redecorating in the morning, and in the evening the Elk Grove police returned and photographed his display drenched in a fresh blanket of snow. Though his address in lights and his plaque in Village Hall were bittersweet, the following year, when he was informed the week before Christmas that he had won again, he proudly left his decorations up until the tenth of January.

Dec. 1–Jan. 10, 5:00PM–10:30PM. *From Arlington Heights Rd., E on J. F. Kennedy Blvd. (Biesterfield Rd.) 1 bl., N on Creighton Ave. 1 bl., W on Keswick Rd. 1 bl., N on Penrith Ave. 1 bl., E on Avon Rd. ½ bl.*

HANGING LIGHTS IN WINDOWS

Diane O'Neil of Hoffman Estates filled the windows in her old house with light by running strands of mini-lights up and down old window screens and attaching them with twist ties through the screen. She then hung the screens, plug-side down, on the inside of the windows from finishing nails installed in the woodwork.

Not wanting to damage the wood trim in her new home, Diane now fills the windows with light using net lights hung from tension rods. Icicle lights can be used in a similar manner for a glittery valance.

Former Arlington Heights decorator Al Eischen built frames from 1x2s to fit snugly within each exterior window frame of his home. After priming and painting the frames, he drilled holes evenly spaced 2½ inches apart along the center of the boards, poked mini-lights through the holes, and hot glued the lights in place. Once constructed, the frames are easily installed year after year and create an attractive, uniform effect.

18 821 DELPHIA AVENUE

After winning second place in the local decorating contest in 1996, Rich Deck was bitten by a holiday decorating bug, whose infectious "wonderlust" has proven incurable. Over the years concerned family, neighbors, and friends, recognizing the symptoms of Rich's malady, have generously come to his aid.

When Rich began building dozens of wooden lawn decorations from mail-order patterns, his wife, Judy, and next-door neighbors Kevin Major and his daughter Anna Marie offered to help paint the figures. When Rich made a sign that counted down from ninety-eight days until Christmas, his kids volunteered to change the numbers every day.

When Rich became intent on turning his brick ranch home into a gingerbread house covered with giant candies, several neighborhood families agreed to attend his giant-candy painting party and even finished a few at home. When the brick walls seemed too inedible for the gingerbread theme, Joe Valenti lent his driveway and assisted in painting a gingerbread pattern on a 175-foot roll

of 10-foot high material used to warm farm fields. When Rich became intrigued with penguins, Joe helped him paint bricks of ice on the same material to alternately turn the house into an igloo. When the decorations required rented storage space, neighbors Tim Werfel and Jeff Fleischer helped cart the decorations home in their trucks.

When Rich grew discontent that the star perched on a 20-foot pole attached to his chimney only made his home visible from two blocks away, Chuck Shearer, Dan Mordan, and Steve Childers helped him construct a higher chimney of 20' x 20' scaffolding. And when the chimney blew down a few days later, Chuck helped Rich repair the holes in his roof and remove the tangled remains.

Though some may deduce that the helpfulness of Rich's friends may have exacerbated his condition, it seems their decorating-afflicted neighbor has at least come to realize it is no longer the thrill of glory but the joy of giving that spurs him on. He repays his neighbors' efforts with an annual holiday party that includes a much-anticipated outdoor quiz about his display. (Naming the hiding place of the 8-inch Saint Fiacre statue seems to be a favorite question.) He collects canned goods from passersby to donate to the Elk Grove Food Bank. He begins reporting the number of days until Christmas a month later. And he no longer enters the holiday decorating contest to allow others a chance.

Dec. 1–Jan. 6, 5:00PM–11:00PM. *From Higgins Rd., S on Arlington Heights Rd. ¾ mi., E on Landmeier Rd. 1 bl., S on Ridge Rd. ½ mi., E on Delphia Ave. 1½ bl.*

19 807 GALLEON LANE

Taryn Ross was quite surprised when her husband, Marty, suddenly began painting Christmas characters for the outside of their home. She jokes, "He's a CPA. They have no artistic talent."

Using pictures from his children's coloring books, Marty drew the figures freehand on plywood, cut them out, and painted them. The results proved he had more than accounting skills.

He began with the Cookie Monster stuffing himself with Christmas treats and went on to create the entire

The Decks' lone "Days 'til Christmas" sign readies neighbors for the season ahead long before the other decorations appear.

cast of Sesame Street characters decked for the holidays. Bert and Ernie sing carols arm in arm, while Big Bird decorates a whimsical tree. Oscar the Grouch smiles at the "Sesame St. Express," as it pulls a trainload of toys. Elmo speeds across an ice rink with his green scarf blowing in the wind, while Zoe stands ready to award him a trophy, even though he's the only contestant. Aloysius Snuffleupagus adds a finishing touch to a snow Snuffy sculpture, as Little Bird flies overhead wishing "Holiday Greetings" to all.

On the other side of the yard, Marty created a winter town complete with a gingerbread house, a log cabin, an igloo with penguins, and a helicopter with a movable propeller.

Marty's creations have not only earned several awards in the competitive Elk Grove Village decorating contest, but one little boy was so convinced with his painting of the igloo that he wanted to go inside.

Dec. 6–New Year's, 5:00PM–10:30PM. *From Meacham Rd., W on Nerge Rd. 2 bl., N on Cutter Ln. 1 bl., W on Galleon Ln. 2½ bl.*

20 779 SCHOONER LANE

The Christmas spirit is bursting from the homes of the Windemere Subdivision, and this Schooner Lane residence is one of the brightest. When asked exactly how many lights are used to cover the trees and bushes and line the eaves, windows, roof, and sidewalk, homeowner Barbara Polich simply answers, "To the point of frostbite."

She and her husband, Michael, decorate for Halloween as well. No sooner do they get the graveyard cleared away and Mike free of his moldy mummy gauze, then they are crawling up on the roof with lights.

Dec. 16–Jan. 6, 7:00PM–11:00PM. *From Meacham Rd., W on Nerge Rd. ¼ mi., N on Cutter Ln. 2 bl., E on Schooner Ln. ½ bl.*

DENNIS O'NEIL'S ARTIFICIAL TREE FARM

To construct Christmas trees of various heights, Dennis O'Neil of Hoffman Estates builds a square base with 2x4s, drills a hole in the center, and inserts a ¾-inch dowel rod. He ties lengths of baling wire from the top of the dowel rod to the four corners of the base and then either winds lights around each individual wire or wraps lights around the tree from top to bottom. For another effect, Dennis sometimes covers the tree with foil wrapping paper before winding the lights.

HOFFMAN ESTATES

21 1385 BEDFORD ROAD

Residents of Hoffman Estates who had made a holiday tradition of viewing the once brightly decorated home at 2031 Parkview Circle can rest easy knowing that the decorators and their trimmings have moved only 2 miles away. Locally famous for the past decade, Dennis and Diane O'Neil have no intention of discontinuing their display. "If I didn't decorate, my seven children would think I lost my will to live," Dennis jokes. In fact, he only intends to expand the decorations. "We're now on a corner lot, so we have a much bigger palette to work with. The new house also has twice as much electrical service, but I don't know if I can afford to use it all."

Their move has elicited a variety of responses from local residents. New neighbors on Bedford Road are delighted that they will no longer need to drive to Parkview Circle to see the display. Old neighbor Ted Bowalski, who had lived across the street, is unhappy that his electric bill will likely go up now that he can no longer rely on the O'Neils' display to light his living room. And former next-door neighbor Bill Hart is thrilled to know that he can finally use his daylight sensor to automatically light his display from dusk to dawn—in the past, his decorations turned off only a short while after being lit when his sensor read the O'Neils' display as the dawning of the morning sun.

Thanksgiving–Jan. 6, 4:30PM–10:00PM. *From Golf Rd., NW on Higgins Rd. 1 bl., N on Jones Rd. 1 bl., E on Cambridge Ln. 2 bl., N on Bedford Rd.*

22 1590 DELLA DRIVE

Before the Christmas season every year, Bill Thomas, regional sales manager for a local construction company, gives his friend and dentist, Greg Neu, a thrill unlike any Greg can experience in his dental practice—he lends him a cherry-picker truck to put up his decorations.

Using the shift-like controls, Greg grins from ear to ear as he glides up and down in the bucket hanging lights from the tall peaks of his two-story home. Like Santa himself, he ascends to the chimney to attach one half of the wiring that will suspend Mr. Claus and his reindeer 20 feet above the ground from the roof to a tree limb. He rides higher still to secure strands of lights to the top of a

The calm setting of the Neus' manger scene once moved eight-year-old Mary Elizabeth Prebys to kneel down amongst the straw and say a prayer.

40-foot metal pole that becomes the trunk of a giant tree. He towers among the branches of a century-old oak to hang the Star of Bethlehem and dangle the 35-foot rays of lights that will shine on the manger far below. He playfully drapes rope lights from the tall birch trees, travels up and down the evergreens with icicle lights, and circles about the maples wrapping the branches in LEDs.

Anxious to share the thrill one season, Greg offered a free ride to his son's friends. Unfortunately, the lift short-circuited leaving two teenage girls suspended 40 feet in the air for nearly an hour until the Hoffman Estates Fire Department came to their rescue. The girls stayed cool, talking on their cell phones and entertaining the crowd of over fifty people who gathered below. "I'll never live it down," Greg says.

Dec. 1–Jan. 6, 5:00PM–10:00PM. *From Barrington Rd., E on Higgins Rd. 1½ mi., NW on Huntington Blvd. 1 bl., E on Della Dr. 1 bl.*

MT. PROSPECT

23 1504 East Barberry Lane

For two days every summer, Springtime-Santa, Inc., a sales representative group for manufacturers of seasonal products, hosts a sample sale at their Northbrook

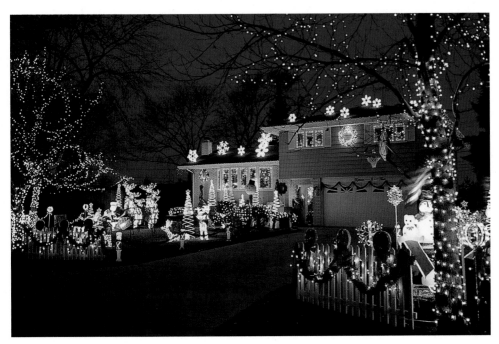

An antique sleigh, a life-size Santa, and an assortment of rooftop snowflakes are among the holiday finds that trim the front lawn of the Ziemba family.

showroom. And since 1992 for one day of the sale, Bob, Terry, Renea, and Randy Ziemba have descended on the showroom and together purchased a sizable portion of the company's reduced-price merchandise.

Known as "The Christmas Family" in their north suburban neighborhood, the Ziembas have been collecting Christmas decorations for over forty years. Though they have earned their local reputation for being seven-time winners of the "Mt. Prospect Decoration Celebration" for their exterior display, the inside of the house is equally festooned—over two hundred animated figures and fifteen Christmas trees cause much of the furniture and knickknacks to go into temporary storage. Satisfied with merely providing financial assistance for his family's addiction, Bob remarks, "My wife, Terry, and two kids have some kind of Christmas radar. If there are Christmas decorations anywhere, they will find them."

On one visit to the summer sample sale, a sales representative said in jest to Renea, as she was making her hefty purchase, "You ought to get a job here." She has now been working her "dream job" as a sales assistant for the company since 1999. "For the first few years, I was spending 50 percent of every paycheck on Christmas decorations," she admits. Though Renea has been able to curb her spending, she acknowledges, "My family still comes to the sample sale, and now we're starting to buy Halloween stuff."

Fri. after Thanksgiving–Jan. 6, 4:30PM–10:30PM.
From Wolf Rd., W on Euclid St. 2 bl., S on Sycamore Ln. 2 bl., W on Barberry Ln.

PALATINE

24 1350 LARKSPUR LANE

To Don and Doreen Jarosz and their children, Derek, Danielle, and Dale, decorating for Christmas is an annual family project that seems to have grown as much as the kids. What started years ago as an outing to the local home-supply store to buy a new decoration or two has become a family tradition appealing enough to lure the older children home to hang lights during their semester break from college.

Though the trip to the home-supply store is still an annual fall tradition, discussing ideas for new and improved displays has become a year-round family activity. Each of the "DJs," as they like to call themselves, seems to enjoy coming up with their own innovations, many of which incorporate store-bought items into imaginative settings.

When it comes to setup, the whole family helps with everything from repairing the decorations to crawling on the roof to hang lights. It had been a family rule that no one was allowed on the roof until they were ten years old. Once everyone was old enough to go up there, Doreen did not want to be left out of the fun. Though afraid of heights, she managed to climb up, but when it came to getting down . . . it was another family project.

Sun. after Thanksgiving–New Year's, 4:30PM–11:30PM.
From Rt. 53, W on Dundee Rd. 1½ mi., S on Hicks Rd. 1 bl., E on Home Ave. 3 bl., S on Larkspur Ln. ½ bl.

25 446 NORTH WILLOW WOOD DRIVE

When Vera Muir first saw the silhouette nativity scene her uncle, Tony Ancel, had built for Saint Joseph Church in Joliet, she remarked, "Oh, I want those." The next thing she knew her dad was pulling up in front of her house with duplicate figures on top of his car.

Thanks to her uncle's skill and her dad's kindness, Vera has proudly displayed the wooden three-quarter life-size figures of the Holy Family on her front lawn during the Christmas season since 1990. Thanks to her own skill and creativity and a little help from her son, Gordon, she has expanded the display to depict the entire Christmas story.

Over the years, blowing up the figures square by square from original sketches on grid paper, Vera has added two shepherds and their sheep, the Three Kings, four angels, a donkey, cow, and camel, several palm trees, and the whole city of Bethlehem.

When a local pastor and his wife rang her bell and asked if they could have patterns of her display to build the figures for their new church in Michigan, she traced the drawings, happy to return the kindness she had received so many years ago.

Sun. after Thanksgiving–Jan. 6, 4:00PM–10:00PM.
From Palatine Rd., N on Northwest Hwy. ½ mi., E on Baldwin Rd. 1 bl., N on Willow Wood Dr. ½ bl.

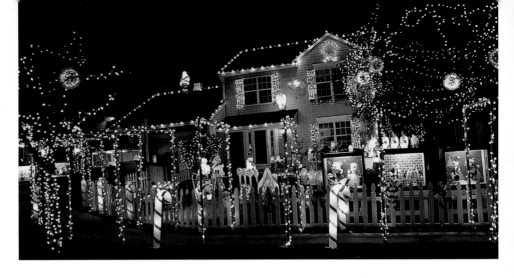

Tom Johnson's display cases always include Mr. and Mrs. Rudolph thanks to his children, who offer their suggestions each year.

balls of lights from his trees. He illuminated his window shutters and outlined his rooftop from gutter to peak. He built a manger for his crib scene, risers for his choirboys, and a mailbox for letters to Santa. Using nearly one hundred extension cords, he plugged everything into whatever outlets were available. Within days his breakers all tripped, and the house lost all electrical power.

With the generous help and instruction of his neighbor Gary Heck, a licensed electrician, Tom not only restored constant power to his home and display but learned enough about electricity to confidently do so without increasing his electrical service. "I felt I got smarter instead of bigger," Tom says. In addition, he pioneered the replacement of his indoor lights with fluorescents, which significantly reduced his normal household electrical usage.

Now fluent in the lingo of amps, watts, and meters, Tom spends an entire week "playing around with the power" after setting up his 50-amp display. Using an amp probe, he measures the draw on each of the four 20-amp circuits he uses for his Christmas decorations to ensure that none exceeds 80 percent usage. He then turns on everything in the house that would normally be lit, measures the draw on the household circuits, and moves the plugs on the Christmas decorations around until the load on the circuits is balanced within 5–10 amps. "If it's way out of balance, it can blow a box," Tom notes knowingly. He is also careful to balance both outlets of the receptacle that services each circuit and to use no more than 5 amps on each of his 15-amp extension cords.

"It was a bit of a war," Tom admits, "but I have begrudgingly made electricity my friend."
Thanksgiving–Jan. 7, 5:30PM–10:00PM. *From Golf Rd., S on Rt. 59 ½ mi., E on Ascot Ln. 2 bl., S on Kensington Dr. 1 bl., E on Dover Ct.*

WHEELING

31 FRIENDSHIP PARK
 MILWAUKEE AVENUE AND DUNDEE ROAD

With its flowing fountain, bubbling ponds, and shady gazebo, Friendship Park offers a quiet respite at the busy intersection of Milwaukee Avenue and Dundee Road. Since its construction in 2003, the corner has become a popular destination for everyone from parents walking their infants to seniors stopping for a rest and a popular photo setting for prom couples, wedding parties, and sports teams. The site of an occasional summer music concert, the gazebo was also used by a romantic suitor to pop the question amidst a swath of glimmering candles.

Though the fountain and ponds go dry for the winter, the park comes alive once again at Christmastime thanks to the efforts of the Wheeling Public Works Department. "The guys in Public Works aren't normally decorators," Director Chuck Spratt admits, "But they're learning new talents." Their efforts have proven successful as visitors return, despite the cold, to view a fanciful array of garland, lights, and glowing characters in an attractive toyland theme. Across the street the fun continues with a snowman theme at Lehmann Fountain and further west on Dundee Road, where Village Hall is surrounded by glistening trees drenched in 75,000 white lights.
End of Nov.–Jan. 14, Day and night. *At Milwaukee Ave. and Dundee Rd.*

Opposite page: Homeowner Bob Kasper of Chicago Ridge continues to decorate his boyhood home (p. 110) with a few of the old decorations and then some.

Street, John explains, "My wife, Jo, and I just wanted something we could enjoy together with the kids."

So every year since 1997, the Slavich children, Anthony, Brandi, Courtney, and Johnny, decide on a new favorite cartoon character addition to the display. Then their dad freehands the figure on plywood, cuts it out, and lets them paint it. "Sometimes I touch it up after the kids go to bed," John confesses.

Sun. after Thanksgiving–New Year's, 4:30PM–12:00AM. *From Elgin-O'Hare Expwy., N on Roselle Rd. 1 bl., W on Pratt Blvd. 4 bl.*

SOUTH BARRINGTON

29 8 WESCOTT DRIVE

Early season visitors to this South Barrington residence should be anything but disappointed if they pull up to a house that seems to have gone dim—it's just part of the spectacle. For there's no greater thrill in looking at Christmas decorations than seeing a dark house suddenly burst into glow, and when this expansive home and front yard come alive and start dancing to the beat of holiday tunes, it's a spectacle that will knock your Christmas stockings off.

The brains and brawn behind the clever orchestration is homeowner John Kazmier. A self-described "jack-of-all-trades and master of none," John began decorating as a lark in 2000, when he completely covered all eighteen of his front windows in white lights and all his shutters in green. The following season he topped his original effort by blanketing the entire brick facade with red lights, much to the amazement of the family across the street, who just happened to be looking out the window when John first tested the effect. But in 2002, he trumped his already stunning display by computerizing all the lights to blink, flash, fade, sparkle, and change colors to the rhythms of seven Christmas songs broadcast on a dedicated FM radio band. He also filled the front yard with an assortment of lighted decorations and built several programmable items including a 16-foot spinning Christmas tree. "I always remember looking at Christmas decorations in Sauganash as a kid and thought it would be neat to do something like that to my own home," John explains.

With an architectural drawing of the front of his house as a guide, he divided the facade into eighty-eight

sections. Using 2,000 feet of ½-inch copper pipe, he welded a two-dimensional custom framework to fit each section and wound Italian lights, 80,000 in all, vertically across each in two different colors. Hooks and eyes were welded to the tops and bottoms, so each framework could be easily hung from the soffit or the framework overhead.

In an operation that requires nearly two months each holiday season, John hangs the frameworks and, according to a detailed schematic, plugs each section of lights into one of sixteen channels on each of over forty electronic boards that have been preprogrammed to perform seven lighting effects in specified intervals of time.

John had originally begun building his own boards and etching them with chemicals but soon opted to purchase ready-made boards. To achieve the detailed movements in his show, John and his wife, Penny, spent twelve to fourteen hours per song programming the desired lighting effect for approximately 640 light sources at 400 different intervals—a boggling 256,000 decision points per song.

The result is a magnificent display that rightfully draws lines of cars the week before Christmas and crowds after holiday services from nearby Willowcreek Church. Even Santa is so impressed he stops by to greet visitors several times a season.

Thanksgiving–Dec. 31, 6:00PM–9:30PM. *From Barrington Rd., W on Mundhank Rd. ¾ mi., S on Lake Adalyn Dr. 1 bl., E on Rose Blvd. 2 bl., S on Wescott Dr. ½ bl. Tune radio to FM 88.5 to synchronize with light show. Visitors must leave license plate number with guard at gate. See photograph on the title pages.*

STREAMWOOD

30 7 DOVER COURT

After seeing the delight on the faces of his youngsters while visiting other holiday displays, Tom Johnson decided to take his moderate decorations to the next level. Over the course of the next few years, he constructed seven 3' x 2' display cases filled with animated scenes and one 8' x 8' case with a G-scale train layout. He encircled the lawn with a homemade fence and decorated it with lights, candy canes, and holiday characters. He filled the yard with an assortment of lighted elves, gingerbread men, toy soldiers, and peppermints. He built a "tunnel of lights" of PVC over his sidewalk and hung

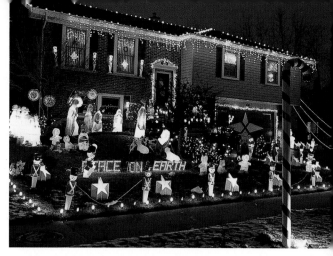

Easily seen from Roselle Road, the Beddards' glowing display features a new homemade decoration every year.

After walking through the park, visitors won't want to miss the fifteen-minute drive through Rosemont's well-decorated residential area to the south, where homeowners caught on to the mayor's spirit and Burgermeister Park offers a stunning surprise.

Though lovely displays can be found on every street, of particular note are John and Diane Frank's glittery handmade decorations at 6111 North Scott Street, Mark and Lisa Stephen's magnificent trees and handmade wooden figures at 9921 West Norwood, Rick and Karen Paloian's playful snowman and penguins at 6031 North Emerson, and Paul and Mary Messina's wooden cartoon characters at 6140 North Byron. Local professional pumpkin carver Steve Dahlke at 6104 North Hawthorne may also display an ice carving if weather permits.
2nd Sun. before Christmas–Sun. after New Year's, Dusk–1:00AM. *From Kennedy Expwy. (I-90), W on I-190 towards O'Hare, N on River Rd. ½ mi., W on Higgins Rd. 1 mi. See photograph on p. 85.*

SCHAUMBURG

27 44 KINGSPORT DRIVE

Many people who elaborately decorate their homes for Christmas are tradesmen whose skills easily apply when building decorations for their front lawns.

Decorators Bruce and Lori Beddard are in the mortgage and title businesses, which seem of little value in trimming a home with icicle lights, reindeer, and gingerbread men. Or are they? According to career descriptions, the job skills of a mortgage broker and a closing coordinator include an ability to identify and assess needs; organizational, analytical and interpersonal skills; knowledge of mathematics; and strong stress-management skills.

Without the ability to identify and assess needs, could they decide each year what to shop for at FIM and American Sales? Without organizational skills, could Bruce have made a handy list of the wattage of each decoration he owns? Without analytical skills, could Lori have built a 6-foot snowman out of wreaths, or Bruce two 8-foot candy canes out of PVC?

Without interpersonal skills, would both their next-door neighbors, Patrick and Meg O'Connor and Marlene Jones, have offered to let them expand their decorations onto their own front lawns? Would Santa and his elf stand outside their house four times a year? Would someone have left two free cows in their manger scene?

Without mathematical skills, could they figure out how to plug each decoration into their sixteen outdoor circuits without blowing a fuse? Or determine how to keep the penguins from toppling over on their sloping lot? Without stress-management skills, could they have handled coming in second in the Schaumburg decorating contest? And without mortgage experience, would Bruce have replied to a question about his future decorating plans saying, "My growth opportunities are on my roof and building"?

The skills of mortgage brokering and coordinating closings have clearly been assets to the Beddards' efforts—in "principal," passersby may fix their interest on the ballooning display for another fifteen or thirty years.
Fri. after Thanksgiving–New Year's, 5:00PM–10:30PM. *From Schaumburg Rd., S on Roselle Rd. 1 mi., E on Kingsport Dr. ½ bl.*

28 128 WEST PRATT BOULEVARD

A caring husband and father of four children, John Slavich is a busy man. He operates his own heating and air-conditioning company. He competes year-round as a professional bowler and ranks among the top one hundred players in the world. He built his own home and recently constructed an addition. And at Christmastime he still manages to put up a display that is easily visible from the Elgin-O'Hare Expressway and for five years running won the "Most Original Award" in the Schaumburg Park District home-decorating contest. Inspired by his father's playful display one block north at 1475 North Lincoln

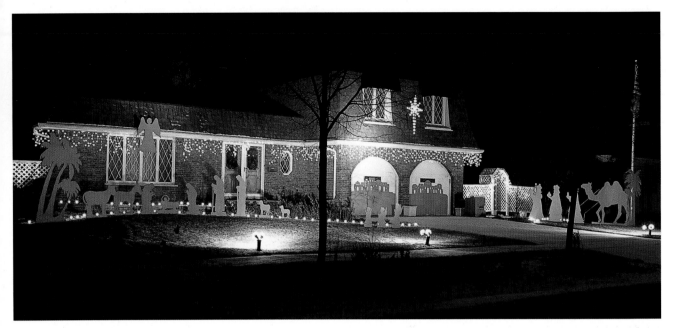

Vera Muir's expansive handmade nativity scene reminds viewers of the true meaning of Christmas.

ROSEMONT

26 VILLAGE DECORATIONS

The village of Rosemont covers 2½ square miles. Crisscrossed by expressways and commercial corridors, the population of the small residential area is only four thousand people. Judging from the glitter that brightens I-90 every Christmas season, it seems safe to say that the inhabitants of Rosemont have the highest per capita holiday wattage of any town in northeastern Illinois.

Credit for this phenomenon most likely belongs to the town's first and longtime mayor Don Stephens. His son Brad recalls the family's past holidays, "My father always loved Christmas. He would take us four kids to my grandmother's, and when we'd come home, Santa Claus would be at the end of the street waving to us. Our house was decorated with a moving snowman that wiped the snow off the window, flocked trees, a big train, and a winter village. Only dad was allowed to place the cotton that made the village look like it was covered with snow."

To Don Stephens's delight, he eventually had a real village to decorate, but he was happy to leave the work to town employees. "We decorate every tree in every park and interchange using approximately twenty-five to thirty thousand fifty-light strands," estimates Mike Raimondi,

director of Rosemont Public Works. Three two-man crews hang lights from the beginning of September to the end of October, when the rest of the department joins the effort until mid-December to complete the task.

In addition to the lighted trees, the department decorates every park with something special. But the grandest park of all is on Higgins Road at Scott Street, where the delightful decorations at Donald E. Stephens Park have been catching the eye of tollway travelers since 1980.

Three 30-foot illuminated hot-air balloons of toy soldiers and a cheery snowman tower over the 1-acre site. The central Christmas tree, constructed of several smaller trees, rises 25 feet from the park's fountain surrounded by a ring of brightly wrapped packages. Paths throughout the park lead to six little houses, just right for children to peek at the animated holiday scenes within and the Christmas tree decorated by Rosemont's school children.

Across from the community's guardhouse, live barnyard animals graze in a petting stable. The farmer who owns them assures animal lovers that the sheep, goats, donkey, geese, pig, and cow are treated better here than at the farm. "If they're cold, they can go into a heat-lamp manger," he says.

Impressed by the fabulous display, Santa appears the week before Christmas. His schedule is posted outside his colorful home on the park's northeast corner.

CHAPTER 6
Cook County ~ South

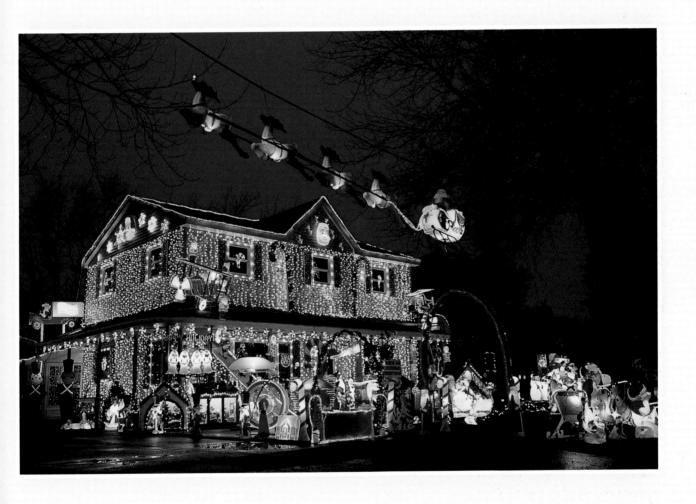

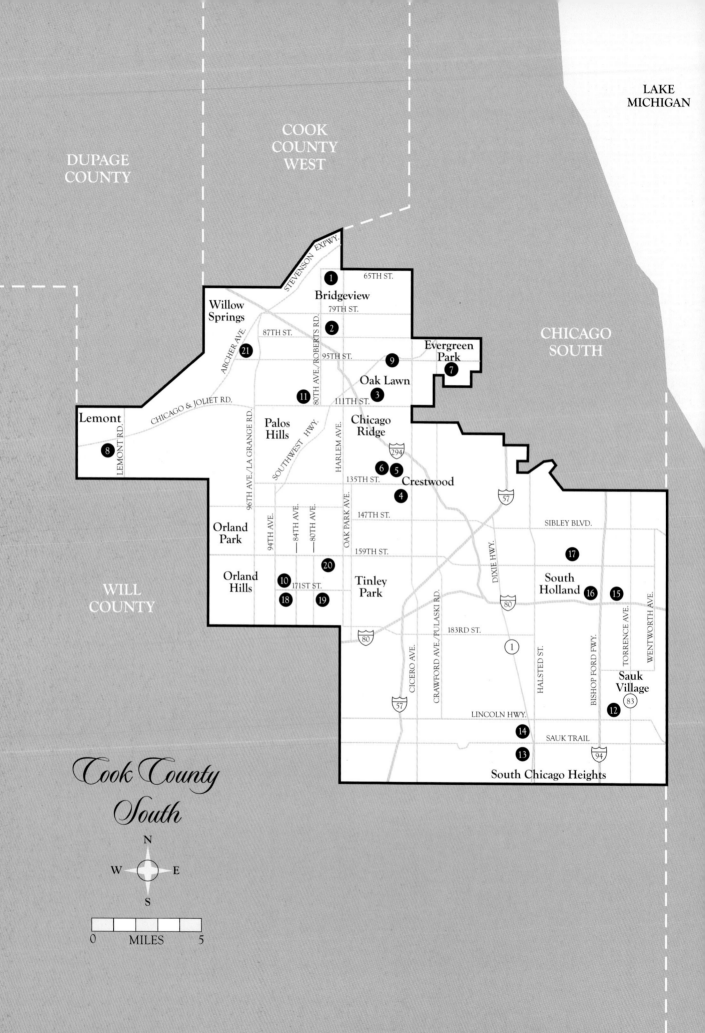

LAKE
MICHIGAN

DUPAGE
COUNTY

COOK
COUNTY
WEST

CHICAGO
SOUTH

STEVENSON EXPWY.

65TH ST.

1

Bridgeview

79TH ST.

Willow
Springs

87TH ST.

2

ARCHER AVE.

80TH AVE./ROBERTS RD.

95TH ST.

21

9

Evergreen
Park

7

Oak Lawn

3

111TH ST.

11

CHICAGO & JOLIET RD.

Lemont

Palos
Hills

Chicago
Ridge

LEMONT RD.

8

SOUTHWEST HWY.

96TH AVE./LA GRANGE RD.

HARLEM AVE.

294

6 5

OAK PARK AVE.

135TH ST.

Crestwood

4

57

147TH ST.

SIBLEY BLVD.

Orland
Park

94TH AVE.

84TH AVE.

80TH AVE.

159TH ST.

17

DIXIE HWY.

South
Holland

16 15

WILL
COUNTY

Orland
Hills

10 171ST ST.

20

Tinley
Park

80

WENTWORTH AVE.

TORRENCE AVE.

18 19

80

CICERO AVE.

CRAWFORD AVE./PULASKI RD.

183RD ST.

1

HALSTED ST.

BISHOP FORD FWY.

Sauk
Village

83

57

12

LINCOLN HWY.

14

SAUK TRAIL

94

13

South Chicago Heights

*Cook County
South*

N
W E
S

0 MILES 5

BRIDGEVIEW

1 7821 West Columbia Drive

There's no malfunction causing Marty Vilimek to change the bulbs in his coach light eight times a year—it's just Valentine's Day, St. Patrick's Day, Easter, Memorial Day, Fourth of July, Halloween, Thanksgiving, and Christmas. Known in the neighborhood for his ever-changing front-yard display, Marty does more than switch the colors of a bulb to match the occasion. But whether it's flags, eggs, shamrocks, or snowmen decorating his lawn, at the center of it all is a firemen's hose cart in homage to his thirty-five years with the Bridgeview Fire Department.

In addition to his holiday trimmings, Marty's extensive collection of firemen collectibles and firemen Christmas collectibles is on display at the Bridgeview Village Hall at 7500 South Oketo Avenue and the Bridgeview Bank at 6366 South Archer Avenue.

Nov. 30–Jan. 3, 4:00PM–11:00PM. *From Archer Ave., S on Roberts Rd. ½ bl., SE on Garden Ln. 1 bl., E on Columbia Dr. 1 bl.*

2 8639 South 78th Avenue

Annette and Joe Mitchell are a match made in decorating heaven—she, a retired jewelry store sales manager with a flare for style; he, a retired chief engineer for the

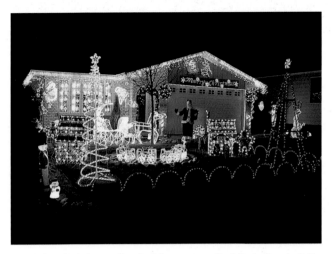

Trimming their house five holidays a year, the Mitchells admit if they ever moved they'd need a truck just for their decorations.

Chicago Park District with a knack for mechanics. Since purchasing their Bridgeview home in 1996, the couple has combined their talents to create car-stopping, year-round front-yard displays that have merited not only local fame but a personal visit from the mayor himself.

One month prior to Valentine's Day, Easter, Fourth of July, Halloween, and Christmas, the decorating twosome unloads the holiday-appropriate trimmings from their attic and basement and sets them on the lawn. Joe hangs the lights from the gutters, while Annette does the trees

The Vilimek display features a patriotic Santa Claus billboard by an artist who formerly painted Riverview carousel horses.

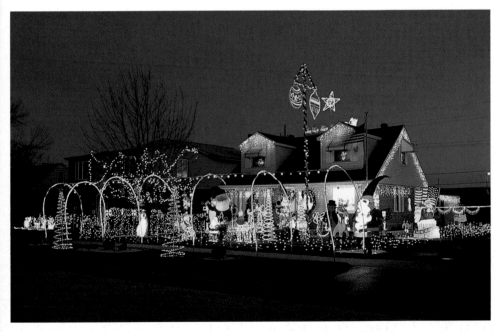

and bushes. Annette sets up the lawn decorations, a few at a time, and Joe works on the electrical connections. Annette walks across the street to get a better look, and Joe moves things to the left or the right according to her direction.

When the laborious week-and-a-half task is finally complete, Annette and Joe celebrate by treating themselves to dinner out. As they pull the car out of the driveway, the couple gaze at their mutual handiwork and sigh, "We did a good job."

Thanksgiving–Jan. 6, 6:00PM–12:00AM. *From Harlem Ave., W on 87th St. ¾ mi., N on 78th Ave.*

CHICAGO RIDGE

3 10936 SOUTH LYMAN AVENUE

"Come on, Dad, buy more stuff," young Bob and John Kasper would plead. "I'll buy it, if you put it up and put it away," their dad would reply. Much to the excitement of their mom, who loved Christmas decorations, Bob and John would fill the front yard of their home on Lyman Avenue with all the plastic figurines they could talk their dad into purchasing. The boys even built a few things themselves, like 8-foot-tall candy canes and a parachuting Santa Claus they made by tracing their nephew on a piece of plywood.

When the boys grew older and started families of their own, they each continued the elaborate Kasper decorating tradition—John at his home at 6859 Van Buren Place in Merrillville, Indiana, and Bob at his home on Lyman Avenue, which he purchased from his folks. Now in control of their own purse strings, both men have far exceeded their childhood display and become locally famous during the holidays.

"The madness started in 1995," Bob explains, "when I built a train out of ¼-inch lauan plywood and had to make the wheels move." A skilled auto mechanic by trade, Bob had the mechanical know-how and the spare auto parts to make it happen. With elastic bands, a small motor, alternator parts, and wooden pulleys he constructed on a lathe, he devised a system that kept the lighted wheels of the train in motion without tangling the cords.

But the wheels on the train weren't the only ones turning, as Bob concocted more ideas every year for new mechanical displays. No longer satisfied with plopping a plastic figurine on the front lawn, he has created a delightful collection of unique vehicles, buildings, and scenes to house his figures—a steepled church, toboggan run, Ferris wheel, merry-go-round, souped-up sports car, jeep toting a camper trailer, candy-cane helicopter, and an old-fashioned bi-plane.

Bob continues to add to the display every year with whatever characters are popular with the kids. "My wife used to think I was nuts," Bob laughs. "Now she helps me draw the characters, but she still thinks I'm nuts." Though he seems to have run out of room, Bob somehow manages to squeeze it all in each year, including the candy canes and parachuting Santa he and his brother made as kids. A recent second floor addition gave him extra space, and neighbors have offered to let him spill onto their yards next door.

He added an upper level on the garage as a workshop and storage area but still needs to store many of the decorations at his parents' home in Merrillville. Though inconvenient, at least Bob's dad knows he's still putting everything away.

Dec. 1–Jan. 2, (Su–Th) 5:00PM–10:00PM, (F–Sa) – 11:00PM. *From Cicero Ave., W on 111 St. 2 mi., N on Lyman Ave. 1 bl. See photographs on frontis and p. 107.*

CRESTWOOD

4 HOUSE OF HUGHES
14300 SOUTH CICERO AVENUE

The House of Hughes may be as renowned for its Christmas display as it is for its barbequed ribs—perhaps because one of its cooks is as skilled at hanging lights as he is grilling over the restaurant's open pit.

Antonio Garcia and his helpers trim the sprawling restaurant and surrounding bushes and trees with tens of thousands of miniature lights, creating a dazzling spectacle. "It takes patience," Antonio recommends. And for the ribs—Hughes' special BBQ sauce.

Thanksgiving–mid-Jan., Christmas display: Dusk–2:00AM. Restaurant hours: 11:00AM–10:30PM (at least). Reservations recommended. (708)389-4636. *From 147th St., N on Cicero Ave. 4 bl.*

5 13301 SOUTH LARAMIE

Among Christmas decorating purists there is one hard-and-fast rule: Never display more than one Santa Claus. But the lone Santa displayed on the lawn of Tim Jagodzinski reveals only a hint of his holiday philosophy.

A man who has cut down his own Christmas tree for nearly thirty years, Tim also believes in making all his own Christmas decorations and doing so with meticulous care. Using ¾-inch plywood, he constructs figures drawn from patterns, pictures, or his own imagination, sometimes routing the edges for a cleaner look. To lend a professional touch to the painting, he recruits his son Mark, an architect, to brush on the details.

Elves, snowmen, reindeer, penguins, ornaments, polar bears, toy soldiers, candy canes, cartoon characters, holiday greetings, a fireplace, a thirteen-piece manger scene, and one Santa Claus may fill Tim's corner lot, but each is grouped by theme, placed mindfully for easy viewing, and assembled squarely to the ground in a process that requires two to three hours of work every evening for three weeks. Lights outlining every window are stapled to custom-built wooden frames and, along with those on the roof and lawn, are spaced evenly apart and straight in a row. Burnt-out bulbs are repaired nightly, and all the decorations are cleaned and covered with cloth before storing away.

Tim's well-crafted effort has been rewarded with several prizes in the Crestwood decorating contest and a cottage industry creating lighted window frames for homeowners throughout town. But when a woman who decorated Marshall Field's windows stopped to tell him how much she admired his "perfect" display, Tim gushed, "It gave me goose bumps!"

Though he works full-time, is an avid golfer, and plays the concertina professionally in a polka band, Tim continues to find the time to perfect his display every year. A new, grander 6-foot Santa Claus is his latest addition. The old Santa will be moving on to his daughter's house. **1st weekend of Dec.–Jan. 2, 5:00PM–11:00PM.** *From Cicero Ave., W on 135th St. 4 bl., N on LeClaire Ave. 2 bl., W on 133rd St. 1 bl.*

6 13302 SOUTH LARAMIE

When Ken Klein's two sons, Kenny and Keith, were in Cub Scouts and building their racecars for the annual "Pinewood Derby," he took them to the home of his friend and co-worker Bob Kasper to borrow some of his tools.

It was Christmastime, when Bob Kasper's front yard is annually filled with one of the most elaborate holiday displays on the south side (see page 110). Suddenly, the kids had another project they wanted to do with their dad. "Can we make Christmas decorations just like Mr. Kasper's?" Kenny and Keith pleaded.

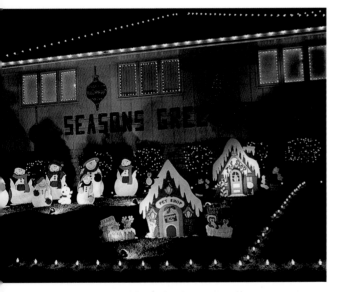
Tim Jagodzinski uses a taut string tied between two stakes to align his lights on the lawn neatly in a row.

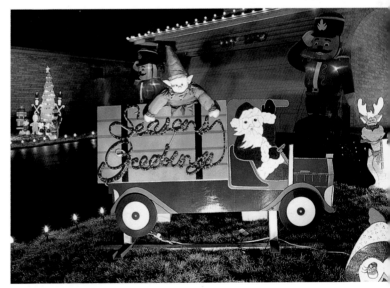
A colorful train is one of many wooden decorations built as a family project by Ken and Peggy Klein and their two sons.

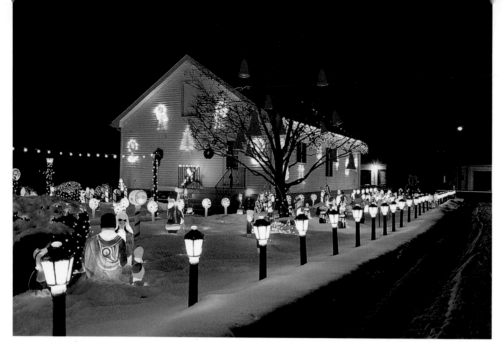

With the assistance of his neighbor Jimmy Joe, Bob Mankowski spends four to five weeks setting up his popular Lemont display.

Happy to work with his boys, Ken built a Christmas train and a toy house with them the first year, using patterns from a woodworking book. In the years to follow, they built new wooden displays each season, got their mom to help out with the painting, and eventually designed their own patterns. The Kleins' front yard is now brimming with a collection of over twenty-five handmade items.

"Kenny likes to do the woodworking. Keith likes to paint, and they both like to decide where everything goes," Ken says. "I pretty much just supervise now that the boys are teenagers."

But Dad's not out of the picture quite yet. An auto mechanic by trade, he's got two new projects to work on with the boys—racing drag cars and building a 1966 Mustang Cobra.
Dec. 1–New Year's, (Su–Th) 7:00PM–10:00PM, (F–Sa) –12:00AM. *From Cicero Ave., W on 135th St. 4 bl., N on LeClaire Ave. 2 bl., W on 133rd St. 1 bl.*

EVERGREEN PARK

7 PIZZA-MAN PIZZERIA
 3939 WEST 95TH STREET

Though most carryout pizzerias do fewer pickups than deliveries in the cold months before the holidays, Pizza-Man Pizzeria experiences a 25 percent increase in pickup orders. In fact, the whole family wants to come along.

It's no wonder, for the little corner shop is bursting with holiday decorations that fill the windows, dangle from the ceiling, hang from the eaves, and dance on the rooftop. Kids in the neighborhood eagerly accompany their parents each season, knowing they'll not only get to push buttons that make the animated dolls move but also get a free candy cane or chocolate Santa.

Spurred by the village "Merchant's Holiday Christmas Decorating Contest" (which they won two years in a row), co-owners Louise Cechowski and Bruce Ogean, their staff, and a couple of Louise's kids now spend three nights each season—sometimes until three in the morning—decorating the store inside and out. They do such a good job that one evening a very confused-looking customer admitted she mistook Pizza-Man for a Christmas decorations store.
Dec. 10–Jan. 2, Day and night. Store hours: (M–Th) 11:00AM–11:00PM, (F–Sa) –12:30AM, (Su) –10:00PM. (708)636-2777. *From Pulaski Rd., E on 95th St. 1 bl.*

LEMONT

8 16086 NEW AVENUE

William Mankowski could not resist his kids' urgings to decorate the house for Christmas. Each holiday season he bought more toy soldiers or candy canes or lanterns or candles until the front yard was brimming with lights and his children were bursting with glee. In the summer of 1972, his own enjoyment of the holiday tradition became apparent when he spent several months constructing a thirteen-piece manger scene from a catalog pattern he had purchased through the mail. The following Christmas, the

large manger scene took up most of the front yard, and the other decorations crept to the other side of the house.

Three years later when William passed away, his son, Bob, and daughter, Sallie, decided to continue decorating in their dad's honor and light the display on his birthday, December 6. Bob discovered additional patterns in the garage his dad had ordered of Mr. and Mrs. Claus, and a snowman and snowwoman, so he built them as his dad had planned and expanded the display onto the side yard, which was visible from the adjacent alley. As the years went by, Bob added a little more each year until the whole front, side, and back yards were filled with over one hundred figures he carefully arranged over a month's time. He was thrilled by the cars passing slowly through the alley and by the kids who would try to guess what was new.

A devastating fire in 1998 destroyed the house, most of the family's possessions, and 75 percent of the holiday decorations. Fellow workers at the Downers Grove Post Office, who knew of Bob's loss, acquired enough decorations from people on their routes to restore his display. When the house was rebuilt, Bob made the best of the situation and had the attic enlarged and more electrical service and outdoor outlets added to accommodate the decorations.

He continues to add to the display with a new look every year and explains with a familiar air, "I do this mostly for kids . . . and maybe me too." Among his decorations are those that were spared in the fire, including some of his dad's original figures and thirteen-piece manger scene.
Dec. 6–Jan. 6, (M–Th) 6:00PM–11:00PM, (F–Su) 5:00PM–11:00PM. *From Lemont Rd./State St., W on Illinois St. 1 bl., N on Lockport St. 1 bl., W on New Ave. ½ mi.*

OAK LAWN

9 TOWN DECORATIONS

Among over three hundred trees destroyed in a violent windstorm that struck Oak Lawn in October 2006 was a 45-foot blue spruce at the corner of 95th Street and Cook Avenue—the town's official Christmas tree. In a tradition begun in 1978, the mayor's flip of the switch to light the magnificent tree had signaled the start of the holiday season. Though village workers were swamped with cleanup after the storm, Director of Business Operations Chad Weiler made replacement of the treasured tree before the holidays a top priority.

Although the new tree will take some time to reach the grand size of the original, its fainter glow will likely go unnoticed, for the town of Oak Lawn gleams brighter every year thanks to the efforts of Chad, Street Division Supervisor Jerry "Chick" Chickerillo, and their crew. "A lot of the guys here are huge on Christmas, including me," Chick says. "So I can send them out to decorate, and I know they'll do a great job." Using over 300,000 lights, the men trim not only every tree and lamppost in the Village Green, but all the trees downtown as well. Chad, a former employee of the well-decorated Butch McGuire's (see page 44) and former owner and decorator of Cork and Kerry Tavern in Chicago, contributes his unique creativity with an assortment of holiday antiques and wintry scenes at the town train station and fanciful lighting effects at Village Hall and the New England Avenue berm.

At season's end, the workers pack away all the holiday decorations, except for the lights, which spread their magic once again at the Village Green for a series of summer concerts and a festival in the fall.
Wed. before Thanksgiving–New Year's, Dusk–dawn.
95th St. between 51st Ave. and 69th Ct.

ORLAND HILLS

10 9337 170TH PLACE

When Valerie Porter was planning her wedding, she told her father she hoped to walk under an arch at the reception. And much to her joy, there it was on her big day, trimming the entryway and glowing with white lights. "Does it look familiar?" her dad coaxed. She suddenly realized it was one of the arches that decorate the driveway at Christmastime.

Leave it to John Porter to be resourceful. Since Valerie and her four siblings were little, John and his wife, Mary, have been decorating their home for their children with Christmas decorations they've imaginatively fashioned from plywood, cardboard boxes, garbage bags, their kids' old toys, and whatever else they could come up with that wouldn't break the bank.

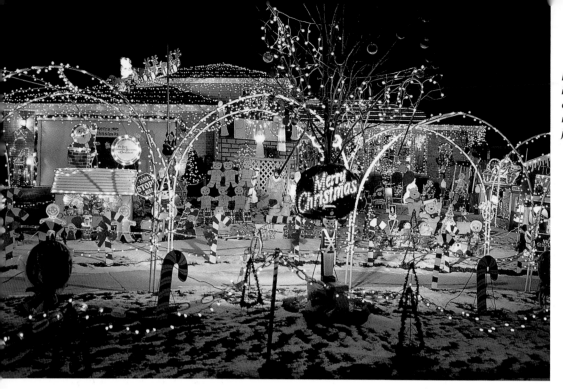

Homemade trimmings, including the Porter family crafted in gingerbread, reflect the loving spirit of this joyful household.

Their front yard now brims with homemade creations. The rooftop twinkles with lights. And the driveway glistens with an arch that's attended a wedding reception. **Dec. 15 – Jan. 9, 6:00PM–10:30PM.** *From 171st St., N on 94th Ave. 1 bl, E on 169th St. 1 bl., S on Hobart Ave. 2 bl., E on 170th Pl.*

PALOS HILLS

11 820 WEST 107TH STREET

Shirley and Dean Diaz annually defer the outdoor Christmas decorating to their teenage son Nick with one simple imperative, "Don't burn down the house." Though the couple and their younger son, Robert, may help carry the decorations to the front lawn, they fully trust the rest of the operation to their oldest boy, who has been helping decorate the house since he was a toddler.

The happy arrangement began in 1992, when Shirley's sister, Beverly, bought plastic lighted figures of Mr. and Mrs. Claus and a snowman to celebrate her new nephew's first Christmas. Each holiday season thereafter, Auntie Bev, who lived on the third floor of the family's two-flat, would take little Nick to the store to buy something new to add to the display, and together they would put up the trimmings.

By the time Nick was seven years old, Auntie Bev relinquished all the worn and half-broken items to her anxious little nephew so he could decorate the backyard on his own. Nick excitedly hung lights on his treehouse, set two nutcrackers and a one-eyed angel in his yard, and ran the extension cord through his window so he could turn the lights on and off from his bedroom. Each Christmas season, as he got older and his aunt bought

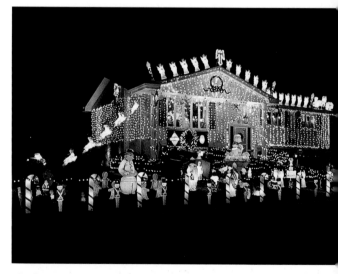

The home of Dorothy and Ed Albrecht at 86th Avenue and 135th Street was an Orland Park favorite from 1972 to 1993. Into his seventies, Ed trimmed the house four and a half hours a day for two months and borrowed electricity from both his neighbors to create the dazzling display, which was dedicated to the memory of their son Ronald.

more decorations, he was given more responsibilities in the front yard and more decorations for the back.

Nick's interest in lights never faded. When his aunt sadly passed away in 2005, he discontinued his backyard display and moved all the decorations to the front of the house. The following year he began computerizing the lights to music. As a sophomore he became the theatrical lighting crew head at Amos Alanzo Stagg High School and has aspirations to become a theatrical lighting designer. Auntie Bev would likely be proud to know that the simple annual holiday tradition she shared with her nephew may lead to a lifelong ambition.

Thanksgiving–2nd weekend of Jan. Computerized show: (M–Th) 5:00PM–9:00PM, (F–Su) –10:00PM. Lights only: –12:00AM. www.nickslights.com. *From Roberts Rd., W on 107th St. 1 bl.*

SAUK VILLAGE

12 1951 219TH PLACE

It's an annual holiday tradition in Sauk Village to kick off the season with Santa Claus riding up and down every street in town in a fire truck as he waves and sounds the horn. It is also an annual holiday tradition of the Machielson family of Sauk Village to light up their elaborate Christmas display for the first time each season as Santa passes by.

Thomas and Darlene Machielson and their two children, Allen and Debra, also made a tradition of decorating the house as a family project since they first moved into their home in 1976. Though the home was simply trimmed with lights the first two years, it was inevitable that Thomas, a steelworker good with his hands, would start making his own decorations, especially with young Allen eager to help.

The father and son established their own tradition of constructing something new every year. They first built a series of toy soldiers of their original design from plywood—some with blonde hair, some brown, some with mustaches and some without. The following year they went three-dimensional with the "Christmas Express," an old-fashioned engine, freight car, and little red caboose. As seasons passed, the family's corner lot was filled with a snowman family, candy canes, a bi-plane, a manger scene, Santa in a Christmas house, and a bright yellow Model A.

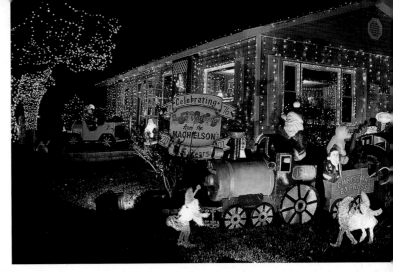

The Machielson family's yard is filled with a delightful assortment of original homemade creations.

It was Debra's annual task to help with the setup, and Darlene, who is pretty handy herself, was in charge of repairing the lights, hanging them on the house, and keeping the peace. Throughout the holidays when folks gathered out front, Thomas also enjoyed donning his Santa hat and greeting them with free candy canes.

Though Thomas has sadly passed away, the Machielson family continues their annual tradition of coming together over the Thanksgiving weekend to decorate the house for Christmas. And when Santa passes their home, in homage to Thomas, a familiar-looking figure in a Santa hat appears to be waving right back from the Model A. **Dec. 3–New Year's, 4:00PM–10:00PM.** *From Torrence Ave., W on Sauk Trail ½ mi., N on Merrill Ave. 1 bl., E on 219th Pl.*

SOUTH CHICAGO HEIGHTS

13 3332 LYNWOOD DRIVE

One Christmas season when Ed Kaminski was shopping with his wife, Becky, he spotted a life-size animated Santa Claus that waved, spoke, and sang Christmas carols. "No, we can't afford this," Becky announced, seeing the want in her husband's eyes. When the couple arrived home, Becky sneakily telephoned their son, Joe, with her credit card number and suggested he buy the Santa for his dad as an early Christmas present.

Buying decorations for Ed has been a habit of his family and friends long before Joe was born. Ed started the trend himself at ten years old when he used his earnings

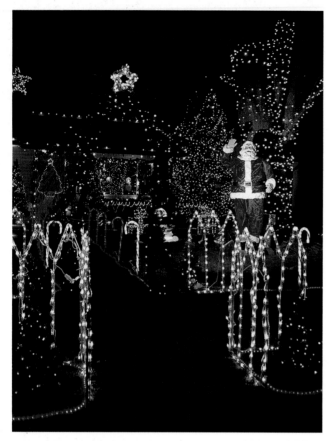

Santa Claus appears in a new location each holiday season in Ed Kaminski's ever-changing display.

Currently an officer with the Sons of the American Legion, Bill also has a son in the National Guard.

He built the flag in 1991 to commemorate the men and women serving in Operation Desert Storm and has displayed it every year since by popular demand of his neighbors. Though Bill's Old Glory is made of wood, lighted stars, and rope lights, it seems to garner the same reverence as the real thing. During a power outage one season that darkened the neighborhood, Bill's flag alone remained lit. His patriotic neighbor had hooked it up to a generator saying, "We can't let the flag go out."

Dec. 1–New Year's, 4:30PM–12:30AM. *From Chicago Rd. (Rt. 1), W on Sauk Trail 2 bl., N on Miller Ave. 7 bl.*

SOUTH HOLLAND

15 16912 MANOR DRIVE

"Christmas decorations are like flowers in the summertime," professes Kesha Marshall. So it's no surprise that her lawn, front and back, sprouts a display around the holidays that makes her house the brightest in the neighborhood.

In one of the few homes where the lady of the house takes charge of the decorating, both inside and out, Kesha still relies on the help of her three children, Walter, James, and Diamond, and her husband, Walter, to complete the task.

from delivering papers and shoveling snow to buy a strand of lights to decorate his family's home. Year after year he purchased more lights for his display and one year even saved enough to buy a plastic manger scene from Sears. "I always looked forward to Christmas," Ed explains. "I loved the old smell when you opened a box of ornaments from the attic. I still do."

He continues to enjoy decorating and adding to his collection every year, and his grandchildren are never at a loss for what to buy Papa.

Dec. 1–New Year's, 4:30PM–10:00PM. *From Chicago Rd., W on Sauk Trail 4 bl., S on Lynwood Dr. 1½ bl.*

14 2805 MILLER AVENUE

The 8' x 16' homemade lighted flag displayed during the holidays on Bill Pillman's garage shines brightly for good reason—since his grandfather and great grandfather first served in World War I, members of his family have been in the military service during every major U.S. conflict.

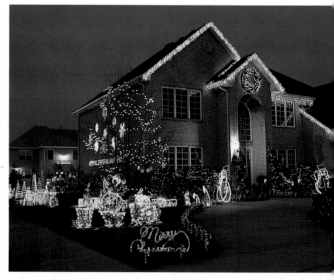

Like a cheery Christmas card, the most brilliantly lit home in the Covington Cove subdivision wishes "Happy Holidays from the Marshalls" to all who pass.

The whole family helps move the decorations from a rented storage space to the garage, where Kesha sorts out new items and those from years past. While the boys are stringing lights on the trees and the bushes, Kesha places the lighted figures in position, and Walter helps stake them in place. Diamond, who is only a toddler, stands by and just enjoys it all.

Dec. 3–New Year's, Dusk–12:00AM. *From Torrence Ave., W on 170th Ave. ½ mi., N on Merrill Ave. 1 bl., W on 169th Pl. 3 bl., N on Manor Dr.*

16 16428 WOODLAWN EAST AVENUE

In the 1940s, a homemade plywood sleigh and reindeer placed on the roof and multicolored 25-watt bulbs hung from the eaves created a Christmas spectacle. Such were the trimmings in the south-side Hegewisch neighborhood of butcher Frank Raczek, whose popular holiday display at 135th and Burley attracted crowds for decades.

After Frank passed away in 1965, his son Ken, a Catholic priest at an Indiana parish, spent Thanksgiving week for several years decorating the house to carry on his dad's tradition and cheer his mom. Though he no longer trimmed the roofline, he continued to make the display a popular destination by lighting two huge spruce trees, building a wooden manger, and purchasing life-size nativity figures from a church supply store.

Ken's sister, Mary Jane, who lived nearby with her husband Richard Draus, would bring their son, Ken, to visit Grandma and Uncle Ken. By the age of three, little Ken was already helping his uncle put up the display. Throughout grammar school, he continued to help every day during the Thanksgiving season while waiting for his dad to pick him up from Grandma's after school. When Uncle Ken tired of the trimming in the mid-1970s, little Ken and his dad took over the annual task until Ken graduated from high school in 1984.

In 1974, Mary Jane persuaded Richard to decorate their home for the holidays as well. Ken joined the effort a few years later but eventually took over when he turned pro. As it seems he was destined to do, Ken persuaded Dave Wietecha, while decorating River Oaks Mall, to hire him on as seasonal help at Decorations Unlimited, a professional decorating company. Conceding, yet unconvinced the young man was up to the task, Dave

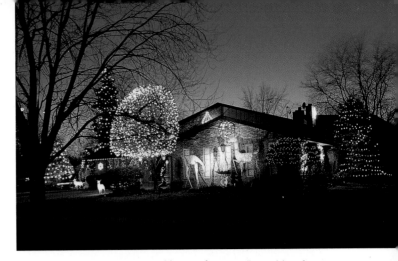

"There's a certain way my son likes to decorate," says Mary Jane Draus of her home's elegant display. "So I say to my husband, 'Richard, just stay in the house and let Kenny be in charge.'"

assigned Ken the tedious job of wrapping eighty concrete columns with red plastic. The surprisingly adept lad completed the job meticulously in one-third the normal time. Within a week Ken was placed in charge of tree lighting and at the end of the season offered full-time employment in his dream job.

Through years of trimming major shopping centers and thoroughfares, Ken not only honed his skill as a decorator and eventual licensed electrician but acquired discarded items and made valuable contacts for future finds to add to his parents' display.

Amidst the professionally lit trees, trimmed with commercial grade lights, that adorn the Draus's yard, the 15-foot tree on the side of the house was originally displayed at Sunset Foods in Northbrook, the 6-foot red ornament hanging from the garage had hung from a lamppost in Pottsville, Pennsylvania, and a pair of life-size golden deer in the front lawn once trimmed Oakbrook Mall. Ken admits, however, that the Grecian statue holding a holiday candle and crowned with a holly wreath is his mom's doing. "I like to dress her up and put little red bows in her hair," Mary Jane says. "That's a lady's thing."

Sun. after Thanksgiving–Jan. 6, 4:30PM–11:00PM. *From Bishop Ford Fwy. (I-94), W on 159th St. (162nd St.) 1 bl., S on Woodlawn East Ave. 1½ bl.*

17 639 EAST 158TH STREET
(SEE 16428 WOODLAWN EAST AVENUE)

With a house of his own, two barns for storage, and a 2-acre wooded lot, it's certain licensed electrician and part-time

Salvaged commercial lamppost trimmings maintain the nostalgic glow of Ken Draus's one-of-a-kind display.

professional Christmas decorator Ken Draus will continue to add to his eye-catching display in the years ahead. "Oh, it's going to be huge," Ken predicts.

Dec. 1–Jan. 6, 4:30PM–11:00PM. *From Bishop Ford Fwy. (I-94), W on 159th St. (162nd St.) 4 bl., N on Cottage Grove Ave. 6 bl., W on 158th St. 2 bl.*

TINLEY PARK (ALSO SEE WILL COUNTY)

18 17321 AVON LANE

Donna Kowalczyk had to suspect that her son Dominic might one day fill the front yard with Christmas decorations. By seven years old, he was already decking his bedroom in hundreds of lights and a full-size tree and covering his entire floor with cotton snow, all of which he purchased with his own money. "Our close friends, the Kuliks (see page 119) and the Albrechts (see page 114), both had elaborate Christmas displays," Donna says. "I'm sure that's where he got this from."

So it came to be that at the age of twelve, Dominic Kowalczyk was the youngest recipient ever awarded a prize in the Tinley Park holiday decorating contest.

The following year the award-winning seventh grader expanded his decorations onto the roof where he created a giant star, candy cane, Christmas tree, and holiday greeting formed in lights. "I wasn't too crazy about the

staples in the shingles," Donna concedes, "But, oh well."

Soon thereafter, Dominic made his first wooden decoration from a catalog pattern at the suggestion of his mom, an avid woodworker. Upon honing his skills in woodshop class, he subsequently ordered every Christmas pattern the company had to offer. With the help of his mom, who painted all the decorations, he has now built over seventy wooden figures from patterns, original ideas, or woodworking magazines. He has also constructed thirty wooden presents to disguise his floodlights, eight illuminated fiberglass stars, a 1,000-pound display case that houses ten animated figures, an arch over the driveway, and a picket fence that spans the perimeter of the lawn.

The talented high-school student not only inherited his mother's skills as a woodworker but the Albrechts' entire display. Locally famous for their brilliant decorations at 86th Avenue and 135th Street, the Orland Park family had wanted to leave their display to someone who would carry on their tradition. Dominic certainly fit the bill. He now had thirty angels, twenty gingerbread men, and twenty toy soldiers to add to his collection.

As a college student, the enthusiastic young man continued to assemble his ever-growing display despite having only five days to set it up during Thanksgiving break. To achieve the task, he worked twelve hours a day, regardless of the weather, with the assistance of his mom, his girlfriend, his brother Kyle, members of the high-school

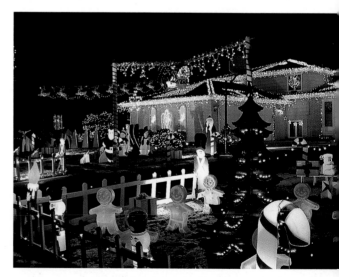

Homemade wooden decorations and plastic figurines inherited from a famous Orland Park display light up the Kowalczyk home.

football team, who lifted the display case, and his ninety-year-old grandmother, who checked the lights.

Having recently graduated with a degree in construction management with plans to start his own construction company, this skilled young man looks forward to having the time and resources to continue improving the display that he started as a child. "I think I'll make some penguins next," Dominic says, "'cause my mom likes them."

Sun. after Thanksgiving–Jan. 2, 5:00PM–10:45PM.
From Harlem Ave., W on 159th St. 2 mi., S on 88th Ave. 1 ½ mi., E on Raintree Rd. 1 bl., N on Avon Ln.

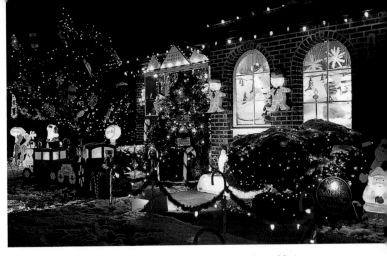

Animated holiday dioramas disguise the front porch and living-room window at the Kulik home.

19 17331 SOUTH OSCEOLA AVENUE

Ed and Lori Kulik have won a prize every year since the Tinley Park decorating contest began in 1989. And if a special award was given for "Best Use of a Front Porch," it would certainly be theirs as well.

Normally, the Kuliks' brick portico has an arched entryway with two matching window wells, but during the holidays Ed transforms it into a delightful snow scene. He fills in the bottom half of the doorway with a decorated wooden partition and hangs divided window panes trimmed with lights in each archway. The enclosed area provides ample space for the fun-filled display of skiing, skating, parachuting, and tobogganing snowmen. As general manager for a major Chicago food retailer, Ed was able to acquire the figures, some originally 1970s "Strohsmen," from outdated point-of-purchase displays.

The large window in the front of the house is also cleverly disguised. A homemade shadow box of Santa's workshop is bolted to the exterior frame. Santa checks his list, and busy elves hammer and paint, while the Kuliks' living room remains undisturbed.

Ed has been a busy little elf himself, building these and many of his other decorations. His three-dimensional "Christmas Express" train, the gingerbread mailbox, the candy tree, and the reindeer are all his handiwork.

During a recent visit to Michigan, Ed and Lori were speaking to a stranger who, upon learning they lived in Tinley Park, asked if they were near "that house that decorates so well for Christmas." They were thrilled to discover the woman was referring to their home.

Dec. 1–Jan. 6, Dusk–11:00PM. *From Harlem Ave., W on 171st St. ½ mi., S on Oriole Ave. 1 bl., E on 173rd Pl. 1 bl.*

20 16423 SOUTH PARLIAMENT AVENUE

"We always decorated an average amount. Then I made two dozen candy canes, and it mushroomed from there." In what sounds like a statement at a meeting of Christmas Decorators Anonymous, Rick Esposito describes the beginnings of his addiction to trimming his home. "I enjoy the lights, the colors, and the fantasy of it all," he explains.

After only a few years, his holiday habit already resulted in one of the most elaborate displays in town. In addition to the original twenty-four candy canes, dozens of toy soldiers now line a front yard brimming with over ninety illuminated figurines, dozens of homemade creations, and nearly 15,000 lights.

Throughout the year, Rick is on the lookout for items to add to his display. Discarded stage props in a dumpster were one lucky find. He used them to build guardhouses for his nutcrackers.

HIDDEN FLOODLIGHTS

Dominic Kowalczyk of Tinley Park builds six-sided boxes from 1' x 1' squares of ½-inch plywood fastened together with L-brackets. He paints each box to look like a present tied with a ribbon and fastens a waterproof bow to the top. One box is then placed over each floodlight with the open sides at the bottom and back so only a lovely wrapped present emitting a mysterious light can be seen from the front of the display.

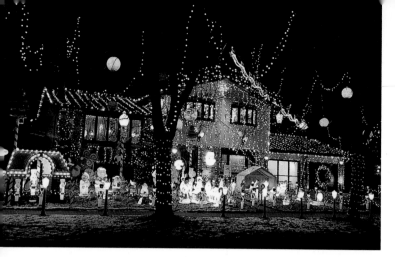

An animated "Christmas Sky Ride," a push-button train exhibit, and a workshop with infinite elves are some of the highlights of the fun-filled Esposito display.

The special attention of restauranteurs Bill and Rebecca Courtright, the fine American cuisine of acclaimed Chef Jonathan Harootunian, and 50,000 sparkling lights make a visit to this south-side establishment a memorable holiday treat.

A professional carpenter, he spends a good deal of time perfecting his decorating techniques. The lights that stripe the front of the house are wound around brass hooks in the wood trim and stainless steel screws that are permanently installed in 3/16-inch plastic plugs in the brickwork. Those on the roof are attached with homemade metal clips that slip under the shingles. Santa and his nine reindeer are suspended from an 8-foot steel structure bolted to the roof. A pulley system allows Rick to attach Santa's team one at a time before hoisting them skyward.

While Rick is credited with decorating the outside of the house, his wife, Cindy, adds to the display by creating a four-tiered snow village of over two dozen miniature buildings in the family room window.

She has also begun to exhibit her husband's zeal by carrying not only pictures of their four children and two grandchildren in her wallet but a photo of their holiday display as well. Christmas addiction is obviously contagious.

Thanksgiving–New Year's, (Su–Th) 5:00PM–10:30PM, (F–S) –12:00AM. *From 171st St., N on 80th Ave. ¾mi., E on Nottingham Rd. 3 bl., N on Parliament Ave. ½ bl.*

AN UNUSUAL PHOTO-OP

As is the custom with many families, the Espositos of Tinley Park do not put the statue of Baby Jesus in the manger until Christmas Day. Cindy was surprised one evening to find a woman taking a picture of her infant in the straw-filled crib.

WILLOW SPRINGS

21 COURTRIGHT'S RESTAURANT
8989 ARCHER AVENUE

A four-star restaurant in a tranquil woodland setting, Courtright's provides the perfect ambiance for any special occasion. But at Christmastime the soft lights, classic furnishings, crackling fireplace, and whimsical decorations make the dining room feel as comforting as a hug from Mrs. Claus, while through wide arched windows the stunning backdrop of a glistening gazebo nestled amidst a forest of lights provides a panorama as picturesque as a holiday lithograph by Courier and Ives. And whether also fortunate enough to witness the quiet of a fresh-fallen snow or the beauty of a delicate fawn posing in the forest, diners sipping a special Christmas coffee, feasting on sumptuous braised venison, or desserting on an eggnog crème brûlée are sure to experience a Christmas memory that will last a lifetime.

Christmas display: Thanksgiving–end of Feb. Dinner hours: (Tu–Th) 5:00PM–9:00PM, (F–Sa) –10:00PM, (Su) 4:00PM–8:00PM. Lunch hours (Dec. only): (Tu–F) 11:30AM–2:00PM. Closed Christmas and New Year's. Available for parties. (708)839-8000. www.courtrights.com. *From Stevenson Expwy. (I-55), S on La Grange Rd. 1 ½ mi., W on Archer Ave. 2 mi.*

Opposite page: A real lighted Christmas tree and a plastic Santa Claus gleam year-round high above H. J. Mohr & Sons Company in Oak Park (p. 125).

CHAPTER 7
Cook County~West

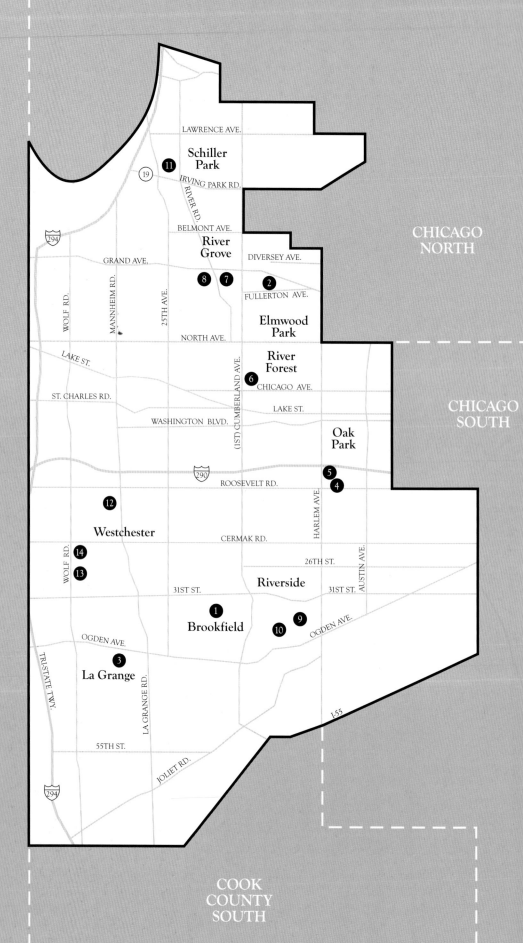

LAWRENCE AVE.

Schiller Park

⑪

⑲ IRVING PARK RD.

RIVER RD.

BELMONT AVE.

I-294

River Grove

GRAND AVE.

DIVERSEY AVE.

⑧ ⑦ ② FULLERTON AVE.

WOLF RD.

MANNHEIM RD.

25TH AVE.

NORTH AVE.

Elmwood Park

LAKE ST.

River Forest

ST. CHARLES RD.

(1ST) CUMBERLAND AVE.

⑥ CHICAGO AVE.

LAKE ST.

WASHINGTON BLVD.

Oak Park

I-290

⑤ ROOSEVELT RD.

④

HARLEM AVE.

⑫

Westchester

CERMAK RD.

WOLF RD.

AUSTIN AVE.

26TH ST.

⑭

⑬

31ST ST.

Riverside

31ST ST.

① ⑨

OGDEN AVE.

Brookfield

⑩

TRI-STATE TWY.

OGDEN AVE.

③

La Grange

LA GRANGE RD.

55TH ST.

I-55

JOLIET RD.

I-294

CHICAGO NORTH

DUPAGE COUNTY

CHICAGO SOUTH

COOK COUNTY SOUTH

Cook County West

N
W · E
S

0 MILES 2

BROOKFIELD

1 BROOKFIELD ZOO
1ST AVENUE AND 31ST STREET

It's a unique nighttime thrill for kids, adults, and animals alike when Brookfield Zoo opens its gates on select December evenings for "Holiday Magic." The park comes alive with nearly one million lights that sparkle along the zoo's winding paths, leading visitors to a variety of fun-filled surprises. Four hundred trees decorated by local groups add to the glitter along with crowd-pleasing theatrical lighting, sometimes including a laser show.

Though many of the animals appear in their outdoor settings, guests may also visit alligators, anteaters, elephants, and other exotic creatures in indoor habitats that are open various evenings throughout the event. Santa and Mrs. Claus, Brookfield Zoo Bear, and other costumed animal characters are on hand to greet children along the way, while an old-fashioned carousel offers a playful twirl.

Special events include an opening ceremony, ice sculpture demonstrations, "Sing to the Animals," magicians, celebrity storytellers, and local entertainers. Zoo restaurants and concession stands offer hot beverages and food, and the gift shops are open for holiday shopping. **Dates vary annually, 4:00PM–9:00PM. Admission and parking fees. Special package rates available at some area hotels. (708)688-8000. www.brookfieldzoo.org.** *From Eisenhower Expwy. (I-290), S on 1st Ave. 2 mi., W on 31st St.*

ELMWOOD PARK

2 ELMWOOD PARK WATER TOWER

In a tradition started in the late sixties by then electrical superintendent John Litrenta Sr., the Elmwood Park Water Tower is an annual beacon of holiday cheer. Covered with nearly 2,500 C-9 bulbs, the tower is visible from miles away and is often used as a landmark by airline pilots.

Two to three men spend a full day stretching heavy steel cables, prestrung with lights, from a ring at the top of the 220-foot tower to the rail surrounding the tank. The cables are then tightened with turnbuckles to prevent damage in heavy winds. The crew returns a few days before Christmas to perfect the lights for their crowning day.

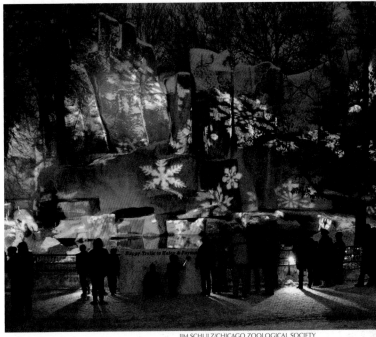

Dramatic theatrical lighting on outdoor animal habitats adds to the wonder of "Holiday Magic" at Brookfield Zoo.

In the midseventies, the public works facility beneath the water tower was destroyed by fire, along with all the Christmas decorations. The tower remained dark until 1987 when the Elmwood Park Fourth of July Committee offered to fund the lighting and restore the town tradition. The huge dome of the tower has glistened every holiday season since without a glitch, except for the year when the lights were rigged with a chasing mechanism that gave the appearance the dome was spinning—the unfamiliar effect resulted in a rash of UFO sightings. **Sun. after Thanksgiving–Jan. 6, Dusk–dawn.** *From Harlem Ave., W on Grand Ave. 4 bl.*

LA GRANGE

3 138 NORTH KENSINGTON AVENUE

Tom Tangney, though a very handy man, does not consider himself to be particularly creative. However, one holiday season when he was hanging lights on the face of his A-frame house in what he had intended to be a giant green triangle, he suddenly realized that if he curved in the sides he could make a big Christmas tree. "It wasn't a real brain trust," he admits. Intending to continue this

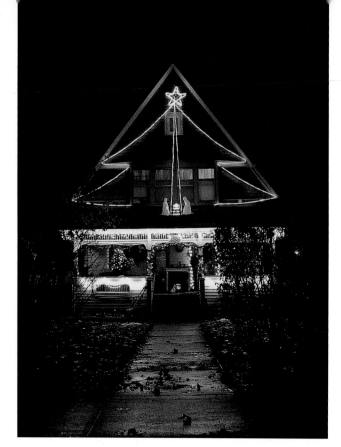

Visitors are welcome to walk up the steps for a closer look at the Tangneys' Christmas village, but don't be fooled into thinking you can warm up by the porch fireplace . . . it isn't real.

stroke of imaginative genius, he put his mechanical juices to work perfecting his technique by the second season.

He now connects green and white light strands and a 4-foot star to a T-shaped fitting at the end of two connected 12-foot lengths of galvanized steel pipe. His wife, Judy, who is positioned in the attic window, drops down a rope he then ties beneath the star. After leaning the pipe against his house, he climbs onto the porch roof and pulls the pipe up, while Judy guides the top with the rope. Once the bottom of the pipe reaches the roof, he slides the end into a hole he has drilled in a block of wood permanently affixed to the shingles. Judy secures the rope inside the attic. Then Tom creates the tree branches by attaching the green lights strands to six reachable hooks that are permanently screwed into the house.

At the base of the tree, Tom also adds a rooftop manger scene. With the pieces screwed to a sheet of plywood, the display is easily placed on the roof and secured with wires and hooks to the windowsill. Tom creates "rays" of light by attaching the white strands from the star to the top of the manger scene. All the lights are then plugged into a power strip that is wired through a small plastic storage box, sealed with tape, and left on the roof. "I can put the whole tree up in fifteen minutes," Tom boasts, "but it takes me six to eight hours to hang the lights on the porch."

He also spends at least ten hours adorning the front yard with an assortment of decorations that change every few years to suit his fancy—behind his simple Christmas tree is an attic packed with trimmings he's been buying at garage sales for years.

Fri. after Thanksgiving–Jan. 6, Dusk–12:00AM.
From La Grange Rd., W on Ogden Ave. ¼ mi., S on Kensington Ave.

OAK PARK

4 1178 AND 1182 SOUTH HOME AVENUE

Though raising a family of ten children left little disposable income for Clara and Charles White, Charles saw to it that their home was decorated inside and out for the holiday he held so dear. With trimmings that included an animated life-size Santa and a loudspeaker that broadcast Christmas music from a record player connected through the mail slot, the family's home on South Scoville Avenue became a popular holiday destination in Oak Park. "I always got so excited when Christmas was coming," recalls Eugene, the couple's fifth eldest son. "As soon as we were old enough, we all helped. I remember untangling all the lights."

Though Charles passed away many years ago, the joy he shared at Christmas with his family and neighbors lives on—his children and grandchildren continue to decorate the family home, his son Ron decorates his house two doors down, and sons Eugene and Michael create a holiday spectacle with adjacent houses on Home Avenue a few blocks away.

Eugene's display features a mechanical hot-air balloon, skating penguins in the window, and vintage Christmas music. Michael's decorations include Disney animation, handmade dog luminarias, and a mailbox for Santa. With lights galore and like archways over the sidewalks, the pair of homes are easily spotted from Roosevelt Road or the grocery store across the street. Though the brothers do not compete, their adjacent displays seem to account for their ever-growing brilliance. "He got more, I got more. I got more, he got more," explains Michael.

Santa hands out candy canes from 6:00 p.m. to 9:00 p.m. the weekend before Christmas and tries to spend equal time in front of each brother's house.

Dec. 1–New Year's, 5:30PM–10:00PM. *From Harlem Ave., E on Roosevelt Rd. 4 bl., N on Home Ave. ¼ bl.*

5 H. J. MOHR & SONS COMPANY
915 SOUTH MAPLE AVENUE

"Oh, you're the company with the Santa Claus and Christmas tree!" new clients reply upon learning the location of H. J. Mohr & Sons Company, a ready-mix concrete supplier. Suspended over 115 feet in the air and easily visible from the Eisenhower Expressway, the year-round holiday decorations have become an Oak Park landmark.

The life-size plastic Santa and 10-foot live evergreen decorated with old-fashioned Christmas lights first appeared in 1957 when, as a holiday lark, young Henry "Bud" Mohr climbed the ladder beside the giant cement hopper, ascended the radio tower, and secured the decorations that became an instant hit with passersby.

When the holidays were over, Bud's dad, who owned the company, repeatedly asked his son, "When are you going to take them down?" To which his son repeatedly replied, "Tomorrow." When Santa and the tree remained up through the winter, spring, summer, and fall and into the next holiday season, it became apparent that Santa and the tree were to become as much a part of the company's tradition as the Mohr family themselves, who have operated the business since 1893.

BEAGLE LUMINARIA

Two plastic gallon milk bottles never looked more adorable than on the Oak Park lawn of Barbara White, who turns them into luminarias cute enough to hug. She first cuts a round hole the size of the lid on the side opposite the handle of the first bottle. She then inserts the mouth of a second bottle into the hole, with the second handle facing the same direction as the bottom of the first bottle, and hot glues the mouth in position. To complete the head, she paints the bottle cap black for a nose, inserts craft eyes, and hot glues ears, a scarf, and a hat made from felt. She then cuts a small "X" in the back of the body, fills the bottle part way with sand, and pokes a bulb from a C-9 strand in the "X."

Year-round, Dusk–dawn. *From Eisenhower Expwy. (I-290), S on Harlem Ave. 1 bl., E on Garfield St.1 bl. See photograph on p. 121.*

RIVER FOREST

6 822 KEYSTONE AVENUE

Chuck Race has enjoyed drawing and painting since he was a kid. But, other than a possible doodle during a phone conversation, his current occupation as a bank examiner provides little occasion to practice his craft. So when

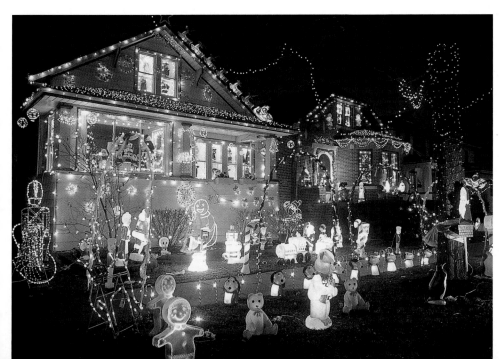

Window animation and lighted arches invite viewers to take a holiday stroll down Home Avenue in Oak Park. (John Scott)

Chuck's wife, Terri, suggested nearly twenty years ago that he paint holiday figures for the front lawn at Christmastime, it didn't take much arm-twisting to set him to the task.

Using an overhead projector, Chuck traced popular cartoon characters onto ¾-inch plywood. After cutting out the figures with a scroll saw, he applied a white base coat to both sides. He then painted the figures, carefully mixing the colors to match the original hues, though often adding a red or green accent to suit the occasion. He weatherized the figures with two coats of varnish and secured them to the ground with a 2x4 hinged from the top of each figure and two pointed wooden stakes at each base. Terri then lent a hand illuminating the figures with spotlights because, as Chuck describes, "She's the 'techie' in the family."

Over the years, Chuck has annually added new figures of whatever is most popular with kids at the time. His four children and their friends have also taken turns helping with the painting, as recorded on the backs of the figures with their dates and names. The family's 75-foot lot is filled with their efforts—colorful cartoon characters in Santa hats and holiday vests opening presents, singing carols, decorating a Christmas tree, and flying though the air.

With his children now grown and no longer helping with the display, Chuck decided in 2006 that, although he would continue to put up the decorations, he would no longer create new figures. Much to his surprise, several of his neighbors, who apparently anticipate the new additions, gave him a "gentle ribbing." Whether he gets help or not, Chuck now plans to continue adding a new figure every year.

Sun. after Thanksgiving–Jan. 15, 5:00PM–11:00PM.
From Harlem Ave., W on Chicago Ave. 1 mi., N on Keystone Ave. ¼ bl.

RIVER GROVE

7 RIVER FRONT PARK

During the term of Mayor Thomas Tarpey, the Village of River Grove initiated the Aesthetic Committee, a volunteer organization of city workers and residents to beautify the town with planters and holiday decorations. Though twelve people, including the mayor, volunteered

to join the group, the name was soon changed to the Beautification Committee when no one could spell "aesthetic."

With greater skills in gardening and crafts, the committee set to work decorating the Grand Avenue bridge with flower boxes for Mother's Day and homemade wooden decorations for St. Patrick's Day, Easter, Halloween, Thanksgiving, and Christmas. When Mayor Tarpey proved he had little artistic skill as well, he was deemed the group's honorary director and praised for his good intentions.

At Christmastime, the committee extended their efforts just beyond the bridge to River Front Park, where the town had erected a magnificent gazebo in 1988, only two years before. The volunteers built wooden snowmen, a huge Santa standing by his workshop, and elves that peeked from behind trees. They also turned picnic benches into elf houses and the gazebo into a carousel of reindeer.

Over the years, as the wooden figures have become worn and the more artistic members of the committee have left, the homemade decorations have been replaced by commercial lighted figures that may not be as charming, but are easier to maintain and just as este . . . I mean, aesthetic.

Wed. before Thanksgiving–Dec. 31, Dusk–12:00AM.
From River Rd., E on Grand Ave. 1 bl.

8 2640 RIVER ROAD

Joe Luce grew up across the street from Saint Maria Goretti Parish, where he attended grade school. When he was a teenager, the parish sponsored an annual summer carnival in the parking lot. Watching with fascination as the rides were being assembled, Joe asked one of the workmen if they needed any help. And to his delight, he became a member of a carnival crew at fourteen years old (if for only a day) earning a hefty fifty bucks to boot.

Working in a team of three to four men, he helped construct a merry-go-round, a Ferris wheel, a tilt-a-whirl, and bumper cars—bolting them together piece by piece like a giant puzzle. And when the carnival was over, he helped take them apart. Throughout the season he joined the crew at other carnivals nearby and was soon giving directions to other helpers in what would become his part-time job for the next four summers.

Visitors are welcome to pull in the driveway for a closer look at the Luce holiday carnival.

Years later, when Joe's future mother-in-law asked him to decorate her River Grove front yard for Christmas, he seized the opportunity to create a miniature carnival. He and his dad, Don, a retired sheet metal worker and skilled handyman, built a Ferris wheel, a double Ferris wheel, spinning swings, a merry-go-round, and a dart-throwing booth, using wood, conduit, disposable aluminum bread pans, and an assortment of his wife's dolls dressed in everything from winter coats to bikinis. Used rotisseries, acquired from garage sales, and an old treadmill that changed speeds provided inexpensive motors to make the rides spin and twirl. "We designed the rides in pieces, so they would assemble just like the full-size ones," Joe said proudly. "We can put up the whole display in one day."

Having purchased a home of his own, Joe packed up his carnival and moved it to his front lawn on River Road, where he has plans to add a ticket booth, parachutes, a sky ride, and a roller coaster . . . and may soon be in need of some carnies.

Dec. 1–Dec. 31, 5:00PM–10:00PM. *From Grand Ave., S on River Rd. ½ bl.*

RIVERSIDE

9 320 GAGE ROAD

The homes of the Allegretti family have been famous in the Galewood neighborhood at Christmastime for over fifty years. Their first house, at Newland and Wabansia avenues, not only looked like a castle but was decorated like a fairyland. Working for a florist, Marlene Allegretti was able to acquire Italian lights before they became

widely available. "She would hang out the second-floor windows and throw them into the trees," her son John recalls, "She had a pretty good arm too."

At the family's next home on Sayre Avenue, a block away, they became known as "The Christmas House" with lights galore and animated dolls in every window. When John, the second youngest of the nine children, married and moved across the street, he too put up a lively display that featured a homemade 18-foot animated Santa's workshop, making the Allegrettis' end of the block a popular holiday destination.

In 2001, John and his family moved to Riverside, where his award-winning display included his Santa's workshop, a homemade animated teeter-totter and ski slope, moose sledding down the roof, and bears decorating the house.

The animated scenes, which John mechanized with old ceiling fans, have moved to the backyard treehouse. His "classic display" now features balsam garland trimmings with old-fashioned bulbs and ornaments, and Santa and his elves still appearing in the windows.

Dec. 1–Dec. 31, Dusk–10:00PM. *From Ogden Ave., N on Harlem Ave. 2 bl., W on Olmsted Rd. 1 bl., N on Delaplaine Rd. 1 bl., W on Gage Rd. ½ bl.*

10 128 RIVERSIDE ROAD

If abstract expressionist Jackson Pollock had decorated his home for Christmas, he would likely have done so in a manner similar to Riverside resident Karen Mitchell Flam.

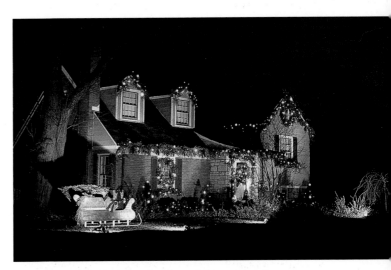

A sleigh built of old plywood and conduit is among the homemade decorations John Allegretti creates from recycled building materials.

The Flam family's front-yard tree is a glowing work of abstract holiday expressionism.

On decorating day, boxes of lights in all shapes, sizes, and colors—Italian lights, multicolored minis, C-7s, C-9s, rope lights, lighted balls, and twinkling stars—are brought out of storage, emptied on the lawn, and arranged in groups like oils on a palette. Karen's four teenagers, Ben, Kayla, Drew, and Jason, check each strand and replace burnt-out bulbs, while her husband, Larry, ponders the electrical connections.

As though preparing a canvas, the trunk and lower branches of the huge elm on the Flams' front lawn are trimmed in white lights. Then the real creativity begins—family, friends, neighbors, and an occasional passerby grab any strands of colored lights, attach them to extension

cords or other strands, and throw them onto the tree. "Kind of like throwing spaghetti on a wall," Karen chuckles.

Although she attempts to provide some artistic direction, she admits in a very Pollock-like manner, "We have very little say in how it looks. The way we throw and the way the tree grabs it makes the look." A work-in-progress, the tree changes continually throughout the season as Karen adds new purchases and moves things around. "Our tree is art," she concludes. "People who see it either laugh or shed a tear."

Nov. 30–Jan. 10, 5:00PM–11:00PM.
From Harlem Ave., W on Ogden Ave. 1 bl., N and W on Lionel 2 bl., NW on Riverside Rd. 3 bl.

SCHILLER PARK

11 4200 AND 4300 BLOCKS OF ATLANTIC AVENUE

The weekend after Thanksgiving, residents on the 4200 and 4300 blocks of Atlantic Avenue receive an annual knock on their door from neighbors Barb and John Piltaver, Frank and Wanda Mazzone, John Chrusciel, and Dennis Katz. "We're here for the soldiers," the volunteers announce. After a quick search of their basement, attic, or garage, each homeowner eagerly complies, calling to duty a 7-foot toy soldier stashed away since last Christmas season. Even Jay's Beef at the corner of Irving Park Road participates. By the end of the weekend, with the neighbors' cooperation and the volunteers' assistance, a battalion of nearly fifty soldiers in red coats and glittered caps stand squarely at attention, evenly lining both sides of the street and welcoming visitors to "Toy Soldier Lane" as they have since 1994. "My grandchildren love to look at the soldiers from the end of the block 'cause they look like they're marching in a row," says longtime Atlantic Avenue resident Claudia Irsuto.

The stalwart soldiers and a few stray lawn decorations on surrounding side streets are all that remain of an enthusiastic attempt instigated by resident Ken Glassner Jr. in 1987 to recreate the famous Candy Cane Lane–themed streets of the Schorsch Village neighborhood from the 1950s and 1960s (see page 32). At the height of Ken's effort, Schiller Park boasted ten themed streets, including lanes trimmed with homemade candy canes, snowmen, stars, candles, stockings, bells, reindeer, lollipops, holiday

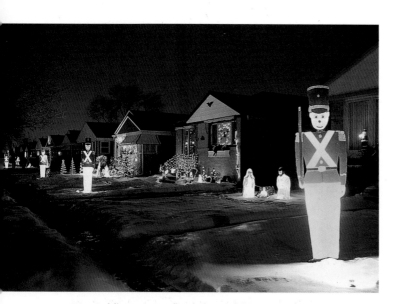

"Toy Soldier Lane" reflects the joyful community spirit of Atlantic Avenue in Schiller Park.

greetings, and toy soldiers. Although the village also supported the effort with street signs and "Santa's Reindeer Stable," it seemed the post-Depression, postwar feelings of prosperity and community spirit that contributed to the success of the original Candy Cane Lane neighborhood proved impossible to duplicate on as grand a scale.

But a spark of the past somehow continues to glimmer on two blocks of Atlantic Avenue. "When we had the painting party in my garage the first year, it began a real camaraderie," explains Barb Piltaver, who organized her street's participation in the original effort. Though some people have moved, most have left their soldiers for the new owners, and neighbor Al Hargus is happy to build new ones. "There's a lot of old-timers on this street who like the tradition and want to keep it going," Claudia adds, "but the new people want to be part of it too." Perhaps a third generation of Candy Cane Lane is yet to come.

Sun. after Thanksgiving–Sat. after New Year's, 6:00PM–9:00PM. *From 25th Ave., E on Irving Park Rd. 1 bl., N on Atlantic Ave.*

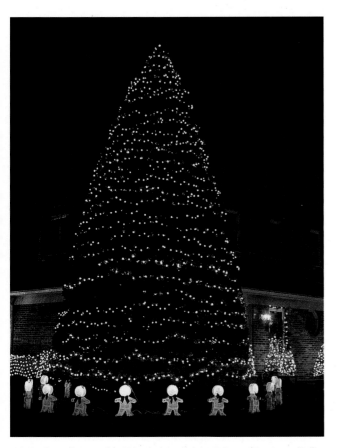

Gingerbread men play "Ring around the 35-Foot Evergreen" of longtime Concord Avenue residents Jeanine and Leon Parent.

WESTCHESTER

12 1400 AND 1500 BLOCKS OF SOUTH CONCORD AVENUE

The dozens of gingerbread men who once lined the sidewalks on Concord Avenue during the holidays in a joint neighborhood effort seem to have taken matters into their own hands. As neighbors moved away or simply stopped decorating, the gingerbread theme faced extinction. But the little gingerbread men—apparently determined to stay in the neighborhood—still appear each Christmas season not only here and there on Concord Avenue but there and here on lawns all around the block—lining sidewalks, circling trees, and mixing in with other holiday characters.

Those who visit Concord Avenue during the holidays are encouraged by the gingerbread men to drive all around the block and play a holiday game with the kiddies seeing who can spot the most of them. And while you are at it, they would appreciate if you would put in a good word by telling any homeowners you see how much you enjoy the little gingerbread men in the neighborhood.

Sat. after Thanksgiving–New Year's, 5:00PM–10:00PM. *From Cermak Rd., N on Mannheim Rd. (La Grange Rd.) ½ mi., W on Waterford Dr. 1 bl., N on Concord Ave. (then around the block)*

13 10907 KINGSTON STREET

Although Steve Buzil is Jewish, as a boy it was an annual tradition in his family (as it is with many Jewish families) to drive around and look at decorated houses on Christmas. "We used to go to Lincolnwood, and I was just enthralled," Steve admits. So when he married a Catholic girl and had two children of his own, he was more than happy to embrace his wife's tradition and delight his kids by putting up outdoor Christmas decorations.

"But . . ." Steve confesses, "I don't do things small." By the late nineties, he was already drawing crowds with unique animated lighted figures of a golfer swinging in a sand trap and galloping horses pulling a stagecoach, which he had custom-built in Indiana by Hermans' Christmasland. By 2001, so many figures had been added to the display that the excessive use of power caused Steve's electric meter to melt. He has since added a separate 200-amp service just for the outside of the house.

Somersaulting gingerbread men, a rooftop helicopter, and a 16-foot ark are among the custom-made animated displays that light the home of Steve and Wendy Buzil.

His current display not only fills his corner lot and covers his roof but spills onto the lot next door. "It's out of control," Steve laughs. "I could retire on what I've spent on extension cords alone."

Dec. 1–Jan. 15, 4:30PM–12:00AM. *From Cermak Rd., S on Wolf Rd. ½ mi., E on Lancaster ¼ mi., N on Boeger 1 bl.*

14 11041 WINDSOR DRIVE

With an artistic flair and a house that suits a modern candyland theme, homeowner Michael Chlada has created a unique holiday display that can best be described as "tastefully tasty."

Peppermint lollipops dance across the rooftop, while gingerbread cookies and sugar candies twinkle across the facade. Windows framed in red candy shutters and

A homemade merry-go-round adds to the fun at the brilliantly lit Chlada home.

DECORATING THE ROOF WITH THINGS THAT NORMALLY DON'T GO THERE

Fifteen 3-foot peppermint lollipops stand straight and secure on Michael Chlada's roof in Westchester thanks to the structure he devised that holds them there. Using enough 8-foot 1x6s to run the length of his roofline, he screwed 18-inch 2x4s at 18-inch intervals and right angles to the underside of the 1x6s, alternately extending the 2x4s above or below the 1x6 boards. He then attached pipe flanges to the top side of the 1x6s, wherever a lollipop would be positioned. After lifting the assembled bases to the roof, he screwed 3-foot sections of 1-inch galvanized pipe into each flange and attached one lollipop to each pipe with plastic cable ties. He then secured the bases every two feet with 50-pound sand bags and plugged the electric cords into extension cords.

lined with shelves of flavorful treats become miniature storefronts named after each member of the Chlada household—Michael's Cookies, Rosie's Peppermints, Gianna's Gingerbreads, and Miabella's Sweets. Some may think the stores are authentic, not only because of the professionally printed signs and the real cookies but because all the living room accessories have been replaced with Christmas items. (Visitors are welcome to peek inside.)

The Chladas' front yard is brimming with decorations as well, but all remain dark until the Friday after Thanksgiving, when family, friends, and Santa are on hand to see the house burst into glow. "My parents don't expect anything different from me," Michael confesses. "I started decorating their house when I was twelve years old." Cicero residents may remember the elaborate display at the corner of 38th Street and Austin Boulevard.

Fri. after Thanksgiving–Jan. 6, 5:00PM–10:00PM. *From Cermak Rd. (22nd St.), S on Wolf Rd. 2 bl., E on Windsor Dr. 1½ bl.*

Opposite page: A front-porch backdrop painted in oil by Lou Eliou is among the unique decorations worth stopping to see at the Hennessy home in Naperville (p. 139).

CHAPTER 8
DuPage County

COOK COUNTY
NORTHWEST

STEARNS RD.

THORNDALE AVE.

IRVING PARK RD.

72

WOODDALE RD.

BARTLETT RD.

GARY AVE.

20

BLOOMINGDALE RD.

LAKE ST.

I-290

Wayne

14

ARMY TRAIL RD.

1

Bensenville

2

YORK RD.

GRAND AVE.

64

FAIROAKS RD.

Glendale
Heights

6

GLEN ELLYN RD.

VETERANS MEMORIAL TWY.

5

NORTH AVE.

ST. CHARLES RD.

ST. CHARLES AVE.

KANE
COUNTY

GENEVA RD.

COUNTY FARM RD.

16

Wheaton

WESTMORE AVE.

MAIN ST.

Elmhurst

MADISON ST.

38

ROOSEVELT RD.

Oak Brook

88

59

12

31ST ST.

BATAVIA RD.

56

BUTTERFIELD RD.

I-355

13

83

COO
COU
W

REAGAN MEMORIAL TWY.

88

MILL RD.

OGDEN AVE.

7

Lisle

Westmont

15

55TH ST.

WASHINGTON ST.

9

CHICAGO AVE.

Downers
Grove

MAIN ST.

8

10

3

63RD ST.

CASS AVE.

AURORA AVE.

Naperville

4

11

HOBSON RD.

75TH ST.

Woodridge

LEMONT RD.

53

17

55

DuPage
County

N

W ✦ E

S

WILL
COUNTY

COOK
COUNTY
SOUTH

0 MILES 4

BENSENVILLE

1 MAIN STREET AT CHURCH ROAD

The holiday lights that trim the old locomotive across the street from the Bensenville Police Station attract deserved attention to this monument to the town's proud heritage. Established in 1884, the Village of Bensenville was a thriving farm community that credited much of its success to the railroad that traversed its acreage, transporting goods to and from its fields. By the early 1900s, over three hundred residents were working for the railroad at the local roundhouse, where the train cars were stored and repaired.

To honor the railroad's important role, the Bensenville Park District purchased three railroad cars to display in the town. The 1922 switch steam engine originally transported Studebaker cars at a plant in Indianapolis and later hauled gravel at an Elgin mine. The 1947 passenger car, which is currently used as a meeting room, ran the Mount St. Helens route of the Milwaukee Road line, and the 1951 caboose, which holds several museum pieces and can be seen by appointment, was the last car built for the same line.
Dec. 15–Jan. 7, Dusk–dawn. *From Rt. 83, E on Irving Park Rd. ½ mi., S on Church Rd. 1 bl., E on Main St.*

2 400 DIANA COURT

After Maria and Dan Pilat purchased wire-frame Santas, angels, wreaths, stars, trees, gift packages, and an archway, all outlined in mini-lights, to decorate their home for the holidays, they decided that the lights were spaced too far apart and should be replaced with rope lights. When they couldn't find the right colored rope lights in the right lengths, they decided to color their own clear ones. When they couldn't find the right colored plastic to wrap around the clear lights, they decided to spray paint clear plastic wrap themselves.

"We really can't find what we want," Maria claims. An avid crafter, she has worked in assorted mediums from origami paper to polymer clay. Dan has a degree in electrical engineering and relishes a challenging mechanical project. Though the couple may credit their discerning taste for their inability to find suitable decorations, it may be their creative propensity that accounts for their artfully rebuilt display.

When Maria first suggested the couple decorate the outside of their new home for Christmas, Dan jumped at the chance to upgrade the electrical system. "That got me going," he recalls.

Maria set to work building over thirty mini Christmas trees from tomato baskets and Italian lights. When a snowplow destroyed three of them, she built new ones the next day.

When the couple couldn't find a large outdoor Christmas tree they liked, Dan decided to build one out of treated deck posts and three varieties of lights. When a heavy snow toppled the tree into a tangled mess, Maria separated the strands, while Dan rebuilt the frame with electrical conduit and reassembled the tree the following day.

When carousels available commercially did not suit them, Dan built one himself of PVC, wood, store-bought characters, and a tree-stand motor. He continues to rebuild it annually until they can find a workable replacement motor meant for outdoor use.

Assorted trimmings that no longer make the grade are relegated to lighting the backyard in what Maria and Dan call "The Land of the Misfit Decorations." But with the couple's creative wheels turning, it's likely the misfits will reappear out front before long with a new look of their own.
Fri. after Thanksgiving–New Year's, 5:30PM–10:00PM. *From Grand Ave., N on York Rd. 2 bl., NE on Jacquelyn Dr. 3 bl., E on Diana Ct. 1 bl.*

A RAINBOW OF ROPE LIGHTS

To color sections of clear rope lights already attached to wire-frame figures, Maria Pilat of Bensenville cuts household plastic wrap to the length needed and then into strips 6-inches wide. Using transparent glass paint, she spray paints one side of the plastic. "I tried painting the rope lights at first, but the paint stays sticky, so I needed a better idea," Maria said. She then folds the strips in half lengthwise, paint-side in, and wraps them around the clear rope lights, securing the plastic with twist ties as needed. "We've been using these decorations over six years," Maria said. "I can't believe the plastic wrap has lasted that long."

TEMPORARY HOLIDAY LANDSCAPING

Dan Pilat of Bensenville created a nifty 2-D Christmas tree from a triangular frame of conduit bolted together at the corners. Into 2x2 boards cut to the width of the triangle toward the bottom, middle, and top of the tree, he partially drilled a row of screws spaced 2 inches apart. After bolting the boards to the tree with the screw heads facing forward, he stretched a dozen strands of 100-count mini-lights up and down the tree, wrapping the strands around a bottom screw and a middle or top screw as needed to fill in the tree and have the plugs end up on the bottom. He then draped two strands of red C-9 bulbs and three strands of snowflake lights from side to side to form ornaments and garland and fastened a star to a vertical board screwed to the top. Lastly, he secured the tree to the ground with ropes tied from the top and staked to the ground in four directions.

DOWNERS GROVE

3 2664 HOBSON ROAD

As an independent truck driver who travels all over the United States, Al Piorkowski has purchased Christmas decorations from holiday stores in Tulsa, Oklahoma, and Waldo, Florida, and gotten decorating ideas from displays he's seen in Des Moines, Iowa, and Pascagoula, Mississippi. As an avid Christmas decorator who owns a sprawling ranch home on a ¾-acre lot in Downers Grove, he needs all the decorations and ideas he can muster.

An estimated 48,000 lights, 37 plastic figurines, 16 lighted displays, and 6 inflatables currently trim the Piorkowskis' windows, eaves, rooftop, wooden fence, swimming pool deck, front yard, backyard, seven trees, and twenty-six bushes, making the display easily visible from the Hobson Road/63rd Street exit of Veterans Memorial Tollway.

Before Al's decorations had grown to such grand proportions, his home's 100-amp service easily accommodated the added holiday wattage. But when the giant evergreen was trimmed with thirty-five sets of C-9 bulbs, the microwave began tripping the breaker, an outlet melted, wires fused in the conduit, and Al realized he needed a safer electrical system.

After fixing the fused wires himself, he calculated his electrical needs and hired an electrician to install

Fred and Ginger strike a pose on ice at the Toms' homemade display.

The Goyettes' five-level train layout, animated scenes, driveway Santamobile, and colossal "Season's Greetings" sign made their bountiful Downers Grove display on 67th Street a favorite of thousands of annual visitors for over twenty years.

200-amp service and create an outdoor panel with sixteen waterproof 30-amp outlets. He created a similar panel for the other side of the house and installed several additional outdoor outlets but still requires nearly 4,000 feet of extension cords. "If you watch my electrical meter, it just spins," Al laments. To reduce usage and save on his electric bill, he lights the display fewer hours on weekdays and is trading his C-9s for energy saving LEDs. He also plans to have a timer installed on his electrical panel. "It's a labor of love and craziness," Al concludes.

Dec. 10–Jan. 2, (M–Th) 7:00PM–10:00PM, (F–Su) 5:00PM–12:00AM. *From Veterans Memorial Tollway (I-355), Exit at Hobson Rd./63rd St., SW on Hobson Rd. ½ bl.*

4 6830 SARATOGA AVENUE

Though Fred and Ginger are fashioned gracefully gliding upon an ice-skating pond in front of Harley and Kerrin Tom's Downers Grove home, the Toms admit to each having two left feet and rotating in place at weddings. And despite Frosty approaching their holiday bowling lane with a confident stride, the couple admits to league averages of 110 and 90.

"We just wanted to come up with something different," Harley explains. A grade-school PE teacher in Park Ridge, Harley brainstorms ideas with art teacher Fred Klonsky during lunch. After numerous ideas are rejected, Fred makes a sketch of the chosen design. Harley enlarges it on 4' x 8' paper using an opaque projector, cuts it out, and traces it onto ¾-inch plywood. He then cuts out the figure with a jigsaw, paints it, and while the paint is still wet, lets his two children throw glitter on it for a sparkly effect. "Simple for some, difficult for me," Harley says of his handyman effort.

The excitement in his children's eyes spurs Harley on to grander schemes. "Our next idea is to build a ski-patrol Santa slushing down a hill. This one makes sense," he says. "I'm in the ski patrol at Wilmot, and we're all avid skiers."

Dec. 1–Jan. 6, 5:00PM–10:00PM. *From 75th St., N on Lemont Rd./Main St. ¾ mi., W on 68th St. 2 bl., S on Saratoga Ave. ½ bl.*

ELMHURST

5 200 BLOCK OF CLAREMONT STREET

The local record for the longest-running group display seems to belong to the residents on the 200 block of Claremont Street. A matching Christmas tree, trimmed with multicolored bulbs, on the lawn of every house has been a holiday tradition since the end of World War II. In the years that have followed, the custom has spread throughout Elmhurst.

On a block so organized it has a mayor, it is no wonder that uniform precision can be achieved. The homeowners purchase the trees in bulk and place one in front of each home, 10 feet from the walkway, and crown them with a twinkling star. Homemade toy soldiers and a trellis of brightly colored bulbs greet visitors at both ends of the block.

The holiday tradition kicks off with a private street party, no matter what the weather, featuring homemade goodies and a visit from Santa in a fire truck or horse-drawn wagon. Each family brings a log for a blazing bonfire. All join in singing carols and sharing their refrains with Claremont residents who are homebound.

The enduring tradition of Claremont Street has kept alive a neighborhood spirit many in our bustling lives have yearned to rekindle.

1st Sun.–New Year's, Dusk–11:00PM. *From York Rd., W on St. Charles Rd. 3 bl., N on Prospect Ave. 2 bl., W on Claremont St.*

GLENDALE HEIGHTS

6 150 CAMBRIDGE LANE

With the dazzle of a rhinestone jumpsuit, professional Elvis impersonator John DeBartolo trims his home in a style that would do "The King" proud. Amidst tens of thousands of lights, a holiday train flies through the air, Santa heads skyward with a sleighload of toys, and a giant homemade present shimmers in the snow. Glowing balloon figures and glittering trees add to the brilliance on the ground, while overhead a trio of penguins slide down the roof between giant twinkling snowflakes and a faded sixties "Jolly Polk Santa" appears at the chimney for yet another year. Glistening homemade archways across the sidewalks entice visitors to take a closer look while

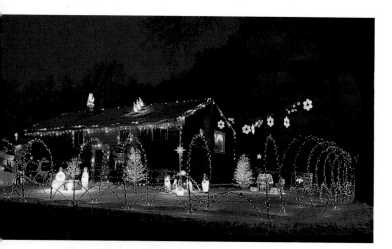

Lighted archways add to the brilliance of John DeBartolo's Glendale Heights home.

strolling to the rhythm of holiday tunes including an entire Elvis Christmas CD.

At a big Christmas party John hosts every year, guests are not only entertained by the festive surroundings but by John Elvis, who provides the entertainment.

Thanksgiving–Jan. 8, 4:30PM–11:00PM. *From North Ave., N on Bloomingdale Rd. ½ mi., W on Armitage 2 bl., S on Westchester 1 bl., W on Cambridge Ln.*

LISLE

7 MUSEUMS OF LISLE STATION PARK
MAIN STREET AND BURLINGTON AVENUE

On the first Saturday in December, the "Lights of Lisle" rings in the holiday season with a dazzling display of three thousand luminarias that line the rolling streets of the downtown area. Throughout the weekend, free hayrides take visitors to Village Hall for refreshments and entertainment and to the Museums of Lisle Station Park, where a nineteenth-century train station, caboose, blacksmith shop, home, and tavern offer a variety of festive treats including warm gingerbread cookies, holiday crafts, musical entertainment, glassblowing and blacksmithing demonstrations, and a visit with Santa.

The Museums of Lisle Station Park also offer special trimmings and treats throughout its "Once Upon a Christmas" celebration, sponsored by the Lisle Heritage Society. The Beaubien Tavern is festooned in fragrant boughs and colorful bows. The Depot Museum displays a Victorian tree decorated with vintage-style ornaments, handmade by the Lisle Woman's Club. The 1850s Netzley/ Yender House features treats baked in a beehive oven, a working HO-scale train layout with trains from the past sixty years, an old-fashioned "Heritage Tree," an American Indian tree, and two "Families of Lisle" trees trimmed with ornaments inscribed with the names of residents and the year they arrived in town.

Lights of Lisle: 1st weekend of Dec., (Sa) 3:00PM–8:00PM, (Su) 11:00AM–4:00PM. Once Upon a Christmas: (Tu, Th, Su) 1:00PM–4:00PM. (630)769-1000. www.stayinlisle.com. *From Maple Ave., N on Rt. 53 2 bl., NE on Main St. ½ mi., E on Burlington Ave.*

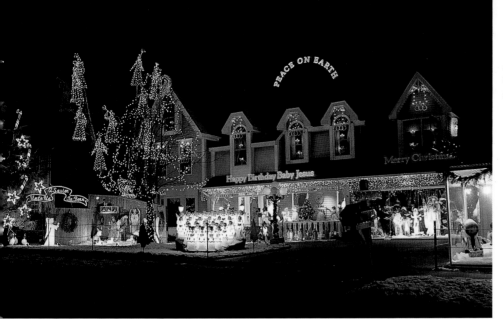

From 1986 to 2000, the Cline family's Christmas display was a Naperville holiday tradition.

NAPERVILLE

A MAN WHO LIVED THE SPIRIT OF THE SEASON

Those who made an annual tradition of visiting the Woodstock Court home of Troy and Glenna Cline each Christmas season were treated to a beautiful array of decorations fondly purchased throughout the couple's blessed years while vacationing all over the continent.

Thirty live Christmas trees carefully laden with cotton balls were backdrop to a snowy forest scene of exquisite reindeer, rabbits, polar bears, and Father Christmas figures that transformed the garage into a stunning diorama. An acrylic case along the driveway held a whimsical scene of Eskimos and penguins frolicking around an igloo. Christmas music broadcast through speakers seemingly flowed from a forty-member children's choir on the front lawn. A huge pine tree drenched with giant candy canes and stars and an adjacent birch brimming with 5-foot angels towered over a life-size manger scene complete with roosting chickens. Four neon signs, custom-built by a friend, offered wishes for the season and proclaimed the true meaning of the holiday.

Delighted with the opportunity to share his good fortune, Troy stood outside every evening amidst the decorations greeting visitors, offering good wishes, and hopping aboard sightseeing buses to pass out candy. Though some may have known him as the owner of Naperville Chauffeuring, few could have guessed what had brought him to this place in his life.

Troy Cline was raised in the small coal company town of Holden, West Virginia. The townspeople were impoverished and undereducated miners living with their families in company houses and compensated with scrip from company stores. This was not the life Troy wanted for himself and Glenna, his high-school sweetheart and bride, but it was understood that people did not move from Holden or Glenna's hometown of Mudfork. The couple held fast until expecting their second child in 1961, when they left for a new life in Chicago and were summarily disowned by their families.

With yet another child and little income, the young couple struggled in the early years. Troy landed a job as manager of a limousine company and soon realized he could do better with a similar company of his own. He opened shop in 1972 with two Oldsmobiles in the then rural community of Naperville, which seemed to have potential.

With Glenna's help in the office and the eventual help of all three of their children, the family grew Naperville Chauffeuring into a thriving enterprise with 140 cars and 200 employees. The couple celebrated their good fortune in 1983 by building a beautiful country Victorian home with a limo-shaped swimming pool in the Century Hill subdivision.

In their youth in West Virginia, neither Glenna nor Troy had had much of a Christmas. After Troy's brother was killed in the Korean War, his distraught and abusive father banned Christmas from the family altogether.

They now had a house that Troy described as "made for decorating." With the means to travel, the couple began purchasing Christmas decorations from around the globe. They filled the inside of the house with a themed tree in every room and the dining room with a lighted village of four hundred buildings. With the help of his children, Troy began decorating the outside of the house as well. By 1987 the elaborate display of neon signs, lush figures, and animation began to draw crowds.

Concerned for the inconvenience the traffic was causing his neighbors, Troy went door to door at the start of each holiday season with a conciliatory box of chocolates for each family on the block. When visitors started offering him money to offset the electric bill, he decided to construct a "collection sleigh" instead and annually received three to four thousand dollars and three truckloads of canned goods to donate to the local food pantry.

With a love of people and a big heart for children, Troy greeted all who came to see the display. His good friend Santa Claus (Mayor A. George Pradel in the off season) would arrive by limo to Troy's exuberant fanfare four or five nights a week to hear kids' wishes from his own special throne. Troy even provided electric heaters to keep Santa and his visitors warm. Teenagers would stop by late at night to talk, and family and friends would pop over throughout the Christmas season. "I didn't dare get into my PJs," Glenna confessed.

Few outside his family knew that Troy's generosity continued well beyond the Christmas season. "He was always helping those in need," said his son Steve, "even when he had little of his own to give." He provided free limos with movies and toys to transport young cancer patients to the hospital for treatment. He supported a Christian school to provide education for poor children and bought burial plots for people whose families could not afford them, including one for a total stranger he heard about on the news. "Whenever there was someone in need of help, Troy was always first in line," said Mayor Pradel. He even provided baskets of food for the folks in Holden every Christmas season.

In the fall of 2001, Troy Cline was sadly killed in a tragic auto accident with a drunk driver. The lights no longer shine from his home at Christmastime, but the joyful memories remain. And those who enjoyed his Christmas display throughout the years may likely know that the real treat was having met Troy Cline. ❄

8 517 WEST BENTON AVENUE

Mike and Nina Tamburo each have glorious memories of their childhood Christmases. Mike and his dad had fun hanging thousands of lights on their house each season, and Nina grew up in a house that was locally famous for its large animated figures.

The Tamburo children are destined to have similar fond memories. Not only are Mike's parents helping on decorating day and Nina's parents buying them large animated figures, but the kids' parents are letting them join in the fun.

Jessica, Michael, and Wendi spend decorating day delivering lights and extensions cords from the garage to the front lawn in their battery-powered Barbie Jeep and John Deere Gator. When the outside work is done, the kids each decorate their own little tree for their bedrooms with lights and plastic ornaments. And when it seems no one is looking, they even get to move the animated figures in the windows and pretend they are talking to each other.
Dec. 1–Jan. 3, 5:00PM–10:30PM. *From Washington St., W on Ogden Ave. 4 bl., S on Mill St. ½ mi., W on Benton Ave. 1½ bl.*

9 827 MORVEN COURT

Rick Tarulis has used several crafty ideas for his Christmas display. He permanently screwed cup hooks and eye hooks into the corners of all the window frames and doorways and under all the eaves so he could easily hang his lights every year. He made reusable light strips for the corners of the house by stapling C-9 strands onto 1x2s painted to match his bricks. He built giant stockings and candy canes from egg-crate plastic sheeting. He mixed twinkling lights with constant lights on his bush for a subtle sparkling effect. He taped a 3-inch pencil to the bottom of a big shoe to create a stiletto heel for his reproduction of the leg lamp from *A Christmas Story*. And he designed a 17-foot wire-frame custom-built snowman that fits snugly on the side of his house.

His wife, Nancy, will insist his most original idea was when he put his newly purchased life-size animated Santa Claus in the darkened living room to scare the heck out of

Anchoring Two-Dimensional Wooden Figurines

Vera Muir of Palatine screws U-shaped brackets near the top and bottom of the back of her figures, positioned to vertically accommodate conduit pipes. She then cuts conduit pipes 12 inches longer than the height of the figures and numbers them to match the brackets.

Aluminum pipes, slightly wider than the conduit, are cut into 15-inch lengths. One end of each pipe is hammered flat to form a point. After determining the placement of the wooden figures, Vera slips the conduit through the brackets on the back of the figures. The aluminum pipes are then permanently pounded into the ground, flattened end first, to align with the conduit until even with the surface.

The figures are easily installed each year by sliding the conduit pipes through the brackets and into the pipes in the ground. In the off-season, plastic caps are placed on the pipes to keep them from filling with dirt.

To deter theft, Vera secures the figures with chains and locks, threaded through eyebolts on the back of the figures and screw-in stakes in the ground.

Because Tim Jagodzinski of Crestwood likes to move his figures around, he prefers to position a figure, hold the conduit flush against it, and then screw in the brackets. Chuck Race of River Forest screws 1x2 pointed wooden stakes to the bottom of his figures. He then creates a "stand" by gluing a 2x4 horizontally across the top of the figure and connecting one end of a 1x4 to the horizontal board with a brass hinge. By drilling a large hole in the 1x4 and placing a cinder block behind the figures, he can chain his figures down for security.

her. Neighborhood kids would likely say his best idea was when he put up his decorations in October to be filmed for an HGTV Christmas program in 2006 and gave out candy canes on Halloween. The City of Naperville would likely contend that the 25-watt light bulb he suspended near the electric eye of the street lamp was a most original, though still illegal, method of shutting off the lamp when his decorations came on.

Thanksgiving–Jan. 7, (Su–Th) 5:00PM–10:00PM, (F–Sa) 5:00PM–11:00PM. *From Ogden Ave., S on Washington St. 4 bl., E on 5th Ave. ¾ mi., N on Monticello Dr. 2 bl., W on Morven Ct. ¼ bl.*

10 326 South Sleight Street

When John and Wendy Hennessy discussed plans with their builder for constructing their new Naperville home, Wendy expressed her desire for walk-in closets, a large entryway, and an eat-in kitchen. John told the builder he wanted electrical outlets in the attic, under the eaves, in the lawn and throughout the garage, on the front porch, at the top and bottom of every interior railing, above the cabinets, on the fireplace mantels, and next to each landing on the steps—all with automatic timers and dedicated circuits. He wanted several large windows across the front of the house with six outlets under each and grommetted window seats with outlets inside. He wanted a ledge above every doorway in the entryway. He wanted a wide front porch with removable railings that could be replaced by Plexiglas panels and a barely sloping roof he could walk on. He wanted storage space under the porch, in the garage and basement, and on the entire fourth floor with extra-wide doors. He wanted it all . . . so he could decorate for Christmas.

"We didn't take him seriously at first," admit Hennessy's builders, Mike Zalud and Keith Rot. "A lot of customers ask us to put in outdoor electrical outlets for their Christmas displays, but as the costs add up, they change their minds." As John's plans progressed, however, it became clear that building a Christmas-friendly house was his primary concern.

His previous home on Tall Oaks Court in the Hobson Hollow subdivision had been locally famous (along with his sister Nina's house across the street) since 1994 for its elaborate decorations and animated garage scene. His boyhood home on Royal Vale Drive in the Ginger Creek subdivision of Oak Brook, which he helped decorate with his father, had been famous for its toy soldiers and animated figures. So when it came to decorating for the holidays, John knew exactly what his new home needed to ease his decorating task.

"When we saw how important this really was to John," Mike laughs, "we stopped razzin' him." In September

2003, after a year and a half of planning and building, the Hennessys' new house was completed incorporating all of John's (and Wendy's) requests.

As their first Christmas season quickly drew near, John admits, "I was like a kid." He excitedly rented a cherry-picker truck, installed permanent hooks along the roofline, hung strands of lights in red and green, and merrily plugged them into outlets under the eaves. He cheerily draped the railings and edged the lawn with lighted garland and shined spotlights on his 6-foot Grinch, 7-foot nutcrackers, and 8-foot Santa, all the while reveling in his lack of extension cords.

After his carpenter, John Wehrli, returned to build the framed Plexiglas panels for the front porch display and instructed him on how to install them, John playfully arranged the scene of Mr. and Mrs. Claus and their busy elves, which had previously filled his garage in Hobson Hollow.

Gleeful as a newly hired elf loading packages in Santa's sack, John arranged his Victorian carolers, his lighted 4-foot Christmas tree, and his leg lamp from his friends the Petersons on the window seats inside the house, fished the cords through the grommets, and plugged them into the hidden outlets. He stood the 7-foot Santa Claus his father had given each of his children in his office window, wondering for a moment which of the six outlets would best make the old elf turn and wave, and arranged a wintry animated doll scene in the three large windows of his sons' bedroom.

He carried the thirty boxes of ceramic buildings and accessories to the second-floor steps and persuaded Wendy to join the fun by taking charge of assembling the Christmas village on the three-tier landing. John then busied himself winding lighted garland on the rails and contentedly plugging them into the outlets as he climbed from floor to floor. He gaily trimmed the tops of the kitchen cabinets with animated Christmas characters, placed holiday dolls over the entryway doors, and spread Santa Clauses throughout the house.

But when it came to turning everything on, John felt as lost as Rudolph with a burnt-out nose. "I had to call Mike repeatedly," he admits. "It had been awhile since we finished the plans, and I couldn't remember where all the switches and timers were." With Mike's help and a few calls to the electrician, John eventually got everything lit and was thrilled to see how well it all worked. "He called me several times to let me know how impressed he was that he wasn't tripping any circuits," Mike says.

The Hennessy display became an instant Naperville favorite. Cars stopped. Flashes went off. Kids' eyes lit up with excitement. And Mike Zalud, Keith Rot, and John Wehrli, who all came by with their families, finally understood the holiday enchantment John had pictured in his mind.

Fri. after Thanksgiving–New Year's, 4:30PM–10:30PM, (2 weeks before Christmas) –12:00AM. *From Ogden Ave., S on Washington St. 1 mi., E on Chicago Ave. ¼ mi., S on Sleight St. 1½ bl. See photograph on p. 131.*

11 NAPER SETTLEMENT
523 SOUTH WEBSTER STREET

A visit to Naper Settlement during its annual "Christmas Memories" celebration is a journey to the Christmases of yesteryear. A horse-drawn wagon takes passengers on a delightful ride through the 13-acre site, where thirty historic buildings are trimmed with red bows, fresh greenery, and glowing lanterns.

Villagers dressed in period costumes reenact nineteenth-century life in a midwestern town during the Christmas season. A printer handsets type for a holiday greeting card. A blacksmith forges a spice hook. Carolers dressed in capes, bonnets, and top hats gather on a porch to share a merry tune. Father Christmas in his fur-lined robe and crown of holly spreads good cheer, and Ebenezer Scrooge mutters, "Bah, humbug."

Varying special exhibits within the buildings include a reproduction of the first electrically lighted Christmas tree and a 5-foot replica of the first Ferris wheel, which was used to hold gifts, such as citrus fruits and candies, for Sunday school children. Musical entertainment, ice-carving demonstrations, refreshments, and souvenirs add to the festivities, while live reindeer set the stage for a perfect holiday photo.

Dates and times vary annually. Admission fee. Free parking. (630)420-6010. www.napersettlement.museum. *From Ogden Ave., S on Washington St. 1¼ mi., W on Aurora Ave. 2 bl., S on Webster St. 1 bl.*

OAK BROOK

12 18 DEVONSHIRE DRIVE

With a sprawling home surrounded by a 130-foot front yard that faces a vacant lot on busy 31st Street, Jim Giandonato knew he had the perfect palette to create a crowd-pleasing Christmas display. "I began with eight reindeer on the house in 1995, and then I just started losin' it," Jim explains. "I now spend 150 man-hours putting up the decorations and $600 on my electric bill, but it's my gift to everyone who enjoys Christmas."

In 1999, his already extensive display melted his main circuit breaker. By 2005, he was pulling so much wattage, he blew an outside electrical line that darkened half his display and much of the house. The electric company initially told him the repairs couldn't be made until mid-January, but when they noticed his decorations, sent two trucks out the next day. The supervisor even returned the following evening to see everything lit.

Using an ohmmeter to avoid future mishaps, Jim now safely decorates his home with approximately 30,000 lights. Two crabapple trees are dramatically lit as high as Jim can reach with a 24-foot pole, while homemade 6-foot snowflakes are hung from a giant oak. After making repeated trips from his garage attic, Jim fills the lawn with a life-size sleigh pulled by nine lighted reindeer, while ten additional reindeer graze throughout the yard. An equally impressive manger scene is surrounded by lighted trees and carolers with seven angels flying overhead. Seventy toy soldiers circle the lawn and forty candy canes line the driveway, while fifteen blinking gingerbread men appear to be having a holiday party of their own. A miniature forest of light trees includes an aluminum tree with rotating gel lights. Though Jim hires a roofer to install his trademark rooftop decorations, they are all his original handmade designs—a 20-foot Christmas tree, two 6-foot candy canes, and twelve twinkling stars. Two particularly successful flashing bells hanging from the eaves are his pride and joy.

When all is lit, Jim joins an old "Jolly Polk Santa" and snowman on his front porch, relaxes on his swing, sips a drink, and wonders in amazement that he was able to get everything to work. When asked what it takes to accomplish such a feat, he simply replies, "Patience and Southern Comfort on the rocks."

Fri. after Thanksgiving–New Year's, (Su–Th) 5:00PM–10:00PM, (F–Sa) –12:00AM. *From Rt. 83, W on Oak Brook Rd. (31st St.) ½ mi., N on Concord Dr. 1 bl., W on Ivy Ln. 1 bl., S on Devonshire Dr. around curve.*

13 2803 OAK BROOK ROAD

Alan Feldman told his four children, "I'm building you a fantasyland, so my grandchildren will always want to bring you back home." And build it he did, over four years, on a rolling 5-acre estate in the village of Oak Brook—a

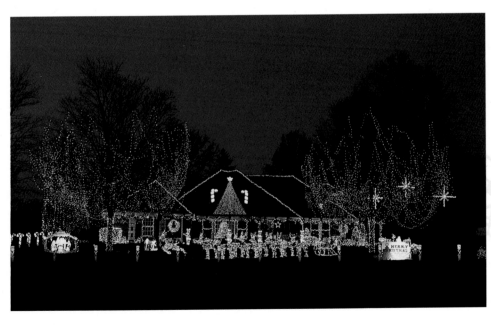

Giant rooftop decorations, flying angels, nine life-size reindeer that light in sequence, and weekend music are among the highlights of Jim Giandonato's stunning display.

fairytale mansion with playful peaks, a lighted turret, and ivy-covered masonry, nestled among the trees at the end of a winding brick road.

He also wanted to please his wife, Joyci, who has always loved bears and had her own growing teddy bear collection. So they dubbed the home "Bear Manor" and cleverly integrated custom-designed bear art about the home and grounds. Formally attired teddy bears are rendered in stained glass pictorials over the entryways and bas-relief portraits on the wrought iron entry gates. Life-size grizzlies, cast in bronze, flank the main entrance. A more sportive sort skates daintily on one foot atop a multi-tiered brick fountain, while others frolic in matching fountains of stone. As they are purchased, bronze bear sculptures in various playful poses are set in scenes throughout the grounds—a bear fishes in a real pond, another putts on a green.

In the summer of 2002, the couple saw Kansas City's public art exhibit "Teddy Bears on Parade," which featured dozens of 6-foot teddy bears, each painted by a different artist. The Feldmans first added four summer bears to their collection, and, shortly thereafter, another dozen were decorating the Bear Manor landscape.

As Joyci maintains, "There's always room for another bear," so dozens of Santa bears line the drive and tens of soldier bears surround the garden. Acrobatic topiary bears, covered in white lights, balance globes of gold. Glittery bears dance on the porch, and a tuxedoed bear in a Santa hat plays the grand piano in the front window. Even the bronze grizzlies hold fresh wreaths to get in the yuletide spirit.

Each season the Feldmans generously share their good fortune and joyous surroundings with the Oak Brook fire and police departments and their families, who are invited to a holiday open house. The couple also welcomes those who visit their display to park briefly on their driveway for a better view through the gate. In years to come, they hope to open the estate to the public as a teddy bear museum. **Thanksgiving–Jan. 6, Dusk–12:00AM.** *From Rt. 83, W on Oak Brook Rd. (31st St.) 1¾ mi.*

WAYNE

14 4N494 MOUNTAIN ASH DRIVE

Phil DiCosola has moved from Carol Stream to Bartlett to Wayne, each time to a larger home. "As the houses have gotten bigger, the decorations have gotten bigger," Phil admits.

He started decorating as a boy with his mom at their Chicago home near Pulaski Road and Division Street. His visions of grandeur showed early on. "I looked at other people's houses and wanted to decorate too, but I always wanted mine to be better," he laughs. His current 5,000-square-foot home with a five-car garage on a 1-acre lot spectacularly trimmed for the holidays with approximately

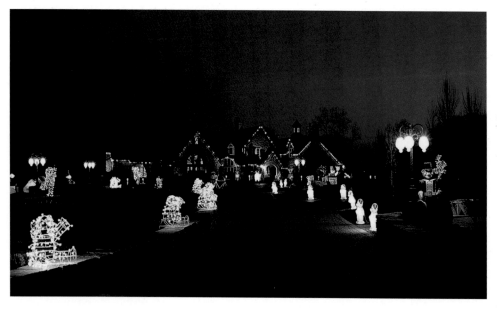

There's no hibernating during the holidays at "Bear Manor," where dozens of whimsical bears frolic throughout the grounds.

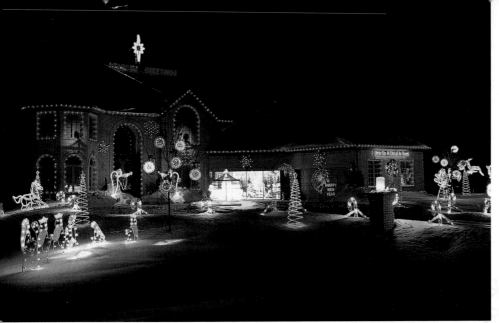

Teddy bears twirl in a Ferris wheel, puppies glide in a sleigh, and snow dolls swing from the ceiling in a delightful animated garage scene amidst the lighted splendor of Phil DiCosola's stunning display.

$50,000 worth of custom-built displays has most assuredly fulfilled his boyhood ambition.

With plenty of ideas, Phil acquired the expertise of Hermans' Christmasland in Pierceton, Indiana, to build commercial-grade animated decorations of his design as well as many of their own creations. His house and yard now come alive with Santa's sleigh and reindeer heading skyward with a load of gifts, skaters twirling about an ice-skating rink, Santa and Mrs. Claus dancing, elves filling a stocking, a spinning carousel, an old-fashioned stagecoach, a steam-engine train, and a rooftop helicopter. Elves tossing packages over the driveway form a welcoming arch that invites visitors to take a closer look at the garage transformed into a wintry playland. And a neon sign proclaiming "Unto Us a Child Is Born" reminds all who pass of the true meaning of the holiday, while Christmas music wafts through the air.

With the help of family and friends, Phil does all the decorating himself, working nearly four hours a day throughout November. He makes his own strands of lights for the house and also trims the backyard with decorations he has tired of in the front.

Though Phil's decorations have earned grand prize in the ComEd holiday decorating contest and a front-page story in the *Chicago Tribune* neighborhood section, his biggest thrill is the look in children's eyes when they see his display. Throughout the Christmas season, he often stands outside handing out candy canes, and once a year

has a holiday party for his friends' children and a special child from the Make-a-Wish Foundation.

He continues to order custom displays from Hermans' Christmasland every year, though owner Tom Guhl jests, "He needs a bigger yard." It may just be the decorations that cause Phil to get a bigger house the next time around. **Dec. 1–Jan. 2, 5:00PM–12:00AM. Visitors are welcome to park on the street and walk (not drive) up the driveway.** *From Army Trail Rd., S on Rt. 59 ¾ mi., W on Smith Rd. 2 bl., N on Mountain Ash Dr. ½ bl.*

WESTMONT

15 VETERANS MEMORIAL PARK
DALLAS STREET AND LINDEN AVENUE

The 10-acre Veterans Memorial Park comes alive with the spirit of the season as Westmont presents "Holly Days Winter Festival." The celebration kicks off in grand style in downtown Westmont on the Friday after Thanksgiving with a host of special events including live reindeer.

Throughout the holiday season, the park's "Holly Days Tree Walk" features holiday music along a winding path of nearly 150 fragrant evergreens, sponsored by local businesses and decorated by local community groups and families. Large lighted displays and animated characters add to the park's splendor.

Visitors can warm up while enjoying an old-fashioned Christmas at the William L. Gregg House Museum. Decorated in an old-time holiday theme that varies from

Glistening and feathered ducks alike make the Cosley Zoo duck pond their home for the holidays.

nighttime fun. Dozens of trees decorated with homemade animal-friendly trimmings by local schools and community groups greet visitors at the entrance. Over 20,000 lights shimmer from rolling white fences and zoo buildings while holiday music and lighted animal figures add to the merriment.

After wandering the paths and visiting the llamas, pigs, turtles, and other animals, which takes little more than an hour, guests can continue their holiday adventure by shopping for a real Christmas tree, greenery, and gifts. **Christmas light display: Fri. after Thanksgiving–Dec. 30, 3:00PM–9:00PM. Crafts and photos: 1st–3rd Sat., 10:00AM–2:00PM. Festival Zoo hours: 9:00AM–9:00PM, Christmas Eve and New Year's Eve –12:00PM. Closed Christmas and New Year's. Free admission. Donations welcome. (630)665-5534. www.cosleyzoo.org.** *From Roosevelt Rd., N on County Farm Rd. 1 mi., E on Jewell Rd. 1¼ mi., S on Gary Ave.*

WOODRIDGE

17 2921 AUTUMN DRIVE

Combine the creativity of a former theater major with the technical skill of a material-handling sales engineer. Toss in a hefty portion of holiday cheer. Mix in a few windshield-wiper motors, bicycle chains, and some old doll heads, and you have the makings for "Elfland"—a delightfully original and well-executed animated display that's earned its reputation as a Woodridge holiday destination.

Thanks to the ingenuity of homeowners Gloria and Bob Pluta, this normally placid Victorian home comes alive with activity for the holidays as nearly two dozen elves frolic on the roof, garage, chimney, porch, and yard—twirling on a giant candy cane, teetering from a ladder, swinging from a trapeze, rocking on a seesaw, spinning on a Ferris wheel, sliding on a ski slope, and riding on a sidecar. Giant red plastic bows from an old store display and spinning 6-foot candy canes along the driveway add to the whimsy. Amidst the playland, a trio of elves tend to their work at a toyshop conveyor belt, while another in a forklift attempts to pick up a skidload of twirling toys and a stretch-wrap machine (an inside joke for visitors from Bob's office). As suits their touring schedules, Elfis and Buddy "Holly" may also appear to rock 'n' roll in the flowerbox.

year to year, this 1872 home (the oldest in Westmont) offers extended holiday hours, tours, and free horse-drawn wagon rides on Saturdays.
Fri. after Thanksgiving–Dec. 31. Tree Walk: Dusk–10:00PM. Gregg House Museum: (W, Su) 1:00PM–3:00PM, (Sa) 5:00PM–8:00PM. (630)963-5252. www.wpd4fun.org. *From Ogden Ave., S on Cass Ave. 1½ mi., E on Richmond St. 1 bl.*

WHEATON

16 COSLEY ZOO
 1356 GARY AVENUE

Playful holiday trimmings simply add to the enchantment of this charming recreational and educational facility operated by the Wheaton Park District. With property donated in 1973 by the family of the original owner, Harvey H. Cosley, the 5-acre Cosley Zoo features domestic farm animals, native Illinois wildlife, a duck pond, the oldest barn in Wheaton, an 1887 train station, and an 1880 caboose, as well as concession stands, a gift shop, educational programs, and special events in an atmosphere that can't help but calm the soul.

Throughout the holiday season, the zoo's most glittering special event, "Festival of Lights," offers magical

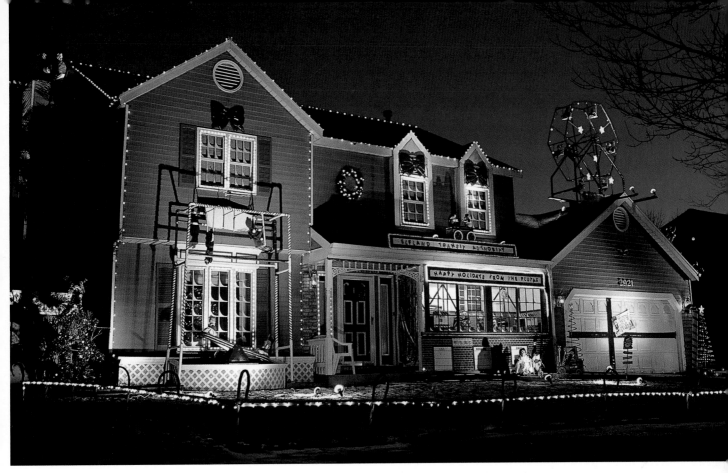

Elves spin, twirl, bounce, and glide to holiday tunes at the Plutas' award-winning "Elfland" display in Woodridge.

Winner of numerous awards, the Plutas began their unique style of animated decorating in 1990 with pulley-drawn angels circling a manger scene. Their $200 first prize not only fulfilled their promise to buy the kids a Barbie Power Wheels, but achieved their goal of winning more than the cost of their display.

"We use whatever takes the least amount of time and money," Gloria confides. A snow saucer is made from an old garbage can lid. Elves are fashioned from resale store clothing and old doll heads. Pointy ears are cut from doll thighs and screwed into the heads. "Don't walk up close to our decorations," Gloria warns. "They are meant to be seen from far away."

A former actress and production manager in local community theaters, Gloria has applied her stage experience to her Christmas display not only in designing props but balancing colors, eliminating dead spots, and avoiding unwanted shadows. Though she willingly accepts credit for Elfland's aesthetic appeal, she forwards kudos on its technical achievement to Bob.

PRESERVING PLASTIC FIGURINES

Whether it's a snowman that's been in the family for years or a blow molded Santa that's hard to come by, plastic figurines are often worth preserving.

Wayne Basica of Round Lake Beach knows firsthand that storing plastic figures in an unheated attic can cause problems with cracking. He uses a hot butter knife to melt the two edges together, giving the repaired area a "snowed on" effect.

Danny Murov of Glenview washes his collection of figures with a mild soap solution and a lambswool glove before storing to remove salt, which causes the paint to fade.

Carrie Sansing of Glenview repairs dents in her blow molds by pushing the dent outward with a stick covered in cloth, while heating the dented area with a hair dryer. She also gives her figures a second life by repainting them, using strippers and spray paints specifically made for plastics.

Besides his creative use of PVC in several of the decorations, Bob also found a unique use for the battery-powered windshield-wiper motors he discovered while rebuilding old Fiats. Reliable in cold weather, the motors proved ideal for animating outdoor decorations and economical when powered by converting 110-volt AC to 12-volt DC through a household battery charger.

His original goal was to build one hundred elves, but he is now more realistic and hopes to add only a few more.

Because he likes to keep the decorations in good working order (he has been known to climb the roof before work in a suit and tie), his current goal is to make everything withstand the elements. "When my family asks me what I want for Christmas," Bob says, "I tell them I don't want to have to touch anything after I put it up. It hasn't happened yet."

Dec. 10–Jan. 6, 6:00PM–10:00PM. *From Lemont Rd., W on 87th St./Boughton Rd. 2 mi., N on Pinecrest Rd./ Mending Wall 1 mi., W on Autumn Dr. ½ bl.*

DECORATING GREEN

LED (light emitting diode) holiday lights offer decorators the best solution for going green (and a wide variety of other colors). Available in minis, C-7s, C-9s, and rope lights, LEDs use up to 80 percent less energy, last up to twenty times longer, produce no heat, and are just as bright and more durable than incandescent bulbs. Improving every year and coming down in price, quality LEDs not only reduce energy usage and lower electric bills but save on bulb repairs and replacements throughout the season.

The wattage of incandescent C-9 and C-7 bulbs currently being sold is as much as half the wattage of those sold in years past. Though the lights appear somewhat dimmer, new bulbs replaced in the original cords and sockets can preserve the nostalgic look of the old bulbs while conserving energy at little expense.

Though CFLs (compact fluorescent lights) are also energy saving, they are not yet recommended for outdoor use as of this writing, in cool or moist locations. Although those plastic gingerbread men may still require an incandescent bulb, changing interior bulbs to CFLs can offset the energy usage for keeping the little fellas aglow.

A 50-watt PAR-38 halogen spotlight in a weatherproof fixture can light up a homemade wooden sleigh as well as a higher wattage incandescent.

Reducing the number of hours a display is lit is recommended by many decorators, who light their displays fewer hours on weekdays and during the early part of the holiday season when there is less sightseeing traffic.

Many decorators also put their lights on timers, which saves energy and a sleepy walk in the cold if they fall asleep before turning off the lights.

Some decorators who have a large collection of cherished decorations arrange them in two or more themes and alternate their displays each year with a different theme, not only saving energy but making the decorations even more special, since they aren't displayed as often.

Broken decorations or light strands can be advertised on one of the websites that features free items or donated to a resale shop that accepts reparable items. Mark Pumper of Oakwood Hills created his own part-time job while in school, repairing old lights strands from resale stores and using them to decorate people's houses.

Extension cords longer than they need be can also waste energy, besides looking unsightly. Former Arlington Heights decorator Al Eischen labeled the lengths of all his extension cords with a permanent marker or white correction fluid on the plug for easy identification.

Though computerized lighting systems that make lights blink, fade, and assorted other choices are not in everyone's budget or decorating scheme, they do save electricity every time a light is off or dimmed.

Opposite page: Santa Claus and glistening archways of lights invite visitors to take a leisurely stroll down Juniper Lane in South Elgin (p. 153).

CHAPTER 9
Kane County

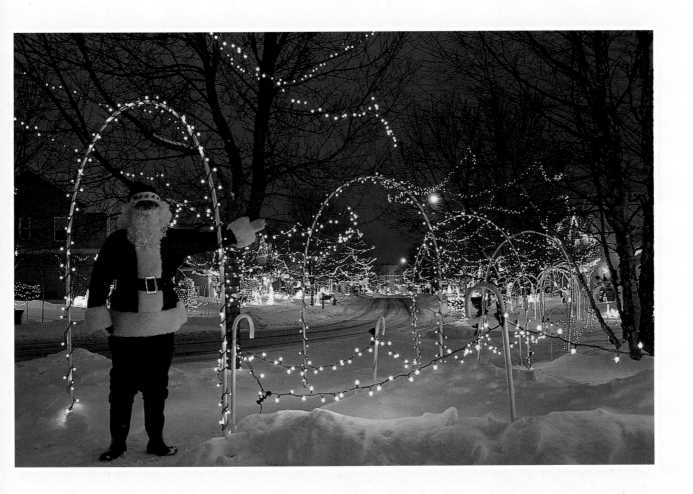

MCHENRY
COUNTY

LAKE
COUNT

COOK
COUNT
NORTHW

DUPAGE
COUNTY

WILL
COUNTY

*Kane
County*

N
W ⊕ E
S

0 MILES 4

47
90
NORTHWEST TWY.
47
31
25
RANDALL RD.
STATE ST.

Sleepy
Hollow
8

WING ST.
CONGDON RD.
20
Elgin
HIGHLAND AVE.
3
4
IRVING
PARK RD.

South Elgin
HOPPS RD. MIDDLE ST.
9

47
31
25

64
St.
Charles

MAIN ST.
7
64

38
5
STATE ST.
6
Geneva

RANDALL RD.
31
88
2
FARNSWORTH AVE./ KIRK RD.

REAGAN MEMORIAL TWY.
Batavia

47
Aurora
Sugar
Grove
56
BROADWAY AVE.
FOREST AVE.
30
10
1
31
30
25

AURORA

1 LEHNERTZ AVENUE AND LEHNERTZ CIRCLE

In the fall of 1952, a new housing development on Lehnertz Avenue was in midconstruction. A few of the young homeowners, Fran Sibenaller, Larry Rowe, and Ed and Ben Michels, had gathered together and were discussing the growing commercialization of Christmas. They decided to build a crèche as a neighborhood project in an effort to bring the focus of the holiday back to the nativity of Christ.

Using scrap lumber from homes still under construction, they built a manger scene on one of the vacant lots. Figures of the Holy Family were made from store-bought prints glued to Masonite boards. Shepherds and sheep, constructed in like manner, were placed in the front yard of each home as though walking toward the manger. The fourteen original homeowners trimmed what shrubbery they had with colored lights or shone a spotlight on a decoration hung on the door. Ben Michels added music by amplifying three Christmas records, which he turned over every hour in his garage. Though lit for only twelve days, the display attracted 2,500 cars. The men were so pleased with the results, they formed the Lehnertz Avenue Improvement Association to organize the effort, which grew each year as more families moved into the neighborhood.

With more men to lend a hand the following year, the association trimmed the lampposts with garlands, 25-watt colored bulbs, and speakers from which tape-recorded carols were played. Resident Bob Michels, who owned a local lumber company, designed a new stable that could be easily disassembled and stored. (Though his original structure has been rebuilt a few times over the years, the same design is still being used today.) Young neighborhood girls began the tradition of taking turns every night displaying their dolls as the Christ Child in the manger.

In 1954, resident and tinsmith Joe Strotz constructed a large sheet-metal banner reading "Gloria in Excelsis Deo" to hang over the west entrance to the street. In 1955, Reverend Joseph Weitekamp of neighboring Saint Joseph Church helped the group choose a series of thirteen verses from the Gospel of Saint Luke, which together would tell

For over half a century, Lehnertz Avenue's popular holiday display has celebrated the birth of Christ.

the story of the birth of Christ. John Murphy, a friend of several of the residents, hand-lettered the verses on large open-book pages built by the association. Flanked by two live Christmas trees, one book was placed on the front lawn of each home on the south side of the street, while the shepherds and sheep were moved to the north side. That same year, the original crèche figures were donated to Mooseheart, a nearby boarding school for disadvantaged children, and replaced with four life-size molded rubber statues purchased by the residents.

The following year, Fran Sibenaller built life-size camels for the lawns of new Lehnertz Avenue homeowners east of Ohio Street, and the association constructed six red candles to light each verse. With vacant lots no longer available, the manger scene was moved to Garfield Park at the east end of the first block of the display. Frank Zenner, father of one of the residents, oil-painted a magnificent 10' x 54' replica of the city of Bethlehem for a backdrop. Using a postcard as his model, he painted the scene sideways on fourteen separate panels. The replica was placed in the distance behind the manger scene, lit by two floodlights and a towering star.

The display had become so bright that an American Airlines pilot wrote a letter to the organizers saying that on clear nights during the Christmas season he took his plane a few degrees off its normal route when leaving O'Hare so his passengers could get an aerial view.

In 1979, residents of Lehnertz Circle, the neighboring cul-de-sac, decided to join their neighbors' effort. Wanting to make a unique contribution, they decided to show

Christmas from the eyes of a child. Using characters from the *Peanuts* comic strip, residents on the outside of the circle built displays showing children and their families preparing for Christmas while the inside circle depicted children enjoying the winter.

Though after over fifty years only a few of the original Lehnertz Avenue homeowners remain, the members of the light, crib, and shepherd committees haven't changed much from year to year and continue to refurbish the display as needed. The crèche now features sixteen figures, and there are four additional wooden Bible pages. A "Noel" sign and a 1950s choir have been added to Garfield Park. And the music is now controlled by a five-disk CD changer. Houses continue to sell very quickly in the three-block area because of its reputation, and new homeowners gladly inherit their part of the display.

Residents in the eighty-eight households of Lehnertz Avenue and Lehnertz Circle enjoy the exhibit as much as the onlookers in the 18,000 cars who visit it annually. On Christmas night the neighbors walk up and down the street wishing each other good cheer. Original committee member Fran Sibenaller says, "My children wouldn't know Christmas any other way."

2nd Sat. before Christmas–weekend after New Year's, 5:00PM–10:00PM (all night Christmas Eve and New Year's Eve). *From Broadway (Rt. 25), E on Forest Ave. 3 bl., S on Sheridan St. 1 bl., E on Lehnertz Ave.*

BATAVIA

2 943 BLUESTEM LANE

Walk under the candy-cane arch of Garran and Julie Sparks's yuletide display, and you've entered the land of inflatables. A straw-covered path leads visitors on a holiday trek through a colorful forest of cartoon characters, spinning carousels, snow globes, and storybook trees as gleefully bloated as Santa's tummy after a Christmas Eve of milk and cookies.

More surprises await as the path playfully winds around the house and to the backyard where a giant snowman and Santa Claus flank a sparkling 30-foot Christmas tree and lights dance to the beat of holiday tunes.

"First we set up the path. Then we plunk down all the big inflatables. Then the lighted trees. Then we fill

INFLATABLES IN CHICAGO WEATHER

Garran Sparks of Batavia recommends leaving inflatables on during light snows because the snow will melt around them, but turning them off during heavy wet snows because the snow will weigh them down and cause them to deflate anyway. And during cold weather, snow-globe inflatables should be left on or condensation will form inside.

in with all the little stuff and just keep going and going," Garran explains with a laugh. "The more the kids ooh and ah, the bigger the display gets."

Sun. after Thanksgiving–New Year's, (Su–Th) Dusk–9:00PM, (F–Sa) –10:00PM. *From Roosevelt Rd., S on Kirk Rd. 3 mi., W on Pine St. 1 bl., S on Woodlandhills Rd. 1 bl., W on Bluestem Ln. 1 bl.*

ELGIN

3 106 MONROE STREET

On the Sunday after Thanksgiving in 2000, Mike Arnold, recovering from a car accident two months prior, balanced himself with a cane outside his Elgin home and thought he was the luckiest man alive. Wearing a hard hat trimmed in colored bulbs and a sweatshirt that read "Foreman Mike,"

William Brown's Du Bois Avenue holiday display, which he continued until his early eighties, delighted Elgin residents for over twenty-five years and earned a decorating award named in his honor and a collection of thank-you notes he and his wife, Virginia, kept framed on the wall.

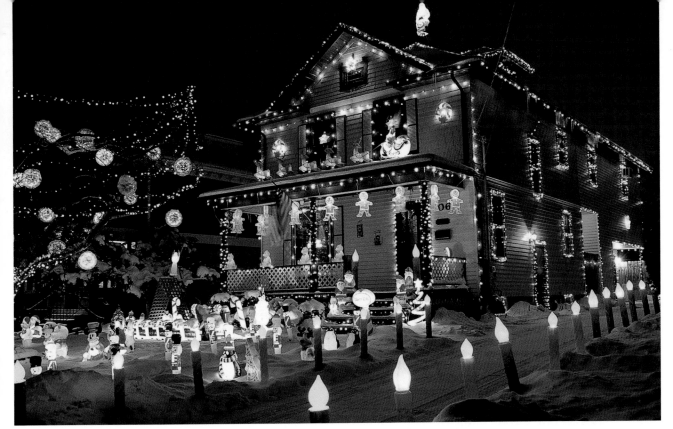

Colorful balls of lights, handmade by Pam Arnold, mark the number of years the family has lit their home for the holidays.

he watched with tearful eyes as fifty friends, neighbors, and their families put up the elaborate Christmas display he had dutifully assembled each holiday season for the last twenty-four years.

Though Lynn and Henry Pittner and Nancy and Art Schueneman had originally organized the event to be a surprise, it became obvious after discussing the plan with Mike's wife, Pam, that trimming a home with over 140 plastic figurines and 16,000 lights required more than eager helpers. Overwhelmed by the kindness of their offer, Mike spent the next two weeks hobbling around to repair the lights and decorations his sons and their friends had helped take down from the attic and drew ten sketches illustrating each section of the display to ease his friends' task.

On decorating day, the enthusiastic crew ceremoniously arrived at noon with an old-time hook and ladder to help reach the high spots. After Mike was presented with his official crew-chief attire, three men ascended the roof to install the plastic Santa that traditionally signaled the start of his holiday handiwork, and the festooning was underway.

Like Santa's workshop on Christmas Eve, the Arnolds' front yard was suddenly abuzz with gleeful workers draping lights from the gutters, dangling gingerbread men from the eaves, attaching teddy bears to the railings, and hanging ornaments in the tree.

Within five hours, the determined friends completed the task that normally takes Mike four to five weeks on his own. When the master switch was flipped, and the neighborhood "Christmas house" reappeared with its warm familiar glow, the crowd cheered and Mike cried. All joined in a potluck feast reveling in the recovery of their friend and the true spirit of the holiday season.
Dec. 5–Jan. 5, 4:30PM–12:00AM. *From State St. (Rt. 31), W on Highland Ave. ¾ mi., SW on Larkin Ave. 1 bl., S on Monroe St. 1 bl.*

LORDS PARK PAVILION

4 100 OAKWOOD BOULEVARD

The rich heritage of Elgin's multiethnic community is authentically portrayed in its annual exhibit "Touching on Traditions," sponsored by the Elgin Public Museum. Community members from all over the world share their winter customs in over sixty displays assembled in the lovely setting of the Lords Park Pavilion.

Exotic Christmas trees, from a small potted sapling decorating a French dinner table to a Honduran Christmas tree covered with balloons and dry moss, represent the diverse customs of the Christian holiday, while the colorful costumes of Korea's Folklore Days and the floating leaf cup of Thailand's Loi Krathong invite viewers to experience the unique celebrations of many cultures.

Dates and times vary annually. Admission fee. (847)741-6655. www.elginpublicmuseum.org. *From Liberty St. (Rt. 25), E on Irving Park Rd. ¼ mi., NE on Bode 2 bl., N on Oakwood Blvd.*

GENEVA

5 SHOPPING DISTRICT

For those whose Christmas shopping experience must include fresh winter air and snowy landscapes to put them in a festive mood, Geneva's shopping district should suit their fancy. Nearly one hundred shops, mostly housed in turn-of-the-century clapboard buildings, are trimmed with fresh greenery, red velvet ribbons, and twinkling white lights. Wrought-iron benches and old-fashioned gas lamps decked in wreaths and bows line the paths from store to store.

On the first Friday in December, the merchants host their annual "Christmas Walk," featuring extended store hours, free refreshments, roasted chestnuts, horse-drawn carriage rides, street caroling, and a tree lighting with Santa Claus and Santa Lucia.

Fri. after Thanksgiving–Christmas Eve, (M–F) 9:00AM–8:00PM, (Sa) –5:00PM, (Su) 11:00PM–5:00PM. (630)232-6060. www.genevachamber.com. *From 1st St. (Rt. 31), W on State St.*

6 813 CHEEVER AVENUE

Greg Parcell is a computer-networking specialist who loves Christmas. In 1999, while searching the Internet for items to add to his family's already notable North Pole–themed display, he came upon a self-described Christmas geek's dream—a programmable lighting device. Though two or three computer-savvy decorators in the Chicago area had already programmed their displays to flash, blink, and fade, only a handful of decorators nationwide had ever synchronized the movements to music. Upon purchase of a $400 Dasher system, Greg became a Chicago-area

pioneer in computerized holiday lighting, destined to spend ten to twelve hours programming each song.

The following Christmas season, penguins, polar bears, elves, handmade Christmas trees, and 20,000 lights, which once stood quietly glowing throughout the Parcells' yard, now danced to the beat of four holiday tunes transmitted to passing cars on an FM radio band. His holiday website, www.twasthenightbefore.com, helped spread word, and carloads of holiday sightseers soon lined the street.

By the next year, the family managed to top their techno-trimmings by featuring Santa himself delivering presents in the Parcells' living room. "Virtual Santa" checks his list, unloads his sack, enjoys his milk and cookies, and waves to visitors outside.

Within a few years, Greg more than doubled the number of lights, quadrupled the number of Christmas songs, and increased his computerized lighting capability twelve-fold, while gradually decreasing his electric bill by replacing his incandescent bulbs with energy-saving LEDs. He enhanced his website with a streaming webcam, which allows browsers to visit the display, and authenticated his North Pole effect with a lighting device that creates the illusion of a falling snow.

Despite Greg's technical wizardry, there seemed, however, to be no computerized solution to prevent rambunctious raccoons from repeatedly gnawing through his extension cords. The barks of the family's two 140-pound Newfoundlands proved to be the most effective, though old-fashioned, solution.

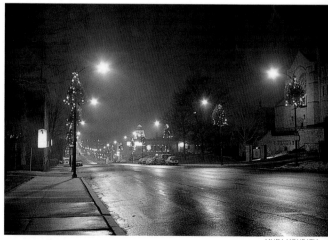

LINDA HONRATH

Holiday lampposts along Main Street in St. Charles set the stage for a spectacular electric parade.

Sun. after Thanksgiving–Dec. 31, 5:00PM–10:00PM.
"Toys for Tots" collection box on site. *From Batavia*
Ave./1st St. (Rt. 31), W on State St. 2 bl., S on 3rd St.
7 bl., W on Cheever Ave. 5½ bl.

ST. CHARLES

7 MAIN STREET

Over the river and through the shopping district, 102
lampposts on Main Street are each festively crowned with
a live Christmas tree (three trees made to look like one)
and 800 multicolored bulbs. On the Wednesday before
Thanksgiving at 4:50 p.m., a lucky child, chosen by the
mayor from the crowd, gets to flip the switch that sets the
street aglow.

Dressed for the holidays, the town flaunts its winter
finery by kicking off the season the following Saturday
with a spectacular "Electric Christmas Parade" and a host
of special events throughout its weekend celebration.
Fri. after Thanksgiving–New Year's. (800)777-4373.
www.dtown.org. *From Randall Rd., E on Main St.*
(Rt. 64) 1 mi.

SLEEPY HOLLOW

8 719 PIMLICO PARKWAY

Karen and Michael Kramer elegantly dress their
colonial home during the holidays in the formal
traditions of its time. Every window shines with
a glowing candle, symbolizing a warm welcome
within, and a wreath, the expression of everlasting
friendship. The air is filled with the wintry scent of
fresh evergreen garlands that drape the columned
portico and frame the carved doorway, as the twenty-
first century nudges in with white Italian lights that
sparkle on the shrubs below.

An avid gardener, whose color-themed flower beds
and French-style potager have been featured in local
garden walks, Karen accents her Christmas decorations
with natural materials from her own back yard and changes
the theme each year.

The care taken in decorating this home is apparent
in the enchanting result that reflects the warm Christmas
charm of an era past.

Natural trimmings and elegant taste create homespun charm at
the Kramer home.

1st weekend of Dec.–Jan. 6, Dusk–10:00PM. *From the*
Jane Addams Memorial Twy. (I-90), N on Randall Rd.
¼ mi., E on Saddle Club Pkwy. 1 bl., S on Arlington Pkwy.
1 bl., E on Pimlico Pkwy.

SOUTH ELGIN

9 300 BLOCK OF JUNIPER LANE

There's a magical feeling on Juniper Lane. Perhaps it's
the playfulness of strolling under a glistening tunnel of
homemade arches or the storybook vision of a fairyland of
lights. Maybe it's the sweetness of a free candy cane or the
warm hugs of Santa and Mrs. Claus in their furry red suits.
Or perchance it's the unexpected surprises in the front yards
of the twenty-two households along the way—a Christmas
tree crowned with a rotating disco ball, giant 9-foot candy
canes, a funny Santa splatted onto a garage door, or the
Star of Bethlehem high above a manger scene.

Since the early 1990s when Sugar Ridge subdivision
was built, neighbors on this block-long street have
informally gathered on weekends in whosever driveway
had the fire pit blazing and beer in the cooler. At one
such gathering in 1997 of the Carroll, Eubanks, Dreher,

Merkel, and Surges families, the notion of decorating their homes for Christmas was born. After what would become the annual kick-off party on Halloween weekend, the five families started out with trimmings of their own and candy canes lining their lawns.

The following year, when Rick Dreher and Al Eubanks built arches of lights to go over the sidewalks, half the neighbors joined the fun. By the fourth Christmas, the whole block was decorating, and Juniper Lane began its annual sweep of South Elgin's "Best Street" award. The street grew brighter still in 2004 when Rich and Kate Stumbaugh moved into the corner house at the southern end of the block—as their decorations grew brighter, the neighbors pleaded, "Stop, you're making the rest of us look bad." Residents who move off the block are now asked to include in their bill of sale, "Juniper Lane lights stay with the house."

At the height of the season, cars line the street bumper to bumper, and families by the dozens saunter down the sidewalks. The neighbors join Santa and Mrs. Claus passing out candy canes and offering holiday wishes, while collection boxes along the way accept canned goods for the South Elgin Food Pantry and donations for the Cal Sutter Foundation, a memorial fund for underprivileged children commemorating a local little-league player who died of leukemia.

At noon on Christmas Day, the neighbors meet in the middle of the street for a brief yuletide toast, "God willing and the creek don't rise, we'll see each other again next year." And there's no mistaking that the magical feeling in the air is the loving spirit of Christmas that gleams bright year-round on Juniper Lane.

Thanksgiving–New Year's, 6:00PM–10:00PM. Santa: 2 weeks before Christmas, (F–Sa) 7:00PM–10:00PM. *From Randall Rd., E on Hopps Rd./Spring St. 1 mi., S on McLean Blvd. ½ mi., E on N. Lancaster Cr. 3 bl., S on Juniper Ln. See photograph on p. 147.*

SUGAR GROVE

10 RICH HARVEST FARMS
DUGAN ROAD AT GRANART ROAD

From April to October, Rich Harvest Farms' acclaimed eighteen-hole private golf course handsomely accommodates its fifty members, amateur and professional golf tournaments, and Kids Golf Foundation events. But throughout the holiday season, the Rich Harvest Farms 1,820-acre estate is the site of a colossal holiday display that has been brightening Dugan Road for nearly twenty years.

Huge animated figures, including bears climbing candy canes, reindeer parachuting from a lift, and teddy bears having a snowball fight, line the edge of the golf course, while handmade decorations by a local artist and lights around the old schoolhouse trim other areas of the estate.

Property owner Jerry Rich is credited for picking out all the decorations himself—after all, he did design his own golf course.

Thanksgiving–New Year's, Dusk–10:00PM. *From Reagan Memorial Twy. (I-88), SE on Rt. 30 (Rt. 56), S on Dugan Rd.*

ARCHES OF LIGHTS

The folks on Juniper Lane in South Elgin make the arches for their cheery tunnel of lights using two 4-foot lengths of ¾-inch PVC joined to either end of a 10-foot length of flexible ¾-inch water line with pipe connectors and glue. They then attach an 18-foot rope light to the assembly using plastic pipe straps. To secure the arches, 4-foot lengths of rebar are pounded no more than 3 feet into the ground on either side of the sidewalk. With the male plug nearest the power source, each end of the assembly is slid over the rebar, forming an arch.

A 14-foot golfer never misses his putt at Rich Harvest Farms.

Opposite page: The multitudes of lights that trim the Wisemans' home in Barrington Hills (p. 157) required the electric company to enlarge the transformers that supply the neighborhood.

CHAPTER 10
Lake County

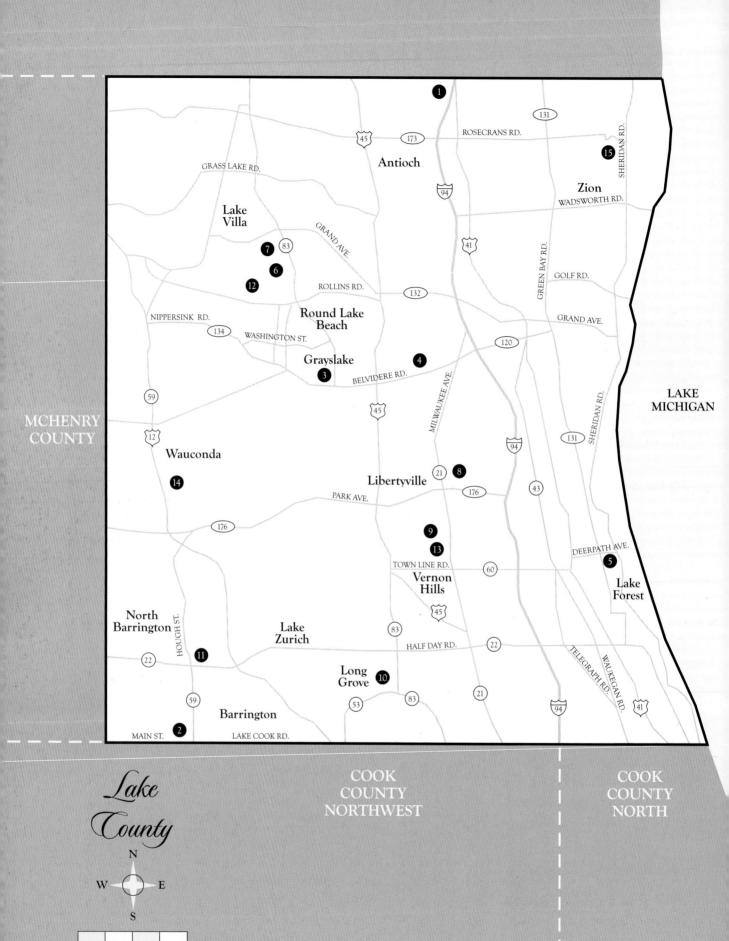

ROSECRANS RD.

131

45

173

Antioch

15

SHERIDAN RD.

94

Zion

WADSWORTH RD.

GRASS LAKE RD.

41

Lake
Villa

GREEN BAY RD.

GOLF RD.

7 83

6

GRAND AVE.

12

ROLLINS RD.

132

GRAND AVE.

NIPPERSINK RD.

134

Round Lake
Beach

120

WASHINGTON ST.

Grayslake

4

3

BELVIDERE RD.

SHERIDAN RD.

59

45

131

LAKE
MICHIGAN

12

Wauconda

94

14

8

Libertyville

21 8

MCHENRY
COUNTY

PARK AVE.

176

43

176

9

13

DEERPATH AVE.

5

TOWN LINE RD.

60

Vernon
Hills

Lake
Forest

North
Barrington

HOUGH ST.

Lake
Zurich

45

83

11

22

HALF DAY RD.

22

TELEGRAPH RD.

WAUKEGAN RD.

Long
Grove

10

59

21

Barrington

53

83

94

41

2

MAIN ST.

LAKE COOK RD.

Lake
County

N

W E

S

0 MILES 4

COOK
COUNTY
NORTHWEST

COOK
COUNTY
NORTH

ANTIOCH

1 17173 WEST EDWARDS ROAD

The fourteen horses, seven parrots, seven dogs, five swans, two llamas, two desert turtles, one miniature horse, and one goose that live on the 25-acre rural property of Terri Sween and Ron Rooding have obviously grown accustomed to moving over for new animals the couple have been known to rescue. So it comes as no surprise that the menagerie also adapts to the two polar bears, four penguins, four plastic reindeer, twelve lighted presents, 50-foot blow-up snowman, and tens of thousands of lights that share their space at Christmastime. Some have even joined the act by wearing antlers for the occasion.

Nov. 15–New Year's, Dusk–12:00AM. Visitors are welcome to enter the property and greet the animals when the gates are open. *From the Tri-State Twy. (I-94), W on Rosecrans Rd. (Rt. 173) ¼ mi., N on Hunt Club Rd. 1 mi., E on W. Edwards Rd. ½ mi.*

BARRINGTON HILLS

2 10 NORTH OLD HART ROAD

When giving directions, people will often say "turn right at the stop sign" or "go just past the railroad tracks," but in Barrington Hills directions frequently include "turn right at the Christmas house" or "go a mile past the Christmas house," regardless of the time of year. Trimmed with over 95,000 lights, the 12,000 square-foot Southern Country "Christmas house" on a 12-acre wooded lot well deserves its name.

Since 1998, homeowners Troy and Tina Wiseman have continued to employ the services of Ryan Bond, the electrician who originally wired their home, to outline the house and cover the bushes and trees with lights on over 5 acres of the property. Six men, along with the Wiseman's teenage sons and their friends, spend seven afternoons completing the task.

The stunning effect has resulted in more than a local nickname and notes of thanks the Wiseman family receives in their mailbox each year. A stranger knocked on their door one night and asked if he could come over with his granddaughter because he promised he would

The magnificent 150-foot tree of lights on the Fort Sheridan Water Tower spread its holiday cheer for nearly thirty years.

bring her to the house where Santa lived. On another night, a Spanish-speaking family was discovered standing amid the lights while having their Christmas photo taken by a professional photographer. Close to midnight one evening, two women, wandering through the yard taking pictures, said they were from Sweden and had never seen anything like this before.

In a switch of roles, it seems the lights are guiding travelers to the Wisemans.

Fri. after Thanksgiving–New Year's, Dusk–12:00AM. *From Hough St. (Rt. 59), W on Lake Cook Rd. 1 mi. See* *photograph on p. 155.*

FORT SHERIDAN

THE ARMY'S TOWERING CHRISTMAS TREE

May 28, 1993, marked the closing of Fort Sheridan, a U.S. Army base since 1892. Its 712-acre site housed ninety-four buildings that have been named historic national landmarks. Among them was the Fort Sheridan Water Tower, an operational storage facility that not only held 90,000 gallons of water but was the dramatic backdrop of the fort's annual 150-foot Christmas tree.

Built by the Owosso Carriage and Sleigh Company in Michigan in the early twentieth century, the Tsarpalases' rooftop sleigh was one of many varieties widely used before automobiles became popular.

Assembled by eight engineers in two days, the tree was formed by wrapping the strands of 3,250 7-watt colored bulbs around 29 cables that were anchored to the ground and tightly connected to an electrical box at the top of the tower. Since 1964, this magnificent tree, crowned with a 6-foot star, could be seen from the air as well as by thousands of spectators driving through or near this open post.

Families of army personnel and North Shore residents alike gathered annually at the fort's community center, where a lucky child, whose name was drawn from a hat, got to flip the giant switch that lit the 21,750-watt tree. (Actually, a ground engineer radioed a signal to the top of the tower where another engineer made the electrical connection at the precise moment the switch was flipped.)

Retired Lieutenant Colonel Hal Fritz, former public affairs officer, recalled with amazement that there was never a malfunction in timing the switch or in maintaining the display throughout the holiday season. He mused that ghosts often rumored to be wandering the barracks may have been "guardians of the electricity" for this much-loved community event. ❄

GRAYSLAKE

3 THE COUNTRY SQUIRE
19133 EAST BELVIDERE ROAD

For an elegant holiday meal in a rich traditional setting, The Country Squire offers a memorable treat. Built as a residence in 1938 for Wesley Sears, descendent of the famous

merchandiser, the seventeen-room home with hand-carved woodwork, brass hardware, and four fireplaces retained most of its original features when converted to a restaurant in 1954. Situated on a beautifully landscaped 13-acre estate, The Country Squire provides breathtaking garden views, making its numerous window tables a popular choice.

Throughout the yuletide season, this lovely restaurant exudes the holiday warmth of a Christmas dinner at Bob Cratchit's. Adorned in Victorian trimmings, the cozy rooms are bathed in the glow of the crackling hearths and the twinkling lights of the surrounding storybook garden. Holiday music played on a grand piano or sung by a choir on weekends adds to the homespun air, while a dinner of the famous beef Wellington is as tasty as a prize goose. **Christmas display: Thanksgiving–2nd week of Jan. Dinner hours: (Tu–F) 3:30PM–10:00PM, (Sa) –10:30PM, (Su) 2:00PM–9:00PM. Lunch hours: (Tu–F) 11:00AM–3:30PM. Sun. brunch: 10:00AM–2:00PM. Open Christmas and New Year's. Reservations recommended. Available for parties. (847)223-0121. www.csquire.com.** *From Rt. 45, W on Belvidere Rd. (Rt. 120) 1½ mi.*

4 17494 WEST HICKORY LANE

Though some Christmas decorators have been known to rent cherry pickers to light the tall branches of their trees, Steve Tsarpalas may stand alone in being the only decorator who borrows a commercial forklift for his trimmings. It seems the life-size sleigh atop his garage roof, which holds

a 4-foot lighted Christmas tree and a waving Santa Claus, is not of the hollow lightweight plastic variety, but rather a genuine 350-pound steel two-seater, complete with sleigh bells, brass hinges, and leather upholstery.

Steve purchased the antique sleigh in 2002 and determined to straddle it across the peak of his garage to prevent vandalism. Owner of Tsarpalas Enterprises, an underground tank-removal company, Steve initially used a variety of his own equipment to accomplish the feat.

When lifting it on his Bobcat left him short, he attempted using the Bobcat from the bed of his truck trailer. When that too proved inadequate, he lifted the sleigh on top of several skids on the Bobcat on the trailer. Exasperated, he and two friends muscled it up the remainder of the way.

For the next several years, he resorted to depositing the sleigh on the roof from the shovel of the industrial backhoe he uses to excavate tanks. But after installing a new driveway, which could no longer support a backhoe's weight, he borrowed a forklift from a friend who owns a rental-equipment company. Though it takes Steve several hours to pick up the equipment and transport it in his semi-truck, he can vertically raise the sleigh and horizontally move it into position in ten minutes.

In addition to the antique sleigh, the Tsarpalas display also features unique handcrafted reindeer and manger-scene figures. Much to Steve's delight, the furry, stuffed-animal-like characters are easily carried onto the lawn by his kids. **Dec. 10–New Year's, Dusk–12:00AM.** *From Milwaukee Ave., W on Belvidere Rd. 1 mi., N on Hunt Club Rd. ⅓ mi., W on Woodland Dr. 2 bl., S on Dartmoor Dr. 1 bl., W on Bluff Dr. 1 bl., S on Hickory Ln. ½ bl.*

LAKE FOREST

5 DOWNTOWN
AND WEST-SIDE BUSINESS DISTRICTS

Selling Christmas greenery has become an annual fundraising event for many a scout troop during the holiday season, but few have had the luck of Troop 48 of Lake Forest. Since the midnineties the boys have earned nearly 40 percent of their sales profits from one customer—the Lake Forest Chamber of Commerce, which annually purchases 1,200 feet of garland and two hundred wreaths to trim the business and shopping districts.

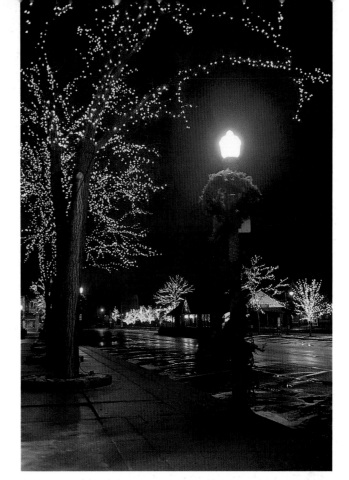

The wintry scent of pine graces the streets of Lake Forest thanks to the efforts of Scout Troop 48.

The sale does not come easy however. After workers hang thousands of white lights throughout town, the scouts and their dads arrive at 7:00 a.m. Thanksgiving morning to complete the decorating task by trimming the train station, the Chamber of Commerce building, three signs, and ninety-seven lampposts with their wares.

The following evening, the sounds of Christmas fill the air as the Lake Forest High School choral group leads thousands of spectators in yuletide carols. At 5:15 p.m. an acclaimed local citizen officially starts the season with a flip of a switch that turns Western Avenue and Market Square into a fairyland. Bathed in the twinkling glow, the choir sings the "Hallelujah Chorus," the crowd feasts on hot cider and donut holes, and the scouts of Troop 48 look on with pride, knowing they have not only beautified their town for the holidays but have earned themselves a summer trip to Camp MaKaJaWan.
Fri. after Thanksgiving–Jan. 6, Dusk–11:00PM.
Downtown: From Green Bay Rd., E on Deerpath Rd. ¼ mi., At Western Ave. West-Side: Everett Rd. at Waukegan Rd.

LAKE VILLA

6 123 BALSAM COURT

Avid decorators often find themselves the butt of two frequently used one-liners: "He probably works for ComEd" and "The Griswolds must live here" (in reference to the movie *Christmas Vacation*). In the case of the Deisenroth family of Lake Villa, the comments actually bear some truth—Ken Deisenroth does work for ComEd, and the little kids next door have heard their parents call the Deisenroths "the Griswolds" so often they think that's their real name.

However true the electric-company myth may be, Ken does not receive a discount on his electric bill as some may also joke. He does, on the other hand, reap other job benefits that help his display: 1) his night shift allows him to decorate the house before work when it's still light; 2) one of his co-workers, who is a welder, has fashioned custom-made brackets for all his rooftop displays; 3) as a guy who spends much of his workday doing pole repairs in a lift truck, decorating his roof does not induce the wobbly knees many decorators experience when over 10 feet off the ground; 4) the steel spools he has salvaged from wiring jobs have provided a nifty storage system for his lights; 5) his professional work habits result in meticulous wiring—all are staked down and out of sight; 6) redoing electrical wiring is a no-brainer—when the family won a ball of lights from the village, Ken replaced the lights and created a one-of-a-kind Santa Claus stuffing a ball in a basketball hoop; and 7) the skill seems to have rubbed off on the whole family—a broken lighted archway was restored on the living room floor like a community jigsaw puzzle in four days as each family member took turns attaching new sections of lights.

As far as the moniker goes . . . when the family lit their display for the first time last season, the kids next door were overheard shouting, "They added more lights!" Perhaps the Deisenroths are the Griswolds after all. **Thanksgiving–New Year's, 5:00PM–11:00PM.** *From Milwaukee Ave. (Rt. 83), W on Grand Ave. 3 bl., S on McKinley Ave. 6 bl., E on Balsam Ct. 1 bl.*

7 66 KEVIN AVENUE

As the parents of three youngsters, avid decorators Joe and Leah Antonucci strive to trim their home for the holidays in the quickest way possible. "We're lucky we can get the decorations up at all," the couple admits.

Rope lights seem to have provided the answer. "They're easier to work with," Joe declares, "less apt to tangle and more durable than mini-lights." Secured with plastic clips, they trim the roof, windows, siding, and garage. Joe uses them on the five arches he constructed to span the driveway. With one strand attached with cable ties to the length of three connected pieces of PVC, he can easily pull the pipes apart and fold them up like tent poles at the end of the season.

The rooftop "Happy Holidays" sign, spelled out in rope lights and permanently attached to two 4' x 8' sheets of plastic lattice, requires only six screws to secure to the roof. Dotted lampposts were easily made from 4-inch drainage piping (which has small holes already drilled along one side), a plastic light fixture attached to the top, and a strand of rope lights suspended inside.

It was only when the Antonuccis strayed from rope lights that they seem to have hit a snag in their decorating goal. Accustomed to the uniformity and hidden wires of their favored lighting, the couple has tried several ways to force the curious C-9s lining their drive and walkway

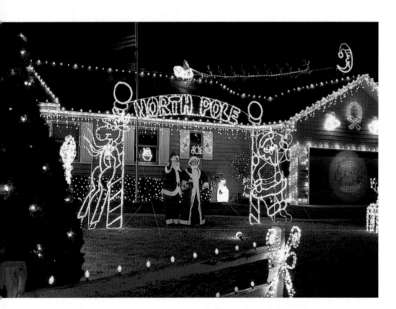

When the Deisenroths gratefully retrieved their missing Santa from the police station one Christmas season, they discovered the police officers had jokingly given him a booking number and taken mug shots.

to perform in similar fashion. When light stakes at even distances proved too time consuming, they created a wooden template to measure even spacing. When that too seemed inefficient, they drilled 5-inch lengths of ½-inch PVC into the ground to hold the stakes. When those became buried in grass and dirt, they sliced 4-inch irrigation tubing in half, drilled a hole every 6 inches, popped in the light sockets, screwed in the bulbs, hid the wires, and staked the tubing to the ground.

With the fate of this most recent idea still awaiting a verdict, it appears the only satisfactory idea may be to encase the bulbs at equal distances in clear plastic tubes. **Fri. after Thanksgiving–New Year's, Dusk–10:00PM.** *From Milwaukee Ave. (Rt. 83), W on Grand Ave. ¼ mi., S on McKinley Ave. 4 bl., W on Kevin Ave. ½ bl.*

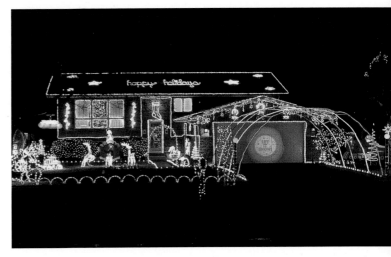

Spinning mobiles are among the homemade features of the Antonuccis' easy-to-assemble display.

LIBERTYVILLE

8 COOK MEMORIAL PARK
413 NORTH MILWAUKEE AVENUE

Throughout the summer Cook Memorial Park is the site of concerts, luncheons, an art fair, a farmers' market, and a fragrant rose garden. The lovely setting comes alive again during the holiday season when the Libertyville Parks and Recreation Department trims the park's towering evergreen with three thousand lights, and a handmade sleigh plays host to Santa during the town's "Dickens of a Holiday" Saturday events, which also include horse-drawn carriage rides around the park.

Aglow in the background is the Ansel B. Cook Home, a treasure of its own during the holidays and throughout the year. Built circa 1876, it is the former residence of state legislator and businessman Ansel B. Cook and his wife, Emily, who willed the estate to the village in 1920.

Though the building was used as the town library until 1968, the rooms were left intact. When restored by the Libertyville-Mundelein Historical Society, the house retained a Victorian air and left many visitors feeling as though they "could move right in." During the holidays the feeling is further enhanced by traditional decorations that radiate the warmth of a Christmas past for the home's "Victorian Christmas" celebration.

James Kay, who had been the mayor of Lake Zurich from 1989 to 1993, trimmed his Manor Road home with so many decorations inside and out that the furnace never kicked on until the display was turned off. On the Saturday before Christmas, a thousand visitors would walk through his home during his annual holiday open house.

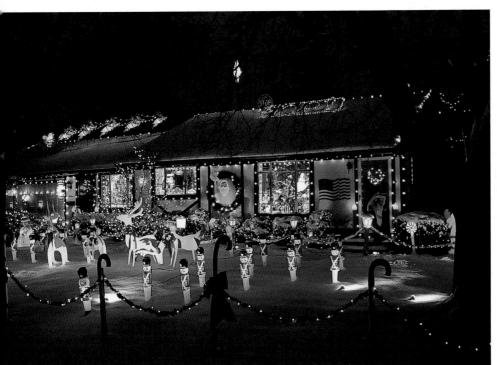

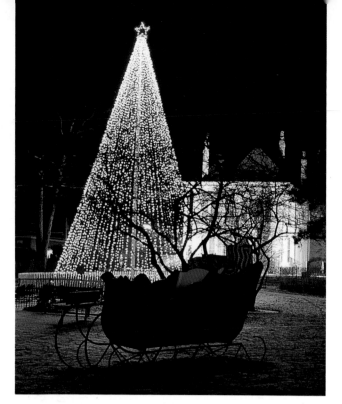

In 2003, a 25-foot evergreen moved from the yard of a local resident replaced the 8,000-light tree made by the Libertyville Parks and Recreation Department from the park's 40-foot flagpole.

Starched doilies of hairpin lace hang from the archways. Evergreen swags drape the stairwell, and pinecones adorn the seven coal-burning fireplaces. The Christmas tree is trimmed with tiny baskets and ivory-colored ornaments made from cotton batting. The dining room table is set for a family feast. And gifts, simply wrapped in white paper and red ribbon, fill an old-fashioned wagon that waits in the foyer for its journey around the neighborhood.

Beverly Schar, chairperson of the Acquisitions and Decorating Committee, comments, "We try to decorate as if a Victorian family were really living here." She and her committee probably receive the most authentic Victorian holiday experience of all—it is their duty to retrieve the decorations from the attic and store them again at the end of the season.

Park decorations: Fri. after Thanksgiving–New Year's, Dusk–2:00AM. Museum holiday hours: (Fri. after Thanksgiving) 7:00PM–9:00PM, (1st three Sat. and 1st two Sun. of Dec.) 12:00PM–4:00PM. Nominal admission fee. (847)680-0336. www.mainstreetlibertyville.org. *From Park Ave. (Rt. 176), N on Milwaukee Ave. ¼ mi. (At Church Ave.)*

9 DYMOND ROAD AND DOVER COURT

In the fall of 1986, Mary Ann and Richard Chamberlain visited each of twenty-eight homes in their two-block area armed with a plastic milk carton and a strand of Christmas lights. Their mission was to promote a decorating idea Mary Ann had seen in her hometown of Oklahoma City.

The couple explained to their neighbors that the materials could be made into inexpensive, reusable luminarias. When spaced uniformly around every sidewalk and driveway, the result would look as beautiful as the Christmas lanterns of New Mexico.

Neighbors were skeptical at first, but Mary Ann's enthusiasm led all to agree to her plan. The residents set to work collecting gallon milk cartons while Mary Ann and Richard made nearly a mile of outdoor lights spaced exactly 5 feet apart.

As the holiday season approached, four hundred of the necessary nine hundred milk cartons had been collected. The Chamberlains drove to a distant dairy bottler and purchased five hundred additional containers, which they packed tightly into their van. The bottles were distributed, along with light strands, sand, and an instruction sheet for each family. On the designated day, the neighbors lined their front yards with the milk jugs in little more than an hour.

When the sun began to set, the displays were lit, lingering doubts were instantly quelled, and Mary Ann's vision became a dream come true. Residents were impressed not only by the enchanting effect but by the feeling of togetherness the unanimous participation in the project had inspired. "We are proud to be associated with the neighborhood," longtime resident Dick Hoffman affirmed.

Over the years, the dazzling display, which only required an initial $30 investment from each homeowner, has earned much attention. Surrounding neighborhoods have imitated the idea, and curious spectators have been seen jumping from their cars to get a closer look at the inner workings. To keep the effort going, the luminarias stay with the house when it's sold.

Mary Ann admits that without snow the plastic containers can look a bit tacky, and another resident worries that an airplane might mistake the street for a landing strip. But on a snowy winter night, the glow of the

nestled milk cartons makes the entire neighborhood look like a glistening fairyland and lauds a spirit of togetherness that grew from a spark of an idea.

Sat. after Thanksgiving–New Year's Eve, 5:00PM– 10:30PM. *From Park Ave. (Rt. 176), S on Milwaukee Ave. 1 mi., W on Golf Rd. 1 mi., S on Dymond Rd. Note: Dover and Dymond are dead-end streets. To avoid having to back up in someone's driveway, park on Golf Rd.*

LONG GROVE

10 SHOPPING DISTRICT

Settled in the 1800s by German farmers, the Village of Long Grove has retained the flavor of its early years. From Route 53 visitors pass through a covered bridge to the historic shopping district, where all the buildings at the crossroads have been carefully preserved. Cobblestone paths wind their way to dozens of boutiques, galleries, restaurants, and specialty-food shops.

Throughout the holiday season, the stores are trimmed with traditional evergreen boughs, red bows, and glistening white lights, while the festive tinkling of chimes fills the air. Weekend festivities, which often include strolling musicians, live reindeer, and horse-drawn carriage rides, add to the old-time charm.

LIBERTYVILLE LUMINARIA

For every 50 feet of distance where luminarias will be placed, the following materials are needed: ten plastic gallon milk containers; 15 pounds of sand, kitty litter, or pebbles; 25 feet of outdoor C-9 lights with removable sockets; and one 25-foot extension cord.

Cut off the tops of the milk containers just above each handle. Cut a 1-inch "X" just below each handle. Fill each carton with 3 cups of sand, kitty litter, or pebbles.

Leaving every fifth socket in place, remove the remaining sockets from the light strand by prying open the tab at the base of the socket with a screwdriver. Tightly cover any holes in the wire with weatherproof tape. Reattach the extra sockets to the extension cord at 5-foot intervals.

Place the milk jugs in position 5 feet apart with the handles away from the sidewalk. Push a bulb into each "X."

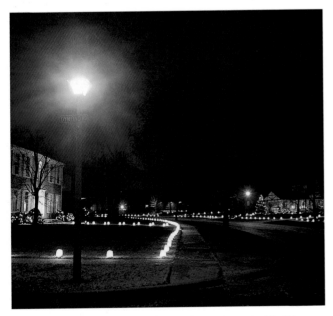

Hundreds of milk-carton luminarias create a magical holiday path on Dymond Road and Dover Court.

The charming shops of Long Grove beckon shoppers to share in an era past.

An elf cookie factory, a reindeer flight deck, and a horse-drawn carriage are among the homemade displays that trim the lawn of nonagenarian Vern Hagenbring.

Weekend before Thanksgiving–New Year's. Store hours: (M–Sa) 10:00AM–5:00PM, (Su) 11:00AM–5:00PM. (Restaurants open later. Some shops open late on Fri.) Closed Thanksgiving, Christmas, and New Year's. (847)634-0888. www.longgroveonline.com. *From Lake-Cook Rd., NW on Rt. 83 2½ mi., W on Rt. 53 1 bl., NW on Old McHenry Rd.*

NORTH BARRINGTON

11 100 OLD OAK DRIVE

"My Santa Claus! Mr. Hagenbring!" Vern seems to hear wherever he goes. Kids growing up in Arlington Heights between 1955 and 1967 remember him well as the former owner of Hagenbring's dime store, but, more importantly, as their childhood Santa Claus, who patiently listened to their Christmas wishes as they sat on his lap in the store window at Campbell Street and Vail Avenue.

It all started in 1946 when Vern and his wife, Trudy, decided to create the first big toy department in Arlington Heights in the basement of the store Vern's father had originally opened in 1922. They cleared out the stock room, painted the ceiling and walls to look like a big-top tent, and called it "The Toy Circus."

Nine years later during the busy holiday season, a local retired minister who had been playing Santa in the store for many years, called in sick. Vern took his place and had so much fun that when the minister decided not to continue, Vern happily added Santa Claus to his list of permanent managerial duties.

Though his gentle nature and twinkling blue eyes were ideal for the role, he made himself yet more convincing with a red woolen suit trimmed in real fur and a $300 genuine yak beard and wig, which he had marcelled every year.

After Santa arrived each evening at 5:00 p.m., the lines of children would grow 'til they wove through the aisles of store. Vern would let each child sit on his lap for as long as they liked and often stayed hours past the 9:30 p.m. closing time. He frequently determined what the kids were getting by watching a mirror that reflected signals from parents standing behind him. He gave each little boy a Tootsie car and each little girl a dolly.

By the midsixties, as big toy stores were on the rise and dime stores were in decline, the Hagenbrings gradually decreased their toy and dime-store business and increased their line of children's clothing and fabrics, which was Trudy's passion. When Vern suffered a heart attack in 1967, the toy department was discontinued completely, and Santa never returned. The couple managed the fabric and clothing store until it closed in 1999.

When Trudy took ill in 2003 and was confined to a wheelchair, Vern decided at eighty-six years old that it might be fun to start decorating the front yard of their 3-acre lot for Christmas. With Trudy sitting beside him in the garage and offering suggestions, Vern designed a 32-foot train with an engine, freight car, and caboose, built it out of ½-inch PVC, and trimmed it with lights. With Santa waving from the engine and the freight car brimming with gifts, the train received many compliments.

The following summer, Vern's wife of sixty-four years passed away. Not one to sit still, Vern continues to busy himself with his old hobby—going on road trips with his antique cars—and his new hobby—building Christmas decorations. "If you sit around, you get old, and I don't want to be a senior citizen yet," Vern explains.

Sticking to a North Pole theme (appropriate for a former Santa), he builds four new displays each year. At last count, when he was ninety, he had completed nineteen displays and had ideas for several more. He sketches a new layout every year, puts the stakes in position, and directs the setup from a golf cart, while his son-in-laws and a few neighbors do the heavy lifting.

Among the homemade elf and reindeer shops is "Santa's Mail Station" with twin mailboxes that have been filled each year with as many as three hundred letters to

Santa. When Vern's neighbor Krista Wordaz volunteered to write responses with several of her friends, he provided specially printed stationery imprinted with an old picture of a familiar dime-store Santa. Vern and his grandson drive 411 miles to have the replies specially postmarked in Santa Claus, Indiana.

"I miss being Santa Claus," Vern admits. "I think that's why I do this."

Wed. before Thanksgiving–Jan. 10, Dusk–10:00PM.
From Rt. 59, E on Rt. 22 ¼ mi., N on Honey Lake Rd. 3 bl., NE on Old Oak Dr.

ROUND LAKE BEACH

12 VILLAGE SPIRIT PUB
1123 NORTH CEDAR LAKE ROAD

When Village Spirit Pub opened in 1927, Round Lake Beach was predominantly a summer resort area for Chicagoans and ten years away from being incorporated as a village. As many such rural establishments of the time, the pub served not only as the local bar, but as the bait shop, gas station, and grocery store.

Under its fifth and current owner, Wayne Basica, Village Spirit Pub continues to thrive as a popular neighborhood bar. Though milk, gas, and minnows are no longer available, the pub offers league play in volleyball, horseshoes, pool, and darts, as well as bi-monthly band performances. Among the special holiday parties, St. Patty's Day is a particular favorite with the best corned-beef sandwich around.

Although its December 23rd "Festivus for the Rest of Us" Christmas celebration (à la *Seinfeld*) may feature the obligatory bare aluminum pole, the unique assortment of decorations that light the tavern inside and out reflect Wayne's affection for deeper traditions than even the tavern may hold.

Having grown up in the fifties on the northwest side of Chicago, Wayne recalls the brightly lit streets of the Candy Cane Lane neighborhood (see page 32) as one of his favorite childhood memories. Nostalgic for the same plastic figures he remembered as a child, he advertised for the old decorations in the former Candy Cane Lane neighborhood.

Since acquiring Village Spirit Pub in 2000, Wayne has trimmed the building with the delightful results. Though the forty-year-old "Jolly Polk Santas" and Pixie and Dixie elves are showing signs of wear, the resolute owner of the eighty-year-old bar said, "I just keep on repairing them."

Fri. after Thanksgiving–Jan. 8, Dusk–2:00AM.
From Milwaukee Ave. (Rt. 83), W on Grand Ave. (Rt. 132) ¾ mi., S on Cedar Lake Rd. 1¼ mi.

VERNON HILLS

13 "A WINTER WONDERLAND"
CUNEO MUSEUM AND GARDENS TOWN LINE ROAD AND MILWAUKEE AVENUE

The 75-acre wooded estate of the Cuneo Museum and Gardens plays magnificent host to "A Winter Wonderland," a dazzling drive-through light display presented by the Village of Vernon Hills and designed and assembled by the town's public works department. Begun in 1994, the event now features over two hundred lighted and animated figures along a picturesque 1½-mile winding drive and attracts over 20,000 carloads of spectators each season.

With a layout that changes from one year to the next, the magical ride may begin under twinkling arches of leaping reindeer or through the gates of a 35-foot castle. As the narrow roadway twists through woods, around a

Giant ornaments that once trimmed Effingham lampposts and Santa Clauses that were distributed in a 1960s Polk Bros. promotion are among the nostalgic trimmings at Village Spirit Pub.

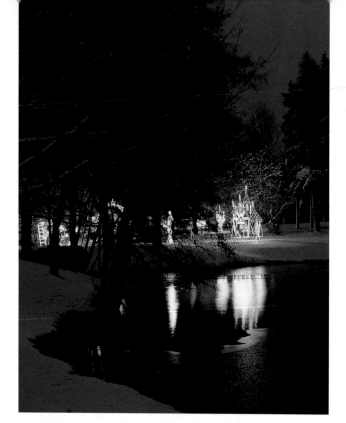

Colorful castles and playful elves add holiday magic to the beautifully landscaped grounds of the Cuneo Museum and Gardens.

pond, and over a bridge, hundreds of lighted tree trunks form glistening columns that lead the way to fun-filled surprises at every turn—monkeys swing from a tree, skiers glide down a hill, a waterwheel spins in a Victorian village, elves play peek-a-boo, teddy bears do cartwheels, and a giant rocking horse sways to and fro.

Amidst the playful scenes, the drive happens upon the magnificent gleaming facade of the Cuneo Mansion itself. Built in 1914 for Samuel Insull, founder of the Commonwealth Edison Company, and purchased in 1937 by John Cuneo Sr., founder of Cuneo Press and Hawthorn Mellody Dairy, the Venetian-style building is one of the few remaining manor homes of twentieth-century gentleman farmers who settled in the area. Designed by renowned architect Benjamin Marshall, who also built the Edgewater Beach and Drake hotels, the mansion also houses a fine collection of art once owned by the Cuneo family. The Cuneo Mansion and its resplendent gardens, designed by prairie-style landscaper Jens Jensen, are open for tours throughout the year, but those who wish a special holiday treat are invited during select days in December to tour the mansion bedecked with a Christmas tree in nearly every one of its eighteen rooms.

Winter Wonderland: Day after Thanksgiving–Sat. after New Year's, 6:00PM–10:00PM. Closed Christmas Eve, Christmas, and New Year's. Admission fee. (847)367-3700. www.vernonhills.org. Museum tours: Dates and times vary annually. Admission fee. (847)362-3042. www.cuneomuseum.org.
From Milwaukee Ave. (Rt. 21), W on Town Line Rd. (Rt. 60) ¾ mi., N on Lakeview Pkwy. ¾ mi.

WAUCONDA

14 530 FARMHILL CIRCLE

In the wee hours of a fall night in 1993, Dave Jakubek lay sleepless in bed thinking about his Christmas decorations. Suddenly struck with what seemed like a brilliant idea, he wakened his wife, Tina, and said, "What if I make a giant snowman?" To which she summarily replied, "Yeah, sure, fine, go back to sleep." Accustomed to her disbelief that a genius lay beside her, Dave stayed awake all night calculating the materials, techniques, and manpower he would need to accomplish the feat.

As co-owner of Dave & Jim's Auto Body in Elk Grove Village, Dave was no stranger to fabrication, nor was he at a loss for materials or consulting experts. For the next several days, he picked the brains of everybody he knew to determine the best plan. "It may have only taken three weeks to build, but I probably did a month's worth of thinking," Dave says.

He turned to his friend Steve Burval, owner of JB Metals in Des Plaines. Using Steve's metal bending apparatus and Dave's welding equipment, the two men bent and welded ⅜-inch steel strapping material to form balls 5, 4, and 3 feet in height. They welded a 1½-inch pipe in the center of each and chicken wire around the entire surface.

"I probably called a hundred different people—welders, painters, and car-repair guys—about how to make something look like snow," Dave said. "I finally talked to a guy in the semi-truck repair business, who told me about some two-part spray stuff they use to insulate refrigerator cars that comes in bulk."

By covering the balls with shrink wrap, a ½-inch layer of the insulation material, a coat of latex primer, and two coats of white automotive paint, Dave was able to

achieve a snowy effect that would do Frosty proud. He built a stovetop hat from a 3-gallon plastic flowerpot, carved buttons from Styrofoam, and fashioned a scarf out of 10 yards of material. To prepare for securing the round-bottomed figure, he poured a concrete footing in the front lawn and installed a 1-inch pipe in a sprinkler valve box.

While Tina was out running errands, Dave and several guys from work sneakily transported the pieces to his house. They attached a 13½-foot matching steel pipe to the one in the valve box and slid each of the 15- to 20-pound balls and the hat over the standing pipe. Four lengths of plastic-coated aluminum clothesline were then wrapped around the top of the pipe and secured to the ground with 12-inch nails. After admiring his achievement, Dave illuminated the snowman with six spotlights and returned with the men to his shop.

Shortly thereafter, Tina called Dave on her cell phone. "I can't get to the house. It's blocked by a line of cars. What did you do?" When she finally realized the cause of the commotion, she was stunned. "I thought he was going to make a 6-foot wooden snowman. I should have known better. Dave never does anything small."

The following year she asked Dave to make a matching snowlady. The snowchildren soon followed.

1st Sat. of Dec.–Sat. after New Year's, 5:00PM–10:30PM. *From Rt. 176, N on Rand Rd. (Rt. 12) ¾ mi., E on Cook St. 1 bl., N and E on Farmhill Cr. ¾ bl.*

ZION

15 "FESTIVAL OF LIGHTS"
EMMAUS AVENUE AND
SHILOH BOULEVARD

Fifty miles north of downtown Chicago, the city of Zion is giving Macy's some stiff competition when it comes to animated holiday displays. Along a walking path sparkling with four hundred lighted evergreens, "Kringle's Kingdom" features over eighty delightful dioramas designed and built by local volunteers. They include such whimsical scenes as Santa arriving for a chiropractic appointment at "The Backcracker Suite," a reindeer lying back for a shampoo and set at "Aunt Lers Beauty Salon," and a family of mice in winter attire posing for the annual Christmas card at "Say Cheese."

The outdoor exhibit is cleverly displayed at the Port Shiloh swimming pool facility, where the entryway is disguised as a giant castle gate, and the wading pool and slide masquerade as the loading dock and conveyor belt for Santa's warehouse. Toy soldier cutouts and glittery thrones are provided for picture-taking, but the real photo op is at "2500 Reindeer Lane" where kiddies can visit with Santa in one of the best holiday cottages around, thanks to the Chicago Regional Council of Carpenters Apprentice and Training Program, whose students built the structure as a training project.

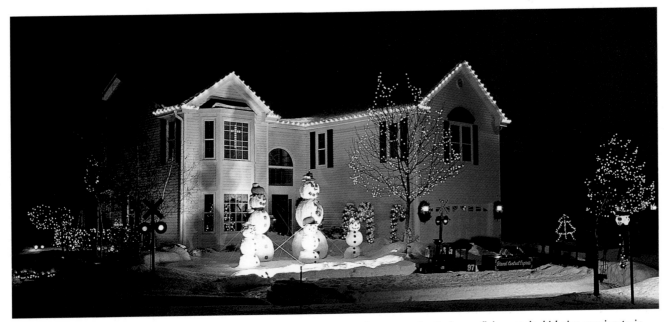

The Jakubeks' snow family takes center stage amid giant homemade candy canes, animated snowflakes, and a kid-size moving train.

Though "Kringle's Kingdom" alone is worth the trip, it is only a part of Zion's fun-filled "Festival of Lights," which also features a ¼-mile drive-through display (27th Street and Enoch Avenue), *'Twas the Night before Christmas* giant storybook (27th Street and Emmaus Avenue), the twenty-three-room Shiloh House holiday tours (1300 Shiloh Boulevard), and rides on the Holly Trolley to the lighted streets of downtown Zion. All the exhibits are free, though donations are cheerfully accepted. "You can't charge people to visit Santa," says Diane Burkemper, deputy city clerk and mayor's executive assistant, who coordinates the annual event.

Though Zion had been trimmed in past Christmases with a handmade miniature village and large lighted displays, former mayor Chuck Paxton in 1996 envisioned something of a grander scale. Inspired by a visit to the popular "East Peoria Festival of Lights" (see page 185), he imagined a similar drive-through display with hand-built lighted floats and perhaps a similar walk-through exhibit (which East Peoria has since discontinued). However, when purchased decorations for the drive-through and handmade exhibits for the walk-through proved to be the more practical idea for the city's volunteers, "Kringle's Kingdom" was born three years later and delightfully so.

Under Diane's direction, local retired carpenters begin building six to seven new display cases in July each year, using old pop-up trailers as a base for the larger displays. By September, volunteers Alene and Tom Backis, Donna and Frank Flammini, Dee and Don Stratmoen, Angie Broker, Rob Spanton, and Lorna Yates start creating the imaginative scenes that have been dancing in their heads all year. By the first of October, Diane spends her mornings, six days a week, supervising the setup, which employs over two thousand hours of free labor by public service workers under the direction of Blake Rogers, supervisor of the City of Zion Public Service Program. "Without their assistance the event would not be possible," Diane notes.

On the second Friday after Thanksgiving, the festival begins at Shiloh Center in equally imaginative style. Santa makes a grand entrance secretly sliding down a chimney and emerging through a fireplace to parade with a cast of costumed characters and hundreds of onlookers to his home in "Kringle's Kingdom."

"The Bobsled Repair Shop" is one of dozens of delightful animated scenes along the lighted forest of "Kringle's Kingdom" in Zion's "Festival of Lights."

2nd Fri. after Thanksgiving–Dec. 30, 5:00PM–9:00PM. Free admission and parking. Donations welcome. Wheelchair and stroller accessible (except Shiloh House). (847)746-4012. www.cityofzion.com/fol. *From Tri-State Twy. (I-94), E on Rosecrans Rd. (Rt. 173) 6 mi., S on Emmaus Ave. ½ mi., W on Shiloh Blvd. (25th St.)*

SO YOU CAN'T AFFORD A BUCKET TRUCK

To get lights high into trees, former Chicago decorator Jon Gausselin recommends making a light-hanging tool by partially pounding a nail into the side of a 1x1 pole. As the tree grows, the pole can be lengthened by attaching additional 1x1s with nails or screws. He has successfully used poles as long as 40 feet.

Dennis O'Neil takes fifteen large metal washers for weight, ties a nylon string through the center, and fastens the washers together with duct tape. He then takes the other end of the string and ties it to the end of a light strand. Being careful to watch his aim, he throws the wad of washers (and the lights with them) into his tree and, hopefully, over a branch.

Opposite page: A backlit silhouetted manger scene is the focal point of Mark Pumper's handcrafted display in Oakwood Hills (p. 173).

CHAPTER 11
McHenry County

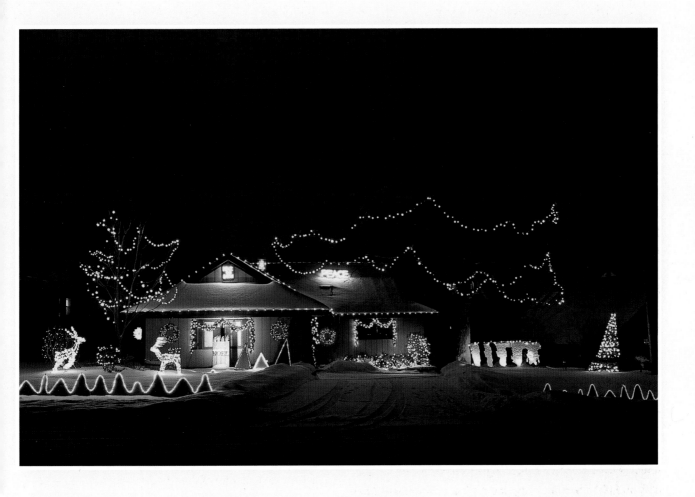

DIVISION ST.

14

173

O'BRIEN RD.

47

12

WILMOT RD.

RAMER RD.

17

31

49

12

173 BRINK ST.

RINGWOOD RD.

GREENWOOD RD.

2

14

23

BELVIDERE RD.

47

120

LAK
COUN

30

8 **Woodstock**

176

14

31

**Oakwood
Hills**

4

6

7

CRYSTAL LAKE AVE.

**Crystal
Lake**

WOODLAND RD.

SILVER LAKE RD.

Cary

47

14

1

90

23

20

45

MAIN ST.

2

JANE ADDAMS MEMORIAL TWY.

HUNTLEY RD.

ALGONQUIN RD.

8

3

CARY-ALG. RD.

5

12

HANSON RD.

**Fox River
Grove**

McHenry
County

N

W E

S

0 MILES 5

CARY

1 61 WEST BURTON AVENUE

Steve and Chris Detwiler had been adding one new item to their outdoor Christmas display for nearly twenty years when in 2002 they finally considered entering the town's holiday decorating contest. But with a small front yard and house compared to others in town, they decided to increase their chances by renting a bucket truck to light their 40-foot elm tree.

Confident with their efforts, they awaited news of their prize. But it never came. The following Christmas the Detwilers didn't enter the decorating contest, by then an understandably sore subject.

In November of 2004, while looking through a stack of old papers, Steve discovered in an unopened envelope an award from the village for "Best Overall Display in 2002." The Detwilers had a good laugh, all was forgiven, and they went on to win prizes the next three Christmases in a row. **2nd weekend of Dec.–Jan. 2, 6:00PM–10:00PM.**
From Cary Algonquin Rd., SE on Crystal St. (Rt. 14) ½ mi., N on First St. 2 bl., NW on Burton Ave. ½ bl.

2 116 CHARLOTTE PLACE

High on the list of decorating frustrations is running out of lights when there's still plenty of Christmas tree to spare. The decorator is faced with two options—start over or buy more lights. In many holiday seasons of decorating their outdoor yew bush, Jerry and Mary Adee have faced this dilemma nearly every year and opted for purchasing lights. What began in 1986 as a sparkling bush of 2,000

The Adees' abundantly lighted yew bush earned an award as the "Best Decorated Christmas Tree" in Cary.

reds, greens, and yellows now dazzles with 8,000 bulbs and counting.

The effect is so adorable that the 18-foot yew has earned the name "The Gumdrop Tree" from admiring neighbors. Mary has a framed photograph hanging at the office, and Jerry adds jokingly, "I just carry a photocopy of the electric bill." **Thanksgiving weekend–Jan. 6, 5:00PM–11:00PM.**
From Rt. 14, W on Main St. ½ bl., S on Spring St. 2 bl., W on Charlotte Pl. ½ bl.

3 945 RIDGEWOOD DRIVE

Those who want a taste of the holiday lights at the Chicago Botanic Garden (see page 64) without having to pay the entrance fee can visit the home of the Schweigel family in Cary. After viewing the Garden several years ago during the Christmas season, Rob was so impressed by the elegantly trimmed trees wrapped in lights he decided to try to create the same effect in his front yard.

With one-fourth of her display purchased at local garage sales, Chris Detwiler is in the habit of inviting the former owners of the decorations to view them at their new home.

Manned with outdoor power strips, a pile of extension cords, and dozens of boxes of commercial-grade Italian lights, Rob wound strands around the trunks of six trees from the bottom up, as high as a 6-foot ladder would carry him. The effect was so pleasing that he now wraps the five maples, two honey locusts, one pear tree, one birch, and nine evergreens that grow in his front and back yards, as high as a 12-foot ladder will carry him.

Though his efforts have earned him honors in the local decorating contest, Rob suggests that you may want to spend a few bucks and go the Botanic Garden too—they have a much bigger yard.

Thanksgiving–New Year's, Dusk–10:00PM.
From Rt. 14, SW on Cary Algonquin Rd. 2 mi., NW on Fox Trails Dr. 1 bl., NE on Ridgewood Dr. 3 bl.

CRYSTAL LAKE

4 416 TALISMON COURT

"Well, hello. Looks like Blinky got the generator running," Santa says, as he waves to his audience from the only part of the house that is lit. The jolly old elf and supposed homeowner continues to unfold the humorous tale of

The Schweigel home is elegantly trimmed with white lights, window wreaths, a cradled manger, and a few items for the kiddies.

his struggle to keep his electrical power going between a series of musical "performances" by decorations on the house and lawn—a polar bear appears to ski across the yard, a Santa glides onto the runway in a helicopter, elves harvest peppermints from a tree, and Santa Clauses light in time to the song "Must Be Santa."

The entertaining twenty-minute show, which takes computerized lighting to a new inventive level, is the handiwork of the actual homeowner Brian Coy (with the assistance of his ever-patient wife, Debbie, who even volunteered to be a board member of the neighborhood association just to ensure her husband could put up his

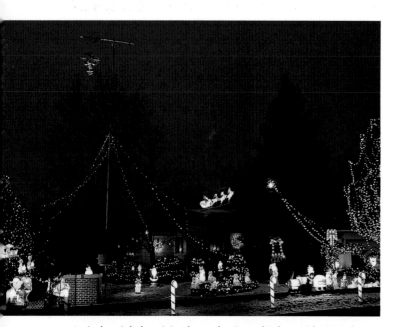

An industrial electrician by trade, Crystal Lake resident Warren Spencer amused visitors from 1983 to 1995 with a front yard alive with his mechanical creations—a moving train, a rocking horse, dancing toy soldiers, kissing penguins, a sleigh and reindeer that ascended to the rooftop, and a parachuting Santa Claus.

THE NORTH POLE MOVES FARTHER NORTH

After running an online ad for old outdoor holiday decorations, Brian Coy of Crystal Lake received an e-mail from a woman in Chicago who had inherited a North Pole sign from her mom but could not use it in her apartment. "I'd love to see your neighborhood kids enjoy it as much as I used to," she said. The only problem was how to get it to Brian. At 11:35 a.m. one Thursday, the Union Pacific Northwest made a stop at the Crystal Lake station. A Chicago woman, en route to visiting a friend in Woodstock, stood in the entryway of the third car with a North Pole sign in her arms. As the doors slid open, a man walked swiftly down the platform, counting off the cars until he saw her in doorway. In but a minute, the strangers exchanged greetings, thank yous, goodbyes, and a North Pole sign that just arrived at its new home.

A Unique Christmas Gift Idea

As a high school student, Mark Pumper earned money decorating neighbors' homes. Having honed his craft, he now expertly decorates a few of his friends' trees with lights as his Christmas gift to them.

The holiday display that formerly filled the Mack family's front lawn across from Saint Thomas Church in Palatine spreads out nicely on a 3-acre lot in McHenry County.

display early). With a history of creative writing and theatrical performance, a degree in film and video from Columbia College, and a minor in animation inspired by the television classic *Rudolph, the Red-Nosed Reindeer*, it seemed inevitable that this full-time Web designer would use his computerized lighting hardware as a creative outlet to spin an original holiday tale. And with only a 100-amp service on his house and over 200 amps of Christmas decorations, it appears the tale is true.

Sat. after Thanksgiving–Sun. after Christmas, 6:00PM–10:00PM. www.985thesnow.com. *From Rt. 31, W on Rt. 176 1¾ mi., N on Walkup Rd. 3 bl., W on Talismon Dr. 1 bl., N on Diamondo St. 1 bl., E on Talismon Ct. 1 bl.*

FOX RIVER GROVE

5 217 Algonquin Road

On the Saturday after Thanksgiving, snowmen, Santas, polar bears, and tin soldiers begin peeking through the branches on the 3-acre wooded lot of the Mack family home. Like busy little elves, Dave, Laura, and their two teenage children, Nina and Jonas, carry dozens of blow-ups, fifty blow mold figures, and thirty-two plastic containers filled with lights and extension cords up the hill from the barn below.

When everything is sorted and roughly put in position, each family member sets to work at their assigned annual tasks—Dad's in charge of the roof and the music, Mom figures out the electrical, Nina sets up the toy soldiers and does nightly bulb patrol, and Jonas hangs the Italian lights. Though three-fourths of the family completes their outdoor setup tasks after nine days of work, Jonas has been known to persevere 'til Christmas Eve, as long as he can find a few more lights and an available extension cord.

Sun. after Thanksgiving–Jan. 6, Dusk–10:00PM. Visitors are welcome to circle the drive but asked to kindly stay in their cars. *From Rt. 22, NW on Northwest Hwy. (Rt. 14) ½ mi., SW on Algonquin Rd. 1½ mi.*

OAKWOOD HILLS

6 106 Lake Shore Drive

Mark Pumper, a licensed clinical psychologist, does not claim to be an artist but has dabbled in artistic projects since minoring in art in college in the early 1980s. Over the years he has practiced some art therapy and toyed with photography, but his most artistic venture of late has been building his front-yard Christmas display.

Using a limited palette of green, blue, purple, gold, and clear lights and plywood as his medium, Mark creates unique abstract silhouettes that reflect his own creative style.

His original rolling mountain peaks and triangular evergreens set the stage for his silhouetted manger scene while handcrafted messages of peace twinkle from the roof and yard. "I wanted to capture what I thought was the true meaning of Christmas—a peaceful image. Creating the decorations myself seems more personal and has more of a message," Mark explains. Spoken like a true artist.

Dec. 1–New Year's, 6:00PM–11:00PM. *From Northwest Hwy. (Rt. 14), N on Silver Lake Rd./Lake Shore Dr. 2½ mi. See photograph on p. 169.*

The Alfrejd display is a beacon of holiday cheer amidst winter's barren trees.

7 7 Woody Way

When Mark Alfrejd's company downsized in 1999, he lost not only his job but the eight weeks of vacation that afforded him the time to decorate his home for Christmas. With a full week off before Thanksgiving, Mark had no problem trimming the house with five thousand big lights, renting a cherry picker to erect a huge Christmas tree, competing with his neighbor down the street, or assembling the 25-foot sleigh and reindeer, 12-foot snowman, rooftop cross, and giant "Merry Christmas" sign he had built during vacation days past. With the help of his wife, Lecia, and their daughter, Katie, the Alfrejd house was handily aglow

LINDA HONRATH

Woodstock's historic opera house glistens with white lights and old-fashioned charm in the town square.

by the week after Thanksgiving. Mark even found time to dress as Santa and surprise passersby as he suddenly moved from his frozen position among the decorations.

But life has changed since Mark started a home-remodeling business with his busiest season right before the holidays. And Katie has married and started a decorating tradition of her own in Plainfield, so Lecia has had to do much more decorating alone.

Though more subdued, the Alfrejd's display is still noteworthy, brightening their dimly lit wooded road. And despite their lack of time and loss of manpower, their former decorating spirit is still obviously alive—they shopped at four stores in two different states to acquire the seventeen green trees that light their drive.

Dec. 1–Dec. 30, Dusk–12:00AM. *From Crystal Lake Rd., N on Silver Lake Rd. 5 bl., E on Woodland Rd. (Rawson Bridge Rd.) ⅓ mi., N on Woody Way ½ bl.*

WOODSTOCK

8 Woodstock Historical Square

The bell tower of the steamboat-gothic opera house stands tall amid the old-fashioned shops that surround the town square. Horse-drawn carriages bounce along the cobblestone streets as a Dickens chorus sings from the park gazebo festooned for the holidays.

Though the scene may appear to be from an era past, Victorian charm still thrives in this town, founded in 1844, which was recently named a "Distinctive Destination" by the National Trust for Historic Preservation.

White lights outline every shop in the square and glisten from every tree with a subtle gleam of modern times. A romantic setting for holiday shopping, the square offers restaurants, Christmas shops, craft stores, antiques, and boutiques, as well as "Groundhog Days" walking-tour maps.

Fri. after Thanksgiving–Sun. after Groundhog Day. Dates and times of special events vary annually. (815)338-2436. www.woodstockilchamber.com. *From Rt.14, N on Rt. 47 1½ mi., W on Calhoun St. 6 bl.*

Opposite page: A colorful, chubby penguin is one of dozens of shimmering floats built by volunteers for the "East Peoria Festival of Lights" (p. 185).

CHAPTER 12
Will County & Outlying Areas

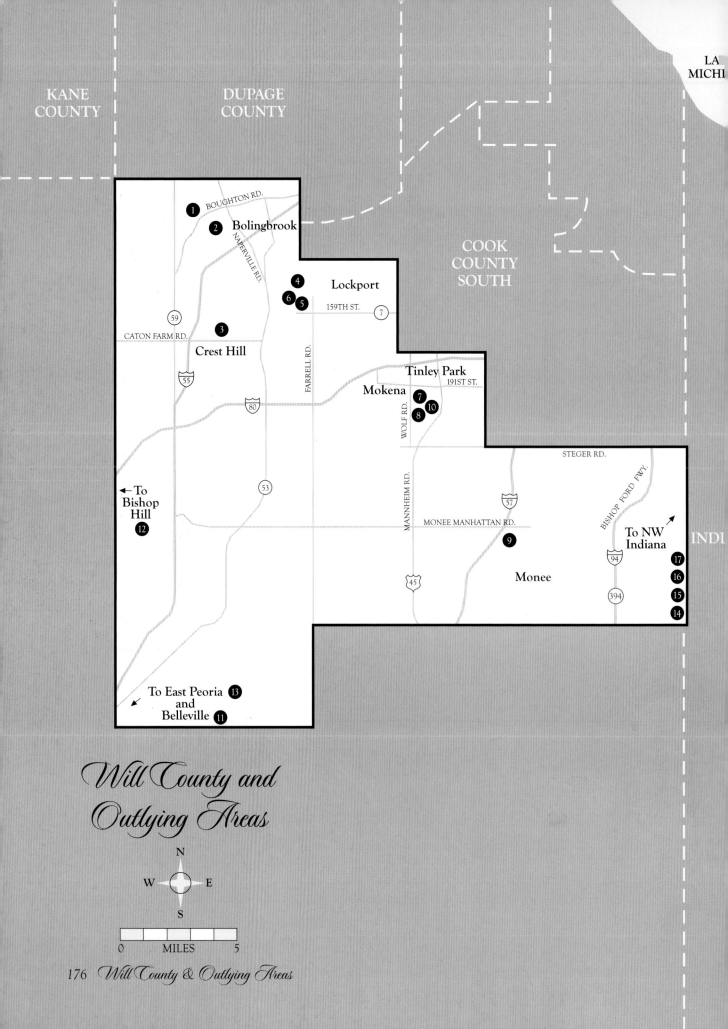

KANE
COUNTY

DUPAGE
COUNTY

LA
MICHI

COOK
COUNTY
SOUTH

BOUGHTON RD.

① 1

② 2

Bolingbrook

NAPERVILLE RD.

④ 4

Lockport

⑥ 6 ⑤ 5

159TH ST.

⑦ 7

59

CATON FARM RD.

③ 3

Crest Hill

FARRELL RD.

55

80

53

←To
Bishop
Hill

⑫ 12

Tinley Park

191ST ST.

Mokena

⑦ 7 ⑩ 10

⑧ 8

WOLF RD.

STEGER RD.

MANNHEIM RD.

57

Monee Manhattan Rd.

BISHOP FORD FWY.

To NW
Indiana

INDI

⑨ 9

94

⑰ 17

⑯ 16

45

Monee

394

⑮ 15

⑭ 14

To East Peoria ⑬ 13
and
Belleville ⑪ 11

*Will County and
Outlying Areas*

N

W ✦ E

S

0 MILES 5

BOLINGBROOK

1 140 Beaver Creek Drive

It's hard to imagine that a jolly old Santa doll with a pudgy nose and rosy cheeks, who's dressed in an ankle-length robe and slowly waving a miniature Christmas tree, could instigate a habit that doubles the electric bill, sends a couple into a postholiday bargain-shopping frenzy, and requires ninety hours of labor on an annual basis. But once Judy and Brian Belva bought their first animated Christmas figure and discovered the joys of decorating for the holidays, the pain seemed well worth the gain.

Adding to their collection every year, the couple has acquired over fifty animated figures, as well as many others that stand still. "We stopped buying new items, but if we see something at a garage sale, we usually still grab it," Brian admits. Though windows had provided sufficient space at their first home on Lawndale Avenue in Chicago, the dolls expanded into their gazebo at their Eliot Lane home in Naperville and have taken over the garage, patio, and portable trailer at their current home in Bolingbrook.

"Brian builds the display cases, and I crawl inside and set everything up," Judy explains. On one side of the garage, snowmen, penguins, and children frolic on a slippery ski slope, while on the other side Santa and his band of elves prepare toys in a colorful workshop. Alongside the driveway, Scrooge, Tiny Tim, and old-fashioned carolers mingle on an English streetscape. A sidewalk lighted with glistening snowballs and glittery arches leads visitors to the backyard, where the patio has been transformed into a country scene of Victorian characters out for a horse-drawn sleigh ride on a snowy day. The acrylic windows and wooden panels that Brian uses to make the display cases are labeled and numbered for easy assembly every year, and each scene is enhanced with a lovely backdrop painted by Lamar "Sparky" Lundburg, a friend of the Belvas and an art teacher at Badger High School in Lake Geneva.

On the Saturday before Christmas, Santa stops by to hear children's wishes and share hot cocoa. The Belvas take advantage of his celebrity by accepting donations for the "Make a Wish" foundation. "We are all still kids with special memories," Brian concludes. "We just want everybody to remember those moments when they see our display."
Dec. 5–Jan. 6, (Su–Th) 4:30PM–10:00PM, (F–Sa) –11:30PM. Santa: Sat. before Christmas, 5:00PM– 8:00PM. *From Weber Rd., W on Boughton Rd. ¾ mi., N on Hickory Oaks Dr. 1 bl., W on Beaver Creek Dr.*

"Hands down, your house is the best from the air," said a neighbor after flying over the Frohns' high-wattage display.

2 1443 WEST BRIARCLIFF DRIVE

Although it's a well-known scientific fact that no two snowflakes are alike, this Bolingbrook home could prove otherwise. Trimmed on all four sides with 40,000 lights and an assortment of other decorations, the house and corner lot are dotted with a collection of over eighty identical snowflakes that twirl from the trees, blink from the windows, dance across the roof, and randomly sparkle in the crisp winter air like a lightly falling snow.

The versatile, long-lasting, 14-inch snowflakes were the invention of homeowners Jack and Laura Frohn, who designed the decoration in 2002. The original snowflakes (which also trim the house) were painstakingly cut from Masonite, drilled with fifty holes, sealed with oil-base paint, and trimmed with Italian lights. By the time Jack and Laura had finished making thirty of them, they had devised so many ways the snowflakes could be displayed that they were certain they had invented a marketable product.

With a burst of entrepreneurial zeal, they built several prototypes (which also trim the house), patented the design, researched manufacturers, and spent a sizable amount of money having 7,500 (a minimum shippable container amount) of the high-quality PVC snowflakes manufactured in China.

The surprise came when the majority of the retail world did not share Jack and Laura's enthusiasm for a well-made decoration with a higher price point, nor did they care to do business with a company that had no other products to offer than a sturdy snowflake. After disappointing sales and numerous attempts to market their invention, Jack and Laura decided to cut their losses and sell their remaining inventory on www.snowflakesinmotion.com—a homemade website that inadvertently screams, "We are not going to throw another dime into this."

Visitors to the Frohn display, who admire the sturdy glittering snowflakes that twirl from the trees, blink from the windows, dance across the roof, and randomly sparkle in the crisp winter air like a lightly falling snow, need only knock on the door to purchase a single snowflake or an entire blizzard. But be advised . . . if you also happen to notice the lovely handmade balls of lights hanging from the trees, you may want to avoid suggesting they try to market them.

Fri. after Thanksgiving–New Year's Eve, 5:30PM–10:00PM. *From Naperville Rd., W on Boughton Rd. ½ mi., S on Vincent Dr. 4 bl., W on Clear Dr. 1 bl., S on Tecumseh Dr. 1 bl.*

CREST HILL

3 2400 BLOCK OF DURNESS COURT

"Our parents can move, but we're not moving," said Nate Albert and Ryan Proffitt as they basked in the glow of the cul-de-sac they helped turn into a holiday showplace with their friend Billy Burns. The boys grew up together on Durness Court, playing ball and running tag, and now they were decorating the block together.

In 1999, Nate got the idea that it would be cool if everybody on the court would light their parkway trees in alternating colors of red and green. Not wanting to go it alone, he got Ryan and Billy to help pass out flyers to all the houses.

Much to their delight, when the holiday season arrived, all the neighbors not only lit their trees but went wild decorating their houses. And cars began driving down the street just to see the display.

Spurred by their success, the boys sent a flyer the following year asking everyone to put arches over their sidewalks. Once again the neighbors responded with wholehearted enthusiasm. Mr. Swanson and his friend Ray

Visitors to Durness Court can take a stroll under the lighted arches to deliver their letters to Santa.

helped make the arches and built a sign that read, "Happy Holidays from Durness Court." Mrs. Burns made signs for each home that said, "From Our House to Yours." The boys helped assemble the arches and hang lights in the trees, and suspended Santa and his reindeer over the street.

Though the boys have since grown and moved away, the gleaming block still celebrates their happy venture on the second Saturday of December with a holiday party for all who visit—including the boys.

Dec. 3–New Year's, Dusk–12:00AM. *From Rt. 53, W on Caton Farm Rd. 2 mi., N on Durness Ct.*

Tropical "palm trees" line Keywest Drive in Lockport.

LOCKPORT

4 1200 and 1300 Blocks of Keywest Drive

For an imaginary tropical escape from the Midwest's frigid winter, take a winding cruise down Keywest Drive where dozens of parkway trees are lighted to resemble island palms in tune with the street's namesake.

Though begun as a fluke in 1998 by Michelle Miranda as she attempted to trim her tree in the cold, admiring neighbors followed suit the following year after Starlynn Londos rallied the effort with a door-to-door flyer. The simple decoration, requiring four strands of lights and an extension cord tucked in the crack of the sidewalk, has resulted not only in a fun-filled Floridian effect but a friendly competition among the neighbors to see who can create the best fronds. A few enterprising residents added lighted "coconuts," and a pink flamingo soon followed.
Weekend after Thanksgiving–New Year's Eve, Dusk– 10:00PM. *From 159th St. (Rt. 7), N on Farrell Rd. ¾ mi., W on Keywest Dr.*

Attaching Lights to Bricks

Though plastic clips offer many solutions to hanging lights from gutters, windows, and roof shingles, hanging lights from bricks presents its own set of problems. Some decorators have drilled anchors and screws into the mortar, while others have found hot glue or rubber suction hooks smeared with petroleum jelly to be effective—and less damaging—solutions.

5 1320 Newbridge Avenue

Born in 1954 to Frances and Glen Durling, who were locally famous from 1944 to 1993 for their phenomenal holiday display in Bancroft, Michigan, Warren Durling never knew childhood Christmases without the glow of lights coming through his bedroom window, the tinkling of carols as he fell asleep, or the sounds of unexpected company wishing holiday cheer.

Years before outdoor holiday lights, plastic snowmen, and waving Santas became familiar holiday sights, Warren's parents trimmed the house with lights and filled their 200-foot front yard with a collection of mechanized plywood figures the couple made themselves. A talented engineer with exceptional mechanical skill, Glen enjoyed building household gadgetry, from an aerial swing set for his kids to a midsize tractor for mowing his 9-acre lot.

His first holiday invention was a revolving Christmas tree base with conducting brushes and plates that allowed a lighted tree to spin in place. In the years to follow, Frances joined the effort by creating enlarged patterns, using a pantograph, of cartoon figures from coloring books, greeting cards, and napkins. Glen would cut them from plywood, the couple would paint them, and Glen would motorize them.

Warren Durling's spinning Christmas tree is an annual tribute to his father, who started the family decorating tradition in 1944.

Warren still describes with pride the homemade decorations that annually drew crowds from Detroit to Flint—the storybook train that climbed a hill, the twirling candy-cane Ferris wheel, the holiday picture with rotating panels, the life-size Santa and reindeer that rocked back and forth and stretched 30 feet across the yard, and the 6-foot angel that flew down from a TV antennae to the shepherds and sheep below.

When Warren was old enough, helping put up the Christmas display became a normal part of his holiday routine, and when he had a family and home of his own, his routine became that of his parents. An engineer with mechanical skills as well, Warren began building his own decorations in 1983 using his dad's techniques and some of his mom's patterns. His job took him from Dayton, Ohio, to Sun Prairie, Wisconsin, to Richmond, Virginia, before arriving in Lockport in 2001, but his decorations and local celebrity followed him wherever he moved.

"My current front yard is the most constrained I've ever been," Warren remarks. So he staggers the decorations to fit more in the space and, as his parents did, annually alternates between his secular and religious displays.

In addition to the repainting and repairing he often starts in August, he continues to create new figures from the boxful of his mom's patterns and plans to recreate some of his father's designs with the original mechanisms he's saved. After working for the last twenty-some years on his own display, Warren laments, "Looking back, I didn't help as much as I should have."

2nd weekend of Dec.–weekend after New Year's, Dusk–11:00PM. *From 159th St. (Rt. 7), N on Farrell Rd. ¾ mi., W on Keywest Dr. 1 bl., S on Glenmore St. 1 bl., W on Newbridge Ave. ¼ bl.*

6 946 EAST NORTH STREET

Among most Christmas enthusiasts, the men decorate the outside of the house, and the women the inside. Though each partner seems to prefer their assigned domain, it's tough to wager who's getting the short end of the stick.

Sitting pretty in the middle of a snowy 5-acre lot, the Matiaseks' country Victorian home is aglow inside and out.

Consider the home of Bill and Jill Matiasek. Those who view their 3,500-square-foot Victorian farmhouse—where the eaves on both stories are trimmed in two kinds of lights reaching up to the highest peak, over twenty bushes are sparkling in a rainbow of colors, the trees are glistening with bulbs of white, and a glowing star is mounted on the very tip of the rooftop turret—would likely bet that Bill has the more difficult and time-consuming task.

However, the savvy observer would note three full-size decorated Christmas trees in the windows of the turret, two in the bay, and one through the front door and place the odds on Jill, who seems to have her work cut out for her.

Then again, both Bill and Jill have their game plans down after decorating in a similar manner for over fifteen years. All Bill's lights and extension cords are labeled and stored in plastic bins. Though some of the high spots require a ladder, an extendable hook used for his boat makes hanging lights in the trees an easy task. Jill, on the other hand, recruits her family to form an assembly line to carry her twenty-some boxes of tree decorations to the rooms for which they are marked, where each tree is trimmed in a different theme. Both partners finish decorating on the same day.

But when the cards are laid on the table, it's Jill who holds the high hand. It seems she starts decorating two weeks sooner . . . there are seven more Christmas trees in the rest of the house.

Dec. 1–New Year's, Dusk–10:00PM. *From 159th St. (Rt. 7), N on Farrell Rd. ½ mi., W on North St. ¾ mi.*

MOKENA

7 10600 AND 10700 BLOCKS
OF FIRST COURT

When newlyweds Cedric and Sharon Hentsch purchased a house on First Court in 1992, they not only moved furniture, dishes, clothes, and wedding presents into their first home but six candy canes, twenty tin soldiers, two lollipops, one sleigh, four reindeer, a 40-inch snowman, a 32-inch Santa, twenty-five sets of lights, and a North Pole sign. Although Cedric's dad, Ervin, had been helping him set up his growing collection in the front yard for the last five years, he made it clear that when Cedric moved, the decorations would go with him.

Though visitors may glimpse First Court from the Rock Island Line or drive past in the warmth of their cars, the twinkling block is best viewed strolling down the street.

As luck would have it, the other homes in the new First Court development were owned by holiday decorators happy to have Cedric join the fray and take the lead. "As more new families moved in, there seemed to be an unspoken understanding that you couldn't live on our street unless you decorated for Christmas," says Suzanne Spurck, one of the original residents, whose home features a lighted horse and sleigh. "You'd feel bad if you didn't jump on the bandwagon," says Mayor Joe Warner, who moved on the block in 1994 and now broadcasts Christmas carols from blow horns mounted in his trees. "Cedric is the guru. He sets the pace and holds the bar."

All twenty homeowners on the block now decorate extensively, including Cedric's sister and her husband, Vern, who built a 6-foot Santa's toyshop with animated characters and a moving train. The neighbors add to the dazzling effect by lighting all the parkway trees in white and green. Many also followed Cedric's lead, lining their walks with candy canes, which earned First Court a local reputation as "Candy Cane Lane" and made it a popular Mokena holiday destination.

And though Ervin Hentsch managed to free himself from the annual job of helping his son set up the display, it seems he still reaped the consequences—one night when visiting Cedric during the holiday season, a driver bedazzled by the lights outside his son's home rammed into the back of Ervin's car.

Dec. 1–New Year's Eve, Dusk–11:00PM.
From Mannheim Rd. (Rt. 45), W on 191st St. (Rt. 84) 1½ mi., S on School House Rd. ½ mi., E on First Ct.

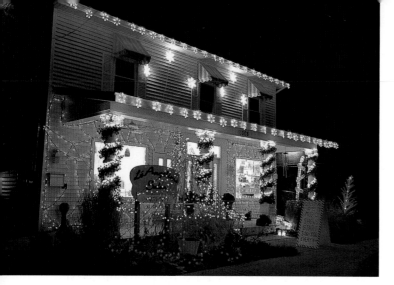

Annual winner of the Mokena Beautification Award, Le Angeline's Salon features a splendid garden from May to October and a colorful light display throughout the holiday season.

8 11008 FRONT STREET

Two-time winner of a national make-over contest, hair stylist Laura Thiel is not one to leave her home/hair salon unadorned for the holidays or her beauty-school techniques back in the shop. A hairnet of green lights stretches across the facade of the 150-year-old farmhouse. Snowy garland is roller set on four Ionic columns. And glittery blue snowflakes frost the eaves.

Weekend before Thanksgiving–weekend after New Year's, Dusk–12:00AM. *From 191st St., S on Wolf Rd. 1½ mi., E on Front St. ½ mi.*

MONEE

9 25825 TRUMAN COURT

Since trimming the balcony of their first apartment for Christmas in 1994, Bill and Lynn Sawallisch had always enjoyed decorating just for fun. But after thirteen years it seemed to have grown into more than a holiday hobby. They had accumulated 35,000 lights and 226 plastic figurines from garage sales, stores, hand-me-downs and online purchases. They had built 6-foot guardhouses, an animated display case, choir risers, and a lighted trellis that spanned the driveway. They had gotten expert electrical assistance from their friend and electrician Dave Wilson. They had worked seven months computerizing their lights to music. They had spent April and May mapping out the display. They had started setting up the decorations in October. And by the time they had finished, they were understandably longing

for more than a handful of people to come and enjoy their efforts. "Our house is off the beaten path, so if ten cars came by a night, we were lucky," Bill says.

As fate would have it, one of the local residents, who happened by the display and was sizably impressed, informed Bill that he was good friends with a reporter for the nightly local news and would tell him about the display. Two long weeks later, the reporter and a film crew arrived at the Sawallisch home, where they remained for five hours preparing the news clip. The three-minute segment aired at 9:00 p.m. and re-aired the following day at 7:00 a.m. and noon.

By that evening, when the station's anchorwoman gave directions to the Sawallisch home due to the "tremendous response to our story last night," Lynn had already been panic struck for several hours frantically calling Bill at the bowling alley, where he was in the middle of league play. "You have got to come home," she pleaded for the seventh time. "There are hundreds

ANCHORING PLASTIC FIGURINES

Though many decorators fill the bottoms of plastic figurines with rocks or sand to keep them from toppling over, there are alternative solutions.

Rick Esposito of Tinley Park makes ⅛" x ½" x ½" pointed metal stakes, which he screws into the back of each figurine, leaving 6 inches extending to push into the ground.

Danny Murov of Glenview cuts pieces of ½-inch rebar in lengths at least 6 inches longer than each figurine. He then pounds the rebar into the ground in position until even with the top of the figurine and secures the figure at the top and bottom to the rebar with #14 electrical wire, which comes in a variety of colors. Conduit can replace the rebar.

Former Downers Grove decorator Rion Goyette drilled three holes evenly spaced an inch above the base of the figurine and large enough to accommodate the hook of a tent stake. After placing the figurine in position, he pushed three stakes into the ground, inserting the hook ends into the drilled holes.

of people standing in the cul-de-sac. Cars have filled up the street. The neighbors are upset—they can't get out of their driveways. There are people putting their faces up to the living-room window and looking in. Bill, please. You have got to come home."

By the time Bill arrived after finishing his second game, the last computerized light show had ended, most of the people had left, and he pulled into the driveway without a problem. "I was freaking out," Lynn told her skeptical husband. "It was scary. It was total chaos." Despite his disbelief, Bill laid awake all night thinking, "What did I just do?"

Hedging his bets the next day, he lined up two buddies to help direct traffic, purchased orange construction cones, and made no-parking signs and placed them in front of the neighbors' driveways. When the light show started, just as Lynn had reported, hundreds of cars began parading down the formerly quiet cul-de-sac. The men directed traffic for five hours. Bill was up again all night, too nervous to sleep.

After the police, the village, and local restaurants were barraged with phone calls from people asking for directions and two neighbors called in complaints about the traffic, Monee Deputy Chief Cipkar stopped by the Sawallisches on Friday afternoon to see if he could help. He agreed to block off the street to nonresidents and provide officers on the weekends to direct visitors to street parking nearby.

With the officers' help, the crowds and cars were successfully under control, the neighbors were happy, and Bill and Lynn were finally able to enjoy their fame. They had food catered every weekend to feed the police and unexpected old friends. They stood outside with their kids during nearly every show and talked to many of the 500 to 1,500 people who visited the display nightly. "It was easier to be outside anyway," Lynn says. "I was living in total darkness in the house. Bill made me keep all the lights off so it wouldn't ruin the effect."

As Christmas drew near, Lynn thought it would be fun to have a visit from Santa. Bill's mom, who got him into decorating as a boy, acquired a donation of coloring books, crayons, and hot cocoa from the local Petro gas station where she worked. On the weekend before Christmas, Santa arrived and passed out the free gifts to the kiddies, while Bill maintained control and Lynn gave out candy canes and one thousand cups of hot cocoa, dressed in an elf costume.

As the following Christmas drew near, the Sawallisches seemed to have the situation completely under control. "Being on TV changed my life. We couldn't go anywhere. I couldn't do anything," Bill said. "It was an amazing experience." To which Lynn added, "I love doing this with Bill."

Bill and Lynn Sawallisch computerize their light display to a few new Christmas songs every year.

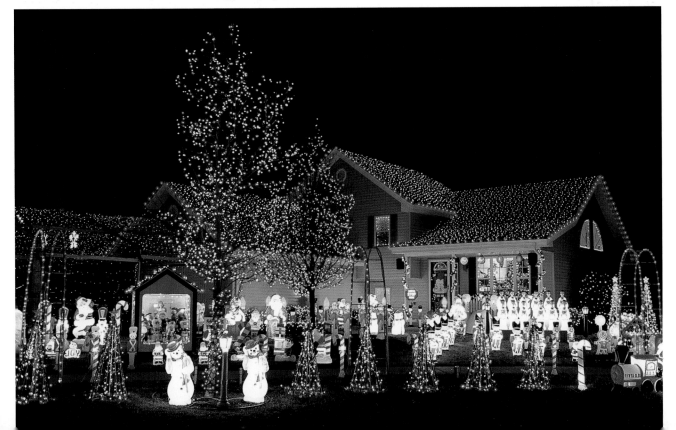

"There must be something about being outside with the sleigh and lights," Santa said of the Telkes's display. "We don't get any criers here."

Fri. after Thanksgiving–New Year's Eve, (Su–Th) 5:30PM–10:00PM, (F–Sa) – 11:00PM. Computerized show begins on the half-hour. Santa: 2nd and 3rd Sat. of Dec. 6:00PM–? *From I-57, E on Monee-Manhattan Rd. ¼ mi., S on Egyptian Tr. 3 bl., W on Roosevelt St. 5 bl., S on Truman Ct. Park and walk to end of cul-de-sac.*

TINLEY PARK (ALSO SEE COOK COUNTY SOUTH)

10 8930 FAIRFIELD LANE

With a playful giggle that could coax the Grinch and Scrooge to exchange gifts and a 285-pound frame that requires no padding, homeowner Henry Telkes seemed destined to add Santa Claus to his family's already popular display.

Having gained local holiday fame at their former home at 120th Street and Laramie Avenue in Alsip, the Telkes family hit the snow running when they landed in Tinley Park in 2000 and proceeded to win first place in the town's decorating contest three times. By 2004, their ever-growing collection of decorations had already covered the house and filled the yard leaving only the driveway and garage untrimmed. So Henry and his son, Henry James, constructed a tunnel, covered with six thousand lights and flanked by nutcrackers in guard stations, that spanned the entire driveway. With the help of his daughter, Sarah, who handles the extension cords, and his wife, Mary Beth, who decides where things should go, Henry filled the entire three-car garage with animated characters in playful holiday scenes that visitors could view through Plexiglas. The large, empty, concrete driveway now begged

for Santa's arrival. So when generous neighbors offered to let the Telkes use their driveways for their cars (one neighbor even put a clause in his sales contract), Henry could almost feel the heat of Rudolph's nose.

He and his son built a shiny red sleigh filled with lighted presents and trimmed with twinkling candy canes. Then Henry bought a warm $600 velvet suit so Santa would be toasty in the frigid south-suburban winds. Finally, he coaxed his mother-in-law, Marion Kelly, the official Telkes household public relations manager and a personal friend of Mrs. Claus (as the story goes) to put in a good word to the North Pole. And, lo and behold . . . two weeks before Christmas, Santa appeared and settled into his new "Midwestern Pole" location.

As soon as word got out, the children began to arrive—150 the first year, 300 the second, and (at last count of candy canes) 900 now visit Santa in the Telkes driveway each holiday season. Though Henry and his family spend four to ten hours a day for nearly five weeks preparing for Santa's arrival, Henry concedes, "The look in the kids' eyes is priceless and worth everything we put into this. Once while we were setting up the display, two little neighborhood girls asked if they could sit in the sleigh. I overheard one of them say, 'You know, the Santa we saw at the mall is just a helper. The one who sits here is the real Santa.' That made my day."

Dec. 7–Sun. after New Year's, 5:00PM–11:00PM. *From La Grange Rd., E on 191st St. 1 mi., S on 88th Ave. 1 mi., W on Fairfield Ln. 1 bl.*

Outlying Areas

BELLEVILLE

11 NATIONAL SHRINE OF OUR LADY OF THE SNOWS 442 SOUTH DEMAZENOD DRIVE

The National Shrine of Our Lady of the Snows is a peaceful retreat throughout the year to pilgrims who visit from all over the world. With 200 acres of beautifully landscaped grounds, it is not only one of the largest outdoor shrines in North America but also hosts one of the oldest light displays in the United States.

COURTESY OF NATIONAL SHRINE OF OUR LADY OF THE SNOWS

Two-thirds the size of the original Lourdes Grotto in France, the replica at the National Shrine of Our Lady of the Snows portrays the story of Christ's birth.

Since 1970, "Way of Lights" has told the Christmas story along a mile-and-a-half wooded path drenched in more than a million white lights. Amidst the glistening trees and bushes, life-size figures of angels and villagers, shepherds and their flocks, the three kings, and the town of Bethlehem light the way to Baby Jesus in the manger.

The flavor of Bethlehem continues at the outdoor petting zoo, which features sheep, burros, cattle, and a baby camel. Camel rides are available for a small fee.

Midway down the path at the Visitors Center, children can have their photo taken while dressed as an angel, adults can marvel at the designer Christmas trees and wreaths, and all can enjoy a joyful choir, a home-cooked buffet, and holiday shopping at the gift shop. **Light display: Nov. 15–Jan. 6, 5:00PM–10:00PM. Closed Thanksgiving and Christmas. Free admission. (618)397-6700. www.snows.org/wol.** *From Chicago, SW on I-55 283 mi., S on I-255 9 mi., E on Rt.15 1½ mi.*

BISHOP HILL

12 TOWN DECORATIONS

For those who long to escape the hectic pace of the holiday season and find a simple Christmas of long ago, a visit to Bishop Hill may be just the right prescription. Three hours west of Chicago, this rural town of approximately 130 residents lies in the rolling farmland of Henry County near the Edwards River. Settled by Swedish immigrants in 1846, the town has retained much of its simplicity and charm. Original paths and buildings of stucco and handmade bricks subtly transport visitors back in time.

During the holidays, candles shine from every window, and Swedish *tomten* (gnome-like creatures) hide in the trees. Shops are filled with traditional ornaments of woven wheat, handmade and imported gift items, and antiques. Swedish meatballs, home-baked rye bread, fruit pies, and luscious tortes enjoyed in the cozy atmosphere of the town's three restaurants add the perfect touch of warm Scandinavian hospitality to a winter's day.

Though Bishop Hill is quiet during the week, on the two weekends after Thanksgiving, it is bustling with the celebration of "Julmarknad"—the Christmas Market, when shops bring out their yuletide wares, offer samples of potato sausage and lingonberry jam, and dress in their holiday finest. Swedish folk characters roam the streets, traditional music fills the air, and the town's best bakers offer homemade treats.

The following weekend, luminarias line the streets for the celebration of "Lucia Nights," the Festival of Lights. Throughout the town, coffee and cookies are served by young girls dressed in white and wearing crowns of candles in honor of Santa Lucia, the patron saint of lights.

A National Historic Landmark since 1984, Bishop Hill is also home to several museums and original structures that tell the story of its beginnings as a religious communal settlement and center of commerce. **Fri. after Thanksgiving–New Year's. Museums: (W–Su) 9:00AM–4:00PM. Restaurants: (Daily) 11:00AM–2:00PM. Shops: 10:00AM–5:00PM (hours may vary). (309)927-3345. www.bishophillartscouncil.com.** *From Chicago, W on I-80 150 mi., S on Rt. 78 11 mi. to Kewanee, S and W on Rt. 34 15 mi. (4 mi. past Galva), follow signs N to Bishop Hill 2 mi.*

EAST PEORIA

13 "FESTIVAL OF LIGHTS"

This riverside town of 22,000 has put its name on the map with a dazzling holiday display that annually attracts crowds over ten times its size. It's the "East Peoria Festival of Lights," an impressive extravaganza of yuletide exhibits and events made possible through the efforts of hundreds of community volunteers.

The festival kicks off on the Saturday after Thanksgiving at 5:45 p.m. when nearly forty brilliant handmade

floats decorated with an estimated half-million twinkling bulbs dazzle thousands of spectators in the "Parade of Lights" along the 3-mile Washington Street route.

Since the parade began in 1985 with twelve floats, each sponsored by a local business, new ones have been added each year. Volunteers construct the black pencil-steel frames and mount them on black stripped-down cars or golf carts. By mid-September, volunteers are working seven days a week attaching light strands to the frames with plastic bread-bag ties. The results of their efforts have been compared to the floats seen at Disneyland.

By the evening after the parade, the lighted floats are on display throughout the Christmas season in a variety of delightful exhibits named for the festival's toy soldier mascot, Folepi, an acronym for Festival Of Lights East Peoria Illinois.

The most extraordinary is "Folepi's Winter Wonderland," a 25-acre municipal park that has been transformed into a holiday fantasyland. A tunnel of leaping reindeer greets visitors to the two-mile drive-through path, which features most of the parade floats along with sixty-five other lighted displays arranged in colossal theme areas. Spectacular throughout, the drive ends in like style with a 40-foot-high fiber-optic fireworks display.

Other attractions include "Folepi's Riverfront Promenade," a one-mile walking path lit with holiday decorations that sparkle off the adjacent Illinois River; "Folepi's Village," an indoor exhibit that features a 700-piece miniature Northwest Territory holiday town created by local craftsman Randy Kellems, a musical laser light show, dozens of decorated Christmas trees, visits with Santa, rides, and refreshments; and "Narrated Nativity," hand-painted murals of the Christmas story with a radio-broadcast soundtrack. East Peoria itself is decked out for the occasion in 2.5 million lights and an assortment of giant decorations that appear throughout the town.

Rated one of the "Top 100 Events in North America" by the American Bus Association and recipient of the 1987 Governor's Hometown Award, the East Peoria Festival of Lights is not only an event worth the three-hour drive from Chicago but a tribute to the spirit of the volunteers that have made it a success.

Sat. after Thanksgiving–New Year's Eve. Lighted exhibits: 5:00PM–10:00PM. Closed Christmas. Some admission fees. (800)365-3743. www.peoria.org.

From Chicago, S on I-55 140 mi., W on I-74 30 mi. Follow signs to exhibits. Brochures available at the Festival Building/ FOLEPI's Village, 2200 East Washington Street. See photograph on p. 175.

Northwest Indiana

DYER

14 2833 LANCELOT LANE

"We're back again," a neighborhood mom told Jim Rodda as her three little girls ran to his animated garage scene. "I don't know how many times I've been here."

Kids and adults alike find plenty to admire on this ½-acre corner lot that features many unique decorations not found in the average front-yard display. "I always try to look for things that no one else has," Jim says, "but it's getting tougher and tougher."

Three fiberglass snowmen on a snowy hill and a propeller plane with a waving Santa were purchased from a commercial display company in California. Two 7-foot

Despite a fall from his roof in 1995, Jim Rodda still manages to assemble a sizable holiday display with help from family and friends.

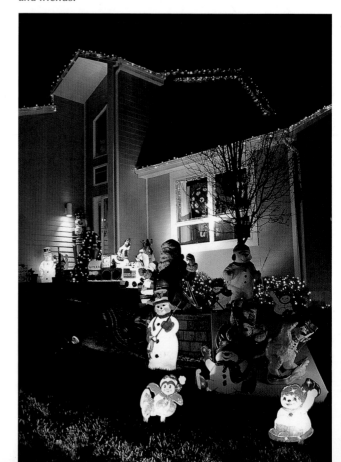

Santas, as wide as they are tall, were acquired from a New York importer. A polka-dotted hot-air balloon had been a Deptartment 56 display piece, and a life-size animated Santa was a midseventies creation of Hamberger Displays (now Center Stage Productions) in New Jersey. Kids playing in the snow and bears rocking on a teeter-totter in the garage scene were products of Marshal Moody Displays in Dallas. Two-dimensional wooden figures were built by a couple in Michigan, and the three-dimensional spinning carousel was handmade by Jim's uncle, Mike Seljan. Even the images projected on the side of the house were custom-made by RazTech Lighting and reflect personal messages, such as "Happy Holidays from the Roddas."

But the decorations that are most dear to Jim's heart are the old plastic figurines of Santas, snowmen, candy canes, lollipops, and teddy bears that once adorned his childhood home. They bring back happy memories of decorating with his dad when he was a little boy.

Jim now hopes to create the same childhood memories with his own son, Gage, and said proudly, "He was already helping me carry things out at three years old." **Dec. 1–New Year's, 6:00PM–10:00PM.** *From Rt. 394, E on Steger Rd./81st St. 3¼ mi., N on Hart St. ½ mi., E on 77th Ave. 1 mi., NW on Calumet Ave. 1 bl., NE on Knighthood Dr. 4 bl., S on Lancelot Ln. 1 bl.*

HAMMOND

15 3033 CRANE PLACE

"Lovely, glorious, beautiful Christmas, upon which the entire kid year revolved," narrates screenwriter Jean Shepherd, as Ralphie Parker, in his 1983 film *A Christmas Story*. A native of Hammond, Indiana, Shepherd based his semi-autobiographical story on his memories of growing up at 2907 Cleveland Street in the 1940s.

Four blocks away at 3033 Crane Place, it may seem that the spirit of Ralphie's "Old Man" exists today in homeowner Pete Basala, who has similarly had his share of laughable holiday mishaps. After carefully outlining his house with lights and running extension cords through his windows, the wires were attacked by squirrels. The 8-foot wooden carousel he built was so big he had to drag it behind the garage for the off-season, where it eventually rotted. And nearly every season in the middle of changing

bulbs, he walks into the house and sits silently in his chair after getting an electrical shock.

However, after twenty years of decorating and honing his technique, Pete is actually more like Ralphie than his accident-prone old man. "I think about Christmas throughout the year," he admits with the enthusiasm of a ten-year-old boy hoping to get a BB gun.

The result is a delightful holiday display dubbed "Peteyville" that has been attracting crowds since 1987. With the help of his wife, Tina, and his neighbor, Marty Stiglitz, Pete trims the roof and sides of the house with over seven thousand C-7 bulbs and fills the yard with over thirty blow-up figures. In addition to a new collapsible 12-foot Ferris wheel, other handmade decorations include a life-size teeter-totter, spinning teddy bears, a pop-open Christmas present, a 7-foot Styrofoam stocking, and a tunnel of lighted archways.

But proudly displayed in the living-room window is the best decoration of all—the old man's famous leg lamp—a Christmas gift Pete had been wishing for all year. **Thanksgiving–New Year's Eve, 5:00PM–10:00PM.** *www.peteyville.net. From Bishop Ford Fwy. (IL-394), E on I-80 6 mi., N on Kennedy Ave. 2¼ mi., E on 165th St. 4 bl., N on Delaware Ave. 2 bl., W on Crane Pl. ½ bl.*

MICHIGAN CITY

16 "WASHINGTON PARK FESTIVAL OF HOLIDAY LIGHTS" LAKE SHORE DRIVE AT FRANKLIN STREET

In 1988, when Maintenance Director Darren Westphal and Assistant Maintenance Director Wally Veden decided on a whim to turn a lamppost in Washington Park into a lighted Christmas tree for the holidays, it took them little over a half-hour to complete the task and light a few small trees as well. Twenty years later, it takes the two men eight to ten weeks to decorate the park with the help of eighteen full-time staff.

It seems the initial lights drew such a positive response that the following year the men also lit the band shell. Maxing out the park's electrical power, they installed wiring for a few more amps to add some metal-frame decorations. In 1990, the entire 30-acre park was rewired with ample power spread throughout the grounds. Darren explains, "That's when we started going crazy."

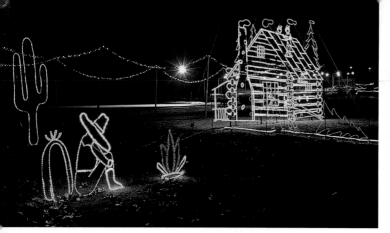

In one of Washington Park's delightfully original animated displays, a cowpoke takes a nap by the log cabin while an elf peeks in from the rooftop and the kids hurry home with a freshly cut tree.

Wanting to feature decorations different from those available commercially, Darren began sketching original ideas for two-dimensional animated displays—kids rolling a ball of snow to build a snowman, penguins climbing a tree to hang a star, children dragging an evergreen to trim a log cabin, and longtime municipal band director Guy Foreman leading a trio of musicians in the band shell. After receiving additional input from his staff, Darren had his drawings refined and manufactured with funding from the city at Hermans' Christmasland, a steel-frame display manufacturing company in Pierceton, Indiana.

One major display is now purchased each season to add to the collection of over two dozen large displays and 125 smaller decorations that annually transform Washington Park into a dazzling holiday extravaganza. "This is really a team effort of the whole staff," Darren says. Recently rated one of the "Top 100 Events in North America" by the American Bus Association, the free drive-through/walk-through display now attracts over 100,000 visitors a year.

On the first Saturday of December, the mayor flips the ceremonial switch to light the park at 5:00 p.m. Additional festivities include a chili cook-off, horse-drawn wagon rides, a giant bonfire, and refreshments. Across the street, Washington Park Zoo (noted for its WPA landmark buildings) joins the fun throughout the weekend with "Zooltide," a nighttime event featuring holiday lights, visits with Santa, free refreshments, carolers, and strolls through its historic landscape.

Washington Park: 1st Sat. of Dec.–weekend after New Year's, Day and night. Free admission. (219)873-1506. www.emichigancity.com.

Zooltide: 1st Sat. and Sun. of Dec., 5:00PM–7:00PM. (219)873-1510. www.washingtonparkzoo.com. *From I-94, N on US-421/ Franklin St. 3¾ mi., W on 11th St. 1 bl., N on Pine St./ Franklin St. 1 mi., W on Lake Shore Dr. 1 bl.*

SCHERERVILLE

17 TEIBEL'S
US ROUTES 30 AND 41

It appears that Teibel's lives up to its slogan, "The Ideal Family Restaurant," in more ways than one. Opened in 1929 by brothers Martin and Stephen Teibel, the locally famous restaurant has operated as a family business for four generations and still uses the same tasty fried-chicken recipe that Grandma Teibel brought back from Austria. And with a menu that offers full, moderate, and children's portions of their fried chicken and famous lake perch, among other tasty entrées, Teibel's offers their patrons dining that every member of the family can enjoy.

But during the holiday season this home-style restaurant delivers on its motto full tilt. Luminarias lead patrons to the parking lot surrounded by twenty-six evergreens glowing with colored bulbs and giant candy canes. Outlined in lights and topped with an assortment of whimsical rooftop figures, the exterior of the restaurant offers a sneak peek of the holiday fantasyland within.

"It's hard to keep the kids in their seats when they know there are trains in the lobby," laughs owner Steve Teibel, who began the holiday trimmings in 1973. An LGB set tours an elaborate Christmas village, and an HO model chugs through a giant globe. Animated scenes of snowmen spinning, Santa waving, and beavers hiding, fill every corner.

Steve and his wait staff spend hours hanging the trimmings in the restaurant's off hours. "You get tired and a little grumpy after spending so much time putting up decorations," Steve admits, "but when that first kid comes running down the lobby all excited, it's all worth it."

Fri. after Thanksgiving–Sun. after New Year's, (M–Th) 11:00AM–9:00PM, (F–Sa) –10:00PM, (Su) –8:00PM. Closed Christmas. Available for parties. Reservations recommended. (219)865-2000. www.teibels.com. *From Bishop Ford Fwy. (IL-394), E on US Hwy. 30 6½ mi.*

Appendix

The following is a list of commercial enterprises mentioned in this book that provide holiday products or services.

DECORATORS AND SUPPLIERS

Applied Imagination Ltd./ Paul Busse
661 Poplar Thicket Road
Alexandria, Kentucky 41001
(859)448-9848
info@appliedimagination.biz
www.appliedimagination.biz
Botanical architecture, garden railways, and seasonal displays. p. 38, 65

Becker Group
901 Cathedral Street
Baltimore, Maryland 21201
(800)777-9627
sales@beckergroup.com
www.beckergroup.com
Custom commercial displays. p. 28

Bronner's Christmas Wonderland
25 Christmas Lane
Frankenmuth, Michigan 48734
(989)652-9931
www.bronners.com
Year-round Christmas store. p. 67

Center Stage Productions
20–10 Maple Avenue
Fair Lawn, New Jersey 07410
(800)955-1663; (973)423-5000
info@cspdisplay.com
www.cspdisplay.com
Standard and custom animation. Animation repair. Commercial holiday décor. p. 83, 187

Decorations Unlimited
1245 Rand Road
Des Plaines, Illinois 60016
(847)827-7953
Commercial holiday décor. p. 117

Greens By White, Inc.
13833 West Boulton Boulevard
Lake Forest, Illinois 60045
(847)367-7200
dwhitejr@greensbywhite.com
www.greensbywhite.com
Interior landscapes, p. 19

Hamberger Displays (see Center Stage Productions) p. 83, 187

JALOR Design, Inc.
1443 West Briarcliff Drive
Bolingbrook, Illinois 60490
jalordesign@yahoo.com
www.snowflakesinmotion.com
Manufacturer and distributor of lighted outdoor snowflakes. p. 178

Marshal E. Moody Display, Inc.
1348 Motor Circle
Dallas, Texas 75207
(800)627-0123; (214)631-5444
timjr@marshalmoody.com
www.marshalmoody.com
Lights, banners, and artificial trees, garland, and wreaths. Animation repair. p. 187

Hermans' Christmasland
2 Arnolt Drive
Pierceton, Indiana 46562
(888)594-5544
htchristmasland@kconline.com
www.lightsforholidays.com
Standard and custom lighted wire-frame displays. Artificial trees and wreaths. Showroom. p. 129, 143, 144, 188

RazTech Lighting LLC
990 Richard Road
Dyer, Indiana 46311
(877)264-2153
sales@razlight.com
www.razlight.com
Standard and custom projectors, images, and lighting systems. p. 187

Sherwood Creations, Inc.
1459 North Leroy Street
Fenton, Michigan 48430
(800)843-2571
info@sherwoodonline.com
www.sherwoodonline.com
Woodcraft patterns, tools, and supplies. p. 36, 98, 112, 118

Springtime-Santa, Inc.
2901 Shermer Road
Northbrook, Illinois 60062
info@springtime-santa.com
Commercial only, sales representative group for manufacturers of seasonal products. Annual showroom sample sale to the public. (E-mail to be notified.) p. 101

TL Tree Service
10654 South Springfield Avenue
Chicago, Illinois 60655
(773)233-7070
Cherry-picker service for high outdoor lighting. p. 55

The Winfield Collection
3150 Owen Road
Fenton, Michigan 48430
(800)946-3435
info@ thewinfieldcollection.com
www.thewinfieldcollection.com
Woodcraft patterns and supplies. p. 36, 98, 112, 118

White Way Sign Company
451 Kingston Court
Mount Prospect, Illinois 60056
(847)391-0200
sales@whiteway.com
www.whiteway.com
Commercial only, lighting and signage. p. 47

CLUBS

The Golden Glow of Christmas Past
www.goldenglow.org.
Organization for enthusiasts of Christmas antiques. p. 31

TO SUBMIT A DISPLAY

Decorators or others wishing to submit a Christmas or Halloween display in Chicagoland or other locations for consideration for possible future editions of this book may do so by e-mailing the form provided online at www.christmashouses.com or by sending as much descriptive information as possible (and photos, if available) to Mary Edsey, P.O. Box 578913, Chicago, IL 60657-8913.

Index